Digital
Photography
THE MISSING MANUAL

*The book that
should have been
in the box*

OTHER DIGITAL MEDIA RESOURCES FROM O'REILLY

Digital
Photography
THE MISSING MANUAL

Chris Grover and Barbara Brundage

Introduction by David Pogue

POGUE PRESS™
O'REILLY®

Beijing • Cambridge • Farnham • Köln • Paris • Sebastopol • Taipei • Tokyo

Digital Photography: The Missing Manual
by Chris Grover and Barbara Brundage

Published by O'Reilly Media, Inc., 1005 Gravenstein Highway North, Sebastopol, CA 95472.

O'Reilly books may be purchased for educational, business, or sales promotional use. Online editions are also available for most titles (*safari.oreilly.com*). For more information, contact our corporate/institutional sales department: (800) 998-9938 or *corporate@oreilly.com*.

Printing History:

June 2006: First Edition.

RepKover™ This book uses RepKover,™ a durable and flexible lay-flat binding.

ISBN: 0-596-00841-4
[F]

Table of Contents

Part Two: Organizing Your Photos

Part Three: Editing Your Photos

Part Four: Sharing Your Photos

The Missing Credits

About the Authors

Chris Grover got his first computer in 1982 when he realized it was easier to write on a computer than an IBM Selectric. He never looked back. Chris has worked as a technical writer, advertising copywriter, and product publicist for more than 25 years. In addition to computer topics, he's written book reviews, software reviews, and articles on subjects ranging from home remodeling to video recorder repairs. His latest project is the launching of Bolinas Road Creative (*www.bolinasroad. com*), an agency that helps small businesses promote their products and services. Chris lives in Fairfax, California, with his wife and two daughters who have learned to tolerate his computer and gadget obsessions.

Barbara Brundage is the author of *Photoshop Elements 4: The Missing Manual*. She's been teaching people how to use Photoshop Elements since it first came out in 2001. Barbara first got interested in Elements for creating graphics for use in her day job as a harpist, music publisher, and arranger. Along the way she joined the large group of people who are finding a renewed interest in photography thanks to digital cameras. If she can learn to use Elements, you can, too!

About the Creative Team

David Pogue (Introduction) is the weekly computer columnist for the *New York Times*, an Emmy-winning correspondent for *CBS News Sunday Morning*, and the creator of the Missing Manual series. He's the author or co-author of 38 books, including 17 in this series and 6 in the "For Dummies" line (including Macs, Magic, Opera, and Classical Music). In his other life, David is a former Broadway show conductor, a magician, and a pianist. News, photos, links to his columns and weekly videos await at *www.davidpogue.com*.

Derrick Story (co-author, digital photography material) focuses on digital photography, music, and Mac computing in his teaching and writing. You can keep up with his online articles, weblogs, and books at *www.oreilly.com*. Derrick's also a regular contributor to *Macworld* magazine and speaker at the Macworld Expo. You can listen to his photography podcasts and browse his daily tips and tricks at *www.thedigitalstory.com*.

Andy Rathbone (co-author, PC hardware and Windows material) started geeking around with computers in 1985 when he bought a 26-pound portable CP/M Kaypro 2X. He's written the *Windows For Dummies* series, *Upgrading and Fixing PCs for Dummies, TiVo for Dummies,* and many other computer books. Today, he has

more than 15 million copies of his books in print, and they've been translated into more than 30 languages. Andy can be reached at his Web site, *www.andyrathbone. com*.

Nan Barber (editor) has worked with the Missing Manual series since its inception—long enough to remember booting up her computer from a floppy disk. Email: *nanbarber@oreilly.com*.

Peter Meyers (editor) works as an editor at O'Reilly Media on the Missing Manual series. He lives with his wife in New York City. Email: *peter.meyers@gmail.com*.

Michele Filshie (copy editor) is O'Reilly's assistant editor for Missing Manuals and editor of *Don't Get Burned on eBay*. Before turning to the world of computer-related books, Michele spent many happy years at Black Sparrow Press. She lives in Sebastopol and loves to get involved in local politics. Email: *mfilshie@oreilly.com*.

Dawn Mann (copy editor) has been with O'Reilly for over three years and is currently an editorial assistant. When not working, she likes rock climbing, playing soccer, and generally getting into trouble. Email: *dawn@oreilly.com*.

Ken Henningsen (technical reviewer) is a digital event photographer, woodworker, Do-It-Yourself-er, and general gadget freak. He covers events of all sorts, including youth sports, weddings, and corporate events. One of his specialties is chroma key *green-screen* photography, digitally inserting fantasy backgrounds behind individual and group portraits. His photography and gadget musings can be found at *www.kenhenningsen.com*.

Rob Bourns (technical reviewer) got his start in the electronic world when he was a Marine working as a Ground Radio Repairman. He now works as a splicing technician for the phone company. On his off time, he uses his digital camera to record the wonders of life in the big city of Sebastopol. Email: *robbourns@yahoo.com*.

Rose Cassano (cover illustration) has worked as an independent designer and illustrator for 20 years. Assignments have ranged from the nonprofit sector to corporate clientele. She lives in beautiful Southern Oregon, grateful for the miracles of modern technology that make working there a reality. Email: *cassano@highstream.net*. Web: *www.rosecassano.com*.

The Missing Manual Series

Missing Manuals are witty, superbly written guides to computer products that don't come with printed manuals (which is just about all of them). Each book features a handcrafted index and RepKover, a detached-spine binding that lets the book lie perfectly flat without the assistance of weights or cinder blocks.

Recent and upcoming titles include:

Access for Starters: The Missing Manual by Kate Chase and Scott Palmer

AppleScript: The Missing Manual by Adam Goldstein

AppleWorks 6: The Missing Manual by Jim Elferdink and David Reynolds

CSS: The Missing Manual by David Sawyer McFarland

Creating Web Sites: The Missing Manual by Matthew MacDonald

Dreamweaver 8: The Missing Manual by David Sawyer McFarland

eBay: The Missing Manual by Nancy Conner

Excel: The Missing Manual by Matthew MacDonald

Excel for Starters: The Missing Manual by Matthew MacDonald

FileMaker Pro 8: The Missing Manual by Geoff Coffey and Susan Prosser

Flash 8: The Missing Manual by Emily Moore

FrontPage 2003: The Missing Manual by Jessica Mantaro

GarageBand 2: The Missing Manual by David Pogue

Google: The Missing Manual, Second Edition by Sarah Milstein and Rael Dornfest

Home Networking: The Missing Manual by Scott Lowe

iMovie6 & iDVD: The Missing Manual by David Pogue

iPhoto 6: The Missing Manual by David Pogue

iPod and iTunes: The Missing Manual by J.D. Biersdorfer

iWork '05: The Missing Manual by Jim Elferdink

Mac OS X: The Missing Manual, Tiger Edition by David Pogue

Office 2004 for Macintosh: The Missing Manual by Mark H. Walker and Franklin Tessler

PCs: The Missing Manual by Andy Rathbone

Photoshop Elements 4: The Missing Manual by Barbara Brundage

QuickBooks 2006: The Missing Manual by Bonnie Biafore

Quicken for Starters: The Missing Manual by Bonnie Biafore

Switching to the Mac: The Missing Manual, Tiger Edition by David Pogue and Adam Goldstein

The Internet: The Missing Manual by David Pogue and J.D. Biersdorfer

Windows XP for Starters: The Missing Manual by David Pogue

Windows XP Home Edition: The Missing Manual, Second Edition by David Pogue

Introduction

In case you haven't heard, the digital camera market is exploding. It's taken a few decades—the underlying technology used in most digital cameras was invented in 1969—but film is rapidly on the decline.

And why not? The appeal of digital photography is huge. When you shoot digitally, you never have to pay a cent for film or photo processing. You get instant results, viewing your photos just moments after shooting them, making even Polaroids seem painfully slow by comparison. As a digital photographer, you can even be your own darkroom technician—without the darkroom. Sharing your pictures with others is far easier, too, since you can burn them to CD, email them to friends, or post them on the Web. As one fan puts it: "There are no 'negatives' in digital photography."

But there is one problem. When most people try to do all this cool stuff, they find themselves drowning in a sea of technical details: JPEG compression, EXIF tags, file format compatibility, image resolutions, FTP clients, and so on. It isn't pretty.

The cold reality is that while digital photography is full of promise, it's also been full of headaches. During the early years of digital cameras, just making the camera-to-computer connection was a nightmare. You had to mess with serial or USB cables; install device drivers; and use proprietary software to transfer, open, and convert camera images into a standard file format. If you handled all these tasks perfectly—and sacrificed a young male goat during the spring equinox—you ended up with good digital pictures.

It took a few years, but the big software companies finally caught on. They made an enormous effort to simplify and streamline the post-shutter-snap experience.

Nowadays, transferring your camera's shots to your PC is a matter of making a couple of mouse clicks—and *doing* something with the pictures is equally easy.

Meet Digital Photography

When you use a film camera, your pictures are "memorized" by billions of silver halide crystals suspended on celluloid. Digital cameras, on the other hand, generally store your pictures on a memory card.

It's a special kind of memory: flash memory. Unlike the RAM in your PC, the contents of flash memory survive even when the machine is turned off. You can erase and reuse a digital camera's memory card over and over again—a key to the great economy of digital photography.

At this millisecond of technology time, most digital cameras are slightly slower than film cameras in almost every regard. Generally speaking, they're slower to turn on, slower to autofocus, and slower to recover from one shot before they're ready to take another.

Once you've captured a picture, however, digital cameras provide almost nothing but advantages over film. For example:

Instant Feedback

You can view a miniature version of the photo on the camera's built-in screen. If there's something about the picture that bothers you—say, the telephone pole growing out of your best friend's head—you can simply delete it and try again. Once the shooting session is over, you leave knowing that nothing but good photos are on your camera. By contrast, in film photography, you have no real idea how your pictures turned out until you open that sealed drugstore envelope and flip through the prints. More often than not, there are one or two pictures that you really like, and the rest are wasted money.

Instant feedback becomes a real benefit when you're under pressure to deliver excellent photographs. Imagine the hapless photographer who, having offered to shoot candid pictures during a friend's wedding reception, later opens the envelope of prints and discovers that the flash had malfunctioned all evening, resulting in three rolls of shadowy figures in a darkened hotel ballroom. A digital camera would have alerted the photographer to the problem immediately.

In short, digital photographers sleep much better at night. They never worry about how the day's pictures will turn out; they already know!

Cheap Pix

Digital cameras also save you a great deal of money. Needless to say, you don't spend anything on developing. Printing out pictures on a photo printer at home costs money, but few people print every single shot they take. (Nor should they. After all, where are most of your film prints now? In a shoebox somewhere?)

Printing out 4×6 prints at home, using an inkjet photo printer, costs about the same as what you'd pay at the drugstore. But when you want enlargements, printing your own is vastly less expensive. Even on the glossy 75-cents-per-sheet inkjet photo paper, an 8×10 costs about a dollar or so (ink cartridges are expensive), compared with about $4 ordered online. A poster-sized print from a wide-format photo printer (13×19) will cost you about $3.00 at home, compared with $15 from an online photo lab.

Take More Risks

Because you have nothing to lose by taking a shot—and everything to gain—digital photography lets your creative juices flow. If you don't like that shot of randomly piled shoes on the front porch, then, what the heck, erase it.

With the expense of developing taken out of the equation, you're free to shoot everything that catches your eye and decide later what to keep. That's how a digital camera can make you a better photographer—by freeing up your creativity. Your risk-taking will lead to more exciting images than you ever dreamed you'd take.

Easy Fixes

Straight from the camera, digital snapshots often need a little bit of help. A photo may be too dark or too light. The colors may be too bluish or too yellowish. The focus may be a little blurry, the camera may have been tilted slightly, or the composition may be somewhat off.

Fortunately, one of the amazing things about digital photography is that you can fine-tune images in ways that, in the world of traditional photography, would require a fully equipped darkroom, several bottles of smelly chemicals, and an X-Acto knife.

More Fun

Add it all up, and digital photography is more fun than traditional shooting. No more disappointing prints and wasted money. Instead, you enjoy the advantages of instant feedback, flexibility, and creativity.

Suddenly photography isn't just about producing a stack of 4×6 pieces of paper; digital photos are now infinitely more flexible. At the end of the day, you get to sit down with your PC and create instant slideshows, professional Web pages, email attachments, greeting cards, custom calendars, hardcover coffee-table photo books, and more. Shoot the most adorable shot ever taken of your daughter, and minutes later it's on its way to your adoring fans.

Photography doesn't get any better than this.

What You Need

Just like film photographers of yore, you won't get very far as a digital photographer without a few items in your toolkit. To get the most out of this book you'll need:

- **A digital camera.** You knew that, of course. But even if you don't have a camera in hand, this book will still serve you well: Chapter 1 is all about what to look for when you're buying a new, or replacement, camera.

- **A Windows-based PC.** Pretty much any flavor of Windows will do, though most of the advice you'll read about in this book is geared toward to folks whose PCs are running Windows XP. If you're one of the early adopters of Windows Vista, don't run away. The programs featured in this book will all run on your system. On the other hand, if you've got a computer from the good people at Apple, you'll want to check out *iPhoto 6: The Missing Manual.* It's got everything you need to get started with digital photography.

- **Photo-editing and -organizing software.** Your choices here run the gamut from free and easy-to-use programs like Google's Picasa to slightly more robust tools like Photoshop Elements. But you don't need to decide just yet which program to use. Each chapter highlights the pro's and con's of the half dozen or so programs covered in detail in this book; once you decide which application is best for you, you can download the one you want to use.

- **A printer.** Actually, this piece of photo-producing hardware is more of an option, than a necessity. That's thanks to the many photo printing services you'll learn about in Chapter 16. But if you want to churn out your own pictures right on the spot, you'll find full instructions on how to use your printer is also in Chapter 16.

About This Book

Even if your digital camera comes with a readable manual (highly unlikely), it doesn't really explain anything more than how to push the buttons. There's a lot more to digital photography than that. Your camera's manual won't help you cut through all the technical jargon and it won't teach you how to take better pictures. And once you have those works of art in your camera, you'll want to move them onto your PC, edit them, print them, and share them with your pals. Don't look to your camera docs for help there.

This book, then, is the manual that should have come with your camera. In these pages, you'll find real world help that covers the whole spectrum of digital photography. You'll find step-by-step instructions that show you how to organize, edit, print, and email your photos.

If you're an experienced film photographer making the move to digital you'll find helpful translations of terms you'd never hear in a darkroom. If you're a photo novice, special sidebar articles called "Up to Speed" provide the introductory

information you need to understand the topic at hand. Whether you take pictures with a Nikon digital SLR or a Nokia phone camera, you'll find new ways to work with your photos and share them with friends and family.

About the Outline

This book is divided into four parts, each containing several chapters:

- Part 1, *Digital Camera Basics*, equips you with the knowledge you need to choose the right digital camera—or navigate your way around the one you've already got—and how to take great photos. You'll learn what makes digital photography different from film photography and you'll also learn how to cut through the camera sales hype when you're shopping for a camera. And since there's a difference between operating a camera and taking good pictures, you'll also find important but easy-to-follow tips for taking great photos in every situation—from school performances to underwater photography. By the end, you'll know some of the time-tested techniques the pros use to take great shots.

- Part 2, *Organizing Your Photos*, gives you real world tips for storing your digital photos on your computer and on the Internet. Just as important, you'll learn how to *find* the photos you're looking for later on. This section introduces three programs that help you store, organize, and search for your photos. Two of the programs are free: Kodak EasyShare and Google's Picasa. And one, Photoshop Elements, descends from the all time champ when it comes to digital photo software (that would be Photoshop). You'll also be introduced to online photo services like Kodak Gallery, Shutterfly, and Snapfish. These companies let you store your photos on their Web sites in the hopes that you'll order prints. Another online service you'll learn about, Flickr, is more like one big photo club where you can store, organize, and share your photos.

- Part 3, *Editing Your Photos*, shows you how to fix up pictures using your computer—no more locking yourself in a darkroom or sending jobs out to the photo lab. You'll learn how to use the free programs EasyShare and Picasa for basic fixes like cropping your photos and removing those annoying red eye blemishes. You'll also learn how to add special effects—everything from transforming your photos into cartoon-like images to creating panoramas from multiple pictures.

- Part 4, *Sharing Your Photos*, details the many new ways you can share digital photos with friends, family, and other photo enthusiasts. You'll find out how to create and share online albums and you'll also meet two special Web sites, Photo.Net and TrekEarth, where you can share your photos with other photographers from all over the world. This section also gives you the lowdown on how to print photos at home and how to order prints through online services. And, as the man on the TV commercial says, "Wait, that's not all." Part 4 shows you how to create photo books, calendars, coffee mugs, and dozens of other cool things with your photos.

About → These → Arrows

Throughout this book, and throughout the Missing Manual series, you'll find sentences like this one: "Click Start → All Programs → Accessories → Windows Explorer." That's shorthand for a much longer instruction that directs you to click the Start button to open the Start menu. Then choose All Programs. From there, click Accessories, and then click the Windows Explorer icon.

Similarly, this kind of arrow shorthand helps to simplify the business of choosing commands in menus, as shown in Figure I-1.

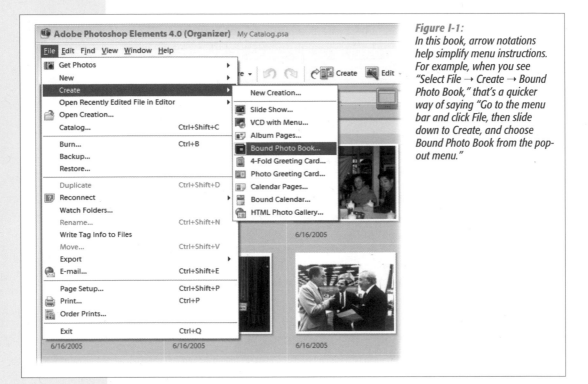

Figure I-1:
In this book, arrow notations help simplify menu instructions. For example, when you see "Select File → Create → Bound Photo Book," that's a quicker way of saying "Go to the menu bar and click File, then slide down to Create, and choose Bound Photo Book from the pop-out menu."

The Very Basics

To use this book, and indeed to use a computer, you need to know a few basics. This book assumes that you're familiar with a few terms and concepts:

- **Clicking.** This book gives you three kinds of instructions that require you to use your computer's mouse or trackpad. To *click* means to point the arrow cursor at something on the screen and then—without moving the cursor at all—to press and release the clicker button on the mouse (or laptop trackpad). To *double-click,* of course, means to click twice in rapid succession, again without moving the cursor at all. And to *drag* means to move the cursor *while* pressing the button.

When you're told to *Ctrl+click* something you click while pressing the Ctrl key (which is near the Space bar).

- **Menus.** The *menus* are the words at the top of your screen or window: File, Edit, and so on. Click one to make a list of commands appear, as though they're written on a window shade you've just pulled down.

- **Keyboard shortcuts.** If you're typing along in a burst of creative energy, it's sometimes disruptive to have to take your hand off the keyboard, grab the mouse, and then use a menu (for example, to use the Save command). That's why many experienced computer mavens prefer to trigger menu commands by pressing certain combinations on the keyboard. For example, in most programs, you can press Ctrl+S to save the file you're currently working on. When you read an instruction like "press Ctrl+S," start by pressing the Ctrl key; while it's down, type the letter S, and then release both keys.

If you've mastered this much information, you have all the technical background you need to enjoy *Digital Photography: The Missing Manual.*

About MissingManuals.com

At the *www.missingmanuals.com* Web site, click the "Missing CD" link to reveal a neat, organized, chapter-by-chapter list of the downloadable practice files mentioned in this book. The Web site also offers corrections and updates to the book (to see them, click the book's title, then click Errata). In fact, you're invited and encouraged to submit such corrections and updates yourself. In an effort to keep the book as up to date and accurate as possible, each time we print more copies of this book, we'll make any confirmed corrections you've suggested. We'll also note such changes on the Web site, so that you can mark important corrections in your own copy of the book, if you like.

Safari® Enabled

 When you see a Safari® Enabled icon on the cover of your favorite technology book, that means the book is available online through the O'Reilly Network Safari Bookshelf.

Safari offers a solution that's better than e-books. It's a virtual library that lets you easily search thousands of top tech books, cut and paste code samples, download chapters, and find quick answers when you need the most accurate, current information. Try it for free at *http://safari.oreilly.com.*

Part One:
Digital Camera Basics

1

Digital Camera Basics

Photographic technology didn't change much for the first hundred years or so. Sure, cameras got smaller and easier to use, lenses grew more powerful, and film quality improved, but folks were still basically taking pictures with a box that focused an image on a light-sensitive piece of film. The world, apparently, was ready for a change.

Barely a decade after they first entered the average consumer's consciousness (and price range), digital cameras started outselling film cameras—a shift of culture-jarring proportions. By early 2006, a staggering 92 percent of cameras sold were digital cameras.

Film photography giants like Kodak, Canon, and Olympus are now major players on the digital market, and they've been joined by manufacturers coming from the electronics side, like Sony, HP, Casio, and Samsung. The makers compete for your dollars by offering dozens of digital camera models with a dizzying array of features. Fortunately, if you understand just a few important digital camera basics, you can evaluate—and take great photos with—almost any camera you pick up. If you're reading this book because you're one of the millions getting ready to take the digital plunge for the very first time, this chapter will familiarize you with digital photography terms like megapixel, flash memory, and burst mode. No camera salesman or newspaper circular will ever again seem quite so daunting.

On the other hand, if you're already the proud owner of a digicam, you've probably spent more time snapping pictures and eagerly showing them off than learning what all your camera's buttons do and what those tiny symbols on its screen mean. Of course, you could wade your way through the manual that came with your camera…and still wind up pretty confused. Or you could just read this chapter for

the plain-English version of the features that appear on most digital cameras, and learn how they can enhance your picture-taking experience.

Point-and-Shoot or Single Lens Reflex?

What type of photographer are you? Do you always have a camera in your pocket or purse so you can pull it out for quick shots at work or at the ball park? Or are you a photographer who loves toting around lots of gear and enjoys having the best tools for the job? Do tripods and macro-lenses sound like fun to you? Pro aspirations anyone? Answers to these questions point you toward the digital camera of your dreams. Your camera should become a natural extension of your vision. If you and your camera don't have that bond, your pictures reflect that—or, rather, your *lack* of pictures. Even if you do most of your researching and shopping on the Web, be sure to actually get your hands on your leading candidate, too.

Today's digital cameras fall into three categories:

- **Point-and-shoot cameras** are small and usually cost around $200 to $400. With automatically retractable lens covers, they're designed to travel in your pocket, purse, or backpack. These cameras usually have simplified and automatic settings, so you can quickly catch your shot without fumbling at the controls. Because point-and-shooters keep getting smaller, thinner, and more jewelry-like, it's important nowadays to make sure the camera's not *too small* for your fingers. When you get your hands on a model you like, try answering these questions: Is it too small to hold comfortably? Does your index finger naturally align with the shutter release? Are your non-trigger fingers constantly slipping over the lens?

- **Advanced digital cameras** are bigger than your average pocket-cam; prices range from $300 to $600. With a larger body and a more defined grip, it's easier to hold these cameras steady when you shoot. Sometimes they resemble the more expensive *single lens reflex* (SLR) models (described next). But unlike SLRs, advanced digital cameras don't accept interchangeable lenses. Usually, they have a single zoom lens that can't be removed, but you do get the option to manually focus (just like in the old days, by turning the focus ring on the lens). With advanced digital cameras you'll get more choices compared to point-and-shoots for tasks like setting your exposure, choosing ISO speeds, and adjusting the color balance (read on for details about all those features).

- **Digital SLR cameras** have a special appeal if you're making the transition from a 35mm film camera to digital. If you loved the 35mm camera experience with its interchangeable lenses, filters, and other gear, the digital SLR is the way to go—provided your wallet is willing (expect to pay anywhere from $500 to $1500 and up). In many cases you can use your favorite lenses from your Canon or Nikon 35mm camera on a new digital SLR camera body, provided you stay with the same brand. There are a couple of gotchas, though. The main

problem is that your 50mm "normal" lens will seem more like a 150mm tele-photo lens on most digital SLRs. It's worth a trip to the camera store with your favorite lenses to make sure you understand how they'll make the transition.

Image Resolution and Memory Capacity

The first number you see in a digital camera description is its *megapixel* rating. A pixel (short for *picture element*) is one tiny colored dot, one of the thousands or millions that compose a single digital photograph. (One megapixel equals one million pixels.) You can't escape learning this term, since pixels are everything in computer graphics. The number of megapixels your camera has determines the quality of your pictures' *resolution* (the amount of detail that appears). A 5-mega-pixel camera, for example, has better resolution than a 3-megapixel one. It also costs more. How many of those pixels you actually *need* depends on how you're going to display the images you shoot.

Resolution for Onscreen Viewing

Many digital photos never get further than a computer screen. After you transfer them to your computer, you can distribute the images by email, post them on a Web page, or use them as desktop pictures or screen savers.

If such activities are the extent of your digital photography ambition, you can get by with very few megapixels. Even a $100, 2-megapixel camera produces a 1600×1200-pixel image, which is already too big to fit on the typical 1024×768–pixel laptop screen (without zooming or scrolling).

Resolution for Printing

If you intend to print your photos, however, your megapixel needs are consider-ably greater. The typical computer screen is a fairly low-resolution device: most pack in somewhere between 72 and 96 pixels per inch. But for a printed digital photo to look as clear and smooth as a real photograph, the colored dots must be much closer together on the paper—150 pixels per inch or more.

Remember the 2-megapixel photo that would spill off the edges of a laptop screen? Its resolution (measured in dots per inch) is only adequate for a 5×7 print. Enlarge it any more, and the dots become visible specks. Your family and friends will look like they have some unfortunate skin disorder. If you want to make prints of your photos (as most folks do), keep the following table in mind:

Camera Resolution	Max Print Size
0.3 megapixels (some camera phones)	2.25×3 inches
1.3 megapixels	4×6 inches
2 megapixels	5×7 inches
3.3 megapixels	8×10 inches

Camera Resolution	Max Print Size
4 megapixels	11 × 14 inches
5 megapixels	12 × 16 inches
6.3 megapixels	14 × 20 inches
8 megapixels	16 × 22 inches

These are extremely crude guidelines, by the way. Many factors contribute to the quality of an 8 × 10 print—including lens quality, file compression, exposure, camera shake, paper quality, and the number of different color cartridges your printer has, among other things. You may be able to print larger sizes than those listed here and be perfectly happy with them. But these figures provide a rough guide to getting the highest quality prints.

The other important advantage that a camera with multiple megapixels gives you is the ability to create high-quality prints of select *portions* of your photo. Say you've taken a great shot of your kids, but they occupy just a smidgen of the overall picture. No problem—if your camera's got a lot of megapixels under the hood. Just crop out all the boring background and keep just the juicy parts (you'll learn about cropping in Chapters 9 and 10). If you try that same maneuver with a picture that comes from a 2 megapixel camera, you'll end up with a photo filled with unsightly pixels.

How Many Pictures per Card?

Instead of popping in rolls of film, you use a *memory card*—a wafer thin sliver of reusable storage—to store your photos on a digital camera. The memory card that comes with most cameras is a joke. It probably holds only about six or eight best-quality pictures. It's nothing more than a cost-saving placeholder, foisted on you by a camera company that knows full well that you have to go buy a bigger one. When you're shopping for a camera, it's imperative to factor in the cost of a bigger card.

> **NOTE** Most cameras come with three picture quality settings: draft, normal, and best quality (or, in the Starbucks-speak you'll often see in the camera's manual: normal, fine, and super-fine). Pick either of the two highest-quality settings if you plan on printing your photos.

It's impossible to overstate how glorious it is to have a huge memory card in your camera (or several smaller ones in your camera bag). Since you're not constantly worrying about running out of space on your memory card, you can shoot more freely, increasing your chances of getting great pictures. You can go on longer trips without dragging a laptop along, too, because you don't have to run back to your hotel room every three hours to offload your latest pictures. Your camera's battery life is more than enough to worry about: The last thing you need is another chronic headache in the form of your memory card. Bite the bullet and buy a bigger one.

The File Format Factor

Just about every digital camera on earth saves photos as *JPEG files.* JPEG is the world's most popular photo file format, because even though it's compressed to occupy a lot less space, the visual quality is still very high.

But JPEGs aren't the only format you'll run across, especially once you start editing your photos, which is covered in Part 3 of this book. While there are a zillion graphical formats known to computer-kind, there are really only two, besides JPEG, that you, the digital photographer, need to know about.

TIFF. Most digital cameras capture photos in the JPEG format. Some cameras, though, offer you the chance to leave your photos *uncompressed* on the camera, in what's called TIFF format. These files are huge—in fact, you'll be lucky if you can fit one TIFF file on the memory card that came with the camera.

TIFF's advantage is that these files retain 100 percent of the picture's original quality. Note, however, that the instant you *edit* a TIFF-format photo, most image editing programs convert the file to the lesser quality JPEG format. That's fine if you plan to order prints or a photo book. But if you took that once-in-a-lifetime, priceless shot as a TIFF file, don't do any editing—don't even rotate it—if you hope to maintain its perfect, pristine quality. Instead, make a *copy* of the file and use that copy when it's time to edit. Then hang onto the TIFF so you'll always have a master version of your original shot.

RAW format. Most digital cameras work like this: When you squeeze the shutter button, the camera studies the data picked up by its sensors. The circuitry then makes decisions pertaining to sharpening level, contrast and saturation settings, color "temperature," white balance, and so on—and then saves the resulting processed image as a compressed JPEG file on your memory card.

For millions of people, the resulting picture quality is just fine, even terrific. But all that in-camera processing drives professional shutterbugs nuts.

They'd much rather preserve *every last iota* of original picture information, no matter how huge the resulting file on the memory card—and then process the file *by hand* once it's been safely transferred onto the PC, using a program like Photoshop Elements (coverage begins starting in Chapter 8). That's the idea behind the RAW file format, which is an option in many pricier digital cameras. (RAW stands for nothing in particular, and it's usually written in all capital letters like that just to denote how imposing and important serious photographers think it is.)

A RAW image isn't processed at all; it's a complete record of all the data passed along by the camera's sensors. As a result, each RAW photo takes up much more space on your memory card. For example, on a 6-megapixel camera, a JPEG photo is around 2 MB, but over 8 MB when saved as a RAW file. Most cameras take longer to store RAW photos on the card, too.

But for image-manipulation nerds, the beauty of RAW files is that once you open them up in a RAW-friendly image editing program, you can perform astounding acts of editing on them. You can actually change the lighting of the scene—retroactively! And you don't lose a single speck of image quality along the way.

Until recently, most people used a program like Photoshop or Photoshop Elements to do this kind of editing. But amazingly enough, humble, free programs like Picasa and EasyShare (both covered starting in Chapter 5), offer some RAW format capabilities.

Not every camera offers an option to save your files in RAW format. Why are only some cameras compatible? Because RAW is a concept, not a file format. Each camera company stores its photo data in a different way, so in fact, there are dozens of different file formats in the RAW world. Programs like Elements must be upgraded periodically to accommodate new camera models' emerging flavors of RAW.

The following table helps you calculate how much memory card storage you'll need. Find the column that represents the resolution of your camera, in megapixels (MP), and then read down to see how many best-quality photos each size card holds.

Camera Resolution	2 MP	3.3 MP	4.1 MP	5 MP
Card Capacity	How many pictures?			
32 MB	30	17	14	8
64 MB	61	35	30	17
128 MB	123	71	61	35
256 MB	246	142	122	70
512 MB	492	284	244	140
1 GB	984	568	488	280

Memory Card Types

As the years go by, high-tech manufacturers figure out new and better ways to fit more pictures on smaller cards. If you were the first on your block to buy a digital camera, it probably used CompactFlash or SmartMedia cards, which now look gargantuan compared to, say, the xD-Picture Card. CompactFlash cards, on the other hand, have stayed the same size but greatly increased their capacity.

When comparing memory card formats, look at price per megabyte, availability, and what works with your other digital gear. The following list will help you compare the currently available card types.

- **CompactFlash** cards are rugged, inexpensive, and easy to handle. You can buy them in capacities all the way up to 8 GB (translation: hundreds upon hundreds of pictures). *Pro:* Readily available; inexpensive; wide selection. *Con:* They're physically the largest of any memory card format, which dictates a bigger camera. A name brand 512 MB CompactFlash card costs less than $45.

- Sony's **Memory Stick** format is interchangeable among all of its cameras, camcorders, and laptops. Memory Sticks are great if you're already knee-deep in Sony equipment, but few other companies tolerate them. *Pro:* Works with most Sony digital gadgets. *Cons:* Works primarily with Sony gear; maximum size is 256 MB. A 128 MB Memory Stick starts at about $35, depending on the brand (Sony's own are the most expensive).

- The **Memory Stick Pro** Sony's newer memory card, is the same size as the traditional Memory Stick but holds much more. Sony's recent digital cameras accept both Pro and older Memory Sticks—but the Pro cards don't work in older cameras. As of this writing, you can buy Pro sticks in capacities like 512 MB ($45), 1 GB (about $65), 2 GB ($115), and 4 GB ($300).

- **Secure Digital (SD)** cards are no bigger than postage stamps, which is why you also find them in Palm organizers and MP3 players. In fact, you can pull this tiny card from your camera and insert it into many palmtops to view your pictures. *Pro:* Very small, perfect for subcompact cameras. *Con:* None, really, unless you're prone to losing small objects. 1 GB cards are now around $65 and 2 GB models are in the $100 range.

- The **xD-Picture Card,** tinier still, is a proprietary format for recent Fuji camera and Olympus camera models (see Figure 1-1). Its dimensions are so inconveniently small that the manual warns that "they can be accidentally swallowed by small children." *Pro:* Some cool cameras accept them. *Con:* Relatively expensive compared to other memory cards (256 MB = $35, 512 MB = $55, 1 GB = $75). Incompatible with cameras from other companies. Also incompatible with the memory card slots in most printers, card readers, television front panels, and so on.

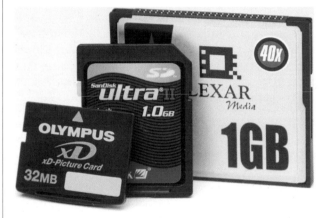

Figure 1-1:
The tiny Secure Digital card (middle) is gaining popularity because you can use it in both your digicam and palmtop. The even tinier XD-Picture Card (left) works only with Fuji and Olympus cameras. The larger CompactFlash card is still the most common (especially in larger cameras).

- Some CompactFlash cameras can also accommodate the **IBM Microdrive**—a miniature hard drive that looks like a thick CompactFlash card. For a while, 1 GB drives were popular with pros, but they're slipping in the polls now that you can get CompactFlash cards of up to 8 GB.

TIP If you're shopping for your second (or third, or fourth) digicam, you may feel obligated to buy one that takes the same kind of memory card as the old one. Don't let the memory cards you've got limit your options. Memory cards are getting cheaper all the time; buying a new supply is not the big deal it once was. And since photo printers, card readers (page 84), and photo kiosks now accept a variety of card types, you can, too.

Batteries

Compared to other 21st century electronic devices, digital cameras are near the top of their game. They're not like those cell phones that still drop calls, or wireless

palmtops with their slow Internet connections. Digital cameras are reliable, high quality, and rewarding in almost every way.

Except for battery life.

Thanks to that LCD screen on the back, digital cameras go through batteries like Kleenex. The battery is likely to be the one limiting factor to your photo shoots. When the juice is gone, your session is over. Here's a guide to the various battery types for digital cameras:

- **Proprietary, built-in rechargeable.** Many smaller cameras come with a "brick" battery: a dark gray, lithium-ion rechargeable battery, as shown at top in Figure 1-2. These subcompact cameras are simply too small to accommodate AA-style batteries.

 The problem with proprietary batteries is that you can't replace them when you're on the road. If you're only three hours into your day at Disney World when the battery dies, you can't exactly duck into a drugstore to buy a new one. Like it or not, your shooting session is over.

 Some cameras come with a separate, external battery charger. If you have an external charger, by all means buy a second battery (usually about $50) and keep one battery in the charger at all times. When the main battery gives up the ghost, swap it with the one in the charger, and go about your business. For a full day at the theme park, fully charge both batteries and take them with you.

 All this recharging roulette is a pain, but it beats any system in which the camera *is* the battery charger, which is the case with some cameras. When the battery dies, so does your creative muse. You have no choice but to return home and plug in the camera, taking it out of commission for several hours as it recharges the battery. Even with a separate charger, though, proprietary batteries can't match the convenience of rechargeable AAs, described next.

- **AA batteries.** Some cameras accept AA-size batteries (usually two or four), and may even come with a set of alkaline AA batteries to get you started. If you learn nothing else from this chapter, however, learn this: *Don't use disposable alkaline batteries in a digital camera.* You'll get a better return on your investment by tossing $5 bills out your car window. Alkalines may be fine for flashlights and radios, but not even "premium" alkaline batteries can handle the massive power drain of the modern digital camera. A set of four AAs might get you 20 minutes of shooting, if you're lucky.

 So what are you supposed to put in there? Something you may have never even heard of—AA-size *rechargeable nickel-metal-hydride batteries* (NiMH) (Figure 1-2, bottom). They last *much* longer than alkalines, and they're far less expensive, since you can use them over and over again. You may also be able to use disposable *photo lithium* batteries. Like alkalines, they're not rechargable, and they're much more expensive than alkalines. But since they last many times longer, photo lithiums are ideal to keep in your camera case for emergency backup.

In a pinch—yes, during a day at Disney World—you can hit up a drugstore for a set of standard alkaline AAs. Yes, you'll be tossing them in the trash after 20 short minutes of use, but in an emergency, 20 minutes is better than nothing.

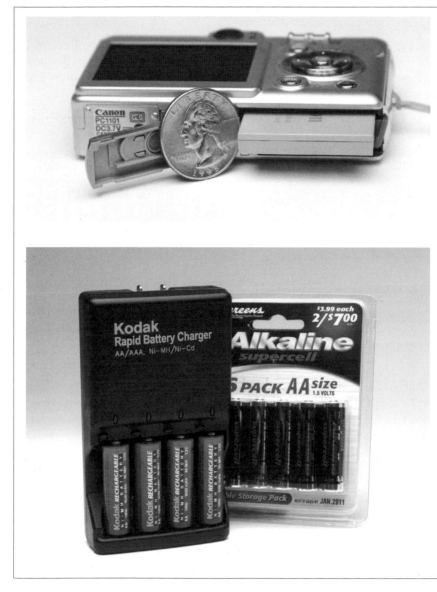

Figure 1-2:
Top: Many digital cameras come with proprietary batteries (quarter not included). They're not very big, and neither is their capacity, so invest in a spare.

Bottom: If your digicam takes AA batteries, use alkaline AAs (right) in emergencies only. In the long run, you're better off investing in a couple sets of NiMH rechargeables (left). You generally won't find NiMHs in department stores, but they're available online and in national drugstore chains. A charger and a set of four NiMH AAs cost about $30.

NOTE Some cameras offer the best of *all* worlds. Certain Nikon CoolPix cameras, for example, come with a lithium-ion battery and matching charger and *also* accept all kinds of AAs, including alkalines, rechargeables, and the Duracell CRV3 battery (a disposable lithium battery that looks like two AAs fused together at the seam). You should always be able to get juice on the road with *these* babies.

Deciphering Optical and Digital Zoom

In digital camera ads (or even on the camera itself) you see announcements like: "3X/10X ZOOM!" The number before the slash tells you how many times the camera's lens can magnify a distant image, exactly like binoculars and telescopes. That measurement is called *optical* zoom.

Then there's the number after the slash—the *digital* zoom. Camera boxes often announce digital zoom stats in big, gaudy type, as though that's all their customers care about. Well, those are the same kind of people who buy into the notion that a higher megahertz rating always gets them a faster computer.

Truth is, digital zoom is nothing to write home about. When a camera's digital zoom kicks in, the camera's merely spreading out the individual pixels, in effect enlarging the picture. The image gets bigger, but the picture's *quality* deteriorates. In most cases, you're best off avoiding digital zoom altogether.

> **TIP** If you're used to traditional photography, you may need some help converting digicam optical zoom units (3X, 4X, and so on) into standard focal ranges. It breaks down like this: A typical 3X zoom goes from 6.5mm (wide angle) to 19.5mm (telephoto). That would be about the same as a 38mm to 105mm zoom lens on a 35mm film camera.

Image Stabilizer (Vibration Reduction)

The hot new feature for 2006–2007 is built-in image stabilization. This feature, available in a flood of new camera models, improves your photos' clarity by ironing out your little hand jiggles.

It's an enormous help in three situations: when you're zoomed in all the way (which magnifies jitters), in low light (meaning that the shutter stays open a long time, increasing the likelihood of blurring), and when your camera doesn't have an eyepiece viewfinder (forcing you to hold the camera at arm's length, decreasing stability).

Flip Screens for Multiple Viewpoints

Every digital camera has an LCD screen, but on some specially endowed models, you can flip and swivel the screen around to gain multiple viewing angles (Figure 1-3). You can frame the shot any way you want—at your waist, above your head, even at your ankles—without contorting yourself into a pretzel.

A flip screen is a godsend when you're stuck in the middle of a crowd, but want a shot of the parade. Simply tilt the screen so you can raise the camera over your head and see what you're shooting. Flip screens let you get more creative, too. You can do low-angle Orson Welles shots for added drama, or capture the world from your baby's eye view (without crawling around on the carpet).

UP TO SPEED

About Lens Quality and Covers

Early digital cameras made a splash with their sophisticated new electronics, but their lenses were hardly state of the art. If you've ever tried reading fine print through a cheap magnifying glass, you have some idea of how the world looks though bad optics—lousy.

These days, the scene is much sharper. Sony, Olympus, Canon, Leica, and Nikon all take pride in the lenses for their digital cameras, and they have solid reputations for great glass as a result. (Other camera makers often buy their lenses *from* Olympus, Canon, and Nikon.)

Unfortunately, there's no easy way to measure a lens's quality, and you can't judge for sure just by looking through it. The best way to learn about lenses (and which cameras have great ones) is to read photo magazines or consult photo review Web sites like Imaging-Resource (*www.imaging-resource.com*), Digital Photography Review (*www.dpreview.com*), or Digital Camera Resource (*www.dcresource.com*).

Of course, lenses of *any* quality need a cover to protect them from dirt, scratches, and damage.

Here's the most important lens cover advice you'll ever get: Use one. Digital cameras come with one of two types: detachable and built-in. Professional photographers (and amateurs who think like the pros) go for cameras that accept filters, telephoto lenses, and other attachments, which usually means a detachable cover.

The downside is that detachable lens covers are a pain. If you tie your lens cover to the camera with that little loop of black thread, it bangs against your hand, or the lens, when it's windy. If you leave it loose, the cover is destined to fall behind the couch cushions, pop off in your camera bag, or get mixed in with the change in your pocket.

Built-in lens covers, like the ones on compact models, eliminate this madness. Just sliding the cover open both turns the camera on and makes its zoom lens extend, ready for action. When you're done shooting, the lens retracts and the cover slides back into place. If your digital camera is a constant travel mate, and you could care less about attachments, a sliding cover is the ultimate in convenience and portability.

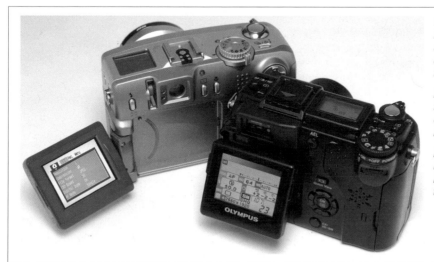

Figure 1-3:
Flip screens first appeared on camcorders and were soon adapted to digital cameras.

Left: The best ones flip all the way out from the camera, providing multiple viewing angles.

Right: Others allow tilting upward and downward, but remain attached to the camera back.

Optical Viewfinder

Every year, digital camera screens get bigger. That's a welcome trend, because framing your photos and, later, showing them off to other people is a heck of a lot more satisfying when they're bigger than a postage stamp.

These days, though, some screens fill the whole back of the camera—and leave no room for an optical viewfinder (the little glass hole you can peek through). Plenty of people are perfectly happy composing their shots on the screen, but remember that holding a camera up to your face helps to brace it, reducing the likelihood of little jiggles that blur the photo. Without an optical viewfinder, you're forced to hold out the camera nearly at arm's length.

Taking Control with Manual Options

Cheapo digital cameras are often called *point-and-shoot* models with good reason: You point, you shoot.

Sometimes these cameras let you pick from a few pre-programmed settings like *Night Snapshot* or *Kids & Pets*, but for the most part your camera is doing all the thinking for you. More expensive cameras, on the other hand, let you take your camera off autopilot.

If you're a first-time buyer, you may think a point-and-shoot is a safe starting point. Before you decide, read Chapter 3 to learn about special situations—sports photography, nighttime shots, fireworks, indoor portraits, and so on—where you can get amazing results with the help of manual controls. If you're looking for a camera that you can grow with as your photo skills increase, manual controls are worth paying for.

On the other hand, you may have chosen your digital camera for its gorgeous flip screen or powerful zoom lens, but never use the manual modes that these models often include. If so, you need Chapter 3 even more. It will help you unleash your camera's potential—and your own creativity.

The following are the most popular manual features (see Chapter 3 for full coverage about when to use each setting).

Aperture-Priority Mode

In aperture-priority mode, you specify how *wide* the camera's shutter opens, and the camera takes care of the other settings (like shutter speed or flash). It's probably the most popular manual mode, because it puts you in control while ensuring proper exposure. Using aperture-priority mode you can create portraits with softly out-of-focus backgrounds, among other professional effects.

Shutter-Priority Mode

Shutter-priority mode lets you decide how *fast* the shutter opens and closes; the camera automatically sets the aperture width—and flash, if you're using it—accordingly. A fast shutter freezes sports action; slow speeds are handy for night photography. You can even use a slow shutter to turn a babbling brook into an abstract, fuzzy blur.

White Balance

To compensate for different background light variations (the noon sun, the late afternoon sun, ugly office lighting, and so on) that can sometimes look crummy in print, most cameras offer a *white balance control,* a setting that lets you pick between conditions with names like Daylight, Cloudy, Tungsten, and Fluorescent. Page 50 has full details on how to use this extremely useful setting.

Variable "Film" Speed

Back in the old days, when photographers had to walk through ten-foot snow drifts just to get to school, they also had to carry around different film types for different lighting situations. For dim lighting, you needed film that was more sensitive to light, since there's only so long you can leave the camera's shutter open to let in more light. Light-sensitive film provided a *faster* (shorter) exposure time (lessening the chance of jiggling the camera while the shutter's open). For bright outdoor light, you'd switch to a *slower* (that is, less light sensitive) film to avoid washed-out, overexposed pictures. Film speeds were expressed in an *ISO (International Standards Organization)* number; higher numbers meant higher light sensitivity and faster exposure times. Popular ISO speeds were 100 for bright (usually outdoor) light, and 400 or even 1000 for low light and indoor shots. To avoid constantly reloading your camera, you could try 200-speed film for the best of both worlds.

On some film cameras, you also had to manually set an ISO dial to match the current film's speed. The ISO setting adjusted the camera's light meter so that you could set the shutter and aperture optimally for that type of film. (Later models automatically read the ISO off the film canister and adjusted themselves accordingly.)

Even though digital cameras don't take film, many give you a manual ISO setting so you can replicate the effect of different film speeds—and that lets you do some pretty cool things. For instance, if you set your digital camera's ISO setting to 100, it's like you're telling the camera, "I'm taking pictures on Miami Beach in July, so act like you're a film camera with 100-speed film." That way, you get better pictures because the digital camera's manual and automatic settings adjust for low light sensitivity—warning you when you need to use a larger aperture setting or a flash, for example. Or, if you want to take pictures in dim light without a flash, you can bump up the ISO to 400 and make your digital camera more light-sensitive. Figure 1-4 shows an example of one digital camera's ISO settings.

NOTE The downside of the digital camera's wonderful ability to change film speeds with a simple menu selection is that higher ISOs generally result in more noise (graininess).

Figure 1-4:
Some cameras provide a menu of film speed options, often under the label "ISO," which is a measurement of light sensitivity familiar to film photographers.

Improving Autofocus

Even though autofocus technology has been around for years, it's not a perfect science. There are plenty of lighting conditions, like dark interiors, where your camera struggles to focus correctly. Autofocus works by looking for patches of *contrast* between light and dark—and if there's no light, there's no focusing.

An autofocus assist light (or AF *assist*) neatly solves the problem (Figure 1-5). In dim light, the camera briefly beams a pattern of light onto the subject, so the camera has enough visual information to focus.

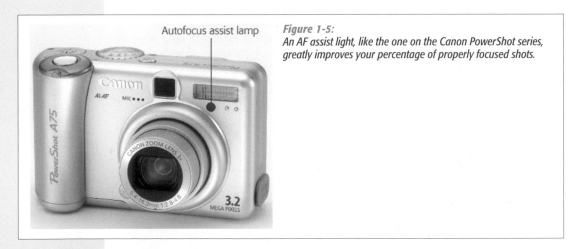

Autofocus assist lamp

Figure 1-5:
An AF assist light, like the one on the Canon PowerShot series, greatly improves your percentage of properly focused shots.

External Flashes and Other Attachments

Most digital camera owners don't see the need for external flashes, filters, tripods, and other fancy attachments. But if you have a hardcore film photography

background, you probably can't imagine life without your beloved accessories. In general, digital cameras that look like full-size, traditional film cameras can accept all the traditional attachments. Most tiny, sliding-cover, subcompact pocket cameras can't.

Filters and accessory lenses often mean fitting your camera with a tubular lens adapter (Figure 1-6). Usually the smaller the adapter and the finer the threads, the more patience you'll need. Nothing is more frustrating than stripping the threads on your camera body because you couldn't screw in the adapter ring properly.

Figure 1-6:
Some digital cameras can accommodate accessory lenses and filters using an optional adapter. You can extend the power of this Olympus, for example, by adding telephoto, wide angle, and macro lenses.

Even if you're not an accessory kind of person, check out your camera's *tripod mount*—a small, threaded hole in the camera base. Nobody *likes* lugging around a tripod, but there are moments when it's the only way to get a beautiful artistic shot, like streaking car lights across a bridge, or almost anything at night. Many of the professional techniques in the next two chapters require a tripod. (And if you don't have a tripod, see the box on page 26 for some buying advice.)

Flip the camera over and find where the socket is located. A tripod mount near the center of the base is easier to work with than one way off to one side or another. A sturdy metal socket is better than a cheap plastic one. A camera's tripod mount may not be a deal breaker, but when you're buying a new camera, it's worth inspecting the socket before you head to the checkout counter.

How to Buy a Tripod

A tripod has two parts: the legs and the *pan head.* The camera attaches to the pan head, and the legs support the head.

You can buy a tripod with any of three pan head types. *Friction heads* are the simplest, least expensive, and most popular with still photographers. *Fluid heads* are desirable if you'll also be using your tripod for a camcorder, as they smooth out panning and tilting. They're more expensive than friction heads, but are well worth the money if you're after a professional look to your footage. Finally, *geared heads* are big, heavy, expensive, and difficult to use.

The tripod's legs may be made of metal, wood, or composite. Metal is light and inexpensive, but easily bent or damaged. Wood and composite legs, which are sturdier and much more expensive, are better for heavier professional broadcast and film equipment. The bottoms of the legs have rubber feet, so they won't slip on hard floors.

Good tripods also have *spreaders* that prevent the legs from spreading apart and causing the entire apparatus to crash to the ground. If your tripod doesn't have spreaders, put the tripod on a piece of carpet, which prevents the legs from slipping apart.

Minimizing Shutter Lag

Shutter lag is the time it takes for the camera to calculate the correct focus and exposure before it captures the scene. In many camera models under $700 or so, this interval amounts to an infuriating half-second to one-second delay between your shutter press and the moment the picture is captured. Trouble is, that's more than enough time for you to miss the precise instant your daughter blows out the candles on her birthday cake, your son's first step, and that adorable expression on your iguana's face. In photography, fractions of a second are a lifetime (Figure 1-7).

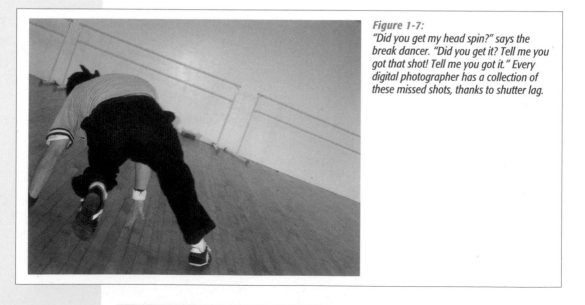

Figure 1-7:
"Did you get my head spin?" says the break dancer. "Did you get it? Tell me you got that shot! Tell me you got it." Every digital photographer has a collection of these missed shots, thanks to shutter lag.

You can reduce or minimize shutter lag in a couple ways. First, you can set the camera's focus and exposure manually, as you'll learn in the next two chapters. That way, the camera has no thinking to do when you squeeze the shutter. Most people, though, eventually learn instead to *prefocus*. This trick involves squeezing the shutter button halfway, ahead of time, forcing the camera to do its calculations. To prefocus, simply keep your finger halfway down until the moment of truth. Then, when you finally press it down all the way, you get the shot you wanted with very little delay.

Unfortunately, neither of these techniques works in all situations. Manually focusing and prefocusing both take time and eliminate spontaneity. Until the electronics of digital cameras improve, the best you can do is to buy a model with the smallest shutter lag possible. Most brochures don't mention shutter lag, so your best bet is to visit one of the camera-review Web sites mentioned in the box on page 21. Many of them list the shutter-lag timings for popular cameras.

Burst Mode for Rapid-Fire Shooting

When you press the shutter button on a typical digital camera, the image begins a long tour through the camera's guts. First, the lens projects the image onto an electronic sensor—a CCD (Charge-Coupled Device) or CMOS (Complementary Metal Oxide Semiconductor). Second, the sensor dumps the image temporarily into the camera's built-in memory (a memory *buffer*). Finally, the camera's circuitry feeds the image from its memory buffer onto the memory card.

You may be wondering about that second step. Why don't digital cameras record the image directly to the memory card?

The answer is simple: Unless your camera has state-of-the-art electronics, it would take forever. You'd only be able to take a new picture every few seconds or so. By stashing shots into a memory buffer as a temporary holding tank (a very fast process) before recording the image on the memory card (a much slower process), the camera frees up its attention so that you can take another photo quickly. The camera catches up later, when you've released the shutter button. (This is one reason why digital cameras aren't as responsive as film cameras, which transfer images directly from lens to film.)

The size of your camera's memory buffer affects your life in a couple of different ways. First, it permits certain cameras to have a *burst mode*, which lets you fire off several shots per second. That's a great feature when you're trying to capture an extremely fleeting scene, such as a great soccer goal, a three-year-old's smile, or Microsoft being humble. Second, a big memory buffer permits *movie mode*, described later. It can even help fight shutter lag, because the ability to fire off a burst of five or six frames improves your odds of capturing that perfect moment. Your camera's documentation probably doesn't specify how much RAM it has, but you can check out *how many* frames per second it can capture in burst mode. The more frames, the bigger the buffer.

NOTE A few expensive cameras can bypass the buffer and save photos directly on the memory card, so that you can keep shooting until the card fills up. This trick usually requires a special high-speed memory card—preferably a big one.

IN THE FIELD

Cool Camera Accessories

Ready to soup up your camera? Some accessories are necessities (tripods for nighttime shooters, for example) and some are just plain cool:

Mini tripods. How many good photos have gone bad because of the shakes? On the other hand, it's a pain to go everywhere with a big tripod. Mini tripods, a foot or less in length, can fit in a briefcase, backpack, or large purse. They sit on a table-top or some other surface to steady your camera, which is great for low light situations or when you want to set the timer and run around in front of the lens to be part of the picture. One of the most interesting entries in the mini tripod category is the $25 Gorilla Pod (*www.joby.com*), which has super flexible legs that can wrap around a fence post or tree limb, giving you many more situations where you can steady your shot. Average mini tripod prices range between $20 and $30.

Wireless remote control. Remote controls let you click the shutter without having your hand on the camera, so they're great for those group shots you want to be part of. In low light situations, you can avoid the blurry-photo syndrome by combining a mini tripod and a remote. Most wireless remotes are smaller than a deck of cards and cost around $25.

Memory card cases. It hardly needs to be said that a camera case protects your camera from weather and accidental drops; but what about your memory cards? They're even more sensitive. If you're backpacking in the Himalayas and decided not to bring your laptop to store your photos, consider getting a weatherproof case to hold all your extra memory cards. Cases are usually designed for a specific type of memory card. You'll find good weather proof cases that holds four to eight cards for under $10.

Underwater housings. If you think some of the most beautiful scenes on earth are under the sea, you'll be interested in an underwater housing for your camera. A good housing is designed specifically for your camera model; it keeps the water out, but lets you click the shutter. For point-and-shoot cameras and advanced digital cameras, prices start at about $100. Housings for digital SLRs begin at about $250. Web sites like *www.ikelite.com* or *www.uwimaging.com* are a good place to start your search.

Travel drives. If you fill your camera's memory card and you're not near your computer, how do you free space up so you can take more shots? The answer is a travel drive, sometimes referred to as standalone storage. You plug your memory card into the drive and it sucks down the photos; then, you're free to erase the card and continue shooting. Some travel drives use mini hard drives, which store 20 gigabytes or more; these cost $200 and up. Other travel drives are CD or DVD burners and look like a CD walkman. These drives are a little less expensive; prices start at about $150.

Multimedia viewers. A variation on the travel drive, multimedia viewers not only store your photos on a hard drive, they let you view them on an LCD screen. The color screen iPods are the most famous of the multimedia viewers. You can buy a $30 Camera Connector (*http://store.apple.com*) to transfer photos directly from your camera to your Pod. Voilà! You have travel storage and a viewer. Epson also offers a viewer, the $500 Epson P-2000 (*www.epson.com*), that reads memory cards directly and has a generous 3.8-inch screen.

Creating Panoramas

How many times have you showed a travel picture to a friend and remarked, "It looked a lot bigger in real life"? That's because it *was* bigger, and your camera couldn't capture it all. Capturing a vast landscape with a digital camera is like looking at the Grand Canyon through a paper-towel tube.

Digital camera makers have created an ingenious solution to widen this narrow view of life: panorama mode (Figure 1-8). With it, you can stitch together a series of individual images to create a single, beautiful vista, similar to what you saw when you were standing there in real life. The camera's onscreen display helps align the edge of the last shot with the beginning of the next one. See Chapter 13 for more about how to create panoramas. Panoramas are a great reason to buy that tripod you've been eyeing (preferably one with a bubble level in the head to keep your pictures straight).

Figure 1-8:
This image is actually four pictures stitched together using the camera's panorama mode.

Software That Comes with Your Camera

Along with an instruction booklet, carrying strap, and battery, digital cameras always come with a software CD nestled in their box. That software isn't for the camera—it goes on your computer. Manufacturers give you these programs to help you pull pictures from the camera's memory card and deposit them on your hard drive. But here's a word of advice: These programs are generally about as useful and friendly as phone-based tech support. The good news is that you can usually get by without ever installing this software. Thanks to the built-in photo importing tools you get with Windows XP (it's called the Camera and Scanner Wizard), you can plug most cameras into your PC's USB port and Windows guides you the rest of the way (Chapter 4 has full details about how to do this import dance).

Eliminating Specks (Noise Reduction)

The longer the exposure to record a scene, the more important *noise reduction* becomes. When you shoot nighttime shots, what should be a jet-black sky may exhibit tiny colored specks—*artifacts*—that put a considerable damper on your photo's impact. (The longer the shutter stays open, the more artifacts you'll get, as the camera's sensor gradually heats up.)

A noise reduction feature usually works like this: When you press the shutter, the camera takes two shots—the one that you think you're getting, and a second shot with the shutter completely closed. Since the camera's electronics produce the visual noise, both shots theoretically contain the same colored speckles in the same spots. The camera compares the two shots, concludes that all of the colored specks it finds in the *closed*-shutter shot must be unwanted, and deletes them from the real shot.

Chances are you'll have to dig through the literature or the specs on the manufacturer's Web site to find out whether the camera you've got or are considering has this feature. But it's worth investigating if you're a nighttime shooter.

Taking Movies with Your Camera

Almost every digital camera nowadays captures video; some do it better than others. Cheaper cameras produce movies that are tiny, low-resolution flicks. These mini-movies have their novelty value, and are better than nothing when your intention is to email your newborn baby's first cry to eager relatives across the globe.

But more expensive cameras these days can capture video at a decent size (320×240 pixels, or even full-frame 640×480 pixels) and smoothness (15, 30, or even more frames per second), usually complete with soundtrack. Better cameras place no limit on the length of your captured movies (except when you run out of memory card space). More on this topic in Chapter 3.

Pointing, Shooting, and Basic Composition

If your eyes are bleeding from the technical underbrush of Chapter 1, switch on your right brain. This chapter has little to do with electronics and everything to do with the more artful side of photography—composition.

What follows are techniques that photographers have been using for years to create good pictures regardless of the camera type. These time-honored secrets do wonderful things for digital imaging too. Good composition is essential whether you're using a $200 pocket digicam or a $3,000 professional camera. When you apply the deceptively simple suggestions in this chapter, you'll take better pictures (and enjoy taking them even more).

First, a few words about composition.

Composition Explained

Composition is the arrangement of your picture: the interplay between foreground and background, the way the subject fills the frame, the way the parts of the picture relate to each other, and so on. Before pressing the shutter, veteran photographers compose pictures by asking themselves a few questions:

Will the shot be clearer, better, or more interesting if you move closer? What about walking around to the other side of the action, or zooming in slightly, or letting tall grass fill the foreground? Would the picture be more interesting if it were framed by horizontal, vertical, or diagonal structures (such as branches, pillars, or a road stretching away)?

It's easy to think, "Hey, it's a picture, not a painting—I have to shoot what's there." Maybe so, but you have more control over the composition than you realize. Photography is *every bit* as creative as painting.

> **TIP** If your photographic ambition is to take casual vacation pictures, some of the following suggestions for professional composition may strike you as overkill. But read them anyway. If some of these tips rub off on you, you can apply them even in everyday snapshot situations. There's no law against casual vacation pictures being *good* casual vacation pictures.

Apply the Rule of Thirds

Most people assume that the center of the frame should contain the most important element of your shot. In fact, 98 percent of all amateur photos feature the subject of the shot in dead center. For the most visually interesting shots, however, dead center is actually the *least* compelling location for the subject. Rather, artists and psychologists have found that the *rule of thirds* (Figure 2-1) ensures better visual balance.

Figure 2-1:
Top: When shooting a head and shoulder portrait, frame the shot so that her eyes fall on the upper imaginary line a third of the way down the frame.

Bottom: When shooting a landscape, put the horizon on the bottom-third line if you want to emphasize the sky or tall objects like mountains, trees, and buildings. Put the horizon on the upper-third line to emphasize what's on the ground, such as the people in the shot.

Imagine that the photo frame is divided into thirds, both horizontally and vertically. The rule of thirds contends that the intersections of these lines are the strongest parts of the frame: They're where the viewer's eye naturally goes. For good composition, strive to put the most interesting parts of the picture at these four

points. In general, save the center square of the frame for tight closeups. (Even then, aim for having the subject's eyes on the upper-third line.)

Get Closer for Better Pictures

You can always tell a professional photograph from a beginner's snapshot…but you might not be able to put your finger on what's different. Here's a clue: Every amateurish photo includes lots of wasted space. Try this experiment with a nearby subject—like your dog. Take a picture standing where you normally would (probably about five feet away and above Rover's head).

Now take a second picture—but first crouch down so that you see the world at dog level. Get close enough that your pet can almost lick your camera lens. (But don't let him *do* it; dog slobber is very bad for optics.) Then snap the picture. Compare the two photos on your camera's view screen, or better yet, on your computer screen. The first shot probably looks pretty boring compared to the second one.

Clearly, you weren't thinking about *composition* the first time. You were taking a picture of your dog. *Taking a picture* is usually a mindless act that doesn't result in the most memorable photos. Getting closer to fill the frame with your subject creates a compelling composition.

So remember: Move your feet toward your subject, and don't stop moving them until the subject fills the frame (Figure 2-2). Of course, the zoom lens on your camera can help quite a bit.

Figure 2-2:
Top: This otter shot looked great in the camera's viewfinder. Onscreen, however, it's a bit disappointing. It looks bland, because the otters are too far away and at an uninteresting angle.

Bottom: By getting (or zooming) closer, however, you get far more interesting results. In this case, the photographer applied the time-honored skill of patience, waiting for the sea otters to drift within better range. Sometimes getting closer means waiting for the action to come to you.

TIP Filling the frame with your subject also means that you'll have less uninteresting background to crop out before making prints. As a result, you'll get a higher resolution, better quality print.

Eliminate Busy Backgrounds

Busy backgrounds destroy photographs. Just look at the top photo in Figure 2-3. Of course, sometimes your *intention* is to confuse and irritate the viewer's eye. But unless you're shooting a headbanger music CD cover, eliminate distracting elements from your picture as much as you can. Make it easy for the viewer to locate—and appreciate—the key elements of your composition.

Figure 2-3:
Top: What's this picture about? The people? The boats? Linear elements in the background usually spell doom for people shots.

Bottom: Avoid clutter and opt for a more subtle background, like water or sky. Your subjects—and audience—will thank you.

In other words, don't become so engrossed in your subject that you don't notice the telephone wires that seem to run through her skull. Train your eye to examine the subject first, and then survey the surrounding scene.

Problems to avoid in your composition's background include:

- **All forms of poles.** Telephone poles, fence posts, street signs, and malnourished trees can creep into your photos and ruin them.

- **Linear patterns.** Avoid busy background elements, such as bricks, paneling, fences, and zebra skins.

- **Incomplete, cut-off objects.** When people see a *part* of something in your picture—a tractor grille, a few ladder rungs, a camel's rear end—they can't help but wonder what the rest of it looks like, instead of focusing on your subject.

Get in the habit of scanning *all four corners* of your frame before clicking the shutter. That way, you'll catch those telephone poles and street signs that you wouldn't normally see until it's too late. Look for backgrounds that have subtle tones, soft edges, and nondescript elements. Moving your subject forward, away from the background, can help soften the backdrop even more.

Go Low, Go High

Change your camera angle often. Look at your subject from a few different points of view before choosing the best place to shoot it from. For example, put the camera on the ground and study the composition. Raise it over your head and see how the world looks from that angle (Figure 2-4). If possible, walk around the subject and examine it from left to right.

> **TIP** When you first approach an interesting subject, snap a quick picture. Once you've got a "safe" shot in the camera, you can relax. Move in closer and take a few more shots from a variety of angles. Experiment as long as time permits. More often than not, the safe shot will be your least favorite of the series. You'll probably find the latter frames far more compelling.

A Final Thought

Finally, one last suggestion: Consider the pointers in this chapter as guidelines only. There is no one right way to take a photograph. When you come down to it, the best photos are the ones you *like*.

Figure 2-4:
Top: To really capture the feel of this breakfast nook, raise the angle of the camera, even if it means standing on a chair to do so.

Bottom: Try going low, too. "Getting to the bottom of things" provides you with dramatic angles and impressive images. (A flip screen comes in handy, as described in the previous chapter.)

Beyond the Simple Snapshot

There you sit, surveying your boxes of old photos. Snapshots of your family. Vacation snapshots. Snapshots of tourist attractions. But they're all *snapshots*. Then you think of professional photos you've seen in magazines and newspapers. There's the extreme close-up of a ladybug on a leaf, with the bushes in the background gently out of focus. There's that amazing shot of the soccer player butting the ball with his head, frozen in action so you can see individual flecks of sweat flying from his hair. And how about that incredible shot of the city lights at night, with car tail-lights drawing colorful firefly tracks across the frame. "How do they *do* that?" you wonder. "And why can't *I* do it, too?"

Actually, you can. You can get most of these brilliant effects with little or no special gear. All you need are a few practical shooting techniques and the willingness to get out there and experiment. With a little practice, you can take pictures that are just as compelling, colorful, and intimate as the shots you see in magazines. This chapter lays bare professional photographers' trusty secrets. You'll never take a dull snapshot again.

Shooting Sports and Action

Everybody's seen those incredible high-speed action photos of athletes frozen in mid-leap. Without these shots (and the swimsuit photos), *Sports Illustrated* would be no thicker than a pamphlet. Through a combination of careful positioning, focusing, lighting, and shutter-speed adjustments, you can take the very same stop action shots. Even if you never take sports photos, knowing how to freeze action lets you capture water splashes, birds in flight, and fleeting childhood moments.

While some of the techniques you'll read about in this section work with any camera, for best results, try to get your hands on a camera that has:

- A **telephoto or zoom lens.** Action shots look more dramatic when your moving subject fills the frame.

- **Manual or shutter-priority mode.** To freeze movement without blur, your camera has to grab the shot in a fraction of a second. Both these shooting modes help that happen.

- **Prefocus.** A great shot can pass right by while your camera focuses. Many digital cameras let you focus in advance by pressing the shutter button halfway *before* you're ready to shoot. (Check the manual to see if your camera has this feature.)

- **Burst mode.** If your camera lets you fire off a few pictures in rapid succession, chances are greater that you'll get *the* shot with one of them.

- **Spot metering.** While not critical, this feature helps ensure that your focus of interest (not the background) is properly lit, and not obscured by a shadow or the sun's glare.

You don't need all these features for sports pictures, and you won't use each of them in every shot. But knowing how these tools work and when to summon them helps expand your shooting repertoire.

Getting Close to the Action

If your digital camera has a zoom lens, it's probably a 3X zoom, meaning that it can magnify the scene three times. Unfortunately, if you're in the stands at the football game hoping for action shots of an individual player, 3X isn't powerful enough. What you really need is one of those enormous, bazooka-like telephoto lenses that protrude three feet in front of the camera to get a good action shot like the one in Figure 3-1.

If you have a 3X zoom, it doesn't mean you can't capture good shots. Find a position on the sidelines that puts you as close to the action as possible. Zoom in with your camera and then use the trick shown in Figure 3-2.

If it's a bright, sunny day, the standard "automatic everything" setting of the camera may work just fine. Take a few sample shots, trying to get the action as it's moving. If the action is passing in front of you, pan with it. This way, you'll do a better job of freezing the subject. The background may be blurred, but this actually adds to the impression of motion.

> **TIP** If your camera's zoom isn't powerful enough by itself, consider turning on the camera's digital zoom. As noted in Chapter 1, you should avoid using the digital zoom most of the time, because it compromises image quality. Still, at low levels (2X or 3X, for example), the deterioration in image quality may be tolerable. Try experimenting with this feature when covering a spectator sport, for instance.

Figure 3-1:
If action photography is a regular part of your shooting, consider a digital camera with an 8X zoom or greater. Better yet, look into a digital SLR (single-lens reflex) camera, which can accommodate a telephoto lens, as described in Chapter 1. A digital SLR outfitted with a 200mm lens captured this moment in sports.

Figure 3-2:
Top: You may not be able to afford a digital SLR with a $10,000 super-telephoto lens attachment. But if you have a 4-megapixel camera or an even better one, here's a way to zoom in on the action. Shoot at your camera's highest resolution—zoomed in as much as you can.

Bottom: Once the picture is in your image editing program, you can zoom in even more by cropping the portion of the picture you want to keep. (See Chapters 9 and 10 for details about cropping.) Thanks to the high resolution of the original photo, you'll still have enough pixels to make a nice print.

Using a Fast Shutter

Many folks give up taking pictures of sports for one reason—blur. A really fast-moving subject can change position *while* the camera's taking the picture, resulting in a blurry, ruined image. With disposable and credit card digicams, you're stuck with the blur. But if your camera lets you adjust a few settings, you'll take better action shots.

For freezing action, put your camera in *shutter-priority* mode. In this mode, you tell the camera that the *speed* of the shot is what matters. For example, you can specify that the exposure lasts for only 1/500th of a second. As long as your subject doesn't move within that tiny window of time, it remains in focus.

Understanding what this mode does is slightly technical, but extremely important. Whenever you take a picture, the amount of light that enters the camera is determined by two things: the *speed* of the shutter opening and closing, and the *size* of the opening of the diaphragm in the lens (the *aperture*).

When the shutter opens and closes very quickly (which is what you want for sports photography), it admits less light into the camera. To prevent the picture from being too dark, the camera has to compensate by increasing the size of its aperture, letting more light through during that fraction of a second.

In shutter-priority mode, that's exactly what happens. You're saying, "I don't care about the aperture. *You* worry about that, little camera buddy. I just want you to snap the picture fast." The camera nods in its little digital way and opens its aperture wide enough to compensate for your fast shutter speed. Of course, you can also set your own shutter speed, along with the aperture setting, in fully manual mode, if your camera has it. The beauty of shutter priority is that it's faster, since you have only *one* setting to deal with—the shutter.

The way you turn on shutter-priority mode differs greatly by camera. On some cameras, you have to fiddle around with the menu system. On others, you simply turn the little control knob on the top to a position marked *S* or *Tv* (old-time photography lingo for *time value*), as shown in Figure 3-3.

Once you're in shutter-priority mode, you need to indicate how *fast* you want the shutter to snap by adjusting the dial or slider on your camera. You can start with 1/1000th of a second and take a series of shots. (Instead of the fraction, the screen may display just 1000.) If the result is too dark, the camera is opening the aperture as wide as it can, so you have to slow down the shutter speed to the next notch—500, in this case.

Saving Time by Focusing in Advance

When you try to photograph a fast-moving target, you may run headfirst into a chronic problem of digital cameras—*shutter lag*. That's the time the camera takes to calculate the focus and exposure from the instant you squeeze the shutter button to the instant the shutter actually snaps, usually about one second.

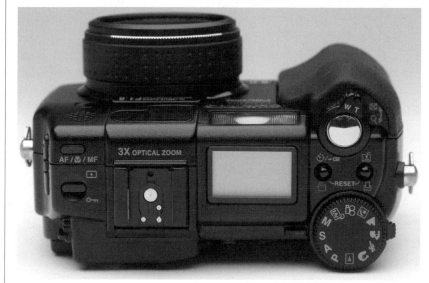

Figure 3-3:
*To freeze the action, use
a fast shutter speed, like
1/1000th of a second.
Find your camera's
shutter-priority mode,
which is usually
designated by an S on
the mode dial. But some
cameras, like Canons,
use the more traditional
abbreviation Tv, which
stands for time value.
Either way, you set the
shutter speed, and the
camera adjusts the
aperture automatically to
admit the right amount
of light.*

Unfortunately, even a delay of one second means death to perfect sports photography. You'll miss the critical instant every time.

The circuitry in more expensive cameras like Nikon and Canon digital SLRs is fast enough to make shutter lag a non-issue. If you're not blessed with such a rig, you can often overcome shutter lag by using your camera's *prefocus* feature. If your camera has it, half-pressing the shutter makes the camera calculate the exposure and focus *in advance*. Since those calculations are responsible for most shutter lag, prefocus nearly eliminates the lag, freezing the action closer to the critical moment. Try pressing your camera's shutter halfway down. When the focus is locked in, the camera usually indicates it with a flashing light or a little beep.

Suppose you're trying to get a shot of the goalie in a soccer game. Take advantage of the time when he's just standing there doing nothing. Frame the shot on your camera screen. Then, as the opposing team comes barreling down the field toward him, press the shutter button just halfway. Keep the button half-pressed until the moment of truth, when the goalie dives for the ball. *Now* squeeze the shutter the rest of the way.

When you use features like prefocus or burst mode (described next), *anticipating* the critical moment pays big dividends in sports photography. With a little practice, you can learn to press the shutter button just *before* the big moment, rewarding you with the perfect shot.

Increasing Your Odds with Multiple Shots

Most recent digital camera models have a *burst mode*, which snaps a series of shots in rapid succession as you hold down the shutter button. Burst mode is like an old

film camera's motor drive, making rapid-fire *buzz-CLICK buzz-CLICK* noises. You may remember hearing it in movies where the main character is a photographer. (Fortunately, digital cameras are a lot quieter.)

When you use burst mode, most cameras capture only about two frames per second, but that's enough to improve the odds that you'll get one good shot. With a little practice, burst mode helps you compensate for shutter lag, especially if you anticipate the action. Strive to start the burst before the batter starts to swing or the skater takes off for a jump. By the time the action comes to a climax, the camera is firing at full-speed, too.

Putting the Spotlight on Your Subject

Ordinarily, a digital camera calculates the amount of light in a scene by evaluating light from all areas of the frame. And usually, that system works perfectly well. In sports photography, however, the surrounding scene is usually substantially brighter or darker than the athletes, leading to improper exposure of the one thing you really want—the action.

Fortunately, many digital cameras offer *spot metering,* so you can make sure the subject is correctly lit, background notwithstanding. In spot-metering mode, you see little bracket markers (or a square or circle) in the center of your viewing frame (Figure 3-4). Whatever you place within these brackets (the star quarterback, your daughter atop her horse, or the finish line, for example) is what the camera pays attention to when calculating the exposure. By turning on spot metering for sports shooting, you'll make sure that the athlete is correctly lit.

Figure 3-4:
In this picture, the athletes are brighter than the baseball field. With most cameras' standard autoexposure mode, which evaluates the lighting in all areas of the scene and tries to strike a balance, the players would likely be too bright (overexposed). Using spot metering, you can tell your camera to set the exposure for the smaller area in the center of the frame, where the subjects of the photo are.

Action Shot Techniques Summarized

The best way to master your digital camera's many buttons and screen menus is through hands-on experience. If setting your camera's shutter to 1/500th of a second gets you that perfect image of your baby mid-bounce, you're more likely to remember how to activate shutter-priority mode next time. So don't spend your time memorizing settings. Instead, remember the following principles for good action photography. Over time, making the camera do your bidding becomes second nature.

- **Move in close.** Using a zoom lens, digital zoom, or your own body, get as close to the action as possible to eliminate distracting backgrounds.

- **Increase your camera's shutter speed.** If your camera has manual mode, shutter-priority mode, or even a preset *action* mode, use it to prevent blurring caused by movement.

- **Anticipate the action.** When you see the perfect moment on your camera's screen, it's way too late to press the shutter, especially if your camera has a substantial shutter lag. Even if you use burst mode to fire off a bunch of shots in a row, the time to begin taking your shot is about a second *before* the best action is likely to occur. It takes practice, but you *will* get the hang of it.

- **Do as much as possible before you take the shot.** Prefocusing and spot metering are easy on most digital cameras. Get in the habit of setting them during breaks in the action. Once your camera has focus and/or exposure locked in, you can concentrate on getting the shot without the drag of shutter lag.

- **Above all, persevere.** Don't get frustrated if many action shots don't turn out, even when you use these techniques. Pros shoot dozens, sometimes hundreds, of frames just to get one good picture. By its very nature, action photography produces lots of wasted shots. Just remember you've got a digital camera, so mistakes don't cost you a thing.

Taking Portraits

Most snapshots feature two, three, or even more people vying for attention with something in the background, like a waterfall or someone's minivan. But as you know from the previous chapter, the best pictures don't show *everything*—they show a single thing really well. If you want your photos to stand out from the crowd, it's time to explore the art of portrait photography. After all, how would you rather remember your son's third birthday: by a snapshot of him standing across the room awkwardly modeling his new outfit, or by a closeup that conveys his personality? Only a portrait can capture the mischievous arch of an eyebrow, or the little dimple he gets when he's thinking of something funny.

Taking good portraits isn't difficult, but it requires a few new skills. You have to examine all the details in the frame more closely than ever, and pay more attention to how light works. In the end, it's worth it. The portraits you take are likely to be your most treasured photos.

Creating Flattering Headshots

In professional portrait photographs, everyone looks great. Surely photographers use some kind of tricks—ancient, carefully guarded trade secrets—to make Uncle Ernie look so distinguished and handsome. On the contrary, there are no fancy secrets to great headshots. You can make any subject (or any uncle) look his best by applying the simple principles in this section whenever you shoot someone from the shoulders up.

You can take good portraits even if you have the cheapest camera on the planet. But a few additional features, like the following, go a long, long way:

- **Manual or aperture-priority mode.** When you take a portrait, you want clear focus on your subject and a softer background. The lenses in point-and-shoot cameras generally put everything in the frame in the same sharp focus. Manual settings, especially aperture-priority mode (page 46), give you greater control over the focal depth.

- **Zoom lens.** Not essential, but helpful for bringing your subject into clear foreground focus.

- **Fill-in flash.** Check to see if your camera's flash offers different settings. Even if you have enough light to shoot without a flash, a reduced flash setting can help eliminate shadows from your subject's face.

Soften the background

Although the next few pages show you several portrait styles, all successful portraits have one thing in common: the subject draws you in. You hardly notice the background because the photographer has intentionally downplayed it, usually by blurring it slightly. A shot with a soft-focus background has what the pros call *shallow depth of field*. Depth of field indicates how much of the picture is in focus. When you're snapping your family in front of the Great Wall of China, you probably want a *deep* depth of field, with both foreground (family) and background (Great Wall) in clear focus. But in typical headshots, you need a *shallow* depth of field—and a blurry background.

So how do you control the depth of field? Here are a few ways:

- **Zoom in.** At first, it doesn't seem logical to use your camera's zoom lens for a portrait. After all, you can get as close as you want to the subject just by walking closer. But thanks to a quirk of optics, zooming in helps create a shallow depth of field, which is just what you want for portraits. So if your camera has a zoom lens, zoom in slightly as you frame your subject. Step back a bit if necessary.

- **Move the background back.** The farther away your model is from the background, the softer the background appears. If you choose an ivy-covered wall as your backdrop, for example, position your subject 10, 20, or 30 feet away from the wall. Usually, the farther, the better.

• **Use a portrait setting.** Many cameras offer a *Portrait* mode, often designated on the control dial by the silhouette of a human head (Figure 3-5). Setting the camera to Portrait mode automatically creates a short depth of field, blurring the background.

Figure 3-5:
If your camera has a Portrait mode—indicated on this camera and many others by a silhouette of a human head—you may not have to fiddle with manual aperture settings.

• **Use a wide aperture setting.** As explained earlier in this chapter, two factors determine how much light fills a shot: how long the shutter remains open (the shutter speed) and how wide it opens (the aperture). In sports photography, what you care about most is usually the shutter speed. In portrait photography, what you care about most is the aperture setting—because the size of the aperture controls the depth of field. Wide aperture settings, indicated by *low* numbers like f-2.8 or f-4, let lots of light through the lens (Figure 3-6). These wide settings also help create soft backgrounds for portraits.

Figure 3-6:
Top: The trick to creating a soft background, whether for a portrait or a landscape shot, is to use a large aperture setting, like f-2.8 or f-4. (Oddly enough, low f-numbers indicate larger aperture settings.) If your camera has an aperture-priority mode, you can lock in this setting and the camera sets the correct shutter speed.

Bottom: For greater depth of field (clear focus from front to back), use a higher setting like f-11 or f-16, as outlined in the table on page 46.

Understanding aperture-priority mode

Expensive cameras offer more control over depth of field in the form of an *aperture-priority mode*. This mode lets you tell the camera: "I want to control how much of this shot is in focus, so I want to set the aperture myself. You, the camera, should worry about the other half of the equation—the shutter speed." Turning on aperture-priority mode (if your camera has it) may be as simple as changing a dial to the A or AV position, or as complicated as pulling up the camera's onscreen menu system.

Turning on aperture-priority mode is similar to turning on your camera's shutter-priority mode (page 23). Often, they're right next to each other. In any case, once you've turned on this mode, you adjust the aperture by turning a knob or pressing the up/down buttons. On the screen, you'll see the changing *f-stop* numbers, which represent different size apertures.

This table should offer some indication of what you're in for:

f-stop	Diameter of Aperture	Depth of Field	Background Looks
f-2	Very large	Very shallow	Very soft
f-2.8	Large	Shallow	Soft
f-4	Medium	Moderate	A little out of focus
f-5.6	Medium	Moderate	A little out of focus
f-8	Small	Moderately deep	Mostly in focus
f-11	Small	Deep	Sharp
f-16	Very small	Very deep	Very sharp

Fill-in flash

Adjust the flash settings so the flash is forced to go off. That provides a nice supplemental burst of light to better illuminate your subject. Don't stand more than ten feet away from your subject or your fill-in flash won't reach. (See "Forcing the flash to fire" on page 52 for more details.)

Taking the picture

If you can, shoot on a cloudy day, first thing in the morning or late in the afternoon, especially if you're shooting outdoors. At these hours, the light is softer and more flattering. Otherwise, try to place the model in open shade—under a tree, for example.

More headshot tips:

• Position your model so the backdrop is in the distance. Check for telephone poles or anything else that may appear to pierce the subject's head.

- Stand within ten feet of your subject, so your fill-in flash reaches. Use your zoom lens so your model's upper body fills the frame and helps soften the background. (Unwittingly, most people stand too far away from their subjects.)

- After a few frames, review your work and adjust as necessary. The soft background effect may not be as strong on a consumer-grade digicam as with a pro camera and a telephoto lens, but you'll definitely notice a pleasant difference.

Shooting in Existing or Natural Light

Cameras love light, that's for sure. In general, you need the flash for indoor shots but not *always*. Some of the best interior photos use nothing more than light streaming in from a window. Pictures taken with only ambient light without adding flash are called *existing light* or *natural light* photos. Portraits taken in natural light have a classic feel, reminiscent of timeless paintings by great artists like Rembrandt.

Of course, relying solely on existing light isn't always feasible, but if you can manage it, natural light has the following advantages over flash photography:

- **More depth.** Flash photography's big drawback is that it illuminates only about the first ten feet of the scene. Everything beyond that fades to black. If you turn the flash off, your camera reads the lighting for the *entire* room. Not only is your primary subject exposed properly, but the surrounding setting is too, giving the picture more depth.

- **Less harshness.** The light in an existing-light photo generally comes from a variety of sources: overhead lights, windows, lamps, and reflections off walls and ceilings. Combined, these factors create soft, balanced lighting, instead of the stark, whitewashed glare that a built-in flash often generates.

- **More expressiveness.** Too often, flashing in your subjects' faces produces that "deer in the headlights" stare. Existing-light pictures tend to be more subtle and expressive, because the *people* you're shooting are more relaxed when they're not being pelted by bursts of light.

The vast majority of digital cameras come with an automatic flash to compensate for any lighting deficits. In the interest of keeping the customer happy, camera makers design the flash to ensure that you get *a* picture every time you press the shutter button—even if it's not the most attractive, artistic one. If you want to get creative and flash-free, these tools come in handy:

- **Flash control.** Before you ask your significant other to perch on a stool by a sunny window, make sure you know how to turn your camera's flash on and off. (It's not always obvious.) An unwanted blast of light is unpleasant for the model and, perhaps, embarrassing for the photographer.

- **Adjustable ISO (film speed).** If your camera lets you adjust the film speed (page 23), try a setting of 200 or 400 to make your camera more light sensitive. (If you have enough light for a decent exposure, though, then *don't* increase the film speed, because it'll slightly degrade the image quality.)

TIP To tell whether you need to increase the film speed, simply review a test shot. (On the LCD screen, zoom in, magnifying the photo, to inspect it more closely.) If the image is too dark or has motion blur, increase the film speed from 100 to 200. Take another test shot. If it still looks dark, try increasing one more time to 400 speed. And open the drapes all the way.

- **Spot meter.** Consider turning on spot metering (page 38). It permits the camera to make exposure decisions based only on the subject, without being affected by the lighting in the surrounding background.

- **Remote control or self-timer.** Holding the camera still may well be the biggest challenge of existing-light photography. If a remote control came with your camera, use it. If not, use the camera's self-timer feature, which counts off a few seconds before snapping the picture automatically.

- **Tripod.** A high-quality tripod is an optional accessory, but if you take a liking to existing-light photography, you'll find it invaluable for holding the camera steady.

- **Reflector.** To help direct existing light where you need it, you can use a photographer's reflector panel. Or you can make do with any white cardboard, paper, or sheets you have lying around (more details in a moment).

Keeping it steady

When you forgo the flash for a natural light portrait, the camera's shutter has to stay open for a relatively long interval to admit enough light for a good picture. As a result, you need to keep the camera very steady, which is much easier with a tripod. Pocket tripods (page 72) are great for this type of shooting. They weigh only a few ounces and steady the camera on all kinds of surfaces like tables, countertops, and so on.

Once the tripod is steady, you face another challenge: taking the picture without jiggling the camera when you press the shutter button. Even a little camera shake can blur your entire image, creating an out-of-focus appearance. So, just avoid pressing the button: Make the camera do it instead. Employ your camera's remote control or self-timer to put some distance between your body movements and the camera.

TIP If your camera has burst mode (page 27), here's a golden opportunity to use it. The jar of your shutter press may ruin the first shot, but by the second or third shot of the burst, things are much steadier.

Managing existing light sources

Creating a natural-light photo means learning to work with light on its own terms. You have to take your model and camera to where the good light is. Great painters of the past preferred the light coming through a *north* window for their portraits, especially in the early hours of the day. Try this positioning for your existing-light portraits.

To adjust your composition's lighting you have to reposition the model, the camera, or both. But you're not as powerless as you think. You can turn overhead lights on and off, open and close window shades, move table lamps around, and take lampshades on and off. The most common problem in existing-light photography is a shadow darkening the model's face. Try turning your subject at a different angle to the incoming sunlight, or pull over a table lamp to illuminate the dark area.

You can also find a reflector and position it so that light bounces off the reflector onto the dark side of the model's face (Figure 3-7). A reflector is a common piece of photographic gear; it's essentially a big white shiny surface on its own pole. If you don't have lighting equipment sitting around the house, but you really want this portrait to look good, just rig a big piece of white cardboard or white foam board to serve as a reflecting surface.

Figure 3-7:
In this existing-light portrait, notice how the tones trail off quickly from light to dark, which is typical illumination from a window. To brighten the shadow areas, use a reflector to bounce the light back toward the mode. You can try a flash for fill light, but be careful not to ruin the mood of the scene. Your best bet is to use the nighttime flash mode, to preserve some of the scene's ambience.

Once you've balanced the tones, take a picture and review your results. Shadowed areas usually look darker to the camera than they do to your eyes. If so, move the reflector closer to brighten the shadows. In this type of photography, you learn to look at the lighting the way the *camera* would see the scene, not the way you would normally view it. See the box on page 50 for more advice.

The Tale of Two Perceptions

The reason photographic lighting is such a challenge is that you have two different systems operating at once: your eyes and your camera. Your pupils are super-advanced apertures that constantly adjust to ambient light. Even in extreme conditions, such as when you go from a completely dark theater to the bright lobby, it takes only seconds for your optical system to adjust.

Furthermore, you can look at a scene that contains both deep shadows and super-bright highlights and see detail in both areas simultaneously. Your eyes, optical nerves, and brain adjust constantly to interpret the ever-changing landscape around you. Unfortunately, your camera can't do the same.

While your eyes can pick up the entire *tonal range* of a scene (the shades from brightest white to darkest black), a camera can pick up detail in only a slice of it. For example, if you're shooting a bright sky filled with clouds and trees casting deep shadows on meadow grass, you have a decision to make.

Which parts of this scene are most important to you, the bright sky, the trees, or the deep shadows? On a good day, your camera records detail in only two of the three elements.

With practice, you can learn to see the world the way your camera does, to the great benefit of your photos. For example, try setting up a natural-light scene, such as a still life with fruit. Put the camera on a tripod. Study the scene with your eyes, and then photograph it. Compare what the lens records with the image in your head.

Are they the same? Probably not. How are the two images different? Make a few notes about your perceptions as compared to what the camera captured, and then repeat the exercise with a different scene. When the image in your head begins to match the one on the camera's LCD screen, then you've truly begun to see the world with a photographic eye.

Tweaking white balance (color balance)

Here's a mind-bending example of the way your eyes and your camera see things completely differently. It turns out that different kinds of lights—regular incandescent lightbulbs, fluorescent office lighting, the sun—cast subtle tinges of color on everything they illuminate. When you shoot non-flash photos indoors or in open shade outside, you'll get a bluish or *cool* cast. If you shoot without a flash under incandescent lighting, then the shots will have a *warm* tint, mostly yellow and red.

So why haven't you ever noticed these different lighting artifacts? Because your brain compensates almost instantly for these different *color temperatures*. (Your brain does a lot of compensating for light. Ever noticed how your eyes adjust to a dark room after a couple of minutes?) Your camera, however, doesn't have a brain. It simply grabs whatever warm or cool tints it sees, and those tints can detract from your onscreen or printed photos. For example, portraits with warmer casts are generally more pleasing to the eye. But natural light from the window imparts a bluish cast, which isn't good for skin tones.

In the days of traditional film photography, you could compensate for (or *correct*) the color temperature by placing a screw-on filter over the lens. With a digital camera, you don't need any external accessories. Almost every digital camera lets you correct the color temperature by adjusting its *white balance* (sometimes called *color balance*).

Most cameras have a little knob or menu offering icons like the following (see Figure 3-8):

- A **sun** icon represents normal daylight conditions in direct light. (If you know about filters in film photography, the sun/daylight setting is equivalent to the Sky 1A filter.)

- A **cloud** icon is for overcast days, open shade, and window-illuminated interiors (81B warming filter).

- A **lightbulb** icon is for incandescent lighting (80A cooling filter).

- A **bar-shaped** icon is for fluorescent lighting (FLD fluorescent correction filter).

TIP To warm up the skin tones in existing-light portraits (like the one in Figure 3-7), use the Cloudy white-balance setting.

Figure 3-8:
Most digital cameras let you adjust color balance. Sometimes the setting is labeled WB for white balance (essentially the same thing as color balance). Most of the time, you can leave this setting on Auto. But if the tones start looking too cool or too warm, you may want to override auto and make the adjustment yourself.

TIP When you're using the flash, change your camera's color balance from Auto to Cloudy. Electronic flashes tend to produce images that have a cool cast. Switching to the Cloudy setting on your digital camera warms them up nicely.

Taking the picture

In natural light photography, think of yourself as an artist, using light as your paintbrush. It takes time and practice to become proficient, but even your first efforts will probably surprise you with their expressiveness. Keep the following points in mind:

- **Don't skimp on setup.** When you're working with existing light, the work you do *before* you shoot is what determines the quality of your results. Take a moment to review your camera's aperture-priority, self-timer, and white balance settings. If you need a tripod, borrow or improvise one so you don't get frustrated trying to hold the camera steady.

- **Don't be too quick to delete shots from the camera before viewing them on your computer.** Existing-light shots sometimes contain subtleties that don't appear on tiny LCD screens. Images that looked uninteresting on your camera's two-inch display may surprise you when you see them full size.

- **Be patient with yourself.** With time and practice, you'll be able to calibrate your eyes so they see shadows the same way your camera does. You'll spend less and less time testing before the shoot, and more time creating your classic image.

- **Be patient with your model.** During a long exposure, fidgety people mean blurry portraits. (Of course, you can use this effect to your advantage, too, if you want to create a moody interior picture with ghostlike subjects.) As the photographer, you set the tone for the shoot. It's your job to persuade your models to sit still, put them at ease if they're nervous, and chat with them when they're bored.

Taking Portraits Outdoors

Taking pictures outside should be a no-brainer, right? There's plenty of natural light from the sun, so why do so many outdoor photos come out underexposed and disappointing, like the top image in Figure 3-9? Your digital camera's built-in flash *is* convenient, but it isn't terribly smart. Outdoor portraits are a perfect example. If you leave the flash on automatic when you shoot outdoors, you can guess what happens: The camera decides that there's plenty of light and doesn't trip the flash. Sure, the camera's correct in concluding that there's enough light in the entire frame. But it can't tell when your *subject* is sitting in a shadow.

Everybody with a little picture taking experience knows how ornery and feeble an automatic flash is, indoors or out. If you're too close to the subject, it overflashes, turning your best friend into a nuked-out ghost. If you're farther than about eight feet away, the flash is too weak to do anything useful at all. Believe it or not, the camera's automatic mode is wrong about half the time. No matter what kind of camera you have, you'll take your best pictures when *you* decide to use the flash, not when the camera decides.

Forcing the flash to fire

The solution to the situation in Figure 3-9 is to force the flash on—a very common trick. If you're close enough to the subject, then the flash provides *fill light* to balance the subject's exposure with that of the surrounding background, as you can see in the bottom photo. (If you're using your on-camera flash, stand within about eight feet of the subject so you can get enough flash for a proper exposure.) The fill-in flash can dramatically improve outdoor portraits. It eliminates the silhouette effect when your subject is standing in front of a bright background and frontal light is very flattering. It softens smile lines and wrinkles, and it puts a nice twinkle in the subject's eyes.

How do you take your flash off auto mode? Most cameras offer a couple of different flash settings. Look for the icon that represents a lightning bolt with an arrow tip on the end—the universal icon for electronic flash. Generally, if you push the button next to this icon, it cycles through the flash modes on your camera. These modes usually include *auto flash* (no icon), *red-eye reduction* (eyeball icon), *no flash* (universal "circle with a diagonal line through it" icon) and *forced flash*

Figure 3-9:
Bright backgrounds often fool the digital camera's exposure meter. The camera may expose the background properly, but throw your subject into darkness. The solution is right there in the camera— the fill-in or forced flash feature. Look for a single lightning bolt in your camera's mode options.

(standalone lightning bolt icon). For a fill-in flash, use the forced flash mode. (In full automatic mode, by the way, you may not be allowed to change the flash mode. Try switching into Portrait mode first.)

> **NOTE** If you're that rare digital photographer who owns an external flash attachment, use *it* in situations where you need a fill-in flash. Its more powerful strobe illuminates the subject better and provides a more flexible working distance. An external flash, on a cord, is also the only way to avoid glare from eyeglasses. Raise it a couple of feet above the camera to minimize the reflection of the flash in the lenses. (See the box on page 55 for more details.)

Creating a flattering effect with rim lighting

Once you've experimented with fill-in flash (page 46), try a variation that pros use to create striking portraits: *rim lighting.* Position the subject with her back to the sun (preferably when it's high in the sky and not shining directly into your camera lens). Now set your camera to fire the flash (the lightning bolt, not the automatic setting). If the sun is shining into the lens, block it using your hand or a lens shade.

The first thing you'll notice is that the sun creates a *rim light* around the subject's hair (Figure 3-10). You'll also notice that her eyes are more relaxed and open. In

one swift move, you've made your subject more comfortable and improved your chances for a dramatic portrait.

Figure 3-10:
Remember how you were told to always have the sun at your back when taking a picture? That's not the best advice for portraits. In fact, you want the sun on the model's back to create a rim light effect. Notice how this model's hair and shoulder are highlighted.

Remember to turn on your fill-in flash so the model's face isn't underexposed. When it works, rim lighting creates portraits that you'll be very proud of. It's not the right technique for every situation, but sometimes it produces jaw-dropping results.

> **TIP** If your camera accepts filters, try a *softening filter* for your rim-lighting shots. It can reduce facial wrinkles and create a nice glow around the subject's head. This effect (and many others) can also be created later in Photoshop Elements; see Chapter 13.

Taking advantage of open shade

Working in open shade, like the shadow of a tree, produces less dramatic portraits than rim lighting, but very pleasing ones nonetheless. Open shade eliminates harsh shadows around the face and keeps the subject from squinting. Here again, forcing the flash on your digital camera is a great idea. Look for a subtle background without distracting elements. The beauty of this technique is that you capture an evenly lit, relaxed subject with a perfectly exposed background. You won't even notice that it was shot in the shade.

Taking Self-Portraits

Sometimes it's easier to take your own picture than to hand the camera to someone else—especially when you're practicing with your camera. Everything you

Built-In Flash vs. External Flash

More expensive digital cameras offer serious photographers a wonderful feature: a place to plug in an external flash attachment. An external flash moves the light source away from the lens, which reduces red eye, especially if the flash is on its own separate bracket rather than a hot shoe right on the camera. The external flash makes your camera's battery last longer, too, because it has its own batteries. You'll be grateful for that during long events like weddings.

The most versatile way to attach an external flash is with a standard hot shoe right on top of the camera, as shown in Figure 3-11. Some cameras just aren't big enough to accommodate a hot shoe. To circumvent this problem, some camera makers have engineered a system that uses a tiny socket on the camera that connects to the flash via a proprietary cord and bracket.

This system isn't the height of versatility, but it does allow you the flexibility of an external flash on a very compact camera.Finally, a detached flash attachment gives you more flexibility, because you can use it to bounce light off the wall or ceiling to provide fill lighting for certain shots.

A good external flash with a dedicated cord costs at least $200, and, of course, only the fancier digital cameras can accommodate them. But as you become more serious with your photographic pastime, you'll find that external flashes help you capture shots that on-camera flashes just can't get.

Figure 3-11:
A hot shoe, like the one shown here, lets you attach an external flash to your camera. You can either connect the flash directly, or you can use a dedicated flash cord that allows you to move the flash away from the camera, but still retain communication between the two.

learned a few pages ago about taking headshots applies to pictures you take of yourself. Helpful camera features for self-portraits include the following:

- **Fill-in flash** (page 46). The ambient room lighting is often bright enough to provide overall evenly distributed illumination, but the flash provides a little burst of front light to smooth out facial blemishes and put a twinkle in your eyes.

- **Flip screen** and **remote control.** The flip screen lets you preview how you look in the frame before you shoot the shot, and the remote control lets you snap the shot without getting up from your stool.

 If you don't have a flip screen or remote, put your camera in self-timer mode. To help you frame the shot while you're not actually on the stool, use a table lamp as a stand-in.

- **Tripod** A standard tripod is best, but you can use a pocket tripod on a table if necessary.

 TIP In a pinch, you can use a standard hotel-room lamp as a tripod. The threads that secure the lampshade to its support bracket are exactly the right diameter for your camera's tripod socket.

Creating a neutral backdrop

If you're on vacation, the natural scenery may be all the backdrop you need. If you're shooting a picture to use on a resumé or to post on your Web page, however, create a neutral, professional backdrop. Find a room with some pale, open wall space and lots of natural light from windows. Find a stool or a low-back chair without arms, and position it about five feet in front of your backdrop. If possible, face it towards the brightest window in the room. Using your tripod or tripod substitute, position the camera about five feet from your stool.

To check the lighting, use your flip screen, take a test shot, or use the table lamp trick described earlier. If you need to add a little light to one side of your face or the other because it's appearing too shadowy, you can construct a homemade reflector out of white cardboard or similar material. Position your reflector as close to you as possible (although not in the photo itself, of course) and angle it so it bounces light off the brightest light source onto the area requiring illumination.

Taking the picture

Check your hair and clothing in a mirror, press the shutter button to trigger the self-timer countdown, and then sit on the stool. Once the camera fires, play back the photo on the screen. Did you zoom in close enough? Are you in focus and centered in the frame? How does the lighting look?

Shoot another round. Once you get the basic setup looking good, experiment with different angles and facial expressions. One advantage of taking your own portrait

is that you can be more creative. Remember, you can always erase the embarrassing frames—or all of them. Remember, too, that self-portraits don't have to be dull headshots; they can be every bit as interesting as any other photo.

Kids and School Performances

Wherever you find kids, camera-toting parents are never far behind. (OK, they're usually far behind, but doing their best to catch up.) And now that email makes it easier than ever for parents and grandparents to share those precious images with the world, the gross national production of kid photos has risen from gazillions to bajillions.

If you're one of those parents, you're right to capture those memories before childhood flies by. But try to sit still long enough to read this section. With a little technique, you can shoot photos that make your kids look even more gorgeous (just don't expect the other parents to admit it).

Getting Great Kid Shots

Children are challenging for all photographers. They're like flash floods: fast, low to the ground, and unpredictable. But with a little patience and perseverance, you can keep up with them and get the shot (Figure 3-12).

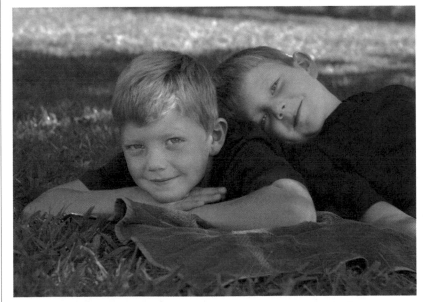

Figure 3-12:
If you want great-looking kid shots, you've got to play on their turf. That means getting down on your hands and knees, or even your tummy.

Many of the action photography tips you learned at the beginning of this chapter are great for kid photos, too. Highlights include:

- **Be prepared.** Rule Number One for capturing great kid pictures is to have your camera handy at all times, charged and with memory card space to spare. Great kid shots come and go in the blink of an eye. Parents don't have the luxury of keeping their equipment snugly stowed away in a camera bag in the closet.

- **Get down there.** The best kid shots are generally photographed at kid level, and that means getting low. (Flip screens are particularly useful for kid shots, because they let you position the camera down low without actually having to lie on the ground.)

- **Get close.** Your shots have much more impact when the subject fills the frame. The less excess space you shoot, the less you'll have to crop out later.

- **Prefocus.** Shutter lag will make you miss the shot every time. In many cases, you can defeat it by prefocusing—that is, half-pressing the shutter button when the kid's not doing anything special. Keep your finger on the button until the magical smile appears, and then press fully to snap the shot.

- **Burst away.** Use your camera's burst mode to fire off several shots in quick succession (Figure 3-13). Given the fleeting nature of many kids' grins, this trick improves your odds of catching just the right moment.

Figure 3-13:
Photographing fast-moving children is easier if you use your camera's burst mode, which lets you hold down the shutter button and fire off a sequence of frames. Chances are, one of them captures the decisive moment. On most cameras, you choose burst mode using the onscreen menus. Nicer cameras offer a choice of several burst modes: for example, one that captures full-resolution shots but not as quickly, or a more rapid-fire mode that takes lower-res photos.

- **Force the flash.** Indoors or out, you'll want the flash to fire, since it provides evenly distributed illumination and helps freeze the action. Switch your camera's flash setting so that it's always on.

- **Make it bright.** Don't bother using the *red-eye reduction* flash mode on your camera. By the time your camera has finished strobing and stuttering, your kid will be in the next zip code.

If red eye is a problem in your flash photos of kids, make the room as bright as possible, shoot from an angle that isn't dead-on into your kids' eyes, and touch up the red eye later on your computer, if necessary. (See the box on page 68 for more red-eye tips.)

• **Fire at will.** Child photography is like shooting a sports event—you'll take lots of bad shots in order to get a few gems. Again, who cares? The duds don't cost you anything. And once you've captured the image of a lifetime, you'll forget all about the outtakes you deleted previously.

Shooting Onstage Performances

Taking effective photos during plays, music recitals, ballets, and other performances is difficult even for professional photographers. What makes theater lighting tricky is that the bright main light on your child star is often right in the same frame with a subdued or even darkened background. If you use automatic mode under these conditions, then the camera calibrates the exposure, brightening up the image enough to display the dominant dim background. As a result, the spotlighted performers turn into white-hot, irradiated ghost children.

The good news is, most digital cameras let you easily adjust for uneven lighting. And once you master features like spot metering and exposure compensation, you can use these techniques to shoot in any theatrical situation, even Carnegie Hall. (Your kid *is* going to perform at Carnegie Hall, isn't she?)

> **NOTE** Your built-in flash is useless in a darkened theater (unless you climb right up on stage beside the actors, which management generally frowns upon). The typical range for a digital camera's flash is about ten feet, after which it's about as useful as an icemaker in Alaska. So *turn your flash off* at theater performances: It's annoying to the rest of the audience, it's worthless, and it's usually forbidden.

Lighting up the stage with spot metering

If your camera has a *spot-meter* mode, your budding performers in the spotlight have a fighting chance against a dark backdrop. As noted earlier in this chapter, your camera generally gauges the brightness of the scene by averaging the light across the entire frame—a recipe for disaster when you're shooting the stage.

Spot metering, however, lets you designate a particular spot in the scene whose brightness you want the camera to measure. (You indicate what spot that is by positioning a frame marker that appears in the center of the frame.) Point the spot-metering area at the brightly lit performers; try to position it on faces rather than costumes, especially if the latter are very dark, light, or glittery. The camera then sets the exposure on your subjects instead of on the vast expanse of the dimly lit set.

Adjusting for poor lighting with exposure compensation

Not all cameras have a spot-metering mode. But even basic cameras generally offer some kind of *exposure compensation,* an overall brightness control. For theater situations, try lowering the exposure to –1 or –1.5, for example. The objective is to darken the entire scene. The background will be *too* dark, of course, but at least the actors won't be blown out.

UP TO SPEED

Vacation Shooting Tips

Vacations are for enjoyment, not stress. Don't feel pressured to take the perfect pictures or capture every single moment. Taking pictures is part of your vacation, so relax and have fun while you're shooting.

Digital cameras encourage playfulness. You can try something silly, look at it on the LCD screen, and if it's too incriminating, erase it before anyone else discovers just *how* amateur an amateur photographer you really are.

Try the following ideas next time you're exploring the world:

- **Get in the picture.** Almost every digicam comes with a self-timer. Position the camera so that you have an interesting background, trip the timer, and get in the shot.

- **Try the close-up mode.** Almost every digital camera offers a *macro* (super-close-up) mode that lets you get within inches of your subject. The world is a very different place at this magnification. Let your imagination run wild. Everything is a potential shot, from local currency to flower petals.

- **Vary the shots.** The standard shot of your travel companions standing posed in front of the Grand Canyon is fine, but that's only the beginning. The little, intimate shots, such as your cousin staring out the train window, or your friend buying flowers from a street vendor, are often more compelling than the typical "stand in front of a building and smile" photo.

- **The city lights from your balcony at sunset.** There's a magic moment every day at twilight when the city lights come on right before the sun sets. Grab your camera, park it on a wall or windowsill for stability, and take a few shots.

- **Shoot from the passenger-side window.** Sitting on the passenger side of the car (with someone else driving, of course), roll down the window and look for interesting pictures. Don't worry about the background blurring and other little glitches, because they're often what make the pictures compelling.

- **Signs and placards instead of notes.** Museums, monuments, and national parks are all loaded with informative signs and placards. Instead of taking notes and lugging brochures, take pictures of these tidbits of information. When you put together an onscreen slideshow of your trip (see Chapter 17), they'll make great introductory shots for each segment.

- **Shooting through shop windows.** Storefront displays say so much about the local culture. But taking pictures through glass can be tricky, thanks to unwanted reflections. The trick is to zoom out, and then get the front of the lens barrel as close to the window as possible. The closer you are, the fewer reflections you'll have in your picture.

- **Don't forget to pack extra batteries.** Also pack a charger (if you have one), a supply of memory cards, and, of course, your camera.

Taking the picture

Depending on the kind of performance you're trying to photograph, getting the right lighting may be just the tip of the iceberg. Do some research about seating and photography regulations ahead of time. Here are some hints:

- **Try to secure a ticket in the first few rows.** When it comes to theater shooting, the closer you get, the better.

- **It's good etiquette to ask in advance for permission to take pictures.** Also, if you find out that photography is OK but flashes are forbidden, ask if you can set up a tripod (much better for low-light photography).

- **Consider taking your pictures at the dress rehearsal.** Schools often allow photography at the dress rehearsal but not the actual performance. You may even be able to grab a seat in the front row, to the immense benefit of your photos.

Weddings and Celebrations

Whether the celebration is an elaborate wedding, a formal bar mitzvah, or a simple home birthday party, photos are a must. They preserve the details and emotions that everyone wants to remember. If there's no hired photographer—or even if there is—charge up your digicam. When they see the prints, folks often prefer the shots taken by guests over the formal professional photos.

One of the advantages you may have over the hired photographer is that you know people at the event. You're in a much better position to take candid, relaxed pictures of the guests that capture the true flavor of the day. Even so, be careful not to *interfere* with the professional photographer's posed shots. Introduce yourself to the photographer and ask if it's OK to take a couple of shots right after the pro has finished each setup. You'll generally receive permission—and the opportunity to capture the highlights of the day.

As a digital photographer, you can bring a new dimension to the celebration that most pros don't even offer—immediacy. If you like, you can hook up your camera to a TV to play the pictures back while the reception is still going on. Or, if you bring a laptop, you can have a photo gallery or slideshow up on the Web before the pro even leaves. (See Chapter 17 for details about creating projects like these.)

> **TIP** Be prepared to overcome the challenges of indoor flash photography in dimly lit places like dance halls, restaurants, and auditoriums. Consult "Shooting Onstage Performances" on page 59 and the box on page 63 for advice.

Photographing Weddings

Your success at shooting a wedding depends primarily on your ability to anticipate the action. Most weddings have a few classic photo ops in common, so professional photographers usually work from a checklist. If you're one of the guests, use the following list for inspiration only. Wedding days provide dozens of opportunities for memorable pictures. If you get only a fraction of them, you'll still have plenty to share at the end of the day.

- **Before the wedding.** Bride making final dress adjustments, alone in dress, with mother, with maid of honor, with bridesmaids. The groom with his best man, with his ushers, with his family.

- **During the ceremony.** The groom waiting at the altar, his parents being seated, the bride's mother being seated, the processional, the bride coming down the aisle, the vows, the ring ceremony, the kiss, the bride and groom coming back down the aisle. And of course the obligatory adorable shots of the flower girl and ring bearer walking down the aisle looking dazed.

- **Directly after the ceremony.** The wedding party at the altar, the bride and groom with family, the bride and groom with officiate, closeup of the bride's and groom's hands on the ring pillow.

- **During the reception.** Guests signing the guest book, the bride dancing with groom/father/father-in-law, the groom dancing with mother/mother-in-law, the cake table, the cake cutting, the cake feeding, the toasts, the bouquet toss, the decorated getaway car.

> **TIP** Bringing your camera to at least one wedding is a great way to hone your photography skills. If you can shoot an entire wedding, then you're prepared for any other event that comes your way. For example, graduations are just weddings without the reception. Birthday parties are just weddings without the ceremony.

Sunsets and Nighttime Photos

Because photography is the art and science of capturing light, you wouldn't think that nighttime would present many photo opportunities. But in fact, nighttime pictures can be the most spectacular ones in your portfolio. Sunsets, evening portraits, city lights, and even car lights can stand out like bright colors on a black canvas.

> **TIP** You won't get far in this kind of photography without a tripod. You can practice the following techniques by bracing the camera against a wall—but you'll find the job infinitely easier with a real tripod.

Sunsets

Your camera usually does a good job of exposing the sky during sunset, even in automatic mode. Keep the flash turned off and shoot at will. The biggest mistake people make when shooting sunsets has nothing to do with the sky—it's the *ground* that ruins the shots. Your eyes can make out much more detail in the shadowy ground than your camera will. Therefore, it's not worth trying to split the frame in half, composing it with the sky above and the ground below. The bottom half of your photo will be just a murky black blob in the final image.

TROUBLESHOOTING MOMENT

Using a Flash Indoors

Over the years, you've probably seen plenty of indoor flash pictures that have a pitch black background and a washed-out, overexposed subject. Many factors conspire to produce these stark, unflattering shots, but one of the major contributors is, once again, your camera thinking on its own. You're letting *it* decide when to turn on the flash and which shutter speed to use.

First of all, you don't always need the flash. Indoor photography offers many opportunities for stunning existing-light portraits and moody interior shots, as discussed in this chapter. And when you do have to turn on the flash, you can make certain adjustments to preserve the ambiance of the room so that your background doesn't fall into a black hole.

Flash shots may have a pitch-black background for a couple of reasons. The first problem is that the light from a typical digital camera's flash reaches only about eight to ten feet. Anything beyond this range, and you've got yourself an inadvertent existing-light photo.

If your camera has a *manual mode* that allows you to dictate both the aperture (f-stop) and shutter speed, you can easily overcome these problems.

Once in manual mode, try this combination as a starting point for flash photography indoors:

- Set your film speed to 100 (page 23).

- Set the aperture (f-stop) to f-5.6.

- Set the shutter speed to 1/15th of a second.

- Use the forced-flash mode. (*Don't* use the red-eye reduction feature. More on that in the box on page 68.)

When you use these settings, hold the camera as steady as possible. At these slow shutter speeds, your shots are more vulnerable to camera shake, and therefore to blurriness. Your flash will help freeze everything in its range—but the background, not illuminated by the flash, may blur if the camera isn't steady.

If your camera doesn't have a manual mode, all is not lost. Almost every consumer model has a *nighttime* or *slow-synchro* mode (look for a "stars over a mountain" icon). The intention of this mode is to let you shoot portraits at twilight. But you can also use Nighttime mode indoors to open up the background (Figure 3-16). Granted, you don't have as much control with this setting as you do with manual mode, but you may be pleasantly surprised with the results.

Taking the picture

Follow these tips for best results when shooting at sunset:

- Fill your composition with 90 percent sky and 10 percent ground or water. This arrangement may feel funny—at least until you look at your prints and see how much more dynamic they are with this composition.

- Don't leave the scene right after the sun dips below the horizon. Hang around for another 10 minutes or so; sometimes there's a truly amazing after-burst of light.

- Keep an eye on your shutter speed (if your camera shows it). If it goes below 1/30th of a second, you may need a tripod or some other steady surface to prevent camera shake.

- Activate the self-timer or remote control to avoid jiggling the camera when you press the shutter.

Trailing Car Lights

You've seen this shot on postcards and in magazines: neon bands of light streaking across the frame, with a nicely lit bridge or building in the background. The trick to these shots is to keep the shutter open long enough for the cars to pass all the way from one side of the frame to the other (Figure 3-14).

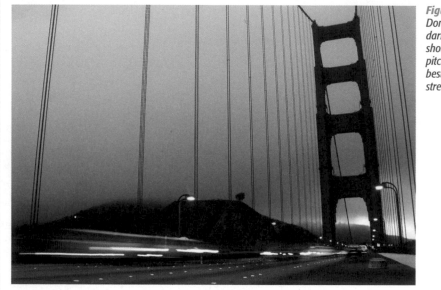

Figure 3-14:
Don't wait until complete darkness for this type of shot, or your sky will go pitch black. Twilight is the best time to shoot streaming car lights.

Bulb mode for extended shutter times

When using film cameras, photographers rely on the camera's *B* setting, in combination with a *cable release* (a shutter button on the end of a cord). The B setting (short for *bulb*) keeps the shutter open for as long as you hold down the release. Many a photographer has stood out in the cold, thumbs pressing down on icy cable releases, softly counting: "One thousand one, one thousand two, one thousand three...."

Your digital camera probably doesn't have a B setting (although a few do have Bulb modes). But you can capture these dramatic shots if your camera offers a shutter-priority mode (page 23). In this mode, you can tell the camera to keep the shutter open for a long time indeed—four seconds or more for car-taillight photos, for example.

Taking the picture

- Pack a pocket flashlight so you can see the camera's controls in the dark.

- Try to find a vantage point high enough to provide a good overview of the scene. A nicely lit building, bridge, or monument in the background provides a good contrast to erratic lights created by the cars passing through the scene.

- Put your camera on a tripod or some other steady surface, and set it in shutter-priority mode (page 23). After you've composed your shot, set the shutter for four seconds. (The camera controls the aperture automatically.)

- Use your remote control, if you have one, or your camera's self-timer mode to prevent camera shake.

When you see cars coming into the scene, trip the shutter. Review the results on the LCD screen. If the streaks aren't long enough, then add a couple seconds to the shutter setting; if the streaks are too long, subtract a second or two. With a little trial and error, you can capture beautiful, dramatic taillight shots just like those postcards you always see.

Star Trails

If you *really* want to impress your friends with your budding photographic skills, try capturing *star trails*. Surely you've seen these dramatic shots: one star, located in the center of the frame, remains a point of light, but all the other stars in the universe seem to carve concentric circle segments around it, as though the galaxy were spinning dizzily. (That one fixed star, in case you were wondering, is the North Star. It remains steady as all the other stars seem to travel in a circular path around it, thanks to the rotation of the earth.)

Find some place dark with a clean horizon line and away from city lights (which will wash out your shot). If you want the ground in the shot at all, compose the frame so that the sky fills 90 percent of it, and the ground occupies only the bottom 10 percent. The setup for this shot is the same as for the taillight trails (page 64), except that you have to keep the shutter open much longer—at least 15 seconds for very short trails as in Figure 3-15, or (if your camera can handle it) up to 15 *minutes* for dramatic star trails.

Twilight Portraits

Twilight is a magic time for photographers. The setting sun bathes the landscape in a warm glow, providing a beautiful backdrop for portraits. Twilight's an ideal time to shoot any type of picture. The result can be an incredibly striking image that makes your travel pictures the talk of the office. It's a great technique when shooting somebody standing in front of illuminated monuments and buildings at night, sunsets over the ocean, and festive nighttime lighting (Figure 3-16).

Slow-synchro or Nighttime flash mode

This automatic mode synchronizes your flash with the very slow shutter. It may have a "stars and mountain" or "stars and person" icon. The camera opens the shutter long enough to compensate for the dim twilight lighting, capturing all of the rich, saturated colors. The flash, meanwhile, throttles down, emitting just enough light to illuminate the subject from the front.

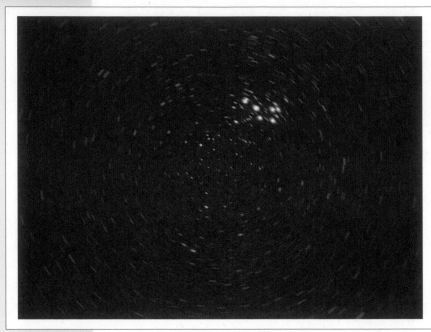

Figure 3-15:
To capture a star trail image like this one of the Pleiades constellation (sometimes called the Seven Sisters), you need a shutter speed of just a few seconds. The longer the exposure, the longer the star trails, so push your camera to the limit. If the trails aren't bright enough, then increase your camera's light sensitivity by changing the film speed setting to 200 or 400.

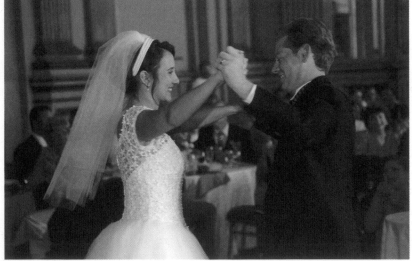

Figure 3-16:
Tired of having your flash subjects lost in a black hole of darkness? Try using what photographers call slow-synchro flash. The camera's flash ensures that the subjects are exposed properly.

NOTE This mode also opens the aperture very wide to help expose the dim background, but you can't control precisely *how* wide. For more control, use aperture-priority mode, as described in the next section.

Taking the picture

Position your model in front of the most beautiful part of the landscape. Since there's far less light during this time of day, you need to slow your camera's shutter down considerably. Here are some secrets to success:

- Put your camera in slow-synchro or nighttime flash more often. Practice with your camera's controls when it's light out so you won't waste time fumbling in the dark.

- When taking twilight portraits in slow-synchro mode, be sure to use a tripod or some other means to steady the camera.

- If your subject is rendered too bright (overexposed by the flash), move back a few feet, zoom in, and try again. Conversely, if your subject is too dark (underexposed by the flash), move in a couple of feet.

Nighttime Portraits

Nighttime portraits can be extremely interesting, especially when your subject is in front of a lit monument or building. The key to this shot is a very wide aperture, to admit as much light as possible. You can use nighttime flash mode, but if your camera has aperture-priority mode (page 22), you can get more control over the results. Either way, use a tripod and follow the general guidelines for twilight portraits in the previous section.

Using forced flash in aperture-priority mode

In aperture-priority mode, set the aperture to f-2.8 or f-4. Take a shot of just the background and review it onscreen. If it looks good, turn on your flash (forced-flash mode) and position your subject within ten feet of the camera. Ask your subject to stand still until you give the OK to move. When you take the picture, the flash will fire very briefly, but the shutter will stay open for another second or two to soak in enough light to pick up the background.

After you take the shot, review the results on the camera. If your subject is too bright, move the camera farther away. Move closer if the subject is too dark.

Landscape and Nature

Unlike portraiture, where *you* have to arrange the lights and the models, landscape photography demands a different discipline—patience. Nature calls the shots here. Your job is to be prepared and in position.

Making the Most of Natural Light

When you shoot natural landscapes, you become as much explorer as photographer. Beautiful shots are all around you; it's your job to locate them in time and space. As you wander through nature with your camera, you develop a new way of

looking at the world. You learn to see the subtle differences in lighting at different times of day, for example, and how shadows affect your photograph. The most important principles of nature photography follow.

TROUBLESHOOTING MOMENT

How to Really Get Rid of Red Eye

For years now, camera manufacturers have been inflicting *red-eye reduction mode* on their customers. It's a series of bright, strobing flashes that's not only annoying to the people you're photographing, but doesn't even work.

What causes red eye? In a dimly lit room, the subject's pupil dilates, revealing more of the retina. On cameras where the flash is close to the camera lens (as it almost always is), the light from the flash shines through the dilated pupil, bounces off the retina, and reflects as a red circle directly back into the lens. (The same thing happens to animals, too, except that the color is sometimes green instead of red.)

The solution is to move the flash *away* from the camera lens. That way, the reflection from the retina doesn't bounce directly back at the camera.

But on a camera that fits in your pocket, it's a little tough to achieve much separation of flash and lens.

Since camera makers couldn't move the flash away, they went to Plan B: firing the flash just *before* the shutter snaps, in theory contracting the subjects' pupils, thereby revealing less retina. Alas, it doesn't work very well, and you may wind up with red eye anyway.

You have three ways out of red eye. If you can turn up the lights, do it. If you have that rare digicam that accepts an external, detachable flash, use it. And if none of that works, remember that you can edit out red eye on your computer, using, for example, the Red Eye reduction tools offered in programs like EasyShare and Picasa (both covered in Chapter 9) or Photoshop Elements (Chapter 11).

Shoot with sweet light

Photographers generally covet the first and last two hours of the day for shooting (which half explains why they're always getting up at five in the morning). The lower angle of the sun and the slightly denser atmosphere create rich, saturated tones, as well as what photographers call *sweet* light.

It's a far cry from the midday sun, which creates much harsher shadows and more severe highlights. Landscape shooting is more difficult when the sun is high overhead on a bright, cloudless day.

Layer your lights and darks

Ansel Adams, the most famous American landscape photographer, looked for scenes in sweet light that had alternating light and dark areas. As you view one of his pictures from the bottom of the frame to the top, you may see light falling on the foreground, then a shadow cast by a tree, then a pool of light behind the tree, followed by more shadows from a hill, and finally an illuminated sky at the top of the composition.

Highlight a foreground object with flash

Sometimes you can lend nature a helping hand by turning on your flash to illuminate an object in the immediate foreground. Remember, just because your eyes can see detail in the dark area at the bottom of the frame doesn't mean that your camera can. Look for an interesting object—a bush, perhaps. Move the camera close to it and zoom out. Then turn on the flash and shoot. The effect can be stunning.

Shooting Underwater

A discussion of nature photography wouldn't be complete without some underwater shooting tips. After all, every school kid knows that 70 percent of the earth's surface is under water. Most people hesitate to take pictures underwater, with good reason: Water is the mortal enemy of digital cameras. Still, you can buy waterproof enclosures for many camera models (Figure 3-17), which opens up a whole new world of photographic possibilities.

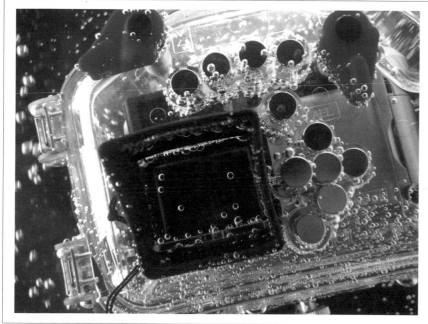

Figure 3-17:
You can buy an underwater housing for your digital camera for as little as $100. Olympus and Canon make housings for nearly all of their compact cameras. Other manufacturers offer underwater gear, too.

The good news is that these enclosures protect the camera at depths down to 100 feet and provide access to the camera's controls. The bad news is that the underwater housing can cost as much as the camera itself.

Sometimes these enclosures are made by the camera manufacturer; for other models, you can often find enclosures for sale at Web sites like *www.ikelite.com* or *www. uwimaging.com*.

When shooting underwater, force the flash to turn on (it's dark down there). You can play with the color balance adjustment (page 50) to help offset the bluish tint of the water. If your camera has a dial that lets you call up different lighting presets, try the Cloudy setting to warm up the tones. Oh, and don't try to change the batteries while you're down there.

Photographing Objects

Most people usually photograph people and places. Every now and then, however, you'll need to photograph things: stuff you plan to sell on eBay, illustrations for a report, your personal belongings for insurance purposes, and so on.

The *macro* (close-up) mode of your digital camera makes it easy to shoot objects. All you need to do is set up and light your shot; the camera does the rest.

Setting Up Your Home Studio

The trick to lighting any object professionally, whether it's a painting or a teapot, is to position *two* lights, each at a 45-degree angle to the plane of the subject. Buy a couple of lamps at a hardware store. Sometimes called *shop lights,* they have clamps and ball joints to lock the lamp at a certain angle.

> **TIP** Buy lamps that accommodate regular lightbulbs, not the high-powered halogen models that melt everything within 50 yards.

Regular 100-watt "soft light" bulbs work fine. While you're at the hardware store, look for some white butcher paper or some other paper that will give you a seamless background at least six feet long and four feet wide. (Camera stores also sell paper backdrops for about $30 a roll.)

Now you're ready to set up your temporary photo studio. Slide a table against the wall, and then hang your butcher paper about three feet above the table. Tape it to the top surface of the table, making sure that it has a gentle curve as it goes from vertical to horizontal. Place the item that you want to photograph in the center of the table, about a foot in front of the paper curve.

Next, it's time to set up your lights. You can use chair backs to clamp your lights, which should be pointing directly at your subject at a 45-degree angle, about three feet away from the subject, pointing slightly downward. Now your subject is evenly lit, with a minimum of glare and harsh shadows. Even though this homemade product rig may not look beautiful, the shots you create with it can be very appealing (Figure 3-18).

> **TIP** Some photographers eschew the two-light setup, preferring a bit of shadow on one side of the object. For a shadow effect, use only one light. On the opposite side, create a reflective surface like a white piece of cardboard, aluminum foil, or white foam board. Make sure that the reflector bounces the light toward the object's non-illuminated side.

Figure 3-18:
You don't need to build a home studio to produce great product shots like the camera shown here. This picture was created by setting a table next to a north-facing window. A piece of white cardboard was used as a reflector to bounce some light back onto the shadow side of the object.

Taking the picture

Once you've set up your inanimate subject and have the lighting just right, here's how to set up your camera for the shot:

- Adjust your camera's white balance for the type of light you're using (page 50). Uncorrected incandescent lights produce an overly warm (reddish) cast; flash tends to produce images a bit on the cool (bluish) side.

- A tripod helps keep the camera in precise position.

- If your camera has a manual-focus mode, use it to lock the focus on the object's area that's most important to you.

- Once your camera is positioned and focused, you may find its remote control or self-timer mode convenient, so you won't have to constantly bend over during the course of a long shoot.

Natural Lighting for Objects

Of course, you won't always be at home with a bunch of lights and roll paper at your disposal. Many of your object shots will be more spontaneous, impromptu affairs, or you may decide that a home studio isn't your cup of tea. In these cases, let nature provide the lighting.

When taking natural-light shots, the trick is to keep your subject out of direct sunlight, which would create harsh contrast and bright hot spots on the object's surface. Instead, work in open shade, preferably in the morning or late afternoon

Packing Photo Gear for a Trip

Digital cameras may be small and compact, but they're often accompanied by just as much accessory junk as film cameras. Here's a pre-trip checklist:

- **Batteries.** The laws of photography dictate that you'll run out of juice just when the perfect shot appears. If your camera comes with a recharge-able battery, consider buying a second one. Charge both batteries every night, and take them both with you during the day. If your camera accepts AA-type batteries, you have much more flexibility. Bring a set of NiMH rechargeables (page 18) and charger. Also pack an emergency set of disposables, like alkaline AAs or Duracell CRV3 lithium disposables, if your camera accepts them.

- **Memory cards.** Nobody ever said, "Oh, I wish I'd bought a smaller memory card." You'll be grateful for every last megabyte. As a rule of thumb, figure that you'll keep 50 shots a day (not including the ones that you delete off the camera). If you have a 4-megapixel camera, a 128 MB card may be enough for one day of shooting. If you brought a laptop on the trip, you can rush back to the hotel room each night and offload the pictures, freeing up the card for the next day's shooting. If you don't take a laptop, buy a much bigger memory card (or several). It's generally cheaper to buy two 256 MB cards than one 512 MB card, but shop around to get the best deal possible. If you plan to use the movie mode to capture video snippets of your adventures, then add one or two 1 GB cards to your kit. Until recently, this option was insanely expensive. But memory-card prices are well below nosebleed territory these days; you can buy 1 GB cards for less than $75.

- **Camera bag.** If your camera didn't come with a case, get one for it. It not only protects your camera (even if it's a compact model with a self-clos-ing lens cover), but it keeps all your batteries, cards, and cables together. If you can find a camera bag that doesn't *look* like a camera bag, it's less likely to be ripped off. An insulated beverage bag does nicely, for example.

- **Tripod.** Nobody likes to lug a tripod across Europe—or across town, for that matter. But if you're a serious photographer, or aspire to be one, you'll occasionally need a way to steady your camera. A miniature tabletop tripod like the Ultra-Pod 2 is an ideal compromise. It weighs only four ounces, costs $22, and provides solid support for your camera in a variety of situations. (A quick Web search should turn up a mail-order company that carries it.)

- **Weatherproofing.** Keep a couple of plastic bags tucked in your carrying case for use in bad weather. Digital cameras hate water, but some of nature's most dramatic shows occur at the beginning and end of storms.

- **Lens cloth.** Microfiber lens cloths are light, inex-pensive (about $5), and easy to pack. They're much better than your t-shirt tail for keeping your optics sparkling clean.

- **Small flashlight.** Don't risk losing a great night shot just because you can't read your camera's controls. Pack a small flashlight to help you work in dim lighting situations.

hours when the light is the sweetest. A north-facing window is perfect for this type of shooting.

Once again, pay close attention to the background. You may have to get creative in setting up the shot so that it has a continuous background without any distracting

edges. Finally, set the white balance controls to the Cloudy setting to offset the blue cast created by open shade.

Taking Museum Pictures

Many museums permit photography, provided you keep the flash off and don't use a full-size tripod. Digital cameras are particularly well suited to these assignments.

Once you're in, here are some techniques to consider:

- Increase the film speed setting to 200 or 400 to better handle the dimmer interior lighting.

- Museums often use halogen lightbulbs to illuminate the artwork, which can lend a red or yellow cast to your photos. If your particular camera automatically adjusts its color balance nicely, then no problem. But if your sample shots look too warm (reddish or yellowish), consider switching the camera's white-balance control to the Incandescent setting (usually denoted by a lightbulb icon on the control dial).

If that doesn't improve the pictures, adjust the camera's white balance as described on page 50.

- To take a picture of something in a glass display case, put the front of your lens barrel right against the glass to prevent nasty reflections. You'll probably have to zoom out all the way to frame the shot properly.

- Finally, hold the camera steady when shooting in museums. Because of the low lighting, your camera will probably choose a slow shutter speed, which introduces the possibility that the camera will shake, introducing blur. The steadier you hold your camera, the sharper your shots are.

Digital Movies

Movie making probably wasn't what you had in mind when you bought a digital *still* camera. Even so, most cameras offer this feature, and it can come in handy now and then. Movie mode lets you capture QuickTime or AVI format videos (both kinds play on Windows and Apple computers) with sound included. You save the videos to your memory card right alongside your still pictures. Some cameras permit only 30 seconds of video per attempt; others let you keep recording until the memory card is full.

Most new cameras these days capture video with frame dimensions of 640×480—big enough to fill a TV screen on playback. Once you've transferred a movie to your computer, you can play it, email it to people, post it on a Web page, or burn it to a DVD. Just keep these pointers in mind:

- **Know your memory.** Digital movies, even these low-quality ones, fill up your memory card in seconds. Remember, you're shooting 15 or 30 little pictures *per second,* which puts you in 512 MB, 1 GB, or 2GB card territory.

- **Steady the camera.** If you don't have a tripod, put the camera strap around your neck, pull the camera outward so the strap is taut, and only then begin filming. The strap steadies the camera.

• **Don't try it in the dark.** The flash doesn't work for movies, so look for the best lighting possible before composing your shot.

• **Set up the shot beforehand.** Most cameras don't let you zoom or change focus during filming.

Cameraphone Photography

There's an old photographer's saying: the best camera is the one you have with you. The day you're faced with a photo op and your multi-megapixel wonder machine is stashed in your sock drawer at home, you'll be thankful if there's a *cameraphone* in your pocket—a cellphone with a tiny, built-in lens that takes tiny, built-in pictures.

Of course, cameraphones don't have all of the handy settings that you've come to adore on your digicam, but they can still take perfectly good shots (see Figure 3-19). Here's a look at the most common cameraphone settings and how they can help you take better pictures.

Figure 3-19:
Cameraphones are designed for moderately close portraits. Head-and-shoulders compositions usually turn out well. But avoid super-closeups: The wide-angle lenses built into most phones can distort your subject. Compose your portraits as shown here; you'll get the shot and keep your friends.

• **Picture size.** This option gives you the choice between two resolution settings: large and small. (They would be more accurately labeled *small* and *smaller,* but that wouldn't fly with the marketing department.) Choose large, which is usually about 640×480 pixels. You can't make a very big print with these images, but they're just right for emailing.

• **Effects.** You may get a menu of oddball settings called *effects.* Here you can change from normal color photography to things like sepia, black and white, or even negative, which is perfect for that X-ray look you've been yearning for.

Generally speaking, don't bother with the options in this menu; shoot your pictures in living color. You can always add an effect later on your computer—with much greater control.

- **Self-timer.** Often considered the best way to include the photographer in family group shots, the self-timer is also a great tool for getting sharp pictures in less-than-perfect lighting. Rest the camera on any steady surface, compose the image, activate the self-timer, and press the shutter button. The camera counts for about 10 seconds and then shoots. (As usual, the steadier the camera, the sharper the shot is.)

One problem with cameraphones is that there's no tripod socket. How the heck do you compose your self-timer shots without a tripod? Figure 3-20 shows one option. You're probably not going to win any photo contests taking pictures this way. But in a pinch, at least now you know how to squeeze every drop of quality from the one camera you'll always have with you.

Figure 3-20:
How do you steady a camera that doesn't have a tripod socket? This beanbag chair for mobile phones is the perfect solution. For $6, Porter's Camera Store (www. porterscamerastore.com) ships you the Pillow Pod. As simple as it sounds, the Pillow Pod lets you align your phone for just the right composition when using the self-timer.

Part Two:
Organizing Your Photos

2

Getting Photos onto Your PC

Getting photos *into* your camera is easy: just point, shoot, and you're done. Getting them onto your PC is another matter. Gone are the days when you could simply pop out your film and drop it off at the photo developer. Nowadays, in order to do the editing, printing, and sharing that makes digital photography so addictive, you need to move your pictures to your PC.

Fortunately, Windows XP makes the transfer process pretty simple; that's what you'll learn about in this chapter. (If you're using Photoshop Elements, you're in luck. The program comes with its own photo importing utility. Read all about it starting on page 173.) You'll also learn how to speed things up by using a memory card reader—a great way to save precious battery time on your camera. And for folks who've still got a foot in the world of prints—in other words, pretty much everyone—the chapter wraps up with a walk-through of everything you need to do to scan in your existing photos.

Moving Pictures from Camera to Computer

Don't bother installing the software packaged with your digital camera; it's generally of mediocre quality, and you don't need it to see your photos. But do hang onto that little cable that comes with your camera. That's the tube for pouring your photos from your camera into your PC. Connect the cable between them, and Windows XP automatically welcomes your digital camera and shuttles your photos into your new digital shoebox: your PC's My Pictures folder (Start → My Pictures).

Follow these steps to move the photos out of your camera and into your PC.

TIP Lost your camera's connection cable? Most cameras use standard USB cables, available at any camera or computer store. Bring your camera when cable shopping; the camera may use any one of three different USB ports (Figure 4-1). For even faster photo transfers, buy a card reader instead (described in the next section).

1. **Connect the smaller connector on your camera's cable to your camera, and turn on your camera.**

 Find a tiny port on your camera. Sometimes named "Digital" or "USB," it's occasionally hidden underneath a little cover, and it's usually near the port that connects your camera to the TV for viewing photos. Plug the cable's small end into your camera's port.

 With some cameras, you need to set them to View or Cable Connection mode before they'll start talking to your PC.

Figure 4-1:
USB plugs and ports come in three main sizes. Digital cameras and MP3 players often use the smallest size called Mini-Series A/B (right). On the other end of the cable, the plug you connect to your computer is usually the rectangular Series A (left). Some devices may use the fatter, six-sided size called Series B (middle).

NOTE Your computer uses ports to move data back and forth to other devices like printers or cameras. Some really old digital cameras connect through the serial port. These oldsters force you to wade through their own, original software. If this program somehow slipped from your grasp, visit the downloads area of the manufacturer's Web site. Sometimes you'll find a special Archive area offering original software for obsolete electronics.

2. **Plug the cable's larger, rectangular end into your PC's USB port.**

 You'll find USB ports on all but the oldest PCs. Start looking for the little rect-angular port on the case's front. If you don't find it there, look at the back of your PC. For added convenience, some keyboards and monitors offer little ports along their sides. Windows XP recognizes your camera and displays a brief New Hardware Found message in the lower-right corner of your screen.

3. **Choose a program to move your photos onto your computer, and then click OK.**

 Windows lists any photo editing software it finds on your PC and lets you choose your favorite to handle the incoming photos (see Figure 4-2). Select one, and Windows assigns it the job of transferring your photos. Your photo editing program takes over from here and explains how to import your pictures. (Instructions for Photoshop Elements owners begin on page 173.) If your PC doesn't have any photo editing software, Windows XP's built-in Scanner and Camera Wizard, which you'll learn how to use in the following steps, automati-cally jumps in to handle the job.

Figure 4-2:
Once you connect your camera to your PC, Windows XP lists all the software on your PC that can talk to cameras. To skip this menu in the future, turn on the checkbox marked "Always use this program for this action." Then choose the program Windows XP should automatically summon the next time you plug in your camera.

4. **Start the Scanner and Camera wizard.**

 Windows XP's friendly wizard pops up with a greeting, ready to handle your photo-moving chores, step by step.

 TIP If you're already a whiz at moving files, dump the wizard. When the wizard opens, click Cancel and the wizard disappears. Then navigate directly to your camera (My Computer → [Your camera's name]), where you can drag your files to other folders on your hard drive. This trick comes in especially handy when your camera holds several separate photo sessions, and you'd rather sort them into separate folders for each session.

When the Wizard Is Missing

If the Scanner and Camera wizard doesn't materialize when you plug in your camera, tighten the cables and make sure the camera's turned on. Also, some cameras don't attract the wizard until you flip their switch from Shoot Pictures to Review Pictures mode. If the wizard still hides, run down the following list.

- **Reactivate the USB port.** Unplug the camera's cord from the PC, wait ten seconds, and plug it in again. That gives Windows XP another chance to recognize your camera at the USB port.

- **Check My Computer.** See if the camera's already waiting for you in My Computer (Start → My Computer). The camera may appear as an icon nestled among the hard drives. If you spot it, double-click the icon to see a folder featuring all your camera's pictures. You can then drag or copy the images into your PC's My Pictures folder.

- **Install the camera's drivers.** Sometimes installing the camera's *drivers* (utility programs that help your PC communicate with external devices) adds support for Microsoft XP's *WIA* (Windows Image Acquisition) system.

WIA lets Windows XP recognize your camera when you plug it in. Visit the downloads section on your camera manufacturer's Web site for more information about drivers and how to install them.

- **Install the camera's software.** Installing the digital camera's software—but not actually using it—sometimes installs WIA, letting Windows XP finally recognize the camera and grab its photos.

- **Give up and use the camera's software.** Using the camera's software isn't the best option, as it bypasses Windows XP's built-in transfer system, but it works in a pinch.

- **Buy a memory card reader.** To upgrade to faster photo transfers, buy a memory card reader (page 84) for your PC. Available for around $20, these handy gadgets add mini-drives that let you slip in your camera's flash card just like slipping in a CD. When Windows XP recognizes the files, drag and drop them to an appropriate folder inside your My Pictures folder.

5. **Choose the photos you want to copy to your PC.**

 The wizard shows you a contact sheet of your camera's photos (Figure 4-3); each photo has a checkmark in its upper-right corner. Click Next to move them all onto your PC.

 On the rare occasion you want to keep some photos on your camera—perhaps you want to move them to a different computer—remove the checkmarks from those photos.

6. **Choose a descriptive name for the photos and select a folder to store them in.**

 The wizard presents you with a Picture Name and Destination screen. The name DSC03612.JPG doesn't help much when searching for your carnivorous plant photos next month. To help track down your pix later, type a descriptive name in this dialog box (Figure 4-4), like "Venus Flytraps." Windows creates a folder with that name inside your My Pictures folder, tosses your photos into the folder, and renames each photo in sequence: Venus Flytraps001, Venus Flytraps002, and so on. Click Next.

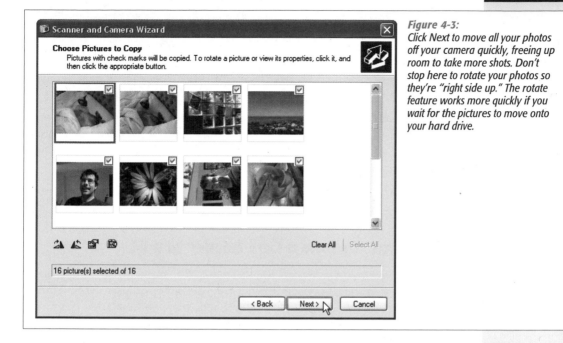

Figure 4-3:
Click Next to move all your photos off your camera quickly, freeing up room to take more shots. Don't stop here to rotate your photos so they're "right side up." The rotate feature works more quickly if you wait for the pictures to move onto your hard drive.

Figure 4-4:
Windows XP creates a folder with the name you entered here, and then renames all the photos in sequence with that name, making it easy for you to find photos later. Be sure to turn on the "Delete pictures from my device after copying them" checkbox. Otherwise, Windows XP copies, rather than moves the camera's photos, leaving them to hog precious storage space.

7. **Choose "Nothing. I'm finished working with these pictures" to exit the wizard.**

 Although Windows XP offers three choices here, opt for the third choice—Nothing—because the other two are so abysmal:

Publish photos to a Web site. This offer certainly sounds gracious, but the wizard isn't offering to publish your photos to your blog, your own Web site, or even your choice of photo-sharing sites. This option simply sends your photos to Microsoft's own MSN Groups—if you have an existing account or want to set one up. Competing sites (which you can learn about in Chapter 14) allow more free photo storage space, easier photo transfers, and simpler menus.

Order Prints. This option emails your photos to an online photo developer, which mails back your prints less than a week later. It's convenient, but certainly not the fastest, best, or cheapest way to print photos. (Chapter 16 shows you some better options.)

Nothing. The Wizard vanishes, but not before opening your newly created folder where you can ogle your new photos.

Moving Pictures from a Card Reader to a PC

The Scanner and Camera Wizard leads you steadily through the camera-to-PC photo transfers, but all that hand-holding takes time. For quicker grabs, connect your camera to your PC as described above and then choose Start → My Computer. Look for your digital camera's icon nestled among your PC's disks and drives. Double-click the camera icon to open it, like any folder. Select the camera's photos, and drag them to your My Pictures folder.

Although that method speeds things up by bypassing the wizard, bypassing your camera's cable altogether speeds up transfers even more. For the speediest transfers, buy a card reader, like the one shown in Figure 4-5 (top). Available for around $20, the card reader plugs into your PC's USB port and creates tiny disk drives for inserting your camera's cards. Push your camera's card into the reader, and use Windows XP's standard copy tools to move the photos to any other folder on your computer. Card readers have several advantages over the wizard:

- **Battery life.** With a card reader, your camera stays turned off during transfer sessions, keeping your battery alive longer for more picture taking.

- **Speed.** Card readers give your PC direct access to the card, and they're built for speed. Camera transfer circuitry isn't nearly as quick.

- **Price.** Card readers cost less than $20, usually much less than the cost of replacing the camera cable you left in the hotel room.

- **Versatility.** Most card readers read *every* card format, including cards used by your friends, relatives, and strangers at coffee shops. (They'll also work with your next camera, as well.)

Importing Photos with a Scanner

You may have photos that aren't digital. Perhaps they're inherited family pictures or shots you took with a film camera. To take advantage of digital photo

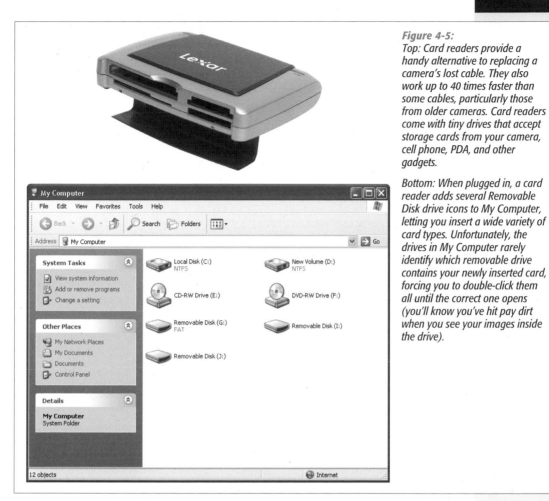

Figure 4-5:
Top: Card readers provide a handy alternative to replacing a camera's lost cable. They also work up to 40 times faster than some cables, particularly those from older cameras. Card readers come with tiny drives that accept storage cards from your camera, cell phone, PDA, and other gadgets.

Bottom: When plugged in, a card reader adds several Removable Disk drive icons to My Computer, letting you insert a wide variety of card types. Unfortunately, the drives in My Computer rarely identify which removable drive contains your newly inserted card, forcing you to double-click them all until the correct one opens (you'll know you've hit pay dirt when you see your images inside the drive).

retouching or to email them to your sister, you need to scan these pictures. Scanners once lived only on the desktops of graphics professionals; today, they're so inexpensive that they're as affordable as a printer. For a growing crowd of photographers, they've become just as indispensable.

The following sections explain how to choose a scanner and set it up to scan color *and* black and white photos.

Choosing a Scanner

You'll generally find three types of scanners on the shelves at most office supply and computer stores

- **Flatbed (price range: $50 to $600).** Flatbed scanners hide a large plate of glass beneath a large lid. Lift the lid, place your photo or other item on the glass, and close the lid. When you tell Windows to scan, the scanner converts your photo or other item into an image file. Flatbed scanners are the most popular model

for consumers because they work so well at the most common tasks: scanning in photos, articles, receipts, and handwritten documents. Once you scan something, you can save it, reprint it, or send it to friends or coworkers. As you go up the price range, you get better resolution, greater *dynamic range* (sensitivity to gradations between black and white), and decent film-scanning capabilities, so you can scan your collection of negatives and slides into digital files.

• **All-in-one (price range: $150 to $300).** These scanners come as part of an *all-in-one printer*, which places a scanner atop a printer, and then throws in the smarts of a copier and fax machine. All-in-one models pack four gadgets into something that costs much less than the sum of its parts. These devices are heavy, making them awkward to carry or move from one room to another. And the individual components are never as versatile as the dedicated models. But if you're shopping for both a scanner and printer, they're certainly convenient, and you can't beat the cost savings.

• **Film scanner (price range: $200 to $2,000).** While many flatbed scanners offer film scanning (as described above), doing so with them is labor-intensive. If you have a large collection of 35mm or smaller slides and/or negatives, you might want to invest in a dedicated film scanner. All but the cheapest of these will provide better quality film scans than the flatbeds offer, and some feature automated handling of filmstrips and slides. The upper end of the price range gives you both top scan quality and the ability to handle medium-format (120mm) film.

Installing a Scanner

Installing a scanner works pretty much like installing a digital camera, but with one exception: Windows XP embraces most digital cameras as soon as they're plugged in. Installing a scanner, by contrast, works better if you install the scanner's bundled software *before* plugging in the scanner.

Follow these steps to connect your scanner to your PC.

> **TIP** Lost your scanner's connection cable? Most scanners use USB or FireWire cables, which are available at any computer or office supply store.

1. **Install the scanner's installation software.**

 Install the software *before* plugging in the scanner. That way Windows XP recognizes your new device as soon as you plug it in.

2. **Unlock the scanner, if necessary.**

 To keep the UPS man from banging around a scanner's sensitive innards, most scanners come with a built-in locking mechanism inside that clenches all the delicate parts together tightly. You need to unlock the scanner before using it, or you'll hear frightening grinding sounds.

Unlocking most models simply means turning a switch along one side of the scanner; on more advanced models, you need to unscrew a panel along one edge of the scanner to access the switch. Some locking switches hide beneath a strip of bright-plastic tape that says, "Unlock before use."

NOTE Always lock the scanner before boxing it up and shipping or moving it.

3. **Plug the scanner into the wall, and turn on its power switch.**

 The scanner's light turns on, and the scanner makes some reassuring power-on test noises.

4. **Connect the scanner's cable to your PC.**

 Most scanners plug into a computer's USB or FireWire port. Both ports let the scanner send large amounts of data to your PC as quickly as possible.

NOTE A USB 2.0 scanner still works when plugged into an older USB 1.1 port, but the connection's pretty darn slow. Most computers sold after 2003 come with USB 2.0 ports. To see if your computer already supports USB 2.0 right-click My Computer and then follow this path: Properties → Hardware tab → Device Manager → Universal Serial Bus Controllers. If you spot the words USB Enhanced Host Controller somewhere on the Device Manager's right-side pane, your computer supports USB 2.0.

When you're finished with the installation, your PC recognizes your scanner, automatically locates the software you installed in step 1, and adds its icon to your My Computer list of attached scanners and cameras (Start → My Computer).

Three Ways to Scan an Image

Chances are, your PC lets you control your scanner in three different ways: using Windows' built-in scanning wizard; using your graphics program's own menus; or using the scanner's own software. Here's the rundown on each method, and when to select it.

- **Windows XP's Scanner and Camera Wizard.** This wizard, the same one you learned about earlier in this chapter, works well for quick, on-the-fly scans: faxing documents, placing images on a Web site, emailing photos to friends, or for treating your scanner like a simple copy machine. (If you want to summon the wizard when using a graphics program, look for the menu choice labeled WIA, which stands for Windows Image Acquisition.) Most programs stick their WIA choices in the File → Import menu.) Full details on how to use the scanner wizard start on page 88.

 The easy-to-use wizard offers another bonus: The wizard works the same way on every modern scanner. Once you learn the wizard's controls, you can apply those skills to operate the scanner at work or a friend's house, or even on your next scanner.

• **TWAIN.** Whereas Windows XP's wizard resembles the easy-to-operate, Point and Shoot setting on a camera, TWAIN is like switching the camera to Manual. Here, you can adjust a scan's size by tenth-of-an-inch increments, save presets of custom settings, tweak color values, and perform other adjustments valued by those who need them—but TWAIN's not essential for most jobs.

A nonprofit group created TWAIN in the early 90s as a way for software and scanners to talk to each other—quite a feat in those days. Most scanners and graphics software still support TWAIN. For instance, choosing TWAIN in Photoshop Elements brings up the advanced controls shown in Figure 4-6, which let you tweak settings that the Windows wizard can't—helpful when choosing specific settings requested by a friend, coworker, graphics shop, or a particular piece of software.

NOTE Unlike most uppercase words in TechTalkLand, TWAIN isn't an acronym. Rather, the word refers to a line in Rudyard Kipling's "The Ballad of East and West:" "And never the twain shall meet." The words summed up the frustration of connecting scanners and PCs in the early 90s.

• **Scanner's bundled software.** Although many scanner manufacturers stick with TWAIN controls, others feel they can do better than the Windows wizard or TWAIN's admittedly technical approach. So they write their *own* set of controllers, usually trying to make things as simple as possible. The result is a program resembling the wizard, with the same ease of use, but added choices tailored to your specific scanner model.

For instance, one scanner's built-in software may offer an option for using an automatic sheet feeder or a Kodachrome slide holder. If the Windows wizard doesn't offer what you need and TWAIN looks too complicated, give the scanner's bundled software a try.

The bottom line? If you're happy with Windows XP's built-in wizard scanner controls, stick with it. But if you plan to spend a lot of time with your scanner, give each method a try; they each put a different steering wheel on your scanner.

Using Windows Scanner Wizard

A scanner is simply an *enormous* digital camera that points in a fixed direction: up. And just like a camera, your scanner comes with scads of settings that most folks live a long and happy life without ever adjusting. That's where Windows XP's built-in Scanner and Camera Wizard (the same one you learned about earlier in this chapter) comes in: It's your ticket to a remarkably pain-free scanning experience. Follow these steps for quick, and easy scanning.

1. **Clean your scanner's surface, and place the photo you want to scan in the upper-right corner of the scanning bed.**

 Before scanning, always wipe the scanner's glass bed with a clean, lint-free cloth. Add a little rubbing alcohol to the cloth for the really nasty goo spots. You want

Figure 4-6:
Choosing TWAIN from Photoshop Elements File → Import menu brings up this screen, which lets you tweak your scan's color, size, and exposure settings, much like a digital camera's manual controls. If you spot TWAIN listed on your graphics software's menus, select it for a few test scans; you may prefer its controls over Windows XP's built-in scanner wizard.

to remove every dust speck before those fibers end up magnified 200 times on your scanned image. Place your image in the corner for one simple reason: Doing so squares the edges, so the image sits nice and straight in the scanned image you create.

2. **Turn on your scanner, choose the Scanner and Camera Wizard (if necessary), and then click Next at the Welcome screen.**

 As soon as you turn on your scanner or plug it into your computer, the wizard appears with a greeting. When you click Next, the wizard lists all the programs on your PC capable of handling scans (Figure 4-7); your first decision is what program you want to handle the job. For the quickest and easiest scanning, choose Windows XP's built-in Scanner and Camera Wizard, the same sorcerer that conjures pictures out of your digital camera.

 Don't see the wizard? You can summon it manually with a double-click of the scanner's icon in My Computer. Don't see the scanner's icon? Then you're probably limited to the software that came with the scanner, described in "Installing a Scanner" on page 86.

3. **Choose Custom.**

 In an attempt to simplify matters, the wizard offers you three preset choices (in addition to the Custom option), shown in Figure 4-8, each tailored to match the image you're scanning: color picture; Grayscale picture; and black and white picture, or text. Each is explained in step 5.

Figure 4-7:
Turn on your scanner, and Windows XP lists all the software on your PC capable of handling scans. Choose the Scanner and Camera Wizard for creating quick scans and saving them as files on your hard drive. If you select a graphics program like Photoshop Elements, the wizard routes the scan into the software, letting you touch it up before saving it. That saves time when scanning old photographs, for instance, where you may need to repair tears and scratches.

However, those choices don't take into account what you'll be *doing* with your image. For instance, if you choose Color Picture, the wizard scans the photo in at a resolution of 150 dots per inch (dpi)—twice the size you need when sending through email. (See page 13 for a quick primer on resolution.) For best results, skip the wizard's preset options and tailor your scans by choosing Custom.

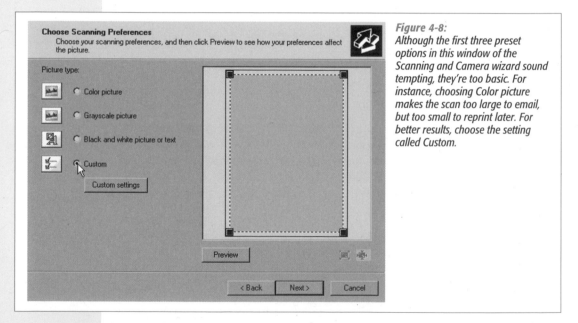

Figure 4-8:
Although the first three preset options in this window of the Scanning and Camera wizard sound tempting, they're too basic. For instance, choosing Color picture makes the scan too large to email, but too small to reprint later. For better results, choose the setting called Custom.

4. **Choose the Resolution setting for your scan.**

When you click Custom, the Properties box shown in Figure 4-9 appears. The wizard lets you choose *any* resolution your scanner offers. Resolution, measured in dots per inch (dpi), controls the amount of detail shown on your

image, as well as its size. You want high resolution for printouts, for instance, but low resolution for items meant to be seen onscreen (like email). Leave the Brightness and Contrast controls set to 0; you can adjust these settings much more effectively using image-editing software like Picasa, EasyShare, or Photoshop Elements.

If you're feeling overwhelmed by the resolution options, use this table for guidance:

Scanned Item or Destination	Its Resolution
Onscreen (for emailing photos or posting them on a Web site)	75 dpi
Miscellaneous letters, receipts, and text (for archiving)	150 dpi
Line drawings (for faxing or printing)	200 dpi
Photos (for printing)	300 dpi

Scan at resolutions higher than 300 dpi only when you want to enlarge something tiny—a postage stamp, for instance—to view minute details.

Figure 4-9:
This Properties box lets you choose a resolution suitable for whatever you intend to do with your scanned image. The Resolution's menu lists all the resolutions your scanner can handle, usually 50 to 2400 dpi or more, but you rarely want anything more than 300. As a general rule of thumb, choose 75 dpi for photos you're going to email, 150 when using your scanner as a copy machine, and 300 for photos you want to print out.

5. **Choose the type of picture you're scanning.**

 The choices listed in the "Picture type" drop-down menu let your scanner know how many colors to grab. (There's no sense making a color scan of Doonesbury if the cartoon ran in the weekly, black and white funnies.) Limiting the colors is an easy way to keep the file size manageable. Choose your image from one of these options:

 • **Color picture.** The natural choice for color scans. Selecting this option takes a color snapshot of anything you place on the scanner's bed.

 • **Grayscale picture.** When scanning a black and white photograph or a newspaper clipping, choose this option. Doing so means your scan preserves up to 256 shades of *gray*, which is what most people consider to be black and white.

- **Black and white picture or text.** Don't choose this option for black and white photos, since the wizard narrows down the colors to either black or white, thereby turning Dalmatians into groups of small black spots. Choose this option only when scanning line drawings, text, diagrams, flowcharts, and other monotone items.

When you're finished making all your selections in the Properties box, click OK.

6. **Back in the Scanner and Camera Wizard main window, click the Preview button, lasso your image (if necessary), and then click Next.**

Don't skip this important step: Clicking the Preview button tells the scanner to make a quick scan, locate your image's position, and lasso it—outline the image's edges with a little square. By locating the image, the scanner then knows to scan only that portion of its bed. If you skip the preview, the scanner simply scans its *entire* bed, creating a huge file with your image floating somewhere inside.

The wizard's usually pretty good with its lasso, but if it's a little off target, drag inward or outward on the lasso's little corner squares, as shown in Figure 4-10, until it completely surrounds your image.

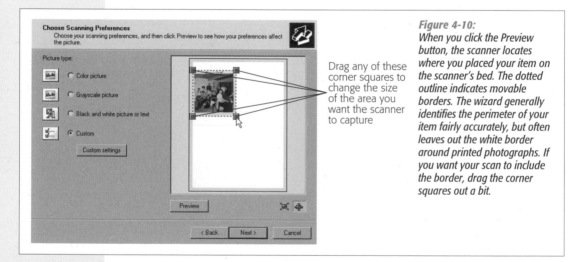

Figure 4-10:
When you click the Preview button, the scanner locates where you placed your item on the scanner's bed. The dotted outline indicates movable borders. The wizard generally identifies the perimeter of your item fairly accurately, but often leaves out the white border around printed photographs. If you want your scan to include the border, drag the corner squares out a bit.

7. **Choose a file format that matches your scan's contents.**

The Picture Name and Destination dialog box, shown in Figure 4-11, also appears when you retrieve photos from a digital camera, but with one major exception: The scanner lets you choose the format it uses to save your file. Here are your options.

- **BMP (Bitmap image).** Avoid this option, as it creates files large enough to store blimps. Nevertheless, graphics programs always offer it because BMP's been around for years, and nobody collects patent fees on the format.

- **JPG (JPEG image).** The best choice for photographs. JPG (Joint Photographic Experts Group) compresses photos by removing subtle nuances imperceptible to most mortal eyes.

- **TIF (TIF image).** Choose TIF (Tagged Image File Format) when you can't afford to lose *any* quality—when creating archives of family photos, for instance, or sending images to a print shop. The images are substantially larger than JPGs, but sometimes quality's more important than saving on storage space.

- **PNG (PNG image).** PNG works best for color images with smooth, defined edges—logos, for instance, color charts, or line drawings. Most Internet browsers support PNG (Portable Network Graphics), which is slowly replacing the old standard, GIF (Graphics Interchange Format).

8. **Choose a descriptive name for your scan, select a folder in which to store it, and then click Next.**

 After choosing the file format, enter a descriptive name (in the "Type a name for this group of pictures" box) and select a storage folder for your scan. The wizard creates a folder with that name inside your My Pictures folder, and tosses in your scan using that same name. (Alternatively, you can click the Browse button if you want to select a folder on your PC that already exists.)

Figure 4-11:
Choose JPG as the file format for most scanned photos. See step 7 on page 92 for a review of when you'd want to pick the other file types.

9. **Choose Nothing to exit the wizard.**

The wizard offers the same three choices as when you use it to transport digital photos to your PC. None really belong here—few people would order prints of something after they've just scanned the print version—so choose Nothing. The wizard closes, dropping you off in the folder that holds your newly created scanned image file.

Once your photo's turned into a file, you can email it as an attachment (Chapter 15) or print it (Chapter 16).

Organizing Photos on Your PC

You can shoot tons of pictures with digital cameras at virtually no cost. Blissfully snap away, offload the pics onto your PC, and then go snap some more. Before you know it, your hard drive is bursting with image files. But with good tools and a solid strategy, you can have as much fun viewing and organizing your digital pictures as you did taking them.

Windows XP is more photo-friendly than any previous version, so you can do all your photo organizing without having to resort to a special program. This chapter shows you every organizational tool and trick that Windows has to offer. But that doesn't mean you have to stick with Windows. This chapter also explores two free programs with slick organizing features—Kodak's EasyShare and Google's Picasa. EasyShare (*www.kodak.com*) lives up to its name by providing an easy-to-use environment to organize photos on your PC (and share them with friends and family); coverage starts on page 103. Picasa (*www.picasa.com*) takes a little longer to learn, but it gives you more advanced sorting and searching tools; flip to page 110 to learn more.

> **NOTE** If you're looking for Web sites that let you store your photos *online,* check out the next chapter. And if you've shelled out $100 for Photoshop Elements, you can use *it* for all your photo organizing needs; Chapter 8 shows you everything you need to know.

Organizing Photos with Windows XP

As far as your computer is concerned, the photos from your digital camera are nothing more than files that happen to contain images. You can treat them exactly like any other kind of document file: Drag them into folders, copy or delete them,

and so on. But pictures *are* different than other kinds of files, so along with a quick review of basic Windows file management techniques, this section shows you how to use XP's juicy new picture viewing features. Even if you use, say, Photoshop Elements or Picasa as your primary tool for organizing photos, someday you'll inevitably find yourself shuffling photos between folders in Windows, so the following pages are worth a read.

> **TIP** Rather than dumping all your photos into one great heap inside your My Pictures folder, consider separating related groups of pictures into *subfolders* within My Pictures. The next section shows you how to do just that.

Navigating the My Pictures Folder

When your PC slurps in pictures from your digital camera, it automatically places them inside a folder called My Pictures (Figure 5-1). The considerate designers at Microsoft have customized this folder for your photo-handling needs. For example:

- The folder is factory set to Thumbnails view, so you actually see miniature snapshots (thumbnails), instead of generic file icons. Even subfolders within My Pictures sport one or more images to hint at their contents.

- The task pane, along the left, provides options for working with pictures, like "View as a slide show," "Print pictures," and "Copy all items to CD."

- The Details box at the bottom of the task pane shows the photo's resolution in pixels along with standard file information (name, size, and the date it was last edited).

> **NOTE** You can apply these picture-friendly options to *any* folder on your computer. See "Customizing Windows Folders for Photos" on page 99.

Figure 5-1:
Windows XP's My Pictures folder is factory-set to work with photos and other images. To open it, go to My Computer → My Documents → My Pictures, or simply choose Start → My Pictures. If you don't see thumbnails of your images, choose View → Thumbnails.

Before you begin moving and copying photos between folders, you can set up your folder window to make the job easier. Click the Folders button on the toolbar (Figure 5-2) to display a list of file folders where the task pane used to be. (If you don't see the Folders button, right-click the toolbar and choose Standard Buttons from the shortcut menu that appears.)

There's a hierarchy to Windows folders, and the folder list in the left pane (now called the *Explorer bar*) maps it out for you. The plus sign next to a folder icon tells you the closed folder contains subfolders. Click the + button to reveal the folder's contents. When you do so, the plus sign changes to a minus sign (like the ones next to My Documents and My Pictures in Figure 5-2). Click the – button to collapse the folder, hiding its contents.

Figure 5-2:
The Folders toolbar button (circled) toggles the Explorer bar in the window's left pane. Clicking a folder at left displays its name in the title bar ("Lola at the Beach") and its contents at right. With this setup, you can easily drag photos to move them. Windows highlights your destination folder ("oregon") as your cursor approaches.

TIP Another way to open a new window like Figure 5-2 is to choose Start → All Programs → Accessories → Windows Explorer.

Adding New Subfolders

When you download photos from your digital camera, they oftentimes all end up in one folder, although they may cover a wide range of subjects and dates. Divide and conquer your photo collection by creating subfolders with meaningful names. Folders with descriptive names and fewer photos per folder make it much easier to find the photos you're looking for. For example, if your Family Pics folder is filled to the brim, you may want to break it down into folders like Vacations, Birthdays, and School Events.

Windows gives you three ways to create a new folder.

• In the My Pictures window's menu bar, choose File → New → Folder.

• In the task pane's File and Folder Tasks panel, click "Make a new folder."

- Right-click any blank spot in the My Pictures window and choose New → Folder from the shortcut menu.

When you use any of these commands, Windows creates a new folder and gives it a temporary (if unimaginative) name: *Untitled Folder*. Windows also selects the folder name, putting you in a perfect position to type a name of your choice.

UP TO SPEED

Right-Click Shortcuts for Photo Files

The right mouse button is a powerful thing. When you right-click almost anywhere on the screen, a little menu pops up next to your cursor. This *shortcut* menu is full of options relating to the item you right-clicked. (That's why some folks call it the *contextual* menu.)

Handy shortcuts for photos include:

- To open the full-size photo in Windows Fax and Picture Viewer, right-click a photo, or its thumbnail, in Thumbnails or Filmstrip view (View → Filmstrip) and choose Preview.

- Select a bunch of photos, right-click any one of them, and the shortcut commands apply to the entire group. This trick is a great way to copy, move, delete, or print several photos en masse. (See the box "Selecting Multiple Photos" on page 100 for a refresher on grabbing a bunch of photos at once.)

- To use a photo as desktop *wallpaper* (background), right-click the photo and choose Set as Desktop Background.

- If you've installed any other image editing software, it may add some commands of its own to the shortcut menu as well.

Moving and Copying Photos

As Figure 5-2 illustrates, you can easily move photos from one folder to another by dragging and dropping. But what if you want to *copy* a photo, leaving a duplicate in the original folder? For example, say you want to separate out a selection of photos to post on a Web site, without disturbing your carefully organized folder arrangement. The trick is to Ctrl-drag: Select one or more photos or folders, press Ctrl, and hold the key down as you drag the photos to the destination folder. Your arrow cursor sports a small + icon to tell you that you're copying the selected photos.

> **NOTE** In general, when you drag files from one folder to another on the same hard drive, Windows *moves* the file. If you drag a file to a folder on a different drive (for example, from C:\photos to D:\new photos), Windows *copies* the file.

When you're moving or copying, the Explorer bar makes it easy to drag photos to any folder on your PC. But if you have several layers of subfolders and multiple drives on your computer, all that long-distance dragging can strain even the most nimble of wrists.

Windows lets you move and copy photos in these additional ways:

- **Dragging between windows.** If you find the Explorer bar too awkward, simply open the destination folder in a separate window. For example, right-click the folder's icon and choose Open from the shortcut menu. Position the windows side-by-side, and then drag (or Ctrl-drag) photos and folders between the two windows to your heart's content.

- **Use the Cut, Copy, and Paste commands.** Select one or more photos or folders, and then choose Edit → Cut (to move them) or Edit → Copy (to copy them). Select the destination folder, and then choose Edit → Paste. You can also right-click and find these same commands on the shortcut menu.

 TIP If the destination folder is open, click anywhere in it before pasting.

- **Use the Copy To (or Move To) Folder command.** Select one or more photos or folders, and then choose Edit → Copy To Folder or Edit → Move To Folder. A small window opens, showing a hierarchical list of folders (just like the one in the Explorer bar). Navigate to the destination folder, and then click the Copy or Move button to seal the deal. This method is the quickest if the destination folder isn't readily visible in an open window or on your desktop.

 TIP If the task pane is showing, click "Move this file" or "Copy this file" to open the same Move Items or Copy Items box.

Deleting Photos

You delete photos just like any other files in Windows. In other words, you have more choices than you'd care to count. For example:

- Select the doomed images, and then press the Delete key, choose File → Delete, or click "Delete this file" in the task pane.

- Right-click the photos and choose Delete from the shortcut menu.

- Drag the photos to the Recycle Bin.

All of these methods send the image files to the Recycle Bin. If you have second thoughts about a deleted photo, then you may be able to rescue it. Double-click the Recycle Bin icon on the desktop to open it. If you see the file you want, right-click it and choose Restore. The length of time a file remains in the Recycle Bin depends on your computer settings. Usually, you have at least a day or two to restore it.

Customizing Windows Folders for Photos

Sometimes, you'll create folders for photos *outside* of My Pictures. Perhaps you want to create a folder on another drive where you plan to keep backups of all your

Selecting Multiple Photos

Before you print, edit, email, move or do almost anything with a photo, you need to select it. And for tasks like moving pictures to a new folder or burning them to a CD, you usually want to select more than one. Most people select multiple items by dragging to highlight them, but selecting by keyboard is often faster than grabbing the mouse.

Once you learn the following timesaving selection tricks, you'll find they work in just about every Windows program:

- **To select all photos in a folder.** Press Ctrl+A. If you're a menu type, choosing Edit → Select All does the same thing.

- **To select consecutive photos.** Click the first image you want to select. Then press Shift as you click the last image in the sequence. Shift-clicking highlights the first and last photos and all photos in between, making it ideal for List view windows.

- **To select random photos.** Even if photos aren't next to each other, you can still work with them as a group: Just use Ctrl instead of Shift. Select an image and then, while pressing Ctrl, click individual images to add them to the selection. In fact, no matter which selection technique you use, the Ctrl key acts as a toggle switch. Ctrl+click any unselected photo to add it to a selection or Ctrl+click a selected photo to remove it.

- **To exclude photos from a selection.** Sometimes it's easier to select a couple of images and then tell Windows, "I want to select everything *except* these." In that case, select the images you want to exclude using one of the techniques above, and then choose Edit → Invert Selection.

photos (see Chapter 7 for more on creating backups). Follow these steps to make any folder just as photo friendly as My Pictures:

1. **Right-click the folder you want to customize, and then choose Properties from the shortcut menu.**

 The Properties dialog box opens revealing basic folder information like location, size, and date.

2. **Select the Customize tab.**

 This tab's options help you fine tune the folder's appearance and behavior (Figure 5-3).

3. **From the drop-down list, choose a folder type: Pictures or Photo Album.**

 The choice you make here determines what view you'll see when you open the folder. Choose Pictures to make the folder open in Thumbnails view (just like My Pictures).

 If you choose Photo Album, you get Filmstrip view, as shown in (Figure 5-4). This view displays a single large image, plus a filmstrip along the bottom to help you navigate through your photos.

Figure 5-3:
*What kind of folder do you want to create today? You can make
any folder photo-friendly by tweaking the settings in its Properties
box (also available by opening the folder and choosing File →
Properties → Customize tab). This box's helpful descriptions
explain each of your options.*

TIP No matter what view a folder opens in, you can always switch views on the fly by choosing from the window's View menu or clicking the Views toolbar button: Filmstrip, Thumbnails, Tiles, Icons, List, and Details. (The Filmstrip option appears only for Picture and Photo Album Folders.)

4. **Turn on the "Also apply this template to all subfolders" checkbox.**

 After all, the folders you put *inside* this folder will probably hold photos, too.

5. **If you wish, dress up the folder's outward appearance using the "Folder pictures" and "Folder icons" settings.**

 In Thumbnails view Windows chooses four photos to show on a folder's cover. You can select a different photo for this job by clicking the Choose Picture button.

 The folder icon helps you identify picture folders in List views like the left pane in Figure 5-2. Click Change Icon, and then you can choose the same icon as My Pictures or any icon that suits your fancy.

6. **When you're happy with your custom settings, click Apply to save your changes.**

 If the Apply button is grayed out, that means you haven't changed any settings.

Examining Photo Properties

Have you ever taken a terrific photo and later wondered what went into making it look so great? If you could only recall what shutter speed you used or whether you

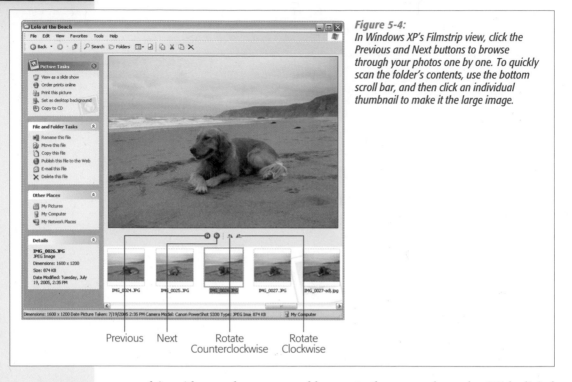

Figure 5-4:
In Windows XP's Filmstrip view, click the Previous and Next buttons to browse through your photos one by one. To quickly scan the folder's contents, use the bottom scroll bar, and then click an individual thumbnail to make it the large image.

Previous Next Rotate Counterclockwise Rotate Clockwise

zoomed in with your lens, you could recreate those superb results. With digital photography, you're luckier than pro photographers of the past, who kept painstakingly handwritten logs. Your digital camera records such details as bits of text called *properties* and stores them right in the photo file.

NOTE Windows XP recognizes the photo properties of universal JPEG and TIFF files (the most common formats produced by consumer cameras), but may not be able to read the properties of photos in the RAW formats developed by different camera manufacturers. A few programs, like Photoshop Elements, can handle these proprietary file formats. See page 15 for more about all three file formats.

To learn all about a photo, simply check out its properties in Windows:

1. **Select the photo you want to examine.**

 If you want to see details such as exposure and aperture settings, examine properties for a single photo file at a time.

2. **Choose File → Properties (or right-click the file and choose Properties from the shortcut menu).**

 The file Properties box opens to the General tab, displaying common computer-related details, like name, file type, location, and file size.

3. **Click the Summary tab.**

 Now *here's* the helpful photo information (Figure 5-5). Different cameras record different properties when they take pictures. You may see the make and model of the camera, the focal length of the lens, whether or not a flash was used, aperture size, exposure time (shutter speed), and even more esoteric information about your photograph.

4. **When you're through investigating, just click OK to close the Properties window.**

If you truly wish to hone your photographic skills, you need to be patient and willing to experiment. As you practice setting the shutter speed, varying the focal depth, and other techniques discussed in Chapter 3, use the information in the Properties box to gain a deeper understanding of how these settings affect your photos.

Figure 5-5:
The Properties box shows details about a single photo file. The Properties window for this photo file shows the make and model of the camera as well as information about the state of the camera when the image was taken. The button at the bottom of the box reveals more detailed properties. Click it to toggle the view between Advanced and Simple modes.

Organizing Photos with EasyShare Albums

As the name implies, Kodak EasyShare provides simple, straightforward tools for the casual family photographer. In that respect, it's like the kind of cameras that made Kodak famous: point-and-shoot Instamatics with easy loading film cartridges.

Once you download and install the free software (see the note below), you can do everything you can in Windows XP—and more—from within one program. There's nothing else to learn or buy. And when you're ready for some basic photo editing, you can do that in EasyShare, too (see Part 3 of this book). Best of all, if you've already organized your photos and folders in Windows XP, you can keep them stored the same way. Then, using EasyShare's Albums, Favorites, and Captions features, you can subdivide and sort your collection in creative new ways without disrupting your underlying Windows folders.

NOTE To download the Kodak EasyShare installer, visit *www.kodak.com*, and then click the "Downloads and Drivers" link. The process is just like installing any other piece of software on your PC, but that's a topic for another book (like *Windows XP Home Edition: The Missing Manual*).

The first time you run EasyShare, the setup program offers to search for photos on your PC so you can work with them in EasyShare. You turn on checkboxes to tell the program which file types to include—JPEG, TIFF, and so on. Select the formats that your digital camera uses. (If EasyShare misses some, you can always add photos later, as described in the next section.)

You can get an overview of EasyShare's features by looking at the large tabs on the left side of the program's window (Figure 5-6). The first tab—My Collection—is where you organize your photos. To the right of the tabs, you see a list of your photo albums and some special collections EasyShare makes.

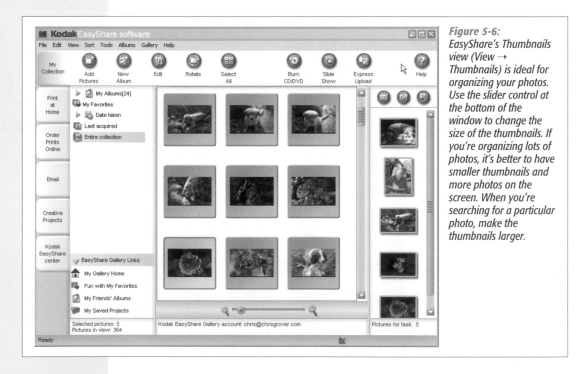

Figure 5-6:
EasyShare's Thumbnails view (View → Thumbnails) is ideal for organizing your photos. Use the slider control at the bottom of the window to change the size of the thumbnails. If you're organizing lots of photos, it's better to have smaller thumbnails and more photos on the screen. When you're searching for a particular photo, make the thumbnails larger.

Getting Your Photos into EasyShare

If your photos are already on your computer, but you don't see them in Easy-Share, then you need to add them to your collection. Open the Add Pictures box using the command File → Add Pictures or by clicking the big Add Pictures button just below the program's menu bar.

The Add Pictures box lists four numbered steps for adding photos to your Easy-Share Collection. Here are the steps, with translations if you need 'em:

1. **Select a location.**

 Translation: Find the folder or device with the photos you want to add to Easy-Share.

 EasyShare shows you a list of folders, drives, and devices (cameras) that it detects. For example, your photos may be in a folder on your hard drive, on a memory card, or on a camera hooked up to your PC by a USB cable. Navigating this list, with its + and – buttons, is similar to using Windows' Explorer bar (page 97).

2. **Select the pictures to add to your collection.**

 Once you navigate to a folder, thumbnails of its contents appear on the right side of the Add Pictures box. You must add photos to EasyShare before you can work with them, as shown in Figure 5-7.

3. **Select or type a new album destination** (*albums* are EasyShare's way of letting you organize groups of similar photos; see page 138 for details).

 Translation: Choose an existing album for your photos or create a new one. From the drop-down menu, choose from a list of existing EasyShare albums, or type the name of a new album you want to create. The first time you use Easy-Share, you see albums with names that match the folders in your My Pictures folder. If you chose not to add photos when you installed EasyShare you see New Album in the drop-down list.

 When you're adding photos that are already on your computer, EasyShare doesn't move the photos or copy them to a different Windows folder. The photos stay put, but in EasyShare, thumbnails of the photos show up in albums.

 On the other hand, if you're adding photos from a memory card or a camera, EasyShare copies them to a folder on your computer's hard drive. The photos are placed in a folder with the same name as the album selected in the Add Pictures box (Figure 5-7). By turning on "Remove pictures from original device," you tell EasyShare to delete the photos from your camera or memory card, freeing up space so you can take more pictures.

 TIP Having trouble finding where EasyShare stashes your imported photos? If you can't find them in your My Pictures folder, look in your Shared Pictures folder: My Computer → Shared Documents → Shared Pictures → Kodak Pictures.

4. **Click Add Pictures or Add Entire Folder.**

If you're adding only a few selected pictures, click the Add Pictures button. If you're adding all the pictures in a folder, click the Add Entire Folder button. In either case, your photos show up in an EasyShare album.

5. **Close the Add Pictures box.**

You can continue to add pictures from other locations while the Add Pictures box is open. When you're through, click Done.

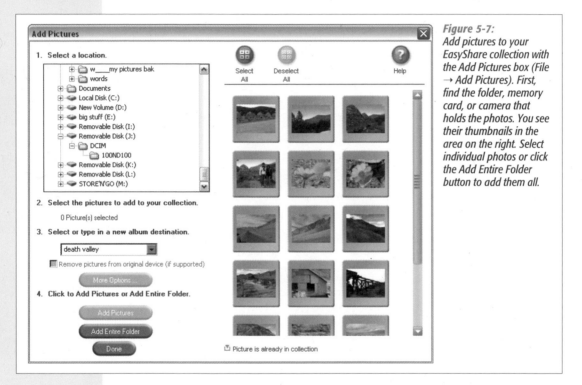

Figure 5-7:
Add pictures to your EasyShare collection with the Add Pictures box (File → Add Pictures). First, find the folder, memory card, or camera that holds the photos. You see their thumbnails in the area on the right. Select individual photos or click the Add Entire Folder button to add them all.

Creating and Removing Albums

Albums are your primary tool for organizing photos in EasyShare (Figure 5-8). You impose order on your photo library by creating albums for different subjects: Museum Sunday, Oregon Vacation, Nature Photos, and so on, much the same way you organize your photos into folders in Windows XP.

Albums have a distinct advantage over folders, though: They don't take up nearly as much room on your computer's hard drive. So go ahead and put a single photo into more than one album if you want. For example, you can put that Crater Lake shot in both your Oregon Vacation and Nature Photos albums and enjoy it twice as often. If you're not sure whether, at some point in the distant future, you'll hunt for a photo of your dog Lola on the beach in your Dogs album or your Beach album, put it in both places. (If you did the same thing in Windows by placing

copies of the same photo in multiple folders, you'd fill up your entire hard drive fast.) You can store your photos in just a few well-organized folders in Windows, and then create a riot of EasyShare albums to show them off.

To create a new album, use Albums → New Album, or click the large New Album button below the program menu. A new album appears in the list below My Albums, and you can give it a name.

If you decide to remove an album, select it in either the main window or the album list and then use Albums → Remove Album. A message box asks if you're sure you want to remove an album. It also explains that by removing the album, you *don't* delete photos from your computer. But if you want to delete an album in the name of cleaning up your EasyShare window, click Yes.

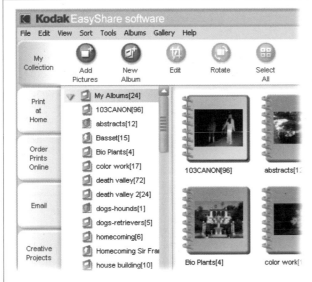

Figure 5-8:
To view your EasyShare albums, click My Albums at the window's upper left. If you don't see your albums in the list, you may need to expand the list by clicking the little triangle to the left of My Albums. Albums sport a spiral binding on their left side so you can distinguish them from photo thumbnails. The bracketed number next to an album tells you how many photos or videos it holds. Double-click to open an album and see its photos at right.

Copying Photos to New Albums

As discussed in the previous section, EasyShare lets you display the same photo in multiple albums without creating extra copies on your hard drive. In fact, Easy-Share's behavior encourages this duplicate photo strategy. When you drag a picture to a new album, EasyShare always leaves the original behind. In other words, you're *copying* the photo to the new album, not *moving* it. If you don't want to leave the original photo in the original album, you need to select it and remove it, as described next.

Removing and Deleting Photos

To EasyShare, removing photos and deleting photos are two distinct operations. *Removing* a photo from an album (Albums → Remove from Album) merely means it no longer appears in that album. It leaves the original image file on your hard

drive untouched. *Deleting* a photo in EasyShare, though, deletes it from your computer—actually placing it in the Windows Recycle bin.

With that consideration in mind, here's a rundown of EasyShare's commands:

- **To remove a photo.** Select the photo and choose Albums → Remove from Album, or right-click it and choose Remove from Album from the shortcut menu. The photo disappears from the current album, but any copies in other albums remain. (To remove multiple photos, simply select them all first.)

- **To remove a photo from *all* of your albums.** Select the photo and choose File → Remove from Collection. This command removes every instance of the photo from EasyShare. If you want it back later, you have to click Add Pictures and start over.

- **To delete a photo from your computer.** Select the photo and choose File → Delete (or just press the Delete key). This command is the exact same thing as deleting a file in Windows.

TIP You can also right-click selected photos and choose any of these commands from the shortcut menu.

Fine-Tuning Your Organization Strategy

Even though EasyShare's organizing tools are simple and basic, you can increase your organizational firepower by adopting a few good strategies.

Use albums to divide and conquer your photo library

Albums are by far EasyShare's most useful organizational tool. To create a photo library where you'll be able to find photos in the distant future, create albums with descriptive names, like Aunt Elsie's 92nd Birthday, or Oregon Vacation 2006. And, as if you haven't heard it enough already, never hesitate to drag photos into multiple albums.

On the downside, EasyShare doesn't support nested albums, so you *can't* place albums inside each other like Windows subfolders. If you want to keep groups of folders together, name them like this: Dogs-Hounds, Dogs-Retrievers, Dogs-Mutts, and so on. That way, all your puppies stay together when you sort your albums by name (Albums → Sort Albums → By Name).

Use Favorites to single out special photos

EasyShare's Favorites feature (Right-click → Tag as Favorite) is a great way to make certain photos stand out from the crowd without cooping them up in a separate album.

To designate a photo as a Favorite, right-click it and choose "Tag as Favorite" from the shortcut menu (or click the heart button that appears in some views). Once your photos sport the favorites tag, you can find them in the My Favorites

collection or use Sort → By Favorites to move your tagged photos to the top of your albums and collections. You can also spot favorites by the little heart icon on the photo's thumbnail.

TIP Most people use the Favorites tag to mark their best shots, but it can mean anything you want: "photos taken with my new Nikon" or "photos to email the next time I'm online," for example. The important thing is to remember *why* you're singling out these photos.

Use the "Date taken" and "Last acquired" albums in your photo hunts

The "Date taken" albums (Figure 5-9) sort your photos by month and year, which is handy when you're looking for a particular shot and have a ballpark idea of when you took the picture.

The "Last acquired" collection is a shortcut to photos you just added to EasyShare. That's pretty helpful, since the photos you just added are likely the ones you want to see, print, or share.

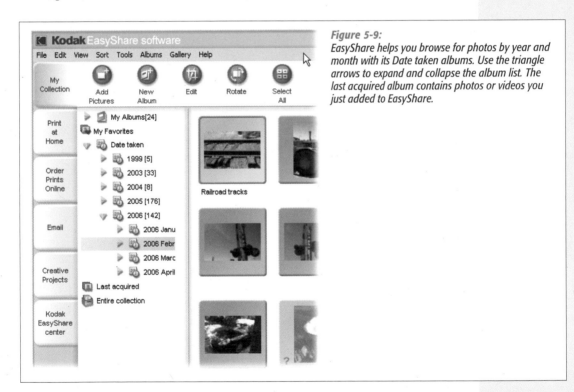

Figure 5-9:
EasyShare helps you browse for photos by year and month with its Date taken albums. Use the triangle arrows to expand and collapse the album list. The last acquired album contains photos or videos you just added to EasyShare.

Use captions to identify and sort photos

A picture may be worth a thousand words, but a few choice words can help you find and identify your pictures in EasyShare. To add a caption to a selected photo, choose File → Properties and type it in the Caption box (Figure 5-10); or you can

add a caption simply by clicking underneath the thumbnail and entering text. When you add captions, use distinct and descriptive words. For example, instead of "mom and her pups," a caption like, "Campbell and her pups Lola, Goose, and Max" will help you remember, ten years from now, *which* litter of pups you're looking at.

EasyShare lets you sort photos by their captions (Sort → By Caption), giving you another way to find photos when you need them. For example, if every photo with Amy has a caption like "Amy Stinson Beach" or "Amy Napa Vineyard," you can easily gather up all your Amy photos with a quick alphabetical sort.

Figure 5-10:
*EasyShare's Properties box (File →
Properties) contains some of the same
photo details that you find in Windows'
Properties box. In the Caption field, you can
type notes to yourself or words to help you
sort the photos alphabetically.*

Organizing Photos with Picasa

Picasa provides more powerful photo search tools than EasyShare, making it better suited for larger photo libraries. The program's features and learning curve put it somewhere between Kodak EasyShare and Photoshop Elements. In other words, if EasyShare makes you itch for more, but Photoshop Elements (or its price) scares you off, Picasa may be just right.

Like EasyShare, described in the previous section, Picasa draws upon your Windows folder and file system, creating thumbnails of your photos that appear in its window. Unlike EasyShare, though, Picasa lets you act directly upon your

Windows folders. When you move a photo from one Picasa folder to another, you're actually moving the file in Windows. Picasa also gives you features like Collections, Labels, and Keywords that give you more photo-handling options than you get in Windows XP.

> **NOTE** Google lets you download Picasa at no charge. To download the installer program, visit *http://picasa.google.com*, and then click the "Free Download" link. (For much more detail on installing software on your PC, consult a book like *Windows XP, Home Edition: The Missing Manual*.)

Getting Your Photos into Picasa

When you download and run Picasa's installer, the final setup screen presents you with a handful of options. Before launching Picasa for the first time, the installer offers to place the program's icon on your desktop, in the taskbar at the bottom of your screen, and so on. Turn off the checkboxes if you don't want to deal with such clutter. The last checkbox is a sneaky bit of marketing: It offers to make Google your browser's default search engine. (Hey, unlike other free programs, Picasa isn't always in your face trying to sell you photo prints or t-shirts, so cut Larry and Sergey some slack.)

The first time you fire up Picasa, it rounds up all the photos on your computer. When it's done, Picasa fills your screen with the main Library view window, described next.

> **NOTE** Picasa organizes and keeps track of both digital photo files and digital video files. Much of the discussion about digital photo files in this section applies to digital video files, too.

Exploring the Library View

Picasa's Library view (Figure 5-11) gives you three main work areas for organizing your photos: the Lightbox, the Folder List, and the Picture Tray.

- **Lightbox.** The largest part of the window is where you view, sort, and sequence your photo collection. The Lightbox reveals only a few thumbnails at a time, but all your photos are within easy reach using the scroll bar (page 112).

- **Folder List.** To the left of the Lightbox is the Folder List, where you see all the folders on your computer that contain pictures. Click a folder's name to display its contents in the Lightbox area. (See page 115 for lots more detail on working with folders in Picasa.)

- **Picture Tray.** At the bottom of your screen is the Picture Tray. It serves as a launch pad when you want to edit, print, or email your photos. You move photos to the Picture Tray by selecting them in the Lightbox. Click the Hold button to keep photos in your Picture Tray as you add more photos.

> **NOTE** Picasa's folders show only photo and video files. You won't see Word files, Excel files or any other types of files in with your photos.

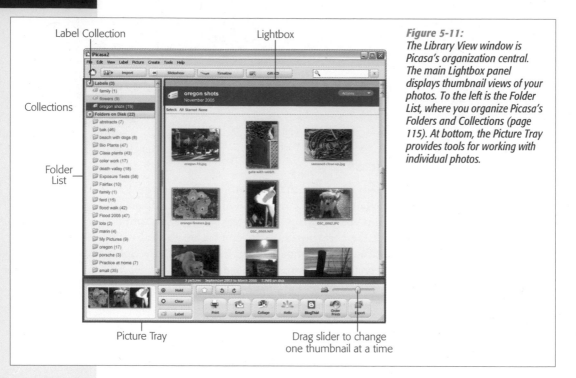

Label Collection

Lightbox

Collections

Folder
List

Picture Tray

Drag slider to change
one thumbnail at a time

Figure 5-11:
The Library View window is Picasa's organization central. The main Lightbox panel displays thumbnail views of your photos. To the left is the Folder List, where you organize Picasa's Folders and Collections (page 115). At bottom, the Picture Tray provides tools for working with individual photos.

Scrolling Through the Lightbox

At most, the Lightbox shows only a few dozen thumbnails at a time; to see more, you need to scroll. Picasa's scroll bar (Figure 5-12) works differently from the standard Windows scroll bar. In the middle of the scroll bar is a single button with arrows pointing up and down. Drag the button, and the Lightbox scrolls through your photos. The farther you drag the button away from the center, the faster the thumbnails scroll by. When you release the button, it snaps back to the middle as though it's spring loaded, and the thumbnails stop moving.

Picasa also has navigation buttons at the top and bottom of the scroll bar. The button that looks like an arrow scrolls the thumbnails a row at a time, while the button that looks like an equals sign scrolls the thumbnails a folder at a time.

Resizing thumbnails

Below the Lightbox is the slider control that adjusts the size of the thumbnails. For a clearer view of individual images, drag the slider to the right to make the thumbnails larger. Want to see more thumbnails per screen? Drag the slider to the left. If you're searching for one photo among many similar shots, a larger thumbnail provides more detail. When you're sequencing dozens of photos, you may want to fill the screen with as many thumbnails as possible.

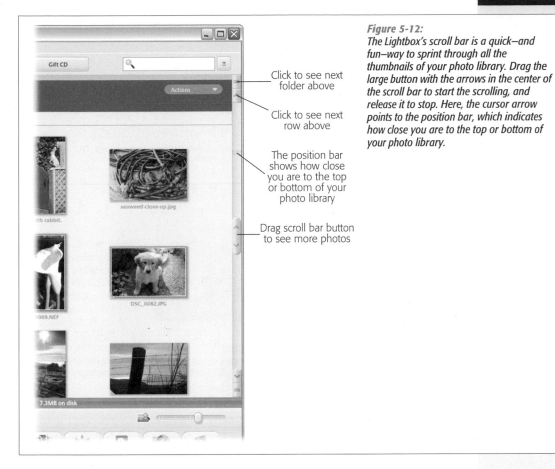

Figure 5-12:
The Lightbox's scroll bar is a quick—and fun—way to sprint through all the thumbnails of your photo library. Drag the large button with the arrows in the center of the scroll bar to start the scrolling, and release it to stop. Here, the cursor arrow points to the position bar, which indicates how close you are to the top or bottom of your photo library.

Click to see next folder above

Click to see next row above

The position bar shows how close you are to the top or bottom of your photo library

Drag scroll bar button to see more photos

Moving thumbnails within and between folders

Say you want to arrange shots of your winter trip to the Bahamas in chronological order: arrival, the first night, day at the beach, and so on. You can rearrange photos within a folder to your heart's desire. Simply drag thumbnails to the desired position in the Lightbox.

Moving a thumbnail to a *different* folder, though, is a little more complicated:

1. **Select one or more of the thumbnails that you want to move.**

 Click to select a single thumbnail and Picasa highlights the image with a border, to show that it's selected. You can also Shift+click to select a group of adjacent photos or Ctrl+click to select random images. (For more multiple selection techniques, see the box on page 100.)

2. **Drag the thumbnail or group of thumbnails to a different folder in the Folder List (Figure 5-13).**

 If the destination folder isn't visible, find it using the Folder List's scroll bar (between the Folder List and the Lightbox). To move a group of selected thumbnails, just drag any one of them and the rest come along.

 When you try to drag a thumbnail to a different folder, Picasa sends up a warning. A message box asks you to confirm the move, reminding you that in addition to moving files within Picasa, you're also moving files from one folder to another on your computer.

3. **If you're sure about the move, click Yes in the Confirm Move box.**

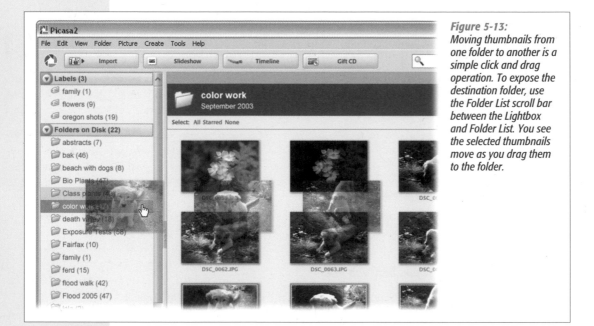

Figure 5-13:
Moving thumbnails from one folder to another is a simple click and drag operation. To expose the destination folder, use the Folder List scroll bar between the Lightbox and Folder List. You see the selected thumbnails move as you drag them to the folder.

Deleting photos

When you delete a photo from the Lightbox, Picasa banishes it to the Windows Recycle Bin. Although you can often rescue deleted photos (page 99), use the same caution deleting photos in Picasa as when deleting them from your hard drive window. If you're sure you don't want to keep that closeup of your thumbtip, here's how to delete it:

1. **Select, and then right-click, the photo(s) you want to delete.**

 The shortcut menu shows several options related to photos and thumbnails.

2. **Near the bottom of the list, click Delete From Disk.**

 Your thumbnail disappears from the Lightbox. Picasa moves the photo file from its folder and into the Recycle Bin.

TIP The length of time a file remains in the Recycle Bin depends on your computer settings. Usually, you have at least a day or two to restore it.

FREQUENTLY ASKED QUESTION

Parsing Picasa

Why should I put photos in a Picasa Collection when I can just keep them in Folders? For that matter, how is a Keyword different from a Label—and how on earth do I know when to use each?

Lots of Picasa neophytes find its features' names confusing, but each gives you a uniquely useful organizing tool. Here's a cheat sheet:

- **Folders.** Actually, Folders aren't a Picasa feature at all. The folders you see in Picasa mirror the folders already on your computer. As you can read below, Picasa's helping you organize your photo folders right in its own attractive window.

- **Collections.** If you have a *lot* of photo folders, Collections (page 118) are a great way to divide them into logical groups, sort of like filing folders in drawers by subject. Unlike folders, Collections exist only within Picasa, so you can create as many as you like and shuffle your folders among them freely without disturbing the folder system on your PC.

- **Labels.** When you add a Label to a photo (page 120), Picasa creates a special folder by the same name in the Labels Collection (at the top of the Folder List). Unlike standard folders, these virtual folders exist only within Picasa, and the thumbnails in them are just placeholders for the actual photos—which are still in their original folder on your computer. A single photo can have as many labels as you care to give it, so you can slice 'n' dice your collection in different ways without making extra copies of the original file. (This type of grouping is called an *album* in Kodak EasyShare and some other programs.)

- **Keywords (page 123).** Unlike Labels, Keywords don't create thumbnails that you can view in a folder. Instead, they're text labels that help you *search* your photo collection. While Labels and Folders let you break a big photo collection into tiny chunks, Keywords work best when you use them for general image *categories*. For example, if you assign all your animal pictures the keyword "pets," you can then use that keyword to extract every shot of your seven cats, four dogs, and two horses from the far corners of your hard drive.

Creating, Editing, and Sorting Folders

As discussed in the box above, the folders you see in Picasa's Folder List (Figure 5-11) are simply a mirror image of the photo folders on your PC. But you may find that Picasa's window makes it easier to see more information at a glance. When you click a folder in the list, the Lightbox displays thumbnails of its contents, topped by a banner showing the folder's name, and the month and year of its creation.

On the right side of the banner bar is a button labeled Actions. As the name implies, it leads to a menu of actions that you can apply to folders and the thumbnails inside your folders. You'll learn about these different actions in the following sections.

NOTE You see exactly the same menu when you click Picasa's Actions button or when you right-click anywhere in a folder that's not a photo thumbnail.

Creating a new folder by selecting photos

Say you decide your Westminster Kennel Club folder is too crowded with dog pictures. Locating shots of your Basset Hound takes way too much scrolling. You can use Picasa to divide your photos into smaller groups and place them in new folders. (When you do, you create new, smaller folders in Windows, which makes it easier to manage them there, too.) Follow these steps to make a new folder for your Hound photos:

1. **In the Lightbox, select the thumbnails of the photos that you wish to move to a new folder.**

 Picasa highlights the selected photos.

2. **Right click one of the selected photos, and choose Move to New Folder from the shortcut menu.**

 A blank Folder Properties box appears (Figure 5-14), letting you enter information about the folder you're creating. For example, a well-chosen folder name, a caption and information about when and where the photos were taken will make browsing and searching your photos much easier three years from now.

3. **Type a name and other details in the Folder Properties box.**

 At the very least, you should enter a name for the folder; otherwise, you'll end up with a lot of folders named Untitled.

 NOTE Since you're also creating a folder in Windows XP, you must use characters that Windows permits in folder names. Spaces and underscores are fine, but colons and slashes are verboten.

4. **Click OK to create the New Folder.**

 Your new folder appears in the Folder List. Behind the scenes, Picasa creates a folder with a matching name on your computer and moves the selected photos to it.

Editing folder names and descriptions

How many times have you stared at an old snapshot and wondered: When did I take this shot and who in the world are these people? To jog your memory later, you can change the names and descriptions of folders by choosing Folder → Edit Description (Figure 5-14). You see the same Folder Properties dialog box as when you create a new folder. In the Properties box, you can change the folder's name, date, place, and caption. Just remember, if you change the folder name, you're changing the name of the matching folder on your computer, too.

*Figure 5-14:
Entering descriptive
details about your photos
and folders in the Folder
Properties box makes it
easier to identify them
months or years later.
Picasa displays this
information in the folder
banner in the Lightbox.
You can write captions as
lengthy as you want, but
they do cut down on
space for thumbnails.*

Sorting your folders and photos

When you have dozens upon dozens of folders and thousands of photos, Picasa's powerful sorting tools make it easier to find what you need. Picasa gives you two ways to sort: You can sort the folders in your folder list *or* sort individual photos within a folder. For example, say you cropped and retouched a photo just a day or two ago (see Chapter 9 for the skinny on editing photos with Picasa). You can sort your folders by Recent Changes, and the folder with that photo jumps to the top of the list. Once you know what folder to look in, you can sort the photos within it to narrow down your search.

> **TIP** If Picasa isn't behaving the way you expect it to, you may be sorting folders when you think you're sorting photo files, or vice versa.

The two procedures are as follows:

- **Sort by folder.** Choose View → Sort Folder List, and then choose one of three options. Choosing "by Creation Date" moves the most recent folders to the top of the list. Sort "by Recent Changes", and the folders with recently changed photos rise to the top. Sorting "by Name" orders the folders alphabetically, with punctuation preceding letters and numbers following.

> **NOTE** Sorting folders doesn't change the order of your Picasa collections (page 118), and it doesn't move folders from one collection to another. Your folders are still grouped within their respective collections. You need to look *inside* of your collections to see the sorted folders.

- **Sort photos within a folder.** Select a folder, and then choose Folder → Sort By. Beginners beware: Because the command is on the Folder menu, you may think

you're sorting folders when actually you're sorting the photos *within* the folder. You have three ways to sort your photos: by Name, by Date, and by File Size.

Organizing Folders with Collections

Wouldn't it be great to have a photo filing cabinet with an unlimited number of drawers? Then, anytime you need to create a new category for your photo folders, you can devote an entire drawer to the subject. It doesn't matter how full or empty any of the drawers are, because you can always create another drawer if you need it. Picasa's *collections* let you create an unlimited number of "drawers" to organize your photo folders.

Picasa automatically creates its own collections as needed using names like Labels, Folders on Disk, Exported Pictures, and Other Stuff. You can't rename or delete these collections, but you can move folders in and out of all of them (except for Labels).

In the Folder List (Figure 5-15), your collections look like metal bars separating the folders. The number next to the collection's name tells you how many folders are in it. The triangle icon in the bar is red if the collection is closed and green if it's open. To expand or collapse the list of folders in a collection, just click the triangle (or double-click anywhere on the collection's bar).

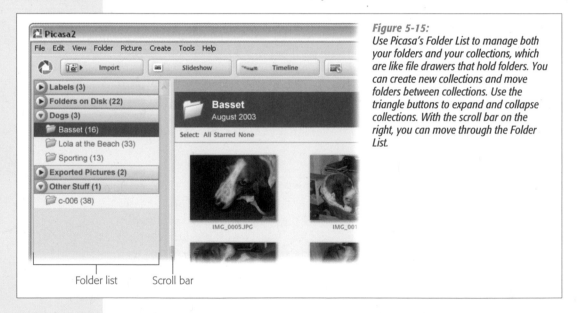

Figure 5-15:
Use Picasa's Folder List to manage both your folders and your collections, which are like file drawers that hold folders. You can create new collections and move folders between collections. Use the triangle buttons to expand and collapse collections. With the scroll bar on the right, you can move through the Folder List.

Folder list Scroll bar

NOTE Unlike Picasa's folders, which match the folders on your computer, collections exist only inside of Picasa. Changes to collections, such as creating and deleting them, only affect the way photos are organized within Picasa.

Collections are easy to use, but for reasons known to only the great minds at Google, Picasa buries the command to make new ones deep in a submenu of a shortcut menu. Here are the secret steps for making a new collection:

1. **In the Folder List, right-click the highlighted folder to reveal the shortcut menu (Figure 5-16).**

 The menu shows a number of actions that apply to folders. The Move to Collection action is the last item in the menu's second section.

2. **From the shortcut menu, choose Move to Collection → New Collection.**

 The Add New Collection box appears.

 NOTE The Move to Collection submenu also shows a list of existing collections. To move your folder to an existing collection instead of creating a new collection, simply choose its name from the list.

3. **In the Enter Name Here box, type a name for the new collection. Then click OK to close the box.**

 Your new collection appears in the Folder List.

Figure 5-16:
You can organize large groups of photos by moving folders into collections. Picasa gives you only two levels of organization: folders and collections. You can't put folders inside of other folders and you can't put collections inside of other collections. (See the box on page 120 for more details.)

Deleting and renaming collections

As you organize your photos and folders, you may find that you no longer need a collection. Perhaps you decide you don't really need to organize your dog photos by breed, so you can get rid of collections like Golden Retriever and Old English Sheepdog.

To delete or remove a collection, in the Lightbox, right-click its bar, and choose Remove Collection from the shortcut menu. What happens to the folders and

No Subfolders Here

The folders shown in Picasa's Folder List mirror the folders on your computer with one major omission: Picasa doesn't deal with subfolders. Even if you've created an elaborate structure of folders within folders on your computer, Picasa simply puts every folder that contains a photo at the same level in the folder list. Grouping your folders within Picasa's collections does give you two levels of organization, but you can't place folders within folders or collections within collections.

If you need a more complex hierarchy to organize your photos, consider using Photoshop Elements.

If you must see the organization of the folders on your computer, select a folder or thumbnail and press Ctrl+Enter. The folder opens in Windows showing the complete path for the photo or folder in the address bar. To get a better view of the folder structure, go to View → Explorer Bar → Folders (page 96).

photos inside that collection? Picasa moves them to the Other Stuff collection—a handy receptacle for items that might otherwise be lost.

Collection names are there to help you identify photo subjects when you browse. If you can think of a better description, by all means, rename your collection. Picasa won't let you change the names of the collections it creates, but you can rename the collections *you* create. To rename a collection, follow these steps:

1. **In the Lightbox, right-click the collection's bar. Then, from the shortcut menu, choose the first option—Rename Collection.**

 A dialog box appears with a single text box where you can enter a new collection name.

2. **Type a new name in the box, and then click OK.**

 (If you have a change of heart and want to stick with the old name, click Cancel instead.)

 Once you click OK, your collection now sports its new and improved name in the Folder List.

Labeling Photos for Quick and Easy Browsing

Wouldn't it be great to be able to file a single image in several different folders at the same time? You could file that Puerto Vallarta sunset under Mexico, Vacation 2006, *and* Perfect Sunsets. Then, years later, no matter which folder you search, there it is. You can't do that with Picasa's folders, where a photo can be in only one folder at a time. But by giving it a *label*, you can make a single photo appear in multiple folders, increasing your chances of finding it when you're browsing. Picasa's labels work much like the album or category features found in other programs.

When you assign a label to a photo, Picasa displays it in a special folder bearing the label's name. At the top of the Folder List is a collection called Labels. Folders in

the Labels collection look and act just like other folders, with the following exceptions:

- When you add a label to a thumbnail (or drag a thumbnail to a label folder in your Folder List), Picasa *doesn't move the photo* from its original folder. Instead, it creates a duplicate thumbnail and displays it in the label folder. Think of the thumbnail in the label folder as a pointer to that original photo file.

- You can add many different labels to a photo. This means, you can place a single photo in many different label folders, unlike normal folders where an image can be in only one folder at a time.

- Unlike Picasa's other folders, your label folders exist *only* in Picasa. There are no folders on your computer that match your labels. When you rename, delete, and reorganize your label folders and their thumbnails, you merely change the way Picasa organizes your photos inside the program.

Creating a new label

Labels are more flexible than folders in that you can give the same photo more than one label. Say you want to organize your dog photos by both breed *and* American Kennel Club group. Attach a Basset label to all your Basset Hound photos, and all the Basset pictures appear in a Basset folder in the Labels collection. Then attach a second label—Hounds—to your Basset pictures, and they appear in the Hounds label folder, too (along with the Bloodhounds, Afghans, and Foxhounds). All the while, the original Basset photos remain tucked away in that original Dogs folder.

The thumbnails in the Basset and Hounds label folders all point to the original photo files in Dogs. When you choose a photo in one of your label folders to print or email, Picasa hunts down the original photo to do the job. Since you're not making extra copies of the photos on your hard drive, there's no real limit to the number of labels you can create.

Take these steps to create a new label and place a photo in the label folder:

1. **In the Lightbox, select the photo you want to label.**

 A border highlight appears around the photo when you select it. (You can choose more than one photo by Shift+clicking or Ctrl+clicking.)

2. **Right-click the photo and choose Add Label → New Label from the shortcut menu.**

 The Label Properties box appears. Its options are the same as those in the Folder Properties box (Figure 5-14).

 NOTE When you click Add Label on the shortcut menu, the submenu also lists all of the Labels that currently exist in Picasa. If you're just applying an existing label, select one off this list.

3. **In the Label Properties box, fill in your new label's name and other details.**

 Don't forget to enter a name. (Untitled isn't a very helpful label.) The other details are optional, but good, descriptive text always makes it easier to browse and search for photos later.

4. **Click OK to close the Label Properties box.**

 The new label folder shows in the Labels collection at the top of the Folder List (Figure 5-17). The label's name and other descriptive text show in the banner in the Lightbox above the thumbnails.

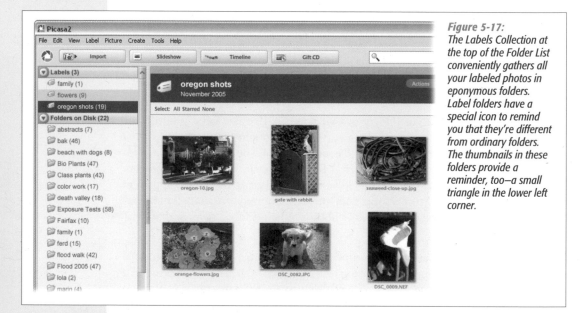

Figure 5-17:
The Labels Collection at the top of the Folder List conveniently gathers all your labeled photos in eponymous folders. Label folders have a special icon to remind you that they're different from ordinary folders. The thumbnails in these folders provide a reminder, too—a small triangle in the lower left corner.

Editing label descriptions

Label descriptions are just as important as folder descriptions. Good names and accurate descriptions make it easier for you to find and identify photos when you're browsing. They also make it easier for Picasa to find the photos when you conduct a search.

Change the names and descriptions of labels by choosing Label → Edit Description. You see the same Label Properties dialog box as when you create a new label. From here, you can change the label's name, date, place, and caption.

Deleting a label

The act of deleting something on a computer always raises alarms (or at least it should). By contrast, when you choose Label → Delete, you simply delete the label folder from the Folder List. Since the thumbnails in a label folder are just pointers

to the photo in your standard folders, you still have the original photo in its original folder.

Adding Keywords, Captions, and Stars to Photos

Have you ever wanted to find all the photos that have something in common, no matter when or where you took them? In Picasa, you can create keywords, attach them to photos, and then use the keywords to pull up those photos later. For example, if you apply the keyword "Canada" to your Montreal vacation pictures when you import them into Picasa, you'll have an easier time locating them later.

Keywords are one of the properties that Picasa's search tool reads when it's looking for photos. They stay with your photo, even if you shuffle the photo into different folders.

> **NOTE** While labels, described in the previous section, help you *browse* your photo collection, keywords help you *search* it.

Follow these steps to add a keyword to your photo:

1. **Select one or more photos, and then choose View → Keywords (or press Ctrl+K).**

 The Keywords dialog box shows you a thumbnail of your photo. If you've selected more than one, the box shows one image and lists the number of selected photos.

 If the image already has keywords associated with it, you see them in the Keywords text box (Figure 5-18).

2. **Type the keywords you wish to add.**

 You can enter more than one keyword at a time in the Add Keywords text box; just leave a space between each word.

3. **Click Add.**

 Picasa adds the keywords you just typed to the photo file. The dialog box remains onscreen, so you can continue adding keywords if you want. (If you want to delete a keyword, select it and then click Remove.)

4. **Click OK to close the Keywords box.**

 Clicking OK accepts your additions to the keyword list and closes the box. Although you don't see any visible changes in your photo thumbnails, rest assured Picasa has stored the keywords with the photo.

Adding captions to your photos

You may think that adding captions to your photos is frivolous or a waste of time—but it's not. A good caption helps you identify your photos and distinguishes one shot from another. Even more important, Picasa reads the words in

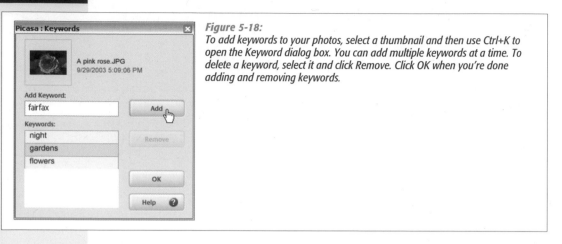

Figure 5-18:
To add keywords to your photos, select a thumbnail and then use Ctrl+K to open the Keyword dialog box. You can add multiple keywords at a time. To delete a keyword, select it and click Remove. Click OK when you're done adding and removing keywords.

captions when you ask it to search for photos. So, captions are helpful when you browse through your photo library *and* when you use Picasa's search tool.

To see captions in the Library View, choose View → Thumbnail Caption → Caption. Picasa shows the caption text below each thumbnail. If the text is too long, it trims the caption to fit.

To add a caption, you need to be in Edit View (Figure 5-19), where you work with single images. Follow these steps:

1. **In the Lightbox, double-click the photo you want to caption.**

 Picasa's window switches to the Edit View, where you see a single large image. If the photo doesn't already have a caption, you see "Make a caption!" just below the image.

2. **Click "Make a caption!" and start typing.**

 As soon as you click, "Make a caption!" (or any existing caption text) goes away, and you can enter a new caption. That's all there is to it—no button to click to confirm the event.

3. **When you're done, click the large Back to Library button (at upper left).**

 If you've set Library View to display captions, your thumbnail sports its new caption.

Adding stars to your photos

Picasa gives you a quick and easy way to single out a photo—just give it a star. Starred photos stand out in the Lightbox. Furthermore, when you search in Picasa, as described in the next section, you can even limit your searches to starred photos.

To add a star, select a photo in your Lightbox and click the Star button (at the window's lower left). Most people probably use stars to mark favorite photos, but they

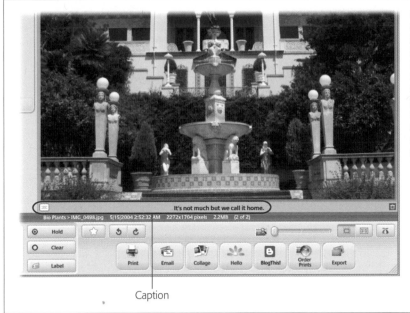

Figure 5-19:
Adding captions to your photos makes it easier for you to identify them when you browse (and easier for Picasa to find them when it searches). In Edit View, type your caption in the space directly below the image. The button to the left of the caption toggles the caption display on and off in Edit View.

Caption

can mean anything you want: photos Joe took, photos to order at wallet size, and so on.

NOTE You can't add more than one star, so it's a yes or no proposition.

Searching for Photos

You desperately need the photo you took three years ago of the wild turkeys in that field near Woodacre. You can picture it in your mind, but you can't find it on your computer. It's time to put Picasa's search tool to work.

Indicated by a magnifying glass icon, Picasa's search box lives in the Library View's upper-right corner. To start a search, type a word in the box (Figure 5-20). As you type, Picasa looks for a match in the photo file's properties. (For more details about file properties, see "Examining Photo Properties" on page 101.)

Picasa's search tool also uses text from features like collection names and label names. So when you enter search terms, Picasa compares them to a fairly broad number of properties, including:

Filenames
Captions
Folder, Label, and Collection names
Picture color
Camera details
Dates
Keywords

Figure 5-20:
Picasa's search tool is always available in Library View. Enter one or more words, and you see thumbnails of matching photos in the Lightbox. After you're through with the search, click the Eject button (line and triangle) next to the search box and you return to the normal Library view.

TIP If you want to narrow the search, leave a space and type another word. For example, if you type *turkey* and *Woodacre*, Picasa looks for photo files that have both words in the filename, keywords, captions, and so on. See below for more advice on making the search tool smarter.

As you search, Picasa reports details, listing how many pictures matched the search, how many albums (folders and labels) are shown, and how long it takes your computer to complete the search. With today's computers, it doesn't take long—Picasa reports in hundredths and thousandths of a second.

To clear the Search text box, click the X button on the right. Entering new text starts a brand new search. When you're done, exit the search tool by clicking the Exit Search button above the Star button, or by clicking the Eject button next to the Search text box.

Refining your search

Because Picasa uses such a broad range of properties for its searches, your results may include *too many* photos. For example, you may wish you could search for "baby" *only* when it appears in keywords, not captions or folder names. Unfortunately, Picasa doesn't give you a way to limit searches to certain properties. With experience, you can find ways to increase the odds of finding the photos you want (and filter out the photos you don't). Here are some techniques to help you refine your searches (Figure 5-21):

- **Enter one or more words in the Search text box.** The Search text box is always in the upper-right corner of the Library View window. You can enter more than one word but be aware that Picasa doesn't search for *phrases*. The search tool considers each word separately and finds photos whose properties contain *both* words.

- **Have a Keyword strategy.** Keywords are a powerful ally when you search, and they work even better if you develop a strategy that matches your photo library. For example, if you're a wedding photographer, you may want to use the couple's last names and first initial as keywords: *jonesb* and *smithj*. (Picasa doesn't let you use spaces or punctuation in keywords.) If you collect car photos, you

might use keywords like *chevycorvette* and *porscheboxster*. Meaningful, distinctive keywords are the goal.

- **Use the Date Range slider to target more recent photos.** Drag the Date Range slider control from All to Newest, and you reduce the number of photos included in the search. As you drag, Picasa shows you the date range above the slider: "Pictures up to 9 weeks old," for example. The slider only works one way—you can't exclude your newer photos and find only the older ones.

- **Refine your search with the Star button.** Click the Star button to the left of the Date Range slider, if you want to limit your search to starred photos (page 124). For example, if you use a star to tag your favorite photos, the search tool shows only your best shots.

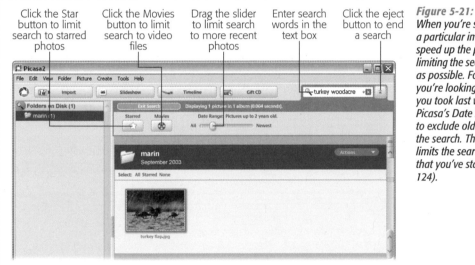

Click the Star button to limit search to starred photos | Click the Movies button to limit search to video files | Drag the slider to limit search to more recent photos | Enter search words in the text box | Click the eject button to end a search

Figure 5-21:
When you're searching for a particular image, you can speed up the process by limiting the search as much as possible. For example, if you're looking for a photo you took last week, use Picasa's Date Range slider to exclude older files from the search. The star button limits the search to photos that you've starred (page 124).

NOTE This book is about digital photography, but Picasa keeps track of video files, too. If you're looking for a digital video file, click the Movies button to limit the search to movies instead of photos.

Storing Your Photos Online

A big part of taking pictures has always been showing off the finished product, whether that meant paging through grandma's big, dusty photo albums or being forced to fidget through slides from Uncle Ernie's trip to Japan. Some things never change: People still love to show their snapshots to anyone who'll sit still long enough to watch. But the Web has streamlined the process of storing photos so that you (and your family and friends) can look at them anytime—and made it way, way cooler.

Several companies offer space on their Web sites where you can store and organize your photos. These services make it easy to email invitations to lots of folks. Why are they so generous? They have a feeling that everyone who looks will order prints, posters, coffee cups, shirts, DVDs, and other merchandise from their sites. Even if *you* don't, maybe some proud grandparents will. It's a win-win exchange that makes great use of the digital nature of today's photography.

This chapter shows you how to upload and organize your photos online. Later chapters discuss how you can use these services to share your photos (Chapter 14), purchase high-quality prints (Chapter 16), and make creative projects like books, calendars, and coffee mugs (Chapter 17).

Why Put Your Photos Online?

As discussed in the previous chapter, your desktop or laptop computer is all you need to store and organize your photos. But putting your photos online has some nice perks:

- When you're on vacation, you don't have to wait until you get home to download your shots from your camera and start sharing them with family and friends. You can log onto any of the sites described in this chapter, upload your photos, and email invitations for viewing them. If you order prints while you're on the road, they just may beat you home.

- If you fill up your memory card, then an online site can store the shots you've taken to date, so you can erase the card and shoot some more. (Then go read page 16 and buy a bigger memory card.)

- If you want to share pictures with lots of family and friends (all your wedding guests, say), then placing them in an online album is much faster than sending individual emails, and doesn't require you to buy space on a Web server or learn any fancy Web site design software. Uploading photos is no harder than filling out a simple Web form or using Windows XP. (Chapter 14 has full details on *how* to actually go ahead and share your photos once you've finished posting them online.)

- If you're hard drive's getting full, then you can use an online site as temporary backup storage. (But you shouldn't *rely* on it as your only backup. See the box on page 135 for more details.)

Now that you're dying to get your shots up on the Web, the next step is choosing the best site for your needs. Read on.

NOTE Organizing your photos online isn't a *substitute* for properly organizing them on your PC. Think of it as an extension of the photo library on your computer, and see Chapter 5 for some good organizational pointers.

Choosing an Online Photo Service

EasyShare Gallery, Flickr, Shutterfly, and Snapfish are the four most popular online photo sites. This chapter covers all four in detail. Each lets you upload photos by creating a free user account. To help you get your pictures online and manage your photo library, the companies provide tools, which may be standalone programs or plug-in tools that work as appendages to your Web browser. But all these services aren't created equal. There's plenty of variation in the features they offer for arranging, sorting, editing, sharing, and so on. Before choosing one, read this section to get an idea of the pros and cons of each service. Then hit the Web and take a couple for a test drive.

TIP For a nutshell comparison of each service's features, see Table 6-1.

• **EasyShare, page 132** (*www.kodakgallery.com*). As discussed in Chapter 5, Kodak EasyShare is a standalone program that runs on your computer; with it, you can organize, touch up, email, and print your photos. Kodak EasyShare Gallery is a companion Web site that lets you share some or all of these pictures online. You can also mail regular rolls of film to Kodak for developing and then have them added as digital photos to your Gallery.

Taken together, the EasyShare software and EasyShare Gallery Web site offer a more complete digital photography package than any other service in this chapter. You can use EasyShare on your computer to organize your photo library better than you can with Windows alone, edit your photos without shelling out for a separate image-editing program, and then use your photos online without leaving your familiar EasyShare world. If you're already using EasyShare on your PC, then this one's a no-brainer.

NOTE Although the two EasyShares work together seamlessly, you don't have to use both. You can upload photos to EasyShare Gallery without using the desktop program. And if you use Easy-Share on your PC, then there's no problem using a different service to put your photos online.

• **Flickr, page 152** (*www.flickr.com*). Part of Yahoo's ever-growing family of online programs, Flickr is a Web site that lets you store, organize, and share your photos (Figure 6-1).

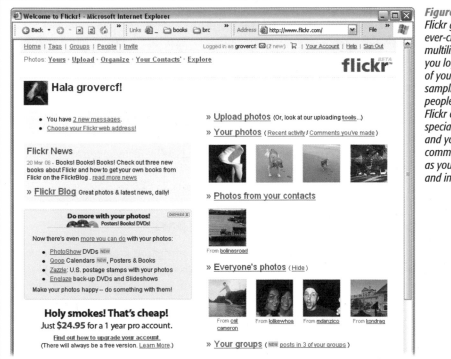

Figure 6-1:
Flickr greets you with an ever-changing, multilingual hello. When you login, you see some of your photos and a sampling of other people's photos. Life on Flickr centers around special interest groups and you'll find a community atmosphere as you share your photos and interests with others.

The site's big emphasis is on sharing photos online with others who share common interests. In some cases, photography is the interest, and you'll get comments on the quality of your photos from other Flickr members. In other cases, the theme may be something like Porsche cars, and you'll get comments on the quality of your Porsche. Flickr does offer to sell you prints, but this feature isn't quite as prominent as it is on other sites. Flickr's great for folks who eat, breathe, and sleep online and who love the idea of interacting with fellow photo enthusiasts.

• **Shutterfly, page 140** (*www.shutterfly.com*). Shutterfly is an online photo service that lets you store, share, and print your digital photos. It gives you a clean, simple window to work in, and your pals can checkout your online photo albums and order prints for themselves, too. Shutterfly does provide some tools for sharing and making basic fixes, but the editing tools aren't as comprehensive as EasyShare's. Shutterfly also offers a downloadable companion program, which makes it easier to upload photos from your PC to the Web, but unlike EasyShare, it doesn't let you create folders or albums on your computer (essential for organizing large collections). Photos need to be in the JPEG file format (page 15) for Shutterfly. Like EasyShare, Shutterfly processes and posts online 35mm and APS film. If you're interested in using your photos in DVD slideshows, photo books, greeting cards, and the like, then you'll find Shutterfly's online store absolutely inspiring.

• **Snapfish, page 148** (*www.snapfish.com*). Like Shutterfly, Hewlett-Packard's Snapfish provides a range of digital photo printing and sharing services. Snapfish also welcomes your 35mm or APS film and develops, scans, and uploads the images to your online albums. Snapfish doesn't offer a standalone program to assist with uploading. Instead, you must do everything in your browser window, while connected to the Internet. Snapfish gives you some very basic photo-fixing tools such as auto color correction and red eye removal. For organizing and sharing your photos, Snapfish is faster and more straightforward than Shutterfly (Figure 6-2). It also offers handy instruction screens for most of its features, so it's a good choice if you just want to print and share your photos without spending lots of time learning online frills. Aspiring photo jockies take note: Snapfish works only with JPEG digital photos, which means you can't use photos if they're in the RAW format (page 15).

Getting Photos Online with EasyShare

Kodak EasyShare gives you two ways to put your photos online. If you use the EasyShare software to organize your photo collection on your PC (as discussed in the previous chapter) then you can upload your pictures from the same window without missing a beat (Figure 6-3). Then, there's EasyShare Gallery (*www.kodakgallery.com*), the online component. This site lets you upload photos using any Web browser, which is great when you're on the road or have your browser window open anyway. (See "Uploading Photos with Your Web Browser" on page 134.)

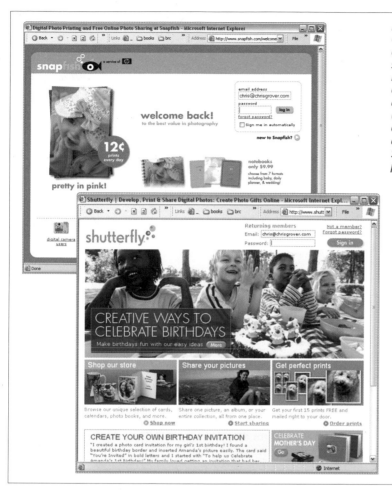

Figure 6-2:
*Online photo-service companies
compete with each other, so it's not
surprising to find many similarities.
For Shutterfly, and Snapfish, the
emphasis is on selling photo prints
and other related merchandise.
(Prices are likely to vary as
companies compete with one
another, but as of this writing,
Snapfish offered the lowest print
prices.)*

Uploading from the EasyShare Program

If you've been organizing photos on your PC using Kodak EasyShare, then upload-
ing them to the Gallery is a snap. If your photos are still in your camera, memory
card, or CD, then see page 105 for instructions on adding them to EasyShare. To
post those masterpieces online, launch EasyShare, and then follow these steps:

1. **At the left side of the window, click the "My Collection" tab.**

 You see your albums listed on the left side, and the main portion of your screen
 is filled with either albums or photos. (If you don't see your albums, then click
 the triangle next to My Albums to expand the list.)

2. **Choose the photo(s) you want to upload.**

 To upload an entire album, in the left pane, simply click the album and go to
 step 3.

Figure 6-3:
The EasyShare PC software is seamlessly integrated with its online counterpart, EasyShare Gallery. Just add photos to the Task tray and click the Express Upload button and, presto, your pictures get beamed online. The Gallery also offers features for sharing photos with friends (page 304) and a few easy photo fixes like cropping and red eye removal (page 197).

To upload individual photos, in the main panel, click an album to open it, and then click to select photos as described on page 137. Selected photos appear in the Task tray at right.

To upload photos from more than one album, you can *hold* photos in the Task tray, so they'll stay in the upload queue while you click another album to select more. At the top of the tray, click the leftmost button to put selected photos on hold (green checkmarks appear in the thumbnails' lower-right corner). To take a photo off hold, select it and click the middle button. The right button removes the hold on *all* of the pictures in the Task tray.

3. **At the top right of the window, click the Express Upload button.**

EasyShare opens a dialog box where you can enter a description for the album or photos you're uploading.

4. **Click OK.**

The description box closes and a new box appears to help you monitor the upload. Be patient. If you have several large files, then uploading may take a while. When the upload is finished, you're invited to view your photos in the Gallery.

Uploading Photos with Your Web Browser

You can upload pictures to your EasyShare Gallery using any Windows XP Web browser, like Internet Explorer or Mozilla Firefox. The beauty of this method is that you can upload the photos on your camera or memory card using a friend's laptop or a hotel computer that doesn't have the EasyShare standalone program installed. All you need is an Internet connection and a way to connect your camera or memory card to the computer.

WORD TO THE WISE

Be Cautious Relying on Online Storage

If you have a large photo library, you may be tempted to use a service such as EasyShare or Snapfish as your primary backup to store and protect your photos. After all, these are big companies with secure Internet servers. Storing your photos would free up a lot of space on your computer, and you wouldn't have to invest in CDs or DVDs. Although there's nothing wrong with using online storage as part of your strategy, there are good reasons *not* to rely on it as your only backup tool.

For one thing, Internet companies come and go, even when they're divisions of big corporations. They could disappear tomorrow—and so could your photos. In addition, make sure you understand the company's policies on inactive accounts, image resolution, downloading, and so on. Many of these companies require you to make purchases or log in at regular intervals, or they consider your account inactive and remove your photos.

Finally, some sites change the resolution of your photos when you upload, so the digital file they store may not be your best quality replacement. And you may have to *pay* to get your photos back (in the form of archive CDs and prints). Here's how the various services compare:

- **EasyShare.** Photos are saved at the original resolution. An archive CD costs about $10 for 50 images. You need to make a purchase every 12 months to keep your account active.

- **Flickr.** With the free account, photos must be less than 5 megabytes in size; Flickr sometimes resizes photos when uploading. You can download your images for free.

- **Shutterfly.** An archive CD with 50 images costs about $10. Shutterfly doesn't require any purchases to keep your account active.

- **Snapfish.** An archive CD with 50 images costs about $10. A single high-resolution image currently costs $.49, and the per-photo cost goes down with quantity. Downloads are available. To keep your Snapfish account active, you need to make a purchase every 12 months.

To truly preserve your memories, you should keep complete copies of your photo library in different places and on different types of media (CD, DVD, and hard-drive are currently the best choices). See the next chapter for full details on creating a reliable photo backup system for yourself.

Table 6-1. Online photo-storage and sharing services compared

	EasyShare	Shutterfly	Snapfish	Flickr
Standalone PC-based program	Available but not required	Available but not required	No	Available but not required
Drag and Drop Upload	Yes	Yes	No	Yes
Upload photos by email	No	No	Yes	Yes
Create photo albums	Yes	Yes	Yes	Limited
Process & upload roll film	Yes	Yes	Yes	No
Price single 4×6 print	$.15	$.19	$.12	$.15

To use EasyShare Gallery, you need to set up an online account. Surf to *www. kodakgallery.com*. On the main page's upper-left, click the Get Started button. When the Welcome screen appears, type your name, email address, and password, turn on the checkbox to agree to the Terms of Service, and then click the Join Now button.

> **NOTE** The first time you upload photos with your browser, the EasyShare Gallery may advise you that you need to install an ActiveX browser plug-in. Click Install to accept this chunk of helper software. You need to install the plug-in only once for each computer that you use for sending photos. If you can't install the plug-in (like when you're on a public computer), then you have to settle for uploading photos one at a time.

Here's how to upload photos to your EasyShare Gallery using a Web browser.

1. **Sign into your EasyShare account. When the Gallery opens, click the Upload Photos tab.**

 A new page appears where you can create a new album (or choose to add your photos to an existing album if you already created an album).

2. **To create a new album for your upload, enter a title, date, and description, and then click Continue.**

 If you want to upload to an existing album, then click the "add photos to an existing album" link. The next page displays your albums; click one.

 After you've chosen an album, you see a window with a large box (see Figure 6-4). The top of the box initially reads: No photos selected. This Easy Upload box is the target where you'll drag your photos.

3. **In Windows, open the folder, camera, or memory card that contains your photos in its own window. Position this window and your browser window so you have a clear dragging path.**

 See the box on page 137 for window-management tips.

 > **TIP** If dragging ain't your thing, then click the "choose photos" button at upper-right to select photos using a plain old Open file dialog box.

4. **Drag photos over to the target box in your browser.**

 As you add photos, you see their thumbnails in the drop box. A link beneath each thumbnail gives you the option to remove the photo if you change your mind.

5. **When you're done adding pictures, click the Start Upload button.**

 You see the upload progress for each photo, and the Gallery estimates the amount of time it will take to complete the process. When the upload is complete, your browser takes you to the Gallery where you see a message verifying that you've uploaded pictures.

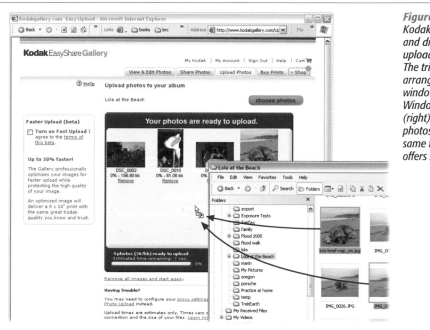

Figure 6-4:
Kodak provides a handy drag and drop tool to help you upload pictures to the Gallery. The trickiest part may be arranging your Web browser window (left) and your Windows Explorer window (right) so you can see your photos and the target at the same time. The box below offers some tips.

UP TO SPEED

Arranging Two Windows for Drag and Drop

To drag photos from one window to another, you need to arrange the windows so that you can see both the photos you want to drag *and* the target destination. For example, say you've got some photos in your My Pictures folder, and the target is your EasyShare Gallery. Here's an easy way to set it up:

Choose Start → My Pictures to open it in a new window. Then, arrange the two windows—the My Pictures window and your browser window with the EasyShare target box (page 136)—so they overlap. You want to be able to see your photos and at least part of the target box simultaneously.

To move windows, drag the bar at the very top. If windows won't budge when you try to move them, then they're probably maximized to fill the whole screen. If that's the case, then click the window's *restore* button (the middle one, with two overlapping rectangles). After you click, you can drag the non-maximized window to a different position.

To arrange your windows just right, you may also need to resize them by dragging the lower right-hand corner or some of the other edges of your window. Your cursor changes to a double arrow when it's positioned at the edge of your window. Just drag to reshape your window.

You can also use the scroll bars in your windows to find your photos and position the target box in your browser.

Organizing Photos with EasyShare

Sooner or later, you'll want to rearrange the photos in your online albums. Perhaps you're creating a slideshow for friends to see, or maybe you're collecting otter photos for a gift calendar (it happens). You simply drag an album's photos to put them in the order you want and EasyShare uses this new arrangement for things like slideshows and photobooks.

> **TIP** To create a *new* album, you can do it when you first upload the photos, as described in the previous section. Or, to create a new album from photos already in EasyShare, make copies of the photos and then create a new album to hold them (page 106).

Arranging Your Photos in an Album

To rearrange photos, click the "View & Edit Photos" tab at the top of the window (Figure 6-5). Each of your albums look like a little stack of slides and you can see one image for each, giving you a visual hint about its contents. Click to open the album you want to work with. In the main part of the window, you see thumbnails of the album's photos. Above the thumbnails, click the "Edit Details & Rearrange" link.

Figure 6-5:
Once you're on the Edit Details & Rearrange page, you can simply drag your photos around the screen until you're happy with their arrangement. When it comes to rearranging your photos online, Kodak Gallery is the easiest Web-based service to use.

Now you can drag your photos around the screen to change their order. You see a highlight around an image when your cursor is over it. After you've organized to your heart's content, click Save.

Copying and Moving Photos Between Albums

Technically, EasyShare Gallery doesn't have a command to *move* a photo from one album to another, so you have to do it in two stages. First, copy the photo to a new album, and then, if you so desire, go back and delete the original.

Here's a step-by-step description of the process.

1. **At the top of the Gallery window click the "View & Edit Photos" tab.**

 The next page displays the albums in your Gallery. If you have more than a dozen albums, then there may be more than one page. (Numbered links at the bottom take you to other pages.)

2. **Click to open the album you want to organize.**

 In the upper left, under Album Activities, are three options: Buy Prints, Share Album, and Copy Photos.

3. **Click Copy Photos (Figure 6-6).**

 A new page opens, with a checkbox below each of your thumbnails.

Figure 6-6:
Click to select the photos you want to copy and a check mark appears in the box below the picture. (Photos with the heart below mean you've tagged them as favorites.) After you've made your selection, choose an album from the Select Destination drop-down menu, or create a new one.

4. **Turn on the checkboxes to select the photos you want to copy.**

 If you want to deselect a photo, then click it again to remove the checkmark.

5. **From the drop-down list at right, choose the album where you want to send the photos.**

 If you want to create a new album, then click the link ("create a new one") above the drop-down list.

6. **Click the Copy Photos button.**

 After copying the photos, EasyShare Gallery displays the destination album with its new contents.

Deleting Photos from Your Albums

Deleting photos is a necessary, if tedious, part of photo organization. For example, if you've copied a photo to another folder, then you may no longer need it in the original location. Or maybe you shouldn't have uploaded the photo in the first place.

In any case, here's how to banish a photo from your EasyShare Gallery:

1. **On the "View & Edit Photos" page, choose the album you want to organize.**

 The next page reveals the album's contents (Figure 6-7).

2. **Click the photo you want to delete.**

 A full-size version of the photo opens on a new page.

3. **Below the photo, click the Options button. On the drop-down menu that opens, click Delete Photo.**

 A box pops up to make sure you want to delete the photo. Click Yes to send it to the great bit bucket in the sky.

Getting Photos Online with Shutterfly

Shutterfly is an online photo service that lets you store, share, and print your digital snapshots. Shutterfly gives you three ways to upload pictures. You can transfer photos one-by-one using your Web browser. With the help of a browser plug-in, known as the Picture Upload Assistant, you can upload several photos at once. Shutterfly also provides a standalone utility program called Shutterfly Express, which you can use to perform minor edits and then upload photos with a few clicks.

> **NOTE** At this writing, Shutterfly was testing out a new program—currently saddled with the ungainly name "Shutterfly Photo Organization Client"—that will eventually replace Shutterfly Express. The new program will be a full-fledged, PC-based image editor and photo organizer.

To get started, go to *www.shutterfly.com* and sign up for a free account.

Figure 6-7:
*Open your Gallery albums and you
can organize your photos. Below
each image is a drop-down menu
providing several options, including
Delete Photo. On the left side of the
screen, under the Edit Album
heading, are commands for deleting
photos and deleting entire albums.*

Uploading Photos with Your Browser

Once you've created your account, the Web-based uploading method is pretty straightforward:

1. **On the Shutterfly Welcome page, click the "Add pictures" button.**

 In Shutterfly, all photos must be in an album, so the next screen offers you a nice big New Album button. (If you don't see this button, then click the My Shutterfly link at top to return to the main page. And then click the "Add pictures" tab.)

2. **Type an album name and then click Next.**

 The first time you upload, Shutterfly shows you a page describing the Picture Upload Assistant and offers to install it. This plug-in lets you upload more than one picture at a time, so you'll probably want to go ahead and click Install. (To skip the installer, click "add pictures one by one.")

 NOTE If you've lowered your browser's security settings, the plug-in installs itself without asking your permission.

3. **When the Select pictures screen appears, click "Choose pictures."**

 If you've installed the Picture Upload Assistant, you'll see the Choose Pictures screen shown in Figure 6-8.

back up open view mode

Current Folder:
abstracts

Shortcuts

Recent Folders

My Pictures

My Documents

My Computer

Desktop

Click on the check-boxes of all the pictures you want to add. Then click "Add Selected Pictures."

□ bamboo shade 06 ☑ bamboo-shad... □ bamboo-shad... ☑ calla-lily-crop...

□ reb-brick-win... ☑ table-and-cha... □ white-arches-...

Select: all | none Cancel Add selected pictures

Figure 6-8:
If you've installed Shutterfly's Picture Upload Assistant, there's no limit to the number of photos you can upload at once. In the Choose Pictures window you see all the photos stored inside whichever folder you've browsed to; turn on the checkboxes (at lower left in each thumbnail) to select individual photos, or click the "all" link at the bottom of the screen to grab everything in the folder.

NOTE If you haven't installed the plug-in, then you instead see a list of ten blank text boxes. Click the Browse button next to the first text box. When the Windows "Choose file" dialog box opens, choose a photo file on your PC (or camera, or memory card), and then click Open. Lather, rinse, repeat until you've added all the pictures you want. Click "Add now" to upload them when you're ready. This method is so slow and tedious, you'll probably use it only on public or shared computers where you're not *allowed* to install plug-ins.

4. **Use the Shortcut buttons on the left or the drop-down menu at top to navigate to the folder that holds your Shutterfly-bound photos.**

 The main area in the box displays thumbnails of the folder's contents.

5. **Select the photos you want to upload by clicking their thumbnail or checkbox.**

 Selected photos show a check in the box next to the image.

6. **After you've made your selection, click "Add selected pictures."**

 When you click upload, a progress box shows you details on the process (Figure 6-9). It can take a while if you're uploading several large files.

Uploading Photos with Shutterfly Express

To use all of Shutterfly's organizing features on your PC—for example, when you're out on safari and not connected to the Internet—you'll need to download and install the free Shutterfly Express program. You can then transfer photos from your digital camera, do some quick-fix editing, and choose which ones you want to print or share online. Then when you get back home or to your hotel, you can upload your finished work to Shutterfly all at once.

To get the software, visit *www.shutterfly.com/downloads* (or click any "FREE software" link you see onscreen). Follow the instructions on the download page, and then go to your desktop and double-click the installer icon (ShutterflyExpress30. exe, for example).

Before using Shutterfly Express for the first time, you must click your way through a setup wizard. The first few screens are pretty standard, but pay attention when you get to the File Associations screen. The wizard is asking whether you want Shutterfly Express to launch automatically whenever you open a JPEG file (page 15) or connect your digital camera or card reader to your PC. You can undo these settings in Windows later, but if you're just trying out Shutterfly Express, then turn these options off to prevent the program from shoving aside any other programs you might use to handle these kinds of image files. Click Finish to close the wizard and complete installation.

3. **Even when you don't want to import all of the shots into Shutterfly Express, click "Get these pictures."**

Back in the main Shutterfly Express window, the folder's (or camera's) contents appear in the left pane. *Now* you get to choose which photos you want to upload.

4. **Turn on the checkboxes for the shots you want to upload. If you're connected to the Internet, then click Upload.**

The Upload Wizard window appears, asking you to sign into your Shutterfly account. Once you've typed your email address and password, you see a "Choose an album" screen that looks a lot like the one on Shutterfly's Web site.

5. **Choose one of the albums you've created previously, or make a new one now. Then click Next.**

The Upload Wizard sends the shots to your online album. When you want to upload more pictures, click Finish to close the wizard window and return to Shutterfly Express.

Navigating Shutterfly's Online Tools

Once you've uploaded your photos, finding your way around Shutterfly is easy. Tabs at the top of the page divide the site into major activities (Figure 6-11):

- **Add pictures.** In Shutterfly, you have to choose an album (or create a new one) before you can add pictures. This screen lets you choose from a pop-up menu of all your existing albums, or type a new album name.

- **View & enhance.** This page displays thumbnails representing each album in your photo library. Click an album to see the photos inside. The commands at left give you quick access to all of Shutterfly's handy tools for organizing and photo editing.

- **Share online.** You can do things like add captions to your photos so your family and friends know what they're looking at, or add photos to shared albums (page 307).

- **Order prints.** Here's where you choose shots for printing, specify sizes and quantities, and submit your order (page 358). If you're eligible for any free introductory prints or special offers, then you see them on this page, too.

- **Shutterfly Store** If you dig online shopping almost as much as you love taking pictures, then hang onto your credit card. This beautifully designed site helps you transform your prized shots into DVDs complete with music and special effects, design photo greeting cards and have Shutterfly *mail* them for you, and much more (see Part 4 of this book for more details on creating special photo projects).

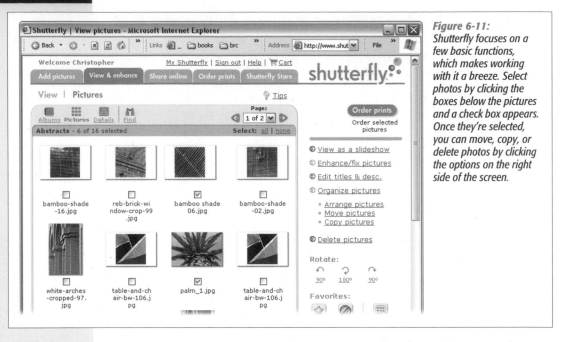

Figure 6-11:
Shutterfly focuses on a few basic functions, which makes working with it a breeze. Select photos by clicking the boxes below the pictures and a check box appears. Once they're selected, you can move, copy, or delete photos by clicking the options on the right side of the screen.

Between the main tabs and your photos are icons that change the view in the main part of the page. For example, you can see your albums, thumbnails of your photos, or details of a single photo. When you want to search for a photo, click the binoculars. The best view for organizing is the Pictures view, which shows you a collection of thumbnails.

When you're in the Pictures view, on the right side of your window, you'll see options such as "View as a slideshow" and "Enhance/fix pictures." Click "Organize pictures" and a list expands below, giving you a new set of options.

Arranging pictures in a Shutterfly album

Unlike, say, EasyShare or Snapfish, Shutterfly doesn't let you drag and drop your photos to rearrange them within an album (when you're putting them in order for a slideshow, for example). Instead, you have to place a checkmark next to the photos first, just like when you're uploading them. Here's how the picture-moving process works:

1. **On the "View & enhance" page, click an album's thumbnail to open the View Pictures screen. Click the "Organize pictures" link at right.**

 Three commands appear below: Arrange pictures, Move pictures, and Copy pictures.

2. **Click "Arrange pictures."**

 A new screen appears—alas, with no pictures on it. Shutterfly is giving you a chance to sort your photos into some kind of neat order before you start dragging them around.

3. From the "Sort all pictures by" drop-down menu at right, choose a sorting order.

You can put them in order by upload date, for example, or alphabetically by filename. If you have a lot of pictures in the album, then sorting helps you see what you have. And you may decide that one of these automatic sorts is a perfectly good sequence, and you don't have to manually rearrange them.

4. Select the photo(s) you want to move by turning on the checkbox below their thumbnail. Then, point to an area between photos to show where you want to move the selected photo(s) (Figure 6-12).

You see the word "Insert" appear between the photos. Click the word and your photos drop into place.

5. When you're finished, click Save Now to lock in your new arrangement.

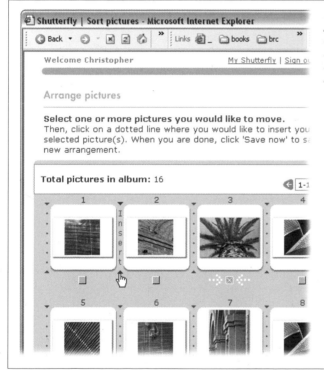

Figure 6-12:
Arranging photos in Shutterfly is a two-step operation. Select a photo by clicking the box below the image, and then point to a space in between two photos. Your selected photo squeezes in between.

Organizing Photos with Shutterfly

In Shutterfly, the procedures for moving and copying photos between albums start out the same as moving them *within* albums as described in the previous section. First, you select photos by adding a checkmark, and then choose from the list of commands at the right of the screen.

Moving, Copying, and Deleting Photos

To move or copy photos, click the "View & enhance" tab to see all your Shutterfly albums. Then follow these steps:

1. **Click the album you want to move or copy photos *from*.**

 You see thumbnails of the album's contents.

2. **Turn on the checkboxes under each shot you want to move or copy.**

 When you want to move or copy all (or most) photos in the album, click "all" at the top of the panel. Then turn *off* the checkboxes for any shots you want to leave out.

 TIP To save time when moving or copying an *entire* album, don't select anything. When you get to step 4, Shutterfly asks if you want all of the photos in the album. To answer yes, click Enter.

3. **At the left of the screen, click "Organize pictures."**

 Three commands appear below: "Arrange pictures," "Move pictures," and "Copy pictures."

4. **Click "Move pictures" or "Copy pictures."**

 The next screen asks you to choose an album (or create a new one), to move or copy the selected photos into.

 You can preview your selection at the bottom of the screen; to start over, click the Cancel button at right.

5. **Choose an existing album from the drop-down menu, or type a name for a new one. Then click Next to seal the deal.**

Deleting photos from an album

Shutterfly is nothing if not consistent. You delete photos almost exactly the same way as you move and copy them. On the "View & enhance" page, choose an album and select the photos you want to do away with (see steps 1–2 above). In the command list at right, click "Delete pictures." A message box pops up asking you to confirm the deletion. Hit Enter.

Deleting pictures in Shutterfly removes them from the Web site only, not from your computer. (Of course, it's always a good idea to *have* a backup copy on your computer or a CD.)

Getting Photos Online with Snapfish

Snapfish, a production of the folks at Hewlett-Packard, provides services for both digital and film photographers. You can upload digital photos or mail rolls of film for them to develop and upload to your online account. Either way, your photos

end up in Snapfish albums, which you can share with friends and family by sending out email invitations. HP also gives you ample opportunity to part with a few bucks by slapping your photos on prints, posters, books, calendars, and so on.

Uploading Photos with Your Browser

You upload photos to Snapfish using your Web browser. First, you need to sign up for a free account at *www.snapfish.com*. Click the Get Started button, and type your name, email address, and password. On the next screen, Snapfish asks for your mailing address so it can send you some postage-paid envelopes for mailing rolls of film for developing. Click "no thanks" at the bottom of the page to skip this step for now. You can always go back to it by clicking the "send film" or "get mailers" links scattered throughout Snapfish.

The link to the upload page is on your Home page; look below and to the right of the top tabs.

Here's how to put your photos up on Snapfish:

1. **On the Home page, click the "upload photos" link.**

 In Snapfish, all photos are stored in albums, so when you upload photos, you must specify an album to put them in. When the upload page opens, type a name in the text box under the "new album" icon to create a new album to hold your uploaded photos. (In the future, this page will display icons of all the albums you've created, so you can upload photos into an existing album.)

 NOTE The first time you upload photos, Snapfish asks you to install QuickUpload, its browser plug-in. Click Install to accept the download, and Snapfish stops bugging you about it.

2. **Click "upload to this album." Then, on the next screen, click "select photos and movies."**

 A dialog box opens that helps you find photos on your computer (Figure 6-13). The buttons on the left and the drop-down menu at top are your navigation tools.

3. **Navigate to the folder that holds the pictures you want to upload.**

 The main area in the box displays your photos.

4. **Select the photos you want to upload by clicking its thumbnail or checkbox.**

 Selected photos show a check in the box to the left of the image.

5. **After you've made your selection, click "upload selected photos."**

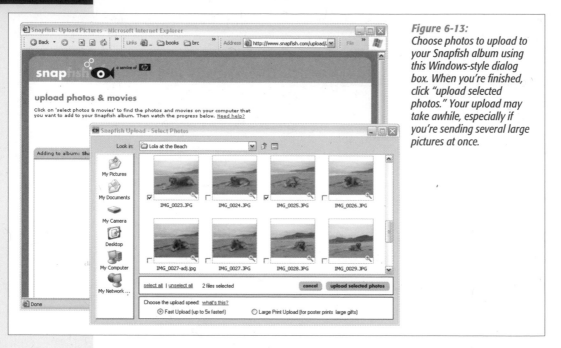

Figure 6-13:
Choose photos to upload to your Snapfish album using this Windows-style dialog box. When you're finished, click "upload selected photos." Your upload may take awhile, especially if you're sending several large pictures at once.

Navigating Snapfish's Online Tools

Snapfish is easy to navigate. The tabs running horizontally at the top of the page divide the Web site into four main sections (Figure 6-14):

• **Home.** You see this screen first when you log in. It displays the albums you created recently, along with an abundance of offers to put your photos on something and sell them back to you. (Fortunately, the ads thin out as you move away from the Home page.)

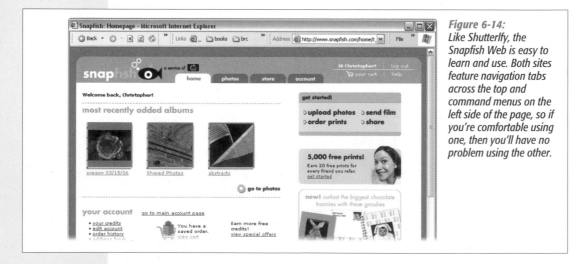

Figure 6-14:
Like Shutterlfy, the Snapfish Web is easy to learn and use. Both sites feature navigation tabs across the top and command menus on the left side of the page, so if you're comfortable using one, then you'll have no problem using the other.

- **Photos.** This page displays thumbnails representing each album in your photo library. Click an album to see the photos inside. It's the launch pad for most of your uploading, organizing, editing, and sharing (page 310).

- **Store.** Here's where you find all the options for turning your photos into merchandise, including, yes, baby blankets and diaper bags. (See Part 4 of this book.)

- **Account.** This tab lets you review past orders and tweak your delivery and credit card information. You can also create email lists so, for example, you can send baby pictures to your entire family.

Ordering photos within a Snapfish album

Rearranging the order of your photos is pretty easy, as you can see in Figure 6-15. Click a photo and drag it to a new location. An arrow appears above the little photo icon when you're in position. Release the mouse button, and the photos rearrange themselves.

Figure 6-15:
Simply drag and drop to rearrange photos in a Snapfish album. Once your album is in order, you've got the basis for a slideshow (page 364) or photo book (page 379).

Organizing Photos with Snapfish

To organize your photo albums in Snapfish, click the Photos tab at the top of the page. In the Things You Can Do box at right, click the triangle next to the words Edit & Organize. A list of options expands below the heading, including commands for moving, copying, and deleting photos.

Moving, Copying, and Deleting Photos

In Snapfish, you can either move photos from one album to another, or copy them, leaving copies in both albums. Either way, the steps are similar:

1. **In the Edit and Organize panel, click either "move photos" or "copy photos."**

 If you aren't already inside of a Snapfish album, then the first screen asks you to choose an album.

2. **Click an album's thumbnail to select it.**

 Another screen appears, showing you thumbnails of all the photos in that album.

3. **Click to turn on the checkboxes next to the photos you want to move or copy.**

 If you change your mind, then just click the checkbox again to deselect it.

4. **After you've made your selection, click Choose These Photos.**

 The final screen asks you to choose a destination for the photos you're moving or copying.

5. **As in step 2, click an album's thumbnail to place the photos there.**

 Snapfish moves or copies the photos and then shows you all the photos in the destination folder.

Deleting photos from Snapfish

As in Flickr and Shutterfly, once you upload digital pictures to Snapfish, nothing you do to them affects the photos on your PC. To delete photos, follow the steps for moving or copying, but click "delete photos" instead. A confirmation screen gives you a chance to complete the delete or back out of the deal.

Getting Photos Online with Flickr

Flickr is fairly different from the other consumer-oriented online photo sites such as Shutterfly and Snapfish. Part of Yahoo, Flickr caters to a much wider online community than just photography buffs. It's less interested in selling you prints and other items and more focused on providing a forum where visitors can share photos and other interests. For example, when you log on to the site, you see not only your *own* photos, you also see a sampling of photos that *other* Flickr members have recently uploaded. Whatever your passion—whether it's hiking, baseball, or manhole covers—you'll find plenty of folks to share photos with on Flickr.

> **NOTE** That's not to say Flickr doesn't want to sell you things. You'll get offers to print your photos or put them on postage stamps. In fact, Yahoo would love you to upgrade to a Pro account (about $25 per year), which buys you unlimited storage, ad-free browsing, and the ability to upload more than 20 megabytes of photos each month.

Perhaps because Flickr has so many different types of members submitting photos from computers, cafés, and cellphones around the world, the site gives you at least three ways to upload your pictures: using an online form in any Web browser; via email; or with a free, downloadable drag-and-drop tool called Uploadr. (Evidently Yahoo is saving money on vowels.)

Uploading Photos with Your Browser

You can upload photos to your Flickr account using only a standard-issue Web browser like Internet Explorer or Firefox (Figure 6-16). The process is quick and, provided you know how to find your photos on your computer, it's no more complicated than opening up a file in any program.

You need to sign into Flickr (*www.flickr.com*) before you can upload or work with your photos. If you have a Yahoo ID (and who doesn't?) then you can use the same user name and password. Or you can create a separate account (another Yahoo ID, actually) just for Flickr. Creating a Yahoo ID requires you to provide a screenful of personal profile information, like your birthday and zip code, but not your address or phone number. As a final step, Yahoo sends you an email with instructions for completing the sign up process.

> **TIP** The confirmation email contains a message that reads, "Click here to review your Marketing Preferences." Do it. When you get to the Yahoo Account Information page, turn *off* all the checkboxes under "Special offers and marketing communications from Yahoo!" Yahoo intends to inundate your mailbox with all the newsletters on that list unless you tell it *not* to.

Each time you sign in, Flickr's home page greets you with a multicultural welcome (see Figure 6-1). Today it's Aloha, tomorrow it might be Giorno or Hola. The left side of the window provides general info about Flickr. The right side displays some of your recent pictures and a few related pictures uploaded by other people. (Flickr makes associations between photos by the keywords—called *tags*—that members apply to them. See page 156 for more details.)

Click any of the photos to see a larger version. You also see prominent links with text such as: Your Photos, Your Groups, and Recent Activity. At the top of the list is "Upload photos."

To upload photos to Flickr with your browser:

1. **On the Flickr home page, click "Upload photos."**

 The next screen shows you a list of six blank text boxes, each with a Browse button next to it.

2. **Click the first Browse button. When the "Choose file" box opens (Figure 6-16), select a photo file, and then click Open.**

 The filename appears in the first text box. Continue until you've got all the shots you want to upload (or you've filled up all six boxes).

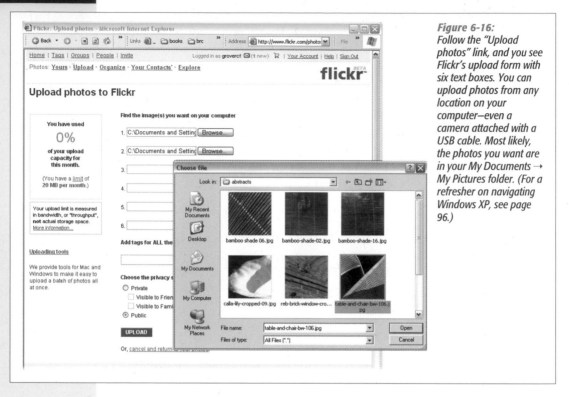

Figure 6-16:
Follow the "Upload photos" link, and you see Flickr's upload form with six text boxes. You can upload photos from any location on your computer—even a camera attached with a USB cable. Most likely, the photos you want are in your My Documents → My Pictures folder. (For a refresher on navigating Windows XP, see page 96.)

3. In the text box below the file names, assign tags to help you find and sort the photos later, if you wish.

 You can click the question mark next to "Add tags for ALL these images" to read a brief explanation of how Flickr's tags work.

4. Select the Private radio button if you want Flickr to reveal these photos only to members you've designated as Friends or Family.

 When you don't select Private, Flickr automatically selects Public, meaning that anyone who signs into Flickr can view your photos. For example, a visitor may stumble upon them if he searches for any tags that happen to match yours.

5. Click Upload.

 Flicker uploads your photos, and then on the next screen, gives you a chance to type a title, description, and, again, tags for each.

6. Fill in the text boxes (you don't have to), and then click Save.

 The "Your photos" page displays an image of each photo you've uploaded, plus any description, tags, and other settings. You can click the picture to change this information, and view a full-size image, at any time.

You can click Upload at the top of page to add more photos. Or, if you have better things to do than select photos one by one, then try Flickr Uploadr, described next.

Installing and Using Flickr Uploadr

If you want to upload dozens of photos at a time, then you probably feel constrained by the upload form's limit of six photos. In that case, Uploadr is the tool for you. With Uploadr you can send many photos at a time to Flickr using Windows XP and a handy drag-and-drop tool.

To install Uploadr, go to *www.flickr.com/tools*, and then download the Windows XP installer program. You need to make two decisions during the installation: whether to place a shortcut to the program on your desktop and whether to add a "Send to Flickr" command to your right-click menu. The shortcut question is simply a matter of taste—your desktop may already be too cluttered with shortcut icons. The right-click menu, though, is a real timesaver. Leave this option turned on, and you can send any photo to Flickr just by clicking on it.

With Uploadr installed, you have two great ways to send photos to your Flickr online library:

- **Send photos with Windows' right-click menu.** Right-click a photo file and choose Send to Flickr from the shortcut menu. Uploadr adds the photo to its list of files-waiting-to-be-uploaded. You can continue to add photos to Uploadr, and then send them all at once by clicking the Upload button.

- **Send photos with Uploadr's drag-and-drop tool.** You can also drag and drop photo files into Uploadr's window to add them to the queue. (Dragging and dropping into Uploadr works exactly as in any Windows window. See the box on page 137 for more advice.)

Emailing Photos to Flickr

As if the Web form, Uploadr tool, and right-click menu command weren't enough, Flickr lets you email photos to your library, too. To get your special Flickr email address, go to *www.flickr.com/tools*, and then click the "Upload by email" link at upper-right. The odd-looking email address you see on the next screen is your dedicated address for uploading photos by email. (It probably consists of a combination of words and numbers and ends in *@photos.flickr.com.*)

On the left side of the "Uploading by email" page is a link that reads, "We can also send you an email to add this address to your address book…." Unless you relish the idea of memorizing your cryptic upload address, click this link. When Flickr's email arrives, add the sender to your address book. In Outlook, for example, right-click the Sender's address and choose Add to Contacts from the shortcut menu. From then on, you can upload photos simply by typing *Flickr* in the "To:" field of a new email message. Enter a title for your photos in the subject line, and, if you wish, type a description for the photos into the body of the email.

> **TIP** Email is often the easiest way to send photos to Flickr when you're traveling. If you didn't make note of the Flickr address before you left, then you can have Flickr assign you a new one. Go back to the "Uploading by email" page, and click the Reset button. Flickr gives you a new email address you can use right away.

Organizing Photos with Flickr

You've uploaded your photos to Flickr and now its time to get organized. On your Flickr home page (*www.flickr.com*), you see a few of your photos and others under the heading: "Everyone's photos." In the upper-left corner are some links to other pages:

• **Home.** Flickr's home page is a no-nonsense, bare bones screen with big, clear links to the pages where the real business takes place: uploading photos, and viewing photos (yours or everyone else's). When Flickr has any news or announcements to tell you about, you'll read it here first.

• **Tags.** In Flickr, these keywords or phrases are your primary tool for both organizing and searching for photos. But they're much more than that. In Flickr's lively online community, tags are a basic unit of currency. Most members add several tags to each photo they upload, hoping to see and be seen by folks all over the world with similar interests. On the Tags page, Flickr displays current lists of the most popular tags for the past 24 hours, past week, and all-time favorite tags.

• **Groups, People, Invite.** These pages connect you to Flickr groups, your friends, and your family for sharing your photos (see page 311). The invite page makes it easy to lure your pals to Flickr; fill out a simple form and Flickr sends them an email.

The next line down shows more links, including "Photos: Yours". Clicking it transports you to your personal page, where you organize your Flickr photos. Your photos are shown in the center running one at a time down the page (Figure 6-17). In Flickr, your entire collection of photos is called your photo *stream*.

On the "Your photos" page, you see thumbnails and information about each image. Click any photo to see a larger version. A button indicates whether the photo is private or public. You can change this setting by clicking on the button. If your photo is public, then you may see that it's received a number of comments. To see the comments, click the link.

On the right side of the page are links that let you upload photos, create photo *sets* (Flickr's version of the "album" feature in most programs), and edit your Flickr profile. Once you create sets (as described in the next section), you see them listed at left.

Creating a New Photo Set

Flickr has its own unique nomenclature (in addition to an aversion to E's). While other services store your photos in albums, Flickr stores them in *photo sets*. When you add photos to a special interest group, you're adding photos to the pool (see page 315). In any case, you can rearrange your photos within a set. If you're using the set for a slideshow, for example, then they'll be in sequence.

Flickr has a few ways to create a new set. Here's the quickest: On the "Your photos" page, click a photo that'll go into your new set. Above the large image, click

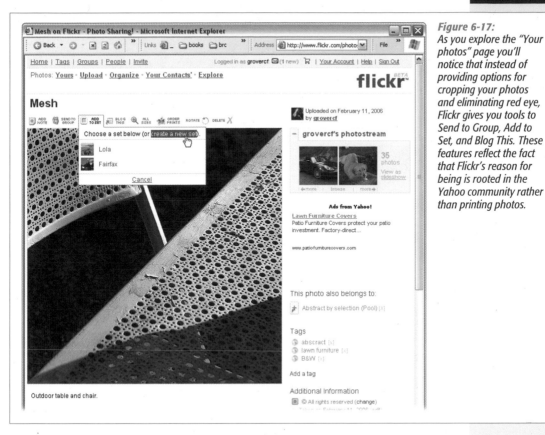

"Add to Set" (Figure 6-17). When the drop-down menu appears, click "create a new set." This same menu is also a great way to add photos to existing sets, since it lists them all.

Browsing and Searching Your Photos by Tag

Photo sets are great if you're accustomed to organizing photos into albums in programs like EasyShare, but when you get in the habit of tagging all your Flickr photos, you can pull up exactly the photos you want to see onscreen even more quickly (and you don't have to pay Flickr for the privilege of creating more than three photo sets). For example, you can add the tags "xmas" and "party" to a photo, and the photo shows up with all your Christmas shots and all your party shots. Or, you can pull up only the shots that are specifically from Christmas parties (and not birthday parties).

Tags are easy to implement and maintain. Here are the basics:

- To add a tag to a photo, go to the "Your photos" page and click the photo. When the photo is open in its own window, click "Add a tag" (to the right of the picture). A little text box pops up, where you can type as many tags as you like, with a space between each. Or click "Choose from your tags" (just below

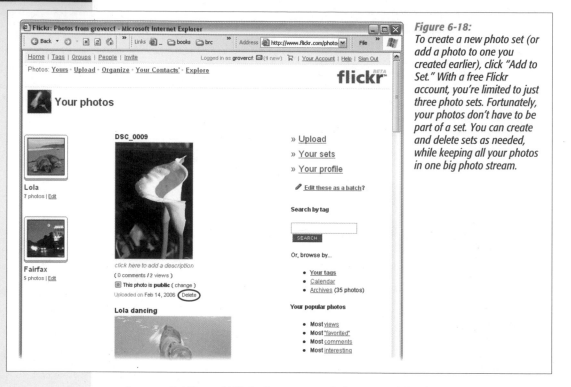

Figure 6-18:
To create a new photo set (or add a photo to one you created earlier), click "Add to Set." With a free Flickr account, you're limited to just three photo sets. Fortunately, your photos don't have to be part of a set. You can create and delete sets as needed, while keeping all your photos in one big photo stream.

the text field), and Flickr lists your existing tags right there onscreen. Click to add them to the displayed photo.

TIP You can also add tags to photos as you upload them to Flickr; see page 156.

• To hunt down photos by their tags, type keywords in the "Search by tag" field (on the "Your photos" page, for example). You can also use the search feature in Flickr Organizr (page 159).

• You can also see all your photos listed by tag instead of by searching. Under the "Search by tag" field, you see the words "Or, browse by…"; click "Your tags." The next page lists all your tags, in descending order of popularity. The big, bold words are tags you (or your Flickr pals) have visited the most often. Click a tag to see its photos onscreen.

• To remove a tag from a photo, open the photo in its own window and click "Edit title, description, and tags." You can then edit right in the Tags text field.

• If you later want to rename or delete a tag from your list (change "bestfriend" to "ratfink," for example), then look under "Manage your tags" (on the "Your tags" page, at right).

Deleting Photos from Flickr

To delete photos, go to the "Your photos" page (Figure 6-17). Click the Delete link beneath the unloved image, and Flickr shows a box asking, "Are you sure?" If the answer is yes, then click OK. The photo completely disappears from Flickr. It's no longer available to any of the photo sets or groups you added it to.

Flickr's Organizr

The Organizr gives you a different Web-based view of your Flickr photo collection. You still use your Web browser to work with your photos, but Organizr gives you one big advantage—it puts all your tools in one convenient window (Figure 6-19). When you're traveling, Organizr makes your browser window act more like the photo organizing program you use at home.

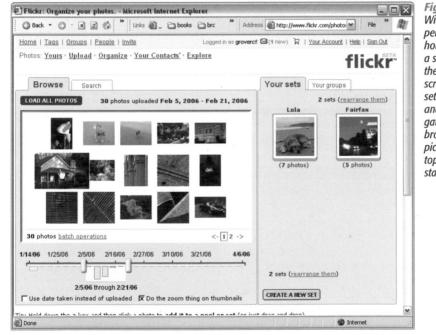

Figure 6-19:
With Organizr, you can perform many Flickr housekeeping chores on a single screen. Tabs on the right side of the screen give you access to sets (your collections) and groups (topic-based gatherings where you browse through others' pictures). The links at the top return you to Flickr's standard Web pages.

To open the Organizr window, go to *www.flickr.com/photos/organize*, or click the Organize link at the top of any Flickr page.

Here's a tour of Organizr's tabs:

- **Browse.** This panel looks reassuringly familiar if you've used Windows' Thumbnails view or a program like, say, Picasa. It shows you thumbnail (miniature) versions of all the photos in your stream (page 156), that you can drag to rearrange.

The timeline at the panel's bottom is the most interesting feature. By dragging the slider, you can limit the date range that Organizr shows you at a time, which comes in handy as your Flickr collection swells. You can organize your photo window by the date you took the photos, or the date you uploaded them. If there's more than one page worth of thumbnails in that range, then click the arrows and page numbers (1, 2, and so on) at lower right.

- **Search.** Clicking this tab reveals a panel where you can find photos by the tags you've applied to them *or* by any words you've typed in the photo's title or description. To have Organizr look for words, type them in the text box at the top of the panel, and then click Search. Any tags you've created appear below the text box. Turn on the checkboxes next to the tags you're interested in, and then click the lower Search button. Organizr displays thumbnails of the search results in the middle of the screen.

- **Your sets.** This panel displays thumbnails of your Flickr sets. You can drag to rearrange them, edit their names, and so on. Click a set's thumbnail to reveal its contents in the Browse panel.

NOTE When you have a Flickr Pro account, Organizr is the easiest way to organize all the new sets you can create. Just click the Create a New Set button at the bottom of the "Your sets" panel.

- **Your groups.** This panel displays a list of any Flickr groups you've created or joined (page 315).

NOTE Organizr operates using Flash, which is the most popular technology for displaying animated graphics on the Web. Most browser programs come equipped to show Flash graphics, but if you need to download or update yours, then go to *www.macromedia.com/downloads*.

Backing Up Your Photo Library

If you ever see a photographer running from a burning building, chances are her arms are full of photos. After all, most photos are literally irreplaceable; it's impossible to go back to that place and time and capture that image. One of the dangers of digital photography is that your shots are vulnerable to accidental deletion, hard drive crashes, and other electronic snafus. But every cloud has a silver lining and in this case it's that digital pictures are very easy to copy. You can make unlimited copies, in fact, and each one's a picture-perfect, exact duplicate of the original. There's no excuse for not having a foolproof backup plan and following it faithfully. That's what this chapter is all about.

Although you can manually copy photo files using Windows XP, it's generally much, much easier to recruit some help from a program like Picasa or EasyShare and use its built-in backup feature. This chapter also has advice on when to back up and an overview of backup media options like CDs, DVDs, and hard drives.

> **TIP** If you own Photoshop Elements, you've got a superior backup tool right in the program's Organizer. Peruse the first part of this chapter for general backup strategies and then skip to page 185 to learn the simple procedure for backing up your photos from within Elements.

Strategies to Protect Your Photos

Photos from your digital camera may not fade, crumble, or turn yellow like your grandfather's old prints, but they're vulnerable in a different kind of way. Digital photo files are nothing more than a series of 0s and 1s stored in a particular order. They only last as long as whatever media they're stored on, and CDs, DVDs, and

hard drives are just chunks of plastic and metal that are vulnerable to water, fire, accidental erasure, and breakage. Scared yet? Good.

Here's rule number one for digital photo backups: More is better. For safety's sake, back up all of your photos in *more* than one place. That way, when a CD breaks, a hard drive crashes, or your laptop is stolen, you've got another copy of your photo library stashed somewhere safe. See the box on page 166 for advice on multiple backup options.

No matter which backup methods you use, consider these general guidelines:

- **Establish a backup routine.** Backing up your photos should be a habit, something you do reflexively. Following the same procedure every time you back up photos prevents mistakes like writing over existing photos or forgetting where you stored something. If you use an electronic datebook like Outlook, consider adding an automatically repeating reminder so that you remember to backup your photos, say, once a month.

- **The best routine is one that you'll stick with.** You can design a bullet-proof backup system, but it won't do you any good if it's so complicated and time-consuming that you dread doing it. For most mere mortals, the best backup routine is quick, easy, and relatively painless.

- **Protect your *original* digital images.** Make backups of your images *before* you make any changes. Before cropping. Before color correction. Before sharpening. That means it's best to back up your photos when you first move them from your camera or memory card to your computer.

 TIP The above advice about backing up before you make changes *includes* rotating your photos in Windows XP. Don't do it. Windows XP's rotation tool tampers with the information your camera stores in the photo file—its EXIF data (page 185). Also, Windows slightly degrades a photo's quality every time it rotates the picture. Most eyes never notice the difference, but it makes professional photographers cringe. Use a proper image-editing program like Photoshop Elements, EasyShare, or Picasa when it's time to rotate.

- **Multiple storage locations give added protection.** One of the great things about digital photos is that they're easy to copy. If you're really determined to safeguard your photos, make multiple backups and store them in different places. For example, keep backups at home and at your office. Or give a backup set to your brother-in-law. That way, a disaster in one location won't destroy your only copies.

- **No media lasts forever.** CDs and DVDs wear out. Hard drives die. Paper fades. What's a photographer to do? Understand the limitations of your media and plan accordingly. Make multiple backups using different media and make sure your strategy takes into account the expected lifespan of your media (see page 163). Refresh your digital backups about every five years and make quality prints of your most important photos.

TIP If you use CDs or DVDs for backups, always check your backup discs once you've burned them. Take a moment to put the disc in your computer and make sure that all your photos are there. If there was an error, you want to know about it now, not six months from now when you may not have those photos still available someplace else.

UP TO SPEED

The More the Merrier

Pro photographers put a lot of effort into making sure they save backups of every photo they take. For the safety-obsessed, the more backups the better. Back up all of your photos in at least two of the following ways, and make sure at least one of them is somewhere other than your home—in case of flood, fire, or theft. For your favorite and special photos, add a third backup on a completely different medium, such as prints or a remote Web site (see Chapter 6 for advice on storing your photos online).

• **Another drive on your PC.** The easiest and fastest backup (read: the one you'll do most often) is to a second internal hard drive in your PC or an external hard drive that's always hooked up to it. If a photo file gets damaged or deleted, or if one hard drive dies, you can hop right over to the other drive and grab a new copy from the backup folder. External hard drives have the additional benefit of being portable, so in case of emergency you can rescue your photo library without attempting to carry your entire PC.

• **CDs or DVDs.** If your PC can burn discs, they're the next easiest backup option, and the best way to create a backup that you can store in a second location—like your office or someone else's house. (They also don't take up a whole lot of room, which "someone else" will thank you for.)

• **Another computer.** If you have more than one PC in the house, then shooting backups across a home network is another option. (See *Home Networking: The Missing Manual* if you're interested in taking on *that* weekend project.) You can also purchase space on a server (a really, really big computer) somewhere on the Internet and upload your photo backups there. This method isn't as user-friendly as the online service option mentioned below, but it's often faster (and you don't have to stare at ads while you're backing up). Type *online file storage* into your favorite search engine to see some of the leading companies in this field.

• **An online service.** As discussed in Chapter 6, Kodak, Shutterfly, Snapfish, and other companies let you store high-resolution copies of your photos on their Web sites. Online services are another quick way to create a remote backup, especially when you're on vacation, away from your own PC and backup drives. But definitely don't rely on an online archive as your only backup system; see "Be Cautious Relying on Online Storage" on page 135.

• **Make and keep prints of your photos.** Most digital photographers don't think of prints as "backups," but a good quality print is a fine way to preserve a favorite photo. You can share and enjoy them without booting up your PC, you can keep them somewhere safe like a storage locker, and you can't erase them by pressing Delete. Plus, you can always scan a print to create a new computer photo file.

CD, DVD, or Hard Drive?

What type of storage should you choose for your photo library? It's the most important question facing you when you set up your backup routine. This section covers the pros and cons for some digital media that are good for backups. See Table 7-1 for a summary and cost comparison.

> **NOTE** The storage capacity estimates in this chapter are based on digital photos about 5 MB in size, which is typical for a 5- or 6-megapixel camera. If you have an older digital camera, your photos may be smaller (and you can store more photos in less space). If you have pro equipment that exceeds 6 megapixels, your photos may take up more space.

Table 7-1. For example, CDs and DVDs offer a low cost-per-photo, but burning them is time-consuming, and they're fragile.

	Number of 5 MB Photos	Media Cost	Cost per 1,000 photos
CD-R (50 pack)	7,000 (per 50 pack)	$10.00	$1.43
DVD, single-sided (50 pack)	47,000 (per 50 pack)	$30.00	$0.64
External drive 60 gigabyte	12,000	$150.00	$12.50
External drive 120 gigabyte	24,000	$160.00	$6.67
External drive 250 gigabyte	50,000	$225.00	$4.50
External drive 500 gigabyte	100,000	$375.00	$3.75

CDs (CD-R)

A single disc is 700 megabytes and holds about 140 photos. CD-R discs are a better choice than CD-RW discs because they're cheaper and you can't accidentally erase your photos once they're saved on the disc. "RW" stands for "rewriteable," which is a geeky way of saying you can always change the contents of a CD-RW disc. In contrast, saving photos to a CD-R ("recordable") disc is a one time only deal (that's why some people call them "write-once"). Once the photos are on the disc you can't delete them, which is just what you want with a backup.

Pro: CDs are inexpensive and you can buy them at office supply or computer stores. You can copy your photos to CDs in Windows, so you won't need any special software.

Con: CDs don't hold a lot of photos, which means you have to burn more discs and need more room to store them.

Single Layer DVDs (DVD-R, DVD+R)

A single layer DVD is 4.7 gigabytes and holds about 940 photos. Use DVDs that can't be erased after you've written to them (that is, don't use any DVD whose name ends in "RW"). DVDs come in two formats: DVD-R and DVD+R. Use the type that's compatible with your PC's DVD drive.

Pro: Write-once DVDs have all the advantages of CDs and then some. They hold almost seven times as many photos as CDs and the overall cost per photo is less than CDs.

Con: Windows Explorer doesn't have an option for saving files to a DVD, so you need another program like Roxio's Easy Media Creator (*www.roxio.com*; $80) or Nero Ultra (*www.nero.com*; $80).

Dual Layer DVDs

If your PC is of a relatively recent vintage you may have a dual-layer DVD burner, which crams data into, you guessed it, two slices of the DVD.

Pro: A dual layer DVD can hold up to 8.5 GB of storage (about 1,700 photos).

Con: You'll need special dual-layer DVDs, which are the most expensive kind.

External Hard Drives

External hard drives, which plug into your PC via a USB or FireWire port, hold anywhere from 40 to 500 gigabytes. A 200 GB drive, which is fairly common, holds about 40,000 photos. Copying your photos to a hard drive is the easiest way to back up your photos.

Pro: External drives work best for several reasons. You can disconnect the drive from your computer to protect your photos. You can use the drive to move photos to another computer. You can keep the drive's power turned off, which increases its life expectancy.

Con: Hard drives have moving parts and are more fragile than other types of media. A hard drive can fail at any time. A pessimistic life expectancy for hard drives is two to five years. Hard drives are a significant expense, since they cost anywhere from around $100 for an 80 GB model to over $400 for a beefy 500 GB unit. You don't need the fastest or the biggest hard drive to back up your photos, but you do want one that's reliable.

> **TIP** Unlike write-once CDs or DVDs, the files on a hard drive can be erased or changed. To add an extra level of protection to your hard drive's backup photo files, change the file properties to *read only* so that the files can't be erased or written over. In Windows, select your photos and then choose File → Properties. In the Properties box, turn on the Read Only checkbox. You can protect multiple files or entire folders at a time; just make your selection before you open the Properties box.

Care and Handling for Your Backup CDs and DVDs

If you've ever worried about how long your backup CDs or DVDs will last, it's comforting to know that professional librarians and archivists use them to store their information. The pros have also researched how to take care of optical media. Here are some tips from the National Institute of Standards and Technology (NIST) and the Council on Library and Information Resources (CLIR). If you're dying to learn more about disc preservation strategies, check out *Care and Handling of CDs and DVDs: A Guide for Librarians and Archivists,* by Fred R. Byers (NIST Special Publication 500-252), from which most of this information is drawn:

Do:

- Handle discs by the outer edge or the center hole.

- Use a non-solvent-based felt-tip permanent marker to mark the label side of the disc.

- Store discs upright (book style) in plastic cases specified for CDs and DVDs.

- Return discs to storage cases immediately after use.

- Leave discs in their packaging (or cases) to minimize the effects of environmental changes.

- Open a recordable disc package only when you're ready to record data on that disc.

- Remove dirt, foreign material, fingerprints, smudges, and liquids by wiping with a clean cotton fabric in a straight line from the center of the disc toward the outer edge.

- Store discs in a cool, dry, dark environment in which the air is clean.

- Use CD/DVD-cleaning detergent, isopropyl alcohol, or methanol to remove stubborn dirt or material.

Don't:

- Touch the surface of the disc.

- Bend the disc.

- Use adhesive labels.

- Store discs horizontally for a long time (years).

- Expose discs to extreme heat or high humidity.

- Expose discs to extremely rapid temperature or humidity changes.

- Expose recordable discs to prolonged sunlight or other sources of ultraviolet light.

- Clean by wiping in a direction going around the disc.

And for CDs only, here's some special advice. Don't:

- Scratch the label side of the disc.

- Use a pen, pencil, or fine-tip marker to write on the disc.

- Write on the disc with markers that contain solvents.

- Try to peel off or reposition a label.

Internal Hard Drives

If your computer has two hard drives, it's good practice to keep a backup of your photos on each drive. A popular size these days is 200 GB, which holds about 40,000 photos (if you don't keep anything else on the drive).

Pro: You can simply drag and drop photos to copy them to your second drive, which jibes with the "best backup routine is the one you'll stick with" maxim. And the photos are equally easy to retrieve.

Con: Anything that happens to your PC can affect anything and everything inside it, so your second drive is in many ways no safer than your first. It's just a duplicate. For example, if your PC is stolen, you've lost both drives. A virus that infects your PC could spread to all internal drives. Also, internal drives are running any time your computer is on, so they get more wear and tear, which means they're more likely to go kaput.

EasyShare's Backup Tools

If your computer has a CD or DVD burner, EasyShare gives you the tools to burn your photos to discs. Again, the best time to back up is as soon as you download photos to your PC and get them into EasyShare albums (page 138).

> **NOTE** EasyShare doesn't make it particularly easy to back up your photos to a hard drive. Here's the short version: In the My Collection tab, select the pictures you want to back up and then choose File → Open in Explorer. A Windows Explorer folder opens up, at which point you can manually copy your photos to any drive you want, just as though you were copying any other type of file.

Backing up your photos is simply a matter of selecting the photos and burning them to a DVD or CD. In EasyShare's My Collection tab, you see three work areas in the program window: a list of folders on the left, thumbnails of your photos in the main window in the middle, and your task pane on the right. With that screen in front of you, you're ready to back up:

1. **In the folder list, click a folder that contains the photos that need backing up. Since you probably want to back up the folder's entire contents, click the Select All button at the top of the screen.**

 EasyShare adds the photos to the task pane. That's right where you want them for the backup. To select individual photos, click thumbnails in the middle panel to add them to the task pane.

2. **If you want to back up the contents of another folder, click the Hold button (the checkmark) at the top of the task pane (Figure 7-1).**

 A checkmark appears in the lower-right corner of the photos that the task pane is holding for you. If you don't hold the photos in the task bar, then EasyShare removes them when you move to a new folder.

3. **When you're done selecting photos to back up, place a CD or DVD in your burner and click the Burn CD/DVD button at the top of the window.**

 A box appears showing information about the backup (Figure 7-2). Make sure the destination drive listed is your CD or DVD drive. You can also choose the writing speed for the backup as explained in the box on page 169.

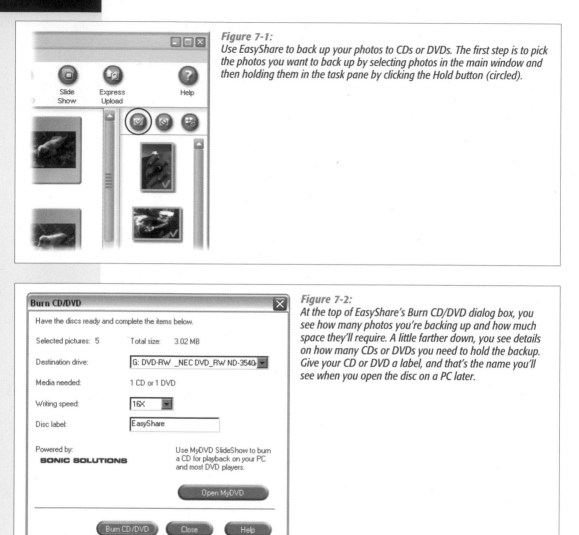

Figure 7-1:
Use EasyShare to back up your photos to CDs or DVDs. The first step is to pick the photos you want to back up by selecting photos in the main window and then holding them in the task pane by clicking the Hold button (circled).

Figure 7-2:
At the top of EasyShare's Burn CD/DVD dialog box, you see how many photos you're backing up and how much space they'll require. A little farther down, you see details on how many CDs or DVDs you need to hold the backup. Give your CD or DVD a label, and that's the name you'll see when you open the disc on a PC later.

4. **When everything's to your liking, click the Burn CD/DVD button at the bottom of the box.**

The burning begins. A progress window opens, so you can see what's going on. You'll see each image go by as EasyShare saves it to the disc.

When it's done, EasyShare checks to make sure there aren't any errors on the disc it just created (you'll see a message boasting that EasyShare is busy "verifying the media"). Finally, you see a new box that says: *Your disc has been successfully created.* You're done.

NOTE You may be done, but Kodak isn't. The company uses this opportunity to make a sales pitch, encouraging you to take your CD to a photo kiosk to make some prints. (You can learn more about printing at kiosks on page 351.)

Choosing a CD or DVD Burning Speed

Confused about which CD or DVD burning speed to use in EasyShare? As you can guess, faster speeds are more convenient because they finish the job quicker. The only problem is if the burner tries to run too fast, it may make errors copying your files. Don't worry though–EasyShare checks the files after they're burned to a CD or DVD and lets you know if there's a problem.

If you're not sure what speed to choose, try one of the slower speeds at first–8x or 16x, say. Keep an eye on the progress box when it verifies your files. If all goes well, great–you may want to try a faster speed on your next backup. Just keep an eye on the progress box as it verifies the files on your CD and make sure you see a message at the end that says: *Your disc has been successfully created*.

Picasa's Backup Tools

Picasa knows you want to protect your original photo files, and it's ready to lend a hand with backup tools that work well and are easy to use. You can use Picasa to back up photos to CDs, DVDs, or to an external hard drive.

NOTE See page 110 if you need help getting started with Picasa.

As mentioned earlier in this chapter, your safest bet is to back up your pictures right away when you move photos from your camera to your computer. So once you've got a new batch of photos on your PC, launch Picasa and then follow these steps:

1. **In Library View, choose Tools → Backup Pictures.**

 When you start Picasa's backup tool, a new panel appears at the bottom of the window. Figure 7-3 explains the two-part backup process.

2. **Under Create a Backup CD, click New Set.**

 A *backup set* keeps track of the files that you're backing up and the location where they're saved. (If you've backed up before, your sets appear on the drop-down menu; pick one of these if you want to follow a previously established backup routine; full details follow after step 5.)

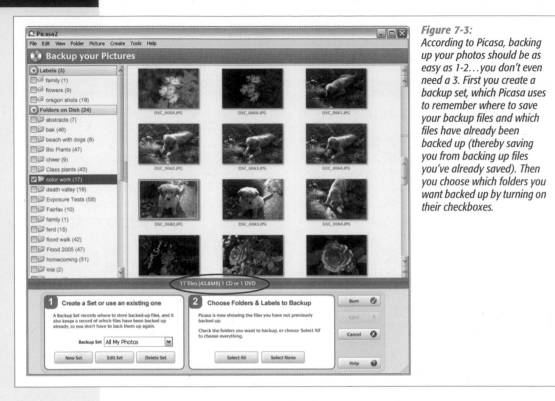

Figure 7-3:
According to Picasa, backing up your photos should be as easy as 1-2...you don't even need a 3. First you create a backup set, which Picasa uses to remember where to save your backup files and which files have already been backed up (thereby saving you from backing up files you've already saved). Then you choose which folders you want backed up by turning on their checkboxes.

3. **In the New Backup Set dialog box (Figure 7-4) give your set a name, and choose where you're backing up to.**

 For example, you can create a set that backs up all your photo files to a CD or DVD. If you're backing up to an external hard drive, choose it here instead.

 The next step is to use Picasa's folder list to select the folders that you want to back up.

4. **In the folder list on the left side of Picasa's main window, turn on checkboxes to select folders and labels for the backup set.**

 Picasa keeps track of the number of files you want backed up and it tells you how many CDs or DVDs you need to do the job (see the thin blue bar, circled, in Figure 7-3).

5. **When you're ready to start the backup, place a disc in your PC's burner and click Burn.**

 If you're backing up a lot of photos, you may need to feed your computer a few more discs. Picasa prompts you when it's necessary. You also see a pop-up progress bar that keeps you informed about the process.

Figure 7-4:
To create a backup set, you choose where to store the backup files and what type of files you want to back up. Picasa works with photo files and movie files—using the options in this box, you can limit Picasa's backup to photo files only.

Because you recorded information about the backup when you created your backup set, Picasa can be even more helpful the next time around. For example, suppose you have photos from Alex's soccer game, and you store them in a folder named "Hornets' Games." Responsible photo archivist that you are, you back up the photos to a DVD and name the backup set "Alex Soccer." Next week you get some more great shots and you add them to the Hornets' Games folder on your computer. You can use the same Picasa backup set, Alex Soccer, to back up the new photos. Picasa even remembers the photos you already backed up, so this time it burns only the *new* photos to the DVD.

Organizing and Backing Up with Elements

If you read the previous two chapters, you know how tricky it can be to cobble together your own photo organization/backup system using Windows XP and other software. But if you own Photoshop Elements—rejoice! Your life just got a little easier. In addition to a powerful image-editing program, you've got tools that make quick work of organizing and backing up your digital photo collection. You don't have to open your My Pictures folder again (unless you really want to). Elements can even help you download shots from your digital camera.

This chapter first takes you through importing photos into Elements from cameras and digital card readers using Elements' Photo Downloader component.

Next, you'll learn how to get your photos *off of* your camera and *into* Elements. From there you'll learn how to use Element's Organizer feature to find and sort your pictures. Finally, you'll get a tour of the program's easy-to-use options for backing up your photo collection to a CD/DVD or backup drive.

Importing with the Photo Downloader

Once you install Photoshop Elements, a helper program called the Photo Downloader automatically appears whenever you connect a camera or card reader—even if Elements isn't running. The Downloader window is divided into two main parts (see Figure 8-1). On the left side are the thumbnails of your photos. The little checkmarks next to each image indicate which photos the Downloader will import; just turn off the checkboxes for the ones you don't want to work with in Elements. (If you've already imported some of the images, Elements tells you so and doesn't import them again.)

On the right side of the Downloader window, you can choose where to store your picture files and control other import settings. From the drop-down menu at top, you select where you're pulling pictures from (a camera, a card reader, and so on).

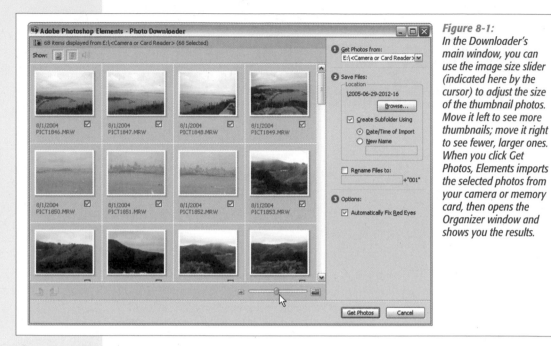

Figure 8-1:
In the Downloader's main window, you can use the image size slider (indicated here by the cursor) to adjust the size of the thumbnail photos. Move it left to see more thumbnails; move it right to see fewer, larger ones. When you click Get Photos, Elements imports the selected photos from your camera or memory card, then opens the Organizer window and shows you the results.

Changing Elements' Download Settings

Unless you tell it otherwise before you import, the Downloader puts your photos in a folder named after the date you imported them. You can find these folders in: C:\your user name\My Documents\My Pictures\Adobe\Digital Camera Photos. But you can also adjust where your photos are saved and what they're named, by changing the settings in the Save Files section of the Photo Downloader window.

- **Location**. If you want to change where your photos are headed, click the Browse button and choose another location. You can permanently change the standard location by going to Organizer → Edit → Preferences → Camera or Card Reader. Set a new location, and from now on, the Downloader always puts your photos in the folder you chose.

- **Create Subfolder**. If you want to put your photos into a subfolder with a name you pick, instead of a date-stamped one, then the Create Subfolder section is where you do it. Giving your subfolder a descriptive name (*SkiTrip06*, for example) is a great idea, as you'll see when you learn about tags (labels) later in this chapter. With just one click in the Photo Browser window, you can apply that name as a tag to all the photos in the folder.

- **Rename Files to.** To name your photos something more meaningful than the cryptic multidigit number your digital camera assigns, turn on the "Rename Files to" checkbox. All the photos you're importing get the name you type here, plus a three digit number. So if you type *obedience_school_graduation*, then you get photos named *obedience_school_graduation001*, *obedience_school_graduation002*, and so on.

If your camera contains photos of different subjects or different events, you probably want to give them different names. Simply use the checkboxes to import them in separate batches, and type a different "Rename Files to" name for each. See, you're organizing your photos already, and they aren't even on your computer yet!

WARNING If you leave the Automatically Fix Red Eyes checkbox turned on, Elements searches your incoming photos for red eye and tries to fix it on the spot. It sounds great, but this feature makes your download take a long, long time, since Elements has to examine every single photo. It's also not 100 percent reliable. (It tends to "fix" things like bright white teeth as well.) You're better off turning this option off and, later, using Elements' Red Eye tool (page 239). Better still, use the flash techniques listed in Chapter 3 to avoid taking red-eye shots.

Once you're done adjusting these settings, click Get Photos, and the Downloader sucks in your pictures and launches the Organizer so you can review your haul. Elements also asks whether you want to keep or delete the photos on the device you're importing from.

ORGANIZATION STATION

Determining When Downloader Kicks In

Downloader's great, but it's not psychic. For example, you may want to use Downloader to get fresh pictures from your digicam, but *not* when you plug in a memory card just to see what's on it. In other words, you may not want Downloader to launch itself every time you plug something into your PC.

To turn off this over-eager behavior, in the Organizer window, choose Edit → Preferences → Camera or Card Reader and then turn off the "Use Adobe Photo Downloader to get photos from Camera or Card Reader" checkbox. Then, when you're ready to import pictures into Elements, choose File → Get Photos to launch Downloader.

On the other hand, maybe you wish Elements took *more* initiative. For example, you may want Downloader to automatically pull pictures into Elements whenever you save attached pictures from email messages, or download them from Web sites (like Flickr), or drag them to your hard drive from a CD. The trick is to save or drag the image files into a folder that you've told Elements to *watch*.

When you set a watched folder, Elements keeps an eye on it and lets you know when there are new photos there. Elements either imports the new files or tells you they're waiting for you, depending on which option you choose. To designate a folder as "watched" select File → Watched Folders.

NOTE Elements is actually composed of two separate but interconnected programs: the Organizer, which you'll learn about in this chapter, and the Editor, which you can learn about in Part 3 of this book. Each program does just what its name suggests. And what about the Downloader? That's more like a helper application than a full-fledged program.

Although the Downloader's pretty reliable, it's always safer to wait until you've checked through all your photos in the Organizer before deleting the originals. Use your camera's delete feature (usually a button with a trash can icon) or, if you're using a card reader, then drag your image files to your PC's trash after you're done importing them.

NOTE If you want to import photos that are *already* on your PC (say, in your My Pictures folder), open the Organizer and choose File → Get Photos → From Files and Folders, or press Ctrl+Shift+G, and then select your photos.

POWER USERS' CLINIC

Scanning Photos into Elements

Another way to get pictures into Elements, especially if they're not digital pictures, is to scan them in. Elements does a fabulous job making scanned photos look their best, and it knows how to work with most popular scanners. (In some cases, though, you may have to install a special *driver plug-in*, a small utility program that lets you scan directly into Elements. Check your scanner's software CD or the manufacturer's Web site for an Adobe Photoshop plug-in.)

To control your scanner from within Elements, you can choose to scan from either the Editor or the Organizer. In the Editor, go to File → Import and you'll find your scanner's name on the list that appears. In the Organizer, go to File → Get Photos → From Scanner, or press Ctrl+U.

You should check out your available options for both locations, since they're probably different. For instance, you may find that you have different file formats available (for your scanned photos) in the Editor than you do in the Organizer.

If you do a lot of scanning, you can use the Divide Scanned Photos command (page 219) to quickly scan several photos on the glass at the same time, and then digitally slice them apart. See "Importing Photos with a Scanner" on page 84 for much more detail on setting up and using a scanner.

Browsing Photos in the Organizer

The Organizer is where you keep track of your photos and start most of your projects for sharing your photos. You can see thumbnails of all your photos in the Organizer, and assign special keywords (called tags and categories) to make it easier to find the pictures you want. You can also gather photos into groups (called collections), and search for photos in all kinds of different ways.

The Organizer has three main windows: Photo Browser, Date View, and Create. The Photo Browser is the most versatile of the three and your main Organizer workspace.

NOTE The Create window is where you make calendars, greeting cards, album pages, and other fun stuff, as described in Part 4 of this book.

A Tour of the Photo Browser

The Photo Browser may look a little intimidating the first time you see it, but it's actually laid out quite logically. Figure 8-2 shows the Photo Browser's main components. In the main part of the window, you see thumbnails of all the photos you've imported (Adobe calls this area the *Image Well*).

You have a lot of control over what you see in the Image Well via the View menu. For example, if you have a lot of photos in front of you, then you can put them in chronological order by choosing View → Arrangement → Date (newest first or oldest first). To see a larger, slideshow-like view of your photos and choose the ones you want to print or edit, choose View → View Photos in Full Screen or View → Compare Photos Side by Side.

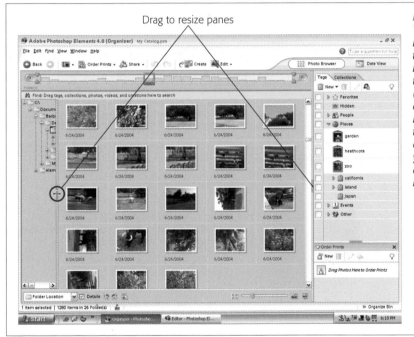

Drag to resize panes

Figure 8-2:
You can customize the Photo Browser window by dragging the dividers to make any area larger or smaller. Notice how the cursor changes shape (circled) when you're in the correct spot to drag a divider. Like the Downloader window, there's an image-size slider to control how many thumbnails you see. You can also enlarge a thumbnail to maximum size by double-clicking it.

Useful Photo Browser highlights include:

- **Shortcuts bar.** At the top of your screen, just below the Organizer's menus, this bar is your main navigational tool in the Organizer. By clicking the relevant icons, you can choose to import photos, print them, share them, create projects, edit your photos, or switch over to Date View (page 179).

- **Timeline.** Just below the shortcuts, each little bump on the Timeline represents a group of photos (based on the sorting method you choose from the View → Arrangement submenu). The higher a bar is, the more photos there are in that batch. Click a bar to see thumbnails of all the photos from that date in the Image Well.

- **Organize bin.** In the right-side panel, *tag* (or label) your photos with keywords for easy searching. Tagging is probably the first thing you'll want to do to your photos in the Organizer. Find directions on how to tag on page 179.

> **TIP** At the bottom of the Organize bin is a shortcut staging area to make it easy to order prints. Read about how to use it on page 361.

Navigating Your Photo Folders in Organizer

If you'd like to get a simultaneous look at your pictures and the folders on your PC where they're stored, choose View → Arrangement → Folder Location (or choose from the drop-down menu at lower left in Figure 8-2). A new pane on the left appears, showing the folder structure, including the exact location of the current batch of photos. Just as in Windows XP's Explorer Bar (page 97), you navigate by clicking plus and minus signs to expand and collapse folders, working your way down to the ones that contain the photos you want to see. Click a folder's icon to see the photos it contains displayed in the Image Well.

You can also move your photos directly within this Folder view pane by dragging them between folders (Figure 8-3). Moving your photos via the Folder view pane is better than moving them by, say, using Windows, because doing so lets Elements keep track of where your photos are.

Figure 8-3:
If you want to move photos around on your PC after you've brought them into the Organizer, either choose File → Move or drag them within this pane of the Photo Browser.

Here's the technical explanation: The Organizer only keeps a record of where your photos are; it doesn't actually make copies for its own use. Behind the scenes, the Organizer stores the information about your photos in a special database called a *catalog*. You don't have to do anything special to create this container. Elements creates your catalog—called *My Catalog*—automatically the first time you import photos.

Once you've imported photos into Elements, you must move them from within the Organizer (as opposed to dragging them around in a folder window, for example). Otherwise, the Organizer's catalog doesn't know where you put them. By the same token, when you delete a photo from your hard drive in Windows, you also delete it from the Organizer.

> **TIP** If you move photos around when you're *not* in the Organizer and Elements loses track of them, then choose File → Reconnect to help Elements find them again.

Viewing Photos by Date

Date View is an alternate way to look at and search for your photos, as explained in Figure 8-4. Date View is fun, and sometimes handy for searching, but it doesn't offer many useful functions that aren't also in the Photo Browser.

Figure 8-4:
Date View offers you the same menu options as the main Photo Browser window, but instead of a contact sheet-like view of your photos, you see your images laid out on a calendar. Click a date, and in the upper-right corner of the screen, you can step through a slideshow view of that day's pictures.

Creating Tags and Categories

The Organizer's got a great system for quickly finding photos, but it works only if you use special keywords, called *tags*, which the Organizer uses to track down your pictures.

A tag can be a word, a date, or even a rating (as explained in the box on page 180). When you import photos into the Organizer, the photos are automatically tagged with the date of import, but you may want to add more tags to make it easier to search for the subject of the photo later on. You can give a photo as many tags as you like.

Elements gives you a few generic tags to help you get started, but you'll want to learn how to create your own tags, too. After all, by the time you've got 5,000 or so photos in the Organizer, searching for "Family" probably isn't going to help narrow things down.

As you create tags to organize your photos, you can organize your tags by grouping them into *categories*. Again, you get a certain number of preset categories, like People, Places, and Events, and you can create your own categories, too. You can also create as many subcategories within categories as you like. You may have a category of "Vacations," with "China trip" and "Cozumel" as subcategories, for instance. Your photos in those categories may have the tags "Jim and Helen," "silk factory," or "snorkeling."

ORGANIZATION STATION

Special Tags

Elements starts you off with two special kinds of tags:

- **Favorites**. Favorites let you assign a one- to five-star rating to your photos. It's a good way to mark the ones you want to print or edit. Ratings are a great searching tool since you can tell Elements to find, say, all your pictures that have ratings of four or more stars. (See page 183 for details on how to perform a search.)

- **Hidden**. When you apply the Hidden tag to a photo, the photo isn't displayed in the Photo Browser until you click the search square next to the Hidden tag icon. The Hidden tag is useful for archiving those photos that didn't come out quite right but that you're not ready to trash. You can save these pictures (just in case) without having them cluttering up your screen while you're working with your good photos.

You create new tags and new categories in the same place: the Create Tag dialog box. Here's how:

1. **In the Organizer bin's Tags panel, click the New button and choose Tag from the drop-down menu. Or just press Ctrl+N.**

 The Create Tag dialog box appears.

2. **Type a name for the new tag in the Name box. Then, assign the tag to a category by picking from the Category drop-down menu.**

 If you'd like to create a new category, go back to the New button in the Tags panel and choose New Category (or Sub-Category) from the drop-down menu.

 Elements uses icons to represent different tags. By editing these icons, you can create your own system to search for tags visually as well as by name.

3. **To change the picture associated with a tag, right-click the tag in the Organize bin. Then, from the pop-up menu, choose "Edit [Tag Name] tag…" and click the Edit Icon button.**

 The Edit Tag Icon dialog box opens, so you can choose an icon as illustrated in Figure 8-5.

4. When you're done, click OK to close the Edit Tag Icon and Create Tag dialog boxes.

Figure 8-5:
In the Edit Tag Icon dialog box, the arrows on either side of the Find button let you step through all the photos that use that tag (the Find button shows you those photos all at once). Or you can click the Import button to use a different image stored on your computer. Once you've chosen the picture you want, drag the dotted square to use only a certain part of your photo.

Assigning Tags to Photos

When an image first gets imported into the Organizer, the Image Well shows only the photos in the batch of photos you've just imported. With the Photo Browser in Folder Location view (Figure 8-2), you'll see an icon in the upper-right corner of the Image Well called Instant Tag. Clicking it assigns the photo's folder name as a tag to all the photos in the group.

To assign a tag to a photo at any time, just drag the tag's icon from the Organize bin onto the photo's thumbnail. To add the same tag to a group of photos, first select the pictures and then drag the tag icon onto any one of the selected photos. It's as easy as that.

You can also delete tags, rearrange their order by dragging them, and even change the size of your tag icons by right-clicking a photo or tag and choosing what you want to do from the pop-up menu. You can also drag tags from one category to another in the Organize bin.

If you decide you want to remove a tag from a photo after you've assigned it:

- **From a single photo.** Right-click the photo's thumbnail, select Remove Tag, and then choose the tag you want to get rid of.

- **From a group of photos.** Select the photos, right-click one of them, select Remove Tag from Selected Items, and then choose the tag you want to remove.

GEM IN THE ROUGH

Face Tagging

Starting with Elements 4, Adobe included a new way to sort through your photos so that you can easily tag them: *Face Tagging*. Go to Find → Find Faces for Tagging. Elements then searches through your catalog for photos with people in them, and opens a new window showing the results.

Face Tagging doesn't work quite the way you may've hoped: You can't somehow tell Elements to find all the photos with Aunt Hildegarde in them. Elements just looks for what it thinks are human faces, and then shows you every photo that includes what it takes to be a person.

If you think about it, this is a pretty tough thing for a program to do, so the results may include a number of things, like leaves or parts of buildings that look like faces to Elements, but not to you.

So what's the point if Elements can't tell one person from another? Face Tagging is designed on the theory that you're most likely to want to tag pictures of your family and friends. By using Face Tagging, you can easily visually locate all the untagged photos of your grandfather, for instance, and quickly tag them all at once. The Face Tagging dialog box gives you access to all your tags, and it also includes a handy Recent Tags section that rounds up the last few tags you used so that you can quickly find them without having to navigate through the category structure to get to those tags.

If you're determined to have a computer help scan your photo collection and automatically apply keywords to faces, check out Riya (*www.riya.com*), a still-in-testing site that claims to do just that.

Creating Collections

You can also group your photos into *collections*, which are handy containers for storing multiple pictures. Collections are great for gathering together pictures taken at a particular event. They can also be used to prepare groups of photos that you plan on using in one of the Create projects, like slideshows or Web Galleries (covered in Chapter 17).

Collections can hold as many pictures as you want to put in them; and individual pictures can be included in multiple collections. Photos inside a collection can appear in any order you choose, which is important, for instance, if you want to control the order of photos in a slideshow.

You work with collections very much the way you do with tags, but you start by clicking the Collections tab in the Organize bin. From there, the steps are similar to those for creating or editing a tag or category, as outlined in the previous section.

TIP For the most part, use Collections for creating temporary groups of pictures that you plan on using in specific projects. They're also handy for gathering together groups of photos you want to export for use with another program. The best way to create *permanent* groupings of your photos is to assign the same tag to all the photos in the group.

Searching for Photos

When you first start importing photos into Elements, it's easy enough to find the batch of photos you're looking for by using the Timeline and the Folder Location panel (Figure 8-2). Once you have a few months worth of photos stored up, though, you'll find it much easier to locate, say, that batch of pictures you took at a picnic last summer if you diligently assign tags to all or most of your photos. Elements makes it very easy to find tagged photos. Still, if you decide that there's just not enough time in your current lifetime to follow a comprehensive tagging system, then you'll be pleased to hear that Elements gives you another way to root out buried pictures—searching by a picture's *metadata* (automatically saved photo stats with info on things like aperture setting and exposure). This section covers both.

Using Tags and Categories to Find Photos

Of course, when you're looking for a particular picture, you can use all the previously listed ways to find photos (viewing by date, for example) and just keep clicking through groups of photos until you find the one you want. But searching by tags and categories is the easiest way to find a particular photo. Elements gives you two main ways to conduct these searches:

• **Organize bin**. Click the empty square next to a tag or category, and Elements finds all the photos associated with those tags and categories. (A pair of binoculars appears inside the square to indicate it's being used to search for photos.) Click as many tags and categories as you want, and Elements searches for them all.

You can exclude a tag from a search by right-clicking the tag's name and, in the menu, choosing to exclude it. So you could search for photos with the tags "sports" and "rock-climbing," but not "broken leg," for instance.

• **Search bar**. The Organizer's Search bar gives you another way to perform a tag search. Figure 8-6 shows how to use it.

Figure 8-6:
To use the Search bar to find individual pictures, just drag any tag (or category) onto the bar with the binoculars. Your tag can hit the bar anywhere, not just on the binoculars icon itself.

Searching by Metadata

In the Organizer, you can search your photos by their *metadata*—aperture setting, exposure time, and other details that your camera records when you take a shot. You can use these statistics to find, say, all the photos you took with a particular camera or at a certain ISO speed (100 for outdoor shots, for example).

To perform a search using your photos' metadata, go to Find → Find by Details (Metadata) to bring up the window shown in Figure 8-7. Choose the category of metadata from the drop-down menu on the left, and then type a search term or choose the exact setting in the box on the right. Click the + button to add additional search terms, up to a total of 10. To remove a criterion, click the search term's – button.

Figure 8-7:
Your camera stores a great deal of information about your images in the form of metadata. See the box on page 185 for a recap of the most important metadata you can search by in Elements.

TIP The Find menu also lets you search for photos with similar colors. Choose Find → By Visual Similarity with Selected Photo(s). This option is awesome when you're looking for pictures with certain tones to use in a project, like all your sunset shots for a romantic slideshow, or the perfect seaside image to put on a blue coffee mug.

Backing Up with the Organizer

When it comes to easy backups, you're in for a treat. The Organizer's backup feature is one of its biggest strengths—it makes keeping a backup of your photo collection easy, even going so far as to remind you to label the CD or DVD you create (Figure 8-8). Just follow these steps:

1. **Choose File → Backup.**

 The Burn/Backup window appears with the Backup the Catalog button selected. (The other choice—Copy/Move Files—is useful for quick backups of selected photos.) Click Next.

INFORMATION STATION

Viewing Data About Your Images

The Organizer is just packed with information about your images. From captions you've written to statistics captured by your camera, the Properties window is chock full of interesting tidbits. To launch it, select any photo in the Organizer and press Alt+Enter, or right-click any photo and choose Show Properties from the pop-up menu. You get four different kinds of information to choose from, each of which you get to by clicking the icon on the top of the Properties window:

- **General**. General information includes the photo's name, location (on your PC), size, date you took the picture, caption (just put your cursor in the box and start typing to add one), and a link to any audio files associated with it. You can also change the photo's file name here by highlighting the name and typing in a new one.

- **Tags**. If you've assigned any tags to your photo, they're listed here.

- **History**. History tells you when the file was created, imported, and edited, and also where you imported it from (your hard drive, for instance).

- **Metadata**. *Metadata* is information about the photo that's stored in the photo file itself. Most notably, it's where you view your *EXIF* data. EXIF data is information that your camera stores about your photos, including the camera you used, when you took the picture, the exposure, the file size, the ISO speed, aperture setting, and much more.

The Metadata screen includes many other kinds of information besides the EXIF data. Click the Complete button at the bottom of the window to see the full listing (clicking the Brief button shows you highlights only).

Adobe Photoshop Elements

Disc 1 is done. Remember to write onto the disc "My Catalog ; Disc 1 of 7".

OK

Figure 8-8:
The Organizer walks you through every step of backing up your photos. It doesn't forget a thing, even reminding you to write the disc's name on it when you're done. OK, Mom.

2. **If necessary, find any missing photos.**

 The Missing Files Check Before Backup window appears. Here Elements is offering to check for any photos you may have moved from within Windows, rather than via the Organizer. Take Elements up on this offer and click Reconnect. Then go get a cup of coffee while Elements searches for any photos you've moved. If Elements can't find the photos, it offers you a chance to try to find the missing photos yourself. You can also let the backup continue without the missing photos, if you prefer, by clicking Continue.

3. **Choose Full Backup or Incremental Backup.**

 This option's really cool. Full Backup backs up *everything* in your catalog. Pick Full the first time you make a backup, or if you're backing up everything to move to a new computer. Incremental backup finds only the stuff that's new since the last time you made a backup, and that's all it copies—a major time and space saver. Click Next.

4. **Select where you want to save your files: on a CD, DVD, or a hard drive.**

 Make your selection by highlighting a choice in the Select Destination Drive box.

5. **If necessary, put a blank CD or DVD in the drive when Elements asks you to.**

 Elements needs to know what kind of discs you're using for backup so it can calculate how many discs you need and how long it will take. (Yes, Elements even tells you how many CDs or DVDs you need.)

6. **In the Name box, type a name for the backup you're creating, and then click Done when you're ready to start your backup.**

 If you don't enter a name, Elements names the backup after the catalog you're backing up (*My Catalog,* for example), even if you're copying only one photo. If you're backing up to CDs or DVDs, as Elements burns each disc, it asks if you want to verify the disc to be sure it's okay. You do. Elements prompts you to feed it more discs if your backup doesn't all fit on one disc. Next time you're ready to backup, just choose Incremental Backup in step 3 and then, in step 6, choose the backup file you've previously created.

 TIP Always check your backup discs once you've burned them. Take a moment to put the disc in your computer and make sure that all your photos are there. If there was an error, then you want to know about it now, not six months from now when you may not have those photos still available someplace else.

Now that all your photos are safe and sound, you're probably ready to spiff them up. Skip ahead to Chapter 10 for an in-depth look at all the photo fixes you can make using Elements.

3

Part Three:
Editing Your Photos

Basic Photo Fixes

Part 1 of this book is filled with tips for taking better pictures, but let's face it: You don't always set up your shots with the patience and expertise of Ansel Adams. You stop the teenagers for a quick photo before the prom. You shoot quickly to catch a squirrel looting the birdfeeder. You hang out the car window and click a shot while going over that famous bridge. The result is you have some photos that are *almost* good, but just need some help. Here's the good news: You *can* fix your less-than-perfect snapshots. (And unlike Ansel, you don't have to lock yourself in a small, smelly dark room to do it.)

Best of all, you can get basic digital photo-repair tools at no cost. Kodak's Easy-Share, and Google's Picasa, the free programs you first met in Chapter 5, include easy to use tools for fixing the most common image problems. EasyShare lets you rotate and trim your photos, and also helps with color correction and the infamous red eye. Picasa has solutions for all the basic problems, plus gives you a little more control over the end result.

> **TIP** If you're willing to pony up about $100 for a program with a lot more horsepower, especially when it comes to advanced photo fixes, then take a look at Photoshop Elements, covered in the next chapter.

Common Problems, Easy Fixes

To begin with, it helps to understand the problems photographers most often face and to be familiar with the tools you'll want to have handy to make things look right. EasyShare and Picasa both tackle basic photo fixes. Picasa provides slightly more

fine-tuning capabilities, while EasyShare's more helpful in other areas, not related to photo-fixing, like making prints and online albums (as you'll see in Part 4).

Below the following list, Table 9-1 gives you a quick summary of how EasyShare and Picasa match up, so you can decide which program you need.

- **Problem: Photos are sideways in your folders and albums.** What are those kids doing lying down in their prom clothes? Ah, you held the camera vertically when you shot the picture. The photo needs to be turned so it's taller than it is wide.

 Solution: You need to rotate some of your photos in 90-degree increments, to view them properly.

 Problem: Photos aren't straight and level within the shot. The horizon isn't horizontal, and buildings appear tilted.

 Solution: Again, you need to rotate your picture, but this time, you need a finer touch and perhaps some gridlines as a reference point. (It's Picasa to the rescue on this one.)

- **Problem: All the good stuff's in the middle of the picture.** Who wants to print the boring bits that surround the main attraction?

 Solution: If you didn't manage to get closer with your camera, then you can crop out the bad stuff. In fact, cropping is handy if you need to size your photos to fit in a specific photo format: 3×5, 5×7, or 8×10.

- **Problem: Uneven exposure.** In a world of light and shadows, almost all photos are too dark in some places and too light in others. For example, you sometimes end up with shadows on people's faces, or the opposite—important details washed out by too much sun.

 Solution: You need to select the areas that are too shadowy and brighten them just a bit. In the over-exposed areas, you need to select the highlights and make them a tad darker to eliminate glare.

- **Problem: Colors are off.** The photo isn't bad overall, it's just that the greens aren't really green and the reds don't look right either. Since bright daylight, cloudy daylight, indoor lighting, and the flash from your camera create light with slightly different hues, your photo's *color temperature* (page 50) may be off.

 Solution: In your digital darkroom, you can adjust color balance to restore true hues.

- **Problem: Your family looks like a casting call for *The Omen*.** Photographers call it red eye, and it's not a becoming look for most people.

 Solution: Since red eye is flash photography's most common pitfall, both Easy-Share and Picasa include special tools to help remove the demonic effect.

Table 9-1. Quick photo touch-ups you can do in EasyShare and Picasa.

Feature	EasyShare	Picasa
Rotating Photos	Yes	Yes
Straightening Photos	*No*	Yes
Cropping Photos	Yes	Yes
Crop Control for Standard Photo Sizes	Yes	Yes
Overall Exposure Control	Yes	Yes
Highlight and Shadow Control	Yes	Yes
Balancing Color by Finding Neutral Gray	Yes	Yes
Balance Color with Slider Controls	*No*	Yes
Eliminating Red Eye, Automatic	Yes	*No*
Eliminating Red Eye, By Selection	Yes	Yes

Now that you know which program does what, you're ready to start making your fixes. For EasyShare instructions, read on; Picasa fans can jump ahead to page 198.

Rotating & Cropping with EasyShare

Any photo software tool worth its bits and bytes helps you rotate and crop your photos. EasyShare makes both these tasks particularly easy.

Rotating Photos

Sometimes you need to rotate your photos (clockwise or counter-clockwise) so portraits are tall and narrow, and landscapes are short and wide, the way things should be. What you need for this job is the Rotate button, which you'll find on EasyShare's My Collection tab.

To rotate a photo, select its thumbnail and then click the button shown in Figure 9-1. What appears to be a single button actually works like two different buttons. To rotate your photo clockwise, click the right side of the button and to rotate counterclockwise, click the left side of the button.

> **TIP** If you need to rotate several photos in the same direction, you can Ctrl+click or Shift+click to select more than one and then rotate away (see the box on page 100 for more on selecting multiple photos).

Cropping Photos

When you've taken a picture and wish you could've gotten closer, or when you need to snip away the boring stuff in the margins, it's time to bring out the cropping tool. Here's what to do:

Figure 9-1:
Rotating photos with EasyShare is truly easy, but the button may make you do a double take. As you move your cursor toward the button's left or right side, a small curved arrow indicates which way your photo will turn.

1. **On the My Collection tab, click to select the photo you want to crop.**

 When you're cropping, you can work on only one photo at a time, so no multiple selections here.

2. **In the bar at the top of the window, click the Edit button (or choose Edit → Edit).**

 EasyShare opens the photo in Edit view, where you see more big buttons at the top of the screen to help with a variety of photo fixes.

3. **In the button bar, click the Crop button (at far left).**

 In the panel at left, EasyShare helpfully displays step-by-step cropping instructions (Figure 9-2). A crop box superimposed on your picture shows you how the cropped photo will look. The darker area outside the box is destined for the digital trash.

Figure 9-2:
EasyShare lists three steps to cropping your photo. First, choose a crop method: either a custom-sized crop that you create or one of the pre-sized crop boxes that match common print photo sizes (4×6 inches, for example). Next, resize or move the crop box. Finally, click Accept.

4. **From the drop-down menu in the left pane, choose one of the standard print sizes.**

 EasyShare makes sure the proportions remain correct as you resize the crop box. You can choose portrait (vertical) or landscape (horizontal) orientation—even if that's different from the way you originally took the photo.

 TIP When you don't want your creativity limited by arbitrary boundaries, select "Free form crop" just below the drop-down menu. You can adjust the crop however you want, as long as the shape is some kind of four-sided rectangle. High school geometry reminder: A square *is* a rectangle.

5. **Move or resize the crop box until it frames just the part of your photo you want to keep.**

 You have two ways to adjust the crop box: To reposition the entire cropping frame, hold your cursor over the inside of the frame. When it changes into a little hand, you can drag the frame around. To change the *size* of the frame, move your cursor over one of the frame's corners. When the cursor changes to a double arrow (Figure 9-3), you can drag the corner.

 If you need a better view of the area you're cropping, use the zoom slider at the bottom of the photo to enlarge the image.

6. **When you have everything just right, click the Accept button.**

 If the whole process has you thinking the photo really wasn't that bad to begin with, click Cancel to undo your crop.

Improving Photos with EasyShare

It's not hard to end up with a photo that looks good in every respect, except the colors are wrong. Your picture may look too blue or it may have an orange cast. Or, you may have a good photo except that the faces of your subjects are in shadows while the background is bright and sunny. EasyShare gives you three ways to improve the exposure and the color of your photos and they're all a snap to use.

You find all these fixes in EasyShare's Edit view, the same place where you crop your pictures:

- **Enhance.** Fastest of all, you can let EasyShare apply whatever fixes its software brain deems necessary.

- **Scene Balance.** To tinker with shadows and highlights, EasyShare gives you slider controls to adjust the exposure for parts (or all) of the photo.

- **Color Balance.** If a photo's color tones are off, then you can have EasyShare coax them toward more natural hues.

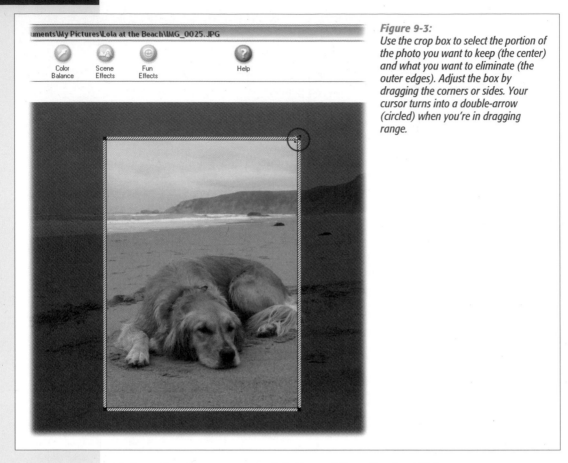

Figure 9-3:
Use the crop box to select the portion of the photo you want to keep (the center) and what you want to eliminate (the outer edges). Adjust the box by dragging the corners or sides. Your cursor turns into a double-arrow (circled) when you're in dragging range.

Enhancing Exposure and Color with a Single Click

If you're not quite ready to make exposure and color corrections on your own, EasyShare's Enhance button may just do the trick. First, select your photo in the My Collection window, click the Edit button, and then click Enhance (Figure 9-4). EasyShare examines your photo and then adjusts the overall exposure and brightness of the image and makes color adjustments. The result may not be perfect, but more often than not EasyShare does a pretty good job.

> **TIP** When you want to inspect and compare a specific part of your photo, zoom in using the magnification slider at the bottom of the edit window. Drag the photo until you get the best view.

Adjusting Exposure with Scene Balance

As with Enhance, the Scene Balance window shows you a before-and-after image of your photo. You can zero in on problem areas, and compare your corrections to the original. Nothing's set in stone until you save the file.

When Cropping Problems Crop Up

Remember that cropping always shrinks your photos. Remove too many pixels, and your photo may end up too small (that is, with a resolution too low to print or display properly).

Here's an example: Say you start with a 1600×1200 pixel photo. Ordinarily, that's large enough to be printed as a high-quality, standard 8×10 portrait. Then you go in and crop the shot. Now the composition is perfect, but your photo measures only 800×640 pixels. You've tossed out nearly a million and a half pixels.

The photo no longer has a resolution (pixels per inch) high enough to produce a top-quality 8×10. The printer is forced to blow up the photo to fill the specified paper size, producing visible, jaggy-edged pixels in the printout.

The 800×640 pixel version of your photo would make a great 4×5 print (if that were even a standard size print), but pushing the print's size up further noticeably degrades the quality.

Therein lies a significant advantage of using a high-resolution digital camera (5 or 6 megapixels, for example). Because each shot starts out with such a high resolution, you can afford to shave away a few hundred thousand pixels and still have enough left over for good-sized, high-resolution prints.

Moral of the story: Know your photo's size and intended use—and don't crop out more photo than you can spare.

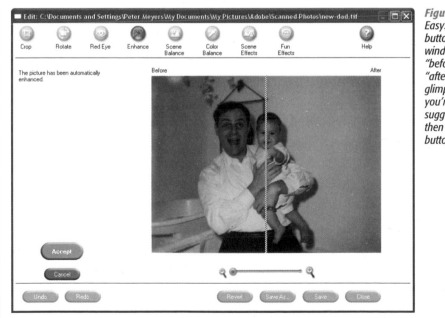

Figure 9-4:
EasyShare's Enhance button launches this window, which shows a "before" (left side) and "after" (right side) glimpse of your photo. If you're happy with the suggested improvements, then click the Accept button.

Photos commonly have one (or more) of three exposure problems. EasyShare's Scene Balance feature gives you a separate slider to adjust each (Figure 9-5):

- **The entire photo is either over-exposed or under-exposed.** The Exposure slider lets you make your picture darker (left) or brighter (right).

- **The shadow areas are too dark.** If parts of your photo appear almost black and there's no definition, then the Shadow slider can lighten them and bring out more detail.

- **The highlight areas are too bright.** When the lightest areas are blown out by a whitish glare, dragging the Highlight slider to the left tones them down and, hopefully, reveals more definition.

Figure 9-5:
EasyShare's Scene Balance tool gives you three sliders to put things right.

Edit: C:\Documents and Settings\Peter Mey

Crop Rotate Red Eye Enhance

**Move the sliders to change
the scene balance.**

Exposure:

Dark Bright

Shadow:

Less More

Highlight:

Less More

Here are the steps to adjust the exposure in your photo:

1. **In the My Collection window, click to select a photo (you can work on only one photo at a time), and then click the Edit button (or choose Edit → Edit).**

 The Edit window appears.

2. **In the Edit window, click the Scene Balance button.**

 You see your photo divided in half in the largest portion of the screen. The left side shows the original photo. The right side shows you the effect of your changes.

3. **If the entire photo is too light or too dark, adjust it using the Exposure slider.**

 It's best to make small, incremental changes and compare the result (on the right) to the original photo (on the left).

4. **If necessary, adjust the Shadow and Highlight sliders.**

 In the edit window, drag the photo to get the best view for the adjustment you're making. For example, if your photo suffers from dark shadows, then drag your picture to bring the darkest areas into the middle of the screen where you can see them.

Moving the Shadow slider to the left (Less) darkens the darker tones in your photo and leaves the brighter tones relatively untouched. Move the slider to the right (More), to lighten dark shadows.

Moving the Highlight slider does the same thing, but affects mainly the lightest parts of your photo. Drag left (Less) to darken them, right (More) to make them even brighter.

5. **Work with the controls until you're happy with the results. Then click Accept.**

 The goal is to have definition in *all* parts of your photo—the shadows and the highlights. On the other hand, you don't want to go overboard to the point that you lose the interesting differences between the dark and light portions of your photo. With most photos, you want to achieve a natural overall effect.

 If you decide not to make any changes, click Cancel.

Balancing the Color in Your Photos

EasyShare has a quick fix solution to make your colors appear more natural. The only thing you need to do is point out a color that *should be* neutral gray. "Should be" are the keywords here. Sometimes people search for a spot that *is* gray. Instead, you want to point to a spot in your photo and tell EasyShare, "This spot ought to be gray." Using that as a reference point, EasyShare's Color Balance tool fixes the gray and fixes the other colors, too.

First, select the photo you want to work on. Here's what you do next:

1. **In Edit view (Edit → Edit), click the Color Balance button.**

 You see a divided screen similar to the Enhance and Scene Balance windows. The left side of the screen shows the original image.

2. **Hold your cursor over your picture. When it turns into an eyedropper, click an area in the picture that *should be* neutral gray.**

 You see the newly balanced photo on the right.

3. **If you think the colors look truer and better, click Accept.**

 Click Cancel to try again. Or try the Enhance feature (page 194), which also attempts to fix overall color balance.

 TIP To see some interesting effects, don't be afraid to experiment and click spots in your image that *aren't* gray. You can always click Cancel if you don't like what you see.

Fixing Red Eye with EasyShare

Red eye is that demonic look your subjects exhibit when flash reflects off their retinas. Even if you use the techniques described in Chapter 3 to avoid red eye, sometimes this problem's inevitable, especially when your subject has blue eyes.

Fortunately, red eye is fixable in most cases (unless your subject is *truly* evil). Easy-Share gives you two different ways to correct red-eye, but neither works 100 percent of the time. You find both methods in Edit view (Edit → Edit). First, select your photo. Then, at the top of the Edit window, click the Red Eye button, and you see instructions to the left of your photo. At this point you have two choices:

- **Auto Correct.** The big Auto Correct button in the left panel is a good place to start. Click it, and EasyShare tries to identify parts of your photo that look like overly red eyes and attempts to give the eyes a more natural look by changing them to a color of its choosing, usually brown or blue.

- **Search and destroy.** If the Auto Correct button didn't find the red eyes, or changed something it shouldn't have, then you can provide an assist. In this second method, you point out the offending eyes: Zoom in with the slider at the bottom of your photo. You can also position the photo using the scroll bars on the side and bottom. When you have a good view of the eyes that need to be fixed, drag a small box around the eyes. When you release the mouse button, EasyShare applies its red-eye fix to the selected area.

NOTE Rotating, cropping, and fixing red eye are just the basic tools EasyShare offers to help improve your photos. For coverage of some of the program's more advanced wizardry, like adding special effects and making color photos black and white, flip ahead to page 274.

Rotate and Straighten with Picasa

If you held your camera sideways to take a tall, vertically oriented picture (a skyscraper, for example), you could end up with your subject lying on its side when you view the photo on your PC. Some cameras, for example, save all pictures the short way, in landscape mode. In Picasa, you can set your photos straight using the rotate buttons (Figure 9-6) at the bottom of the Lightbox.

Follow these steps to rotate a picture:

1. **Select the thumbnail image you want to rotate.**

 When you click a thumbnail, a border appears around the image showing that it's selected. You can select and rotate more than one image at a time.

2. **Click one of the arrow buttons below the Lightbox to rotate the thumbnail 90 degrees.**

 You'll see two buttons: one for clockwise rotation, the other for counterclockwise. Keep clicking until the image is positioned the way you want it.

Straightening Your Photos

Sometimes, when you click your camera's shutter, you're paying so much attention to your subject that you don't notice everything else is askew. The horizon is sloping, trees are ready to topple, and buildings lean over like cheap stage scenery

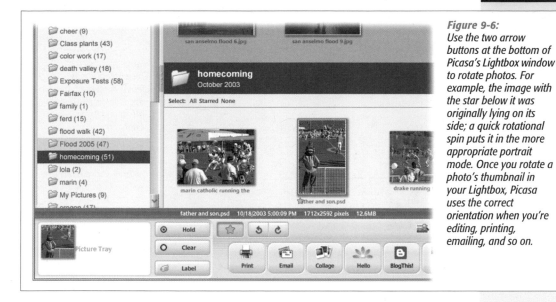

Figure 9-6:
Use the two arrow buttons at the bottom of Picasa's Lightbox window to rotate photos. For example, the image with the star below it was originally lying on its side; a quick rotational spin puts it in the more appropriate portrait mode. Once you rotate a photo's thumbnail in your Lightbox, Picasa uses the correct orientation when you're editing, printing, emailing, and so on.

(see Figure 9-7 for an example). For times like this, Picasa makes it easy to straighten your photo and put things back on the level. The Straighten tool is a slider that pivots your photo around the center point in small increments, cropping it slightly (if necessary) to maintain a rectangular image.

NOTE The Straighten tool is one feature you *won't* find in EasyShare.

To straighten a photo, you must first open it in Edit View, which is also where you do all your cropping, photo retouching, and special effects work. There are several ways to get to Edit View from Library View, the first screen you see when you start Picasa. The quickest way is to double-click the photo you want to edit. Alternatively, you can press Ctrl+3 or choose View → Edit View.

Then follow these steps to straighten a photo:

1. **In the Basic Fixes panel at left, click the Straighten button.**

 Picasa places a grid over your image, providing you with vertical and horizontal reference lines (Figure 9-7). Along your photo's bottom are a slider control, and Apply and Cancel buttons. You'll use the slider to pivot the photo.

2. **Drag the slider to pivot your photo until it aligns with the gridlines.**

 Adjust the photo with the slider until you're happy with the results. Notice that the image appears to zoom in and out slightly as Picasa adjusts the crop.

3. **Click the Apply button to make the change.**

 As with all Picasa edits, you can preserve the change by clicking the Apply button, or click Cancel to go back to the original.

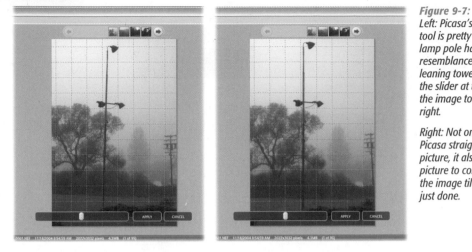

Figure 9-7:
Left: Picasa's straighten tool is pretty smart. This lamp pole has a striking resemblance to the leaning tower of Pisa. Use the slider at the bottom of the image to set things right.

Right: Not only does Picasa straighten the picture, it also crops the picture to compensate for the image tilting you've just done.

Cropping Photos with Picasa

When you shoot photos, it's best to compose the picture in the camera exactly the way you want it in your prints. Unfortunately, that noble and artistic goal isn't always possible. For example, sometimes when shooting a sports event or a performance, you can't get close enough to the subject. Other times, there's something in the frame that you didn't notice when you were focusing on the subject. Or perhaps you want your image to be a perfect square instead of the rectangular format your camera shoots. Whatever the reason, Picasa is there to help you crop your image. (For a word of caution about when *not* to crop, check out the box on page 195.)

Picasa makes it easy to crop any photo so it'll fit exactly on standard print paper (4×6, 5×7, and 8×10), but you can crop to any size as long as it's rectangular.

Here are the steps:

1. **In the Lightbox, double-click the photo to open it in Edit View.**

 You see your soon-to-be-cropped photo in the work area filling most of the screen. To the left are several buttons, tempting you with photo-fixing options.

2. **In the Basic Fixes panel at left, click the Crop button.**

 Picasa presents you with radio buttons showing dimensions: 4×6, 5×7, and 8×10 (Figure 9-8). If you plan to print your photo to one of these sizes, then choose that format. When you're feeling in more of a freeform mood, choose the Manual option.

3. **Drag your cursor across the image to indicate the area you want to keep.**

 A rectangle appears over the picture representing what your newly cropped photo will look like. You don't have to drag perfectly the first time, because you can adjust the rectangle (also known as the *marquee*) as much as you want.

4. **Make adjustments to the crop.**

If you need to move the crop rectangle, just click in the middle and drag it. To resize the crop, simply point at an edge or corner of the crop box and drag it. Picasa maintains the proper proportions throughout (assuming you haven't chosen the Manual option).

5. **When everything's just right, click Apply.**

Picasa completes the crop and presents you with your new and improved image.

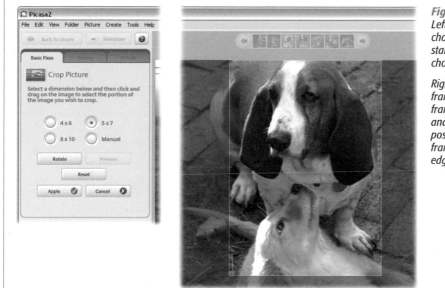

Figure 9-8:
Left: To crop your photo, choose from one of the standard dimensions or choose Manual.

Right: Adjust the crop frame. To move the frame, click in the center and drag it to a new position. To size the frame, drag one of the edges.

TIP Even after you've cropped a photo and clicked Apply, you still have an opportunity to fine-tune the crop: In the Basic Fixes panel, you'll see the Crop button now reads Recrop. Clicking Recrop, returns you to the cropping screen with the crop overlay in place over the *original* photo. At this point, you can adjust the crop to a new setting.

Fixing Exposure Problems with Picasa

You can't always control the lighting for your photos as if you were in a studio. Sometimes your subject is hidden in shadows. In other pictures, the detail is washed out by too much light. As discussed in Chapter 3, you can take measures to balance these problems when you take your pictures (like using a fill-in flash or adjusting your camera's aperture), but when you need more help, it's time to turn to your digital darkroom.

Adjusting Fill Light in Your Photos

Picasa's Fill Light tool is designed to fix a problem that's pretty common for out-door pictures. How many times have you seen beach pictures where the background is bright but the faces are lost in shadows? With the Fill Light slider, found in Picasa's Edit View (View → Edit View) you can make the shadowy faces a bit brighter.

The Fill Light slider bar appears on both the Basic Fixes panel and the Tuning panel in Edit View. Adjustment is a simple matter of moving the slider until you're pleased with the results. Technically, this tool is supposed to add light to the foreground when you use it on photos with too much brightness in the background. In reality, as shown in the before and after images in Figure 9-9, the Fill Light tool seems to find the darker areas in the image and increase their brightness. Whether *you* consider the areas to be foreground or background doesn't really matter, so you can use this tool on any photos where lighting is uneven.

Figure 9-9:
The Fill Light control in Picasa balances the brightness in different parts of an image. In this floral photo (top), the green leaves are in shadow and the pink and white petals are barely visible. After using the Fill Light tool (bottom), everything looks a lot better.

Don't be afraid to experiment with Picasa's tools. By playing around, you'll learn when the tools work and when they don't.

Fixing Contrast & Color with Picasa

Problems with contrast and color often ruin otherwise good snapshots. Many cameras have settings that help eliminate these pitfalls (see Chapter 1 for a quick

overview), but when your photos get to your computer screen and still look too dark, too light, or have a blue or orange cast, it's time to open Picasa's toolbox.

The "I'm Feeling Lucky" Button

One of the coolest (and probably most underappreciated) features of Google's search engine is the "I'm Feeling Lucky" button. If you click this button instead of Search, Google instantly whisks you to the Web site most likely to be exactly what you're looking for—with sometimes eerie accuracy.

Not surprisingly, Google intends Picasa's "I'm Feeling Lucky" button to be the ultimate, one-stop-shopping photo fix. Use it when you'd prefer to have the software do all the work for you. Picasa analyzes your photo, and then adjusts the exposure, contrast and color as it sees fit. If Picasa thinks no changes are needed, then none are made. Sometimes you'll be pleased with the results and other times you'll feel like Google should stick to search engines. In other words: keep the changes if you like them but if you don't, then click the Undo button.

Applying Auto Contrast and Auto Color

The "I'm Feeling Lucky" button tries to fix both color and contrast problems in your photo, but sometimes, well, you don't get lucky. Sometimes you only need one or the other of these fixes and you're the best one to decide which to use. Mabye the colors in your photo have an odd color cast to them; for example, everything may be too yellow. You need a color adjustment. Or perhaps the colors blend together in an indistinct mush—everything is the same tone, and there are no light and dark variations. You need a contrast adjustment. If you already tried the "I'm Feeling Lucky" button and didn't like the results, you'll want to apply the Auto Color and Auto Contrast buttons independently of each other.

In the Basic Fixes panel, Picasa takes an all-or-nothing approach to color and contrast problems. It's easy to apply and to undo these fixes, so feel free to experiment. Try one, undo, and then try the other. For example, if the colors in your photo don't seem true, click the Auto Color button. It may make your blues a better blue and your reds look right. If you like the result, then you're done. If you don't like the result, click the Undo button at the bottom of the panel. The Auto Contrast button works exactly the same way, except that it doesn't change the hues in your image—it contracts or expands the light-to-dark range within your photo. If these one-click fixes don't do the job, use the tools in the Tuning panel, as discussed next.

> **NOTE** Confused about the difference between the Fill Light control and the Auto Contrast button, and when to use which? You're not alone. In a nutshell, use the Fill Light control to brighten the shadows in your picture. Use the Auto Contrast, if you'd like to see more separation in the colors and tone of your picture.

Fine-Tuning Your Photos

If "I'm Feeling Lucky," Auto Color, and Auto Contrast all fail to do the job, there's still hope. Picasa's Tuning panel lets you dig a little deeper in making adjustments to your photos. Rather than one-click fixes, you have slider controls to fine-tune your changes (Figure 9-10). On the Tuning panel, you adjust the fill light and the brightness of highlights and shadows. With the color temperature slider and neutral color picker you make changes to the hue or color cast of your photos.

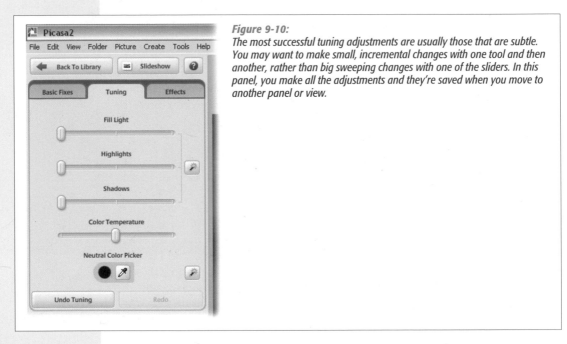

Figure 9-10:
The most successful tuning adjustments are usually those that are subtle. You may want to make small, incremental changes with one tool and then another, rather than big sweeping changes with one of the sliders. In this panel, you make all the adjustments and they're saved when you move to another panel or view.

The tuning panel is a sensitive tool. It pays to be patient and to experiment—you can always undo any messes you make by clicking Undo Tuning. Here's one approach to Tuning to get you started:

1. **Open the ailing photo in Edit View (Edit → Edit View), and then click the Tuning tab.**

 The Tuning panel offers three slider controls: Fill Light, Highlights, and Shadows.

 There's also the Neutral Color Picker, which looks like a palette with a big black dot and an eyedropper. If your photo suffers from an inappropriate color cast, like orange or blue, then set the Neutral Color first, which you'll do in the next step.

2. **Click the eyedropper, and your cursor changes to an eyedropper (Figure 9-11). Then, click a portion of your image that should be pure white or neutral gray.**

 Picasa defines *this* color as neutral and makes adjustments to the other colors in the image, if necessary. If you don't like the changes, then click Undo and try again.

Figure 9-11:
The color picker (in the lower-right corner of this photo) looks like an eyedropper. Use it to select a portion of the photo that should be a neutral gray color. The key words here are "should be." When Picasa fixes the color you choose to be gray, it also adjusts the colors in the rest of your photo.

3. **If parts of your photo are obscured by insufficient lighting, drag the Fill Light slider towards the right to brighten them.**

 Often you'll want to retain some definition between the areas in your images that naturally should be lighter and darker, so don't go overboard here.

4. **If the lighter, brighter portions of your image need to be brighter still, use the Highlights slider.**

 Moving the slider to the right increases the brightness of highlights to the point that they can become blown out—all white with no definition at all. When that happens, back off on the slider. Experiment until you find the sweet spot, a natural-looking highlight with clear definition.

5. **If the shadowed parts of your picture aren't dark enough, move the Shadows
 slider to the right for a deeper, more dramatic look.**

 Sometimes using the Fill Light or Highlights tool may lighten areas that are sup-
 posed to be darker, so the Shadows tool can come in handy. The tools really are
 interdependent.

6. **Continue fiddling until you're happy.**

 When you're satisfied with your changes, simply click a different tab panel or
 move back to Library View. Picasa saves your changes. Later, if you want, you
 can undo the changes by clicking the Undo Tuning button.

 TIP These fine-tuning adjustments are subjective. If you're serious about massaging a particular
 photo until it's at its best, then you may want to try different tunings and export them to new files.
 You may even want to keep a log of the changes you applied to each image. Print these different
 versions of your photo and ask friends what they think.

Fixing Red Eye with Picasa

Red eye is such a common problem in casual photography that cameras provide
built-in tools to minimize it. For tips on how to avoid red eye when you take pic-
tures, see page 68. When all else fails, you can use Picasa's Red Eye tool after the
fact. For some photos it works well. With others, it may leave red remnants, but
it's almost always an improvement.

Use these steps to clear up that red eye:

1. **Open the photo in Edit View (View → Edit View), and then click the Red Eye
 button on the Basic Fixes tab panel.**

 The Red-Eye Repair tab appears, with written instructions, but no apparent
 tools to use.

2. **Draw a marquee (selection box) separately around each offending eye.**

 To eliminate red eye, use your mouse to draw a marquee around each demon-
 like eye. Picasa is quite forgiving if you include an eyebrow or part of a nose in
 this selection. It seeks out the bright red part of the image and tones it down by
 several degrees.

 TIP You may be tempted to zoom in to get a better view of the eyes you're trying to fix, but
 Picasa doesn't want to cooperate. See the box on page 207 for a workaround.

3. **Click the Apply button to accept the change.**

 After you've exorcised the red to your satisfaction, click the Apply button to
 accept the changes.

Zooming in Before Fixing Red Eye

Picasa's Red Eye feature isn't really a precision tool. It seems to work pretty well even if you draw a fairly wide marquee around your subject's eyes. But what if you have a strong urge to zoom in on those demon-like eyes before you apply the fix? Picasa doesn't cooperate. When you zoom in and then hit the Red Eye button, Picasa zooms out before putting you in the Red-Eye Repair view. When you're in the Red-Eye Repair view, Picasa dims out the Zoom slider, making it inaccessible. Here's a workaround to bend Picasa to your will.

1. With the photo in Edit View, click Crop. Select the Manual option. so you can crop the image to any shape. You're going to crop the image in order to get a closeup of the eyes that need correction.

2. Draw a marquee around the offending eyes, and then click Apply. You should have a cropped image that's mostly eyes. Don't worry, soon you'll have your whole image back.

3. Click the Red Eye button. Drag around each eye to remove red eye as explained on page 206. But this time, the image is larger and it's easier to see where you're working.

4. When you're happy with the results, click Apply. Picasa returns to Edit View.

5. In the Basic Fixes panel, click the Recrop button. Before you cropped your photo down to the eyes, this button used to say Crop. Now you can undo the previous crop (but keep the red-eye fix).

6. Click Reset to return the photo to its original size. (Or you can recrop it to any size you like, using the steps on page 200.)

7. Click Apply to accept the changed crop. The final result is an image with fixed red eye.

Rotating, Cropping, and Resizing with Elements

After you move photos from your camera to your computer, you're ready to spruce them up for public consumption. It's time to straighten out crooked shots, trim off unwanted areas, and resize those photos for emailing or printing. If you're an Elements owner, you possess much more power and control than with free programs like EasyShare and Picasa, described in the previous chapter, but, not surprisingly, it takes a little longer to find your way around the program.

Not to worry. This chapter starts out showing you how to manipulate Elements so you can get the best view of the photos you're working with. Then you'll learn how to rotate your shots into full, upright position, and realign photos—even scanned photos—that are slightly off-kilter. You'll also learn how to reframe just the best part of your image and crop out the rest, and how to resize the *entire* photo, which usually changes its resolution, as well. This chapter clarifies all.

> **NOTE** Unless otherwise specified, the tools in this chapter work in the Elements Editor (Figure 10-1). If you're in the Organizer, then press Ctrl+I to go to the Standard Edit window. See the note on page 175 for a quick recap of the difference between the Editor and the Organizer.

Changing Your View of Your Photos

Sometimes, rather than changing the size of your photo, all you want to do is change its appearance in Elements so you can get a better look at it. For example, you may want to zoom in on a particular area, or zoom out, so you can see how edits you've made have affected your photo's overall composition.

Options bar

Toolbox

Figure 10-1:
The Standard Editor is your control center for sprucing up your photos. This window's jam-packed with loads of tools, but for this chapter all you need to know about are the Toolbox and the Options bar.

Nothing you do with the tools and commands in this section changes anything about your actual photo. You're just changing the way you see it onscreen as you work with it. Elements gives you lots of tools and keystroke combinations to help with these new views.

Image Views

When you first launch Elements, if you've opened multiple pictures, your photos *tile* themselves so that you can see them all simultaneously. If you have two photos open, for example, each photo window spreads itself out to take half the available space on your desktop. You're not stuck with this layout, though. When you choose Window → Images, you get several choices for how your image windows appear:

• **Maximize.** The active photo window (the one you're working on) takes up the entire Elements desktop. You can also click the large square at the right of the Editor shortcuts bar to switch to this view.

• **Cascade.** Your image windows appear in overlapping stacks.

• **Tile.** Your image windows appear edge to edge so that they fill the available desktop space. With two photos open, each picture gets half the window. With four photos open, each gets one quarter of it, and so on. If you click the four squares in the Shortcuts bar, then you get Tile view.

• **Match Zoom.** All your windows get the same magnification level as the active image window.

- **Match Location.** You see the same part of each image window, like the upper-right corner or the bottom left. Elements matches the other windows to the active window.

The View menu also gives you four handy commands for adjusting the view of your active image window:

- **New Window for.** Choose this command and you get a separate, duplicate window for your image. This view is a terrific help when you're working on very fine detail. You can zoom way in on one view while keeping the other window in a regular view to help you know where you are in the photo. Don't worry about version control or keeping track of which window you're working in, since both windows just represent different glimpses of the same image.

- **Fit on Screen.** This command makes your photo as large as it can be while still keeping the entire photo visible. You can also press Ctrl+0 for this view.

- **Actual Pixels.** Actual Pixels is the most accurate look at the onscreen size of your photo. If you're emailing your photos, this view shows the size your image will be in your email program. Keystroke shortcut: Alt+Ctrl+0.

- **Print Size.** This view is really just a guess by Elements, because Elements doesn't know exactly how big a pixel is on your monitor. But it's a rough approximation of the size your image would be if printed it at the current resolution. (Resolution is explained in the section on resizing your actual photo, on page 225.)

NOTE You can zoom in or out from the View menu, but it's much faster to learn the keystroke shortcuts. The next section explains the Zoom tool in detail.

The Zoom Tool

Some of Elements' tools require you to get a very close look at your image to see what's going on. Sometimes you may need to see the actual pixels as you work, as shown in Figure 10-2. The Zoom tool makes it easy to zoom your view in and out.

The Zoom tool's Toolbox icon (see Figure 10-1) is the little magnifying glass. Click it or press Z to activate the tool. Once the tool is active, you see two magnifying glasses in the Options bar. If you want to zoom in (to make the view larger), click the one with the + sign on it. To use the Zoom tool, just click the place in your photo where you want the zoom to focus. The point where you clicked becomes the center of your view, and the view size increases again each time you click.

You can also select the Zoom Out tool in the Options bar, by clicking the magnifying glass with the minus sign (–) on it. Or you can press Alt as you click, and make either Zoom tool zoom in the opposite direction. For example, if you're clicking with the + tool and decide you've zoomed in too far, Alt-click to zoom back out. No need to click the Zoom Out tool.

Figure 10-2:
At times you'll want to zoom way, way in when working in Elements.
You may even need to go pixel by pixel in tricky spots, as shown
here.

The Zoom tool has several Options bar settings you can use as well:

- **Zoom Percent.** Enter a number here and the view immediately jumps to that percentage. 1600 percent is the maximum, 1 percent the minimum.

- **Resize Windows to Fit.** Turn this option on, and your image windows get larger and smaller along with the image size as you zoom. The image always fills the entire window with no gray space around it.

- **Ignore Palettes.** This setting lets windows resize so that they don't stop getting larger when they reach the edge of a *palette* (the controls on the right side of Elements). Instead, they continue resizing *underneath* the palettes. This choice isn't available until you turn on "Resize Windows to Fit."

- **Zoom all Windows.** If you have more than one image window open, turn this option on and the view changes in all the windows in synch when you zoom one window. (Or use the keyboard shortcut: Pressing Shift as you click with the zoom tool applies the same zoom to all open windows.)

The Option bar buttons for Fit on Screen, Actual Pixels, and Print Size work the same as the menu commands described in the preceding section.

> **TIP** You don't need to bother with the actual Zoom tool at all. You can zoom without letting go of the keyboard by pressing Ctrl+= to zoom in and Ctrl+– to zoom out. Just hold down Ctrl and keep tapping the equal or minus sign until the view is what you want.
>
> It doesn't matter which tool you're using at the time—you can always zoom in or out this way. Since you'll do a lot of zooming in Elements, this keyboard shortcut is a great one to remember.

The Hand Tool

With all that zooming, sometimes you're not going to be able to see your entire image at once. Elements includes the Hand tool to help you adjust which part of

your image you can see. It's very easy to use. Just click the little hand in the Tool-box or press H to activate it.

When the Hand tool is active, your cursor turns to the little hand as shown in Figure 10-3. Drag with the hand to move your photo around in the window. The hand tool is very helpful when you're zoomed in or working on a large image.

Figure 10-3:
The easiest way to call up the Hand tool is to press the Space bar on your keyboard. You can tell the Hand tool is active by this little white-gloved cursor (circled in red here). No matter what you're doing in Elements, the Space bar activates the Hand tool until you release the bar. Then the tool you were previously using returns.

The Hand tool gives you the same Scroll All Windows option you have for the Zoom tool, but you don't have to use the Options bar to activate it. Just press Shift while using the Hand tool, and all your windows scroll in synch. The Hand tool also gives you the same three Option bar buttons (Fit on Screen, Actual Pixels, and Print Size) that the Zoom tool does. Once again, they work the same as the menu commands described at the beginning of this section.

Figure 10-4 shows the Hand tool's somewhat more sophisticated assistant, the Navigator palette, which is very useful for working in really big photos or when you want to have a slider handy for micro-managing the zoom level. Choose Window → Navigator to call it up.

Figure 10-4:
Meet the Navigator. You can travel around your image by dragging the little red rectangle—it marks the area of your photo that you see onscreen. You can also enter a percent number to designate your photo's display size, or move the slider or click the zoom in/out magnifying glasses on either side of it to change the view.

Now you know how to position and zoom your photos onscreen so you can see exactly what you want to work on; the tools in the rest of this chapter, and the chapters that follow, help you make changes to your actual photo file.

Rotating Photos

When you shoot with your camera turned 90 degrees, you can look at the shot even years later and see immediately which way is up. Digital cameras and computers, however, aren't quite so smart. For example, not all cameras output photos so that Elements (or any other image-editing program, for that matter) knows the correct orientation for your picture. Fortunately, Elements has rotation commands just about everywhere in the program. If all you need to do is get Dad off his back and stand him upright again, then here are the ways you can perform a quick 90-degree rotation on any open photo:

- **In the Editor.** Select Image → Rotate → 90° Left (or Right).

- **In the Organizer (page 175).** You can rotate a photo almost anytime in the Organizer by selecting the photo and then pressing Ctrl+ the left or right arrow key. Another way to rotate is to choose Edit → Rotate 90° Left (or Right). Finally, there's a pair of Rotate buttons to click at the bottom of the Photo Browser window.

Those commands get you one-click, 90-degree changes. But Elements has all sorts of other rotational tricks up its sleeve, as explained in the next section.

Rotating and Flipping Options

Elements gives you several ways to change the orientation of your photo. To see what's available, in the Editor, choose Image → Rotate. You'll notice two groups of Rotate commands in this menu. For now, it's the top group you want to focus on.

In the first group of commands, you'll see:

- **Rotate 90° Left or Right.** Use these commands, as explained in the previous section, for digital photos that come in on their sides.

- **Rotate 180°** turns your photo upside down and backward.

- **Flip Horizontal.** Flipping a photo horizontally means that if your subject was gazing soulfully off to the left, now she's gazing soulfully off to the right.

- **Flip Vertical.** This command turns your photo upside down without changing the left/right orientation (which is what "Rotate 180°" does).

NOTE When you're flipping photos around, remember you're making a mirror image of everything in the photo. So someone's who's writing right-handed becomes a lefty, any text you can see in the photo is backward, and so on.

• **Custom Rotate.** Selecting this command brings up a dialog box where, if you're mathematically inclined, you can type in the precise number of degrees to rotate your photo.

Figure 10-5 shows these commands in action.

Figure 10-5:
Even the most uncooperative cat turns somersaults for you if you use the rotate commands.

Top row: From left to right, you see the original, the photo rotated 90 degrees to the right, and the photo rotated 180 degrees.

Bottom row: The photo flipped horizontally (left), and flipped vertically (right).

If you want to position your photo at an angle on a page (as you would in a scrapbook), use Free Rotate Layer, which is described on page 217.

Straightening Photos

What about all those photos you've taken where the content isn't quite straight? You can flip those pictures around forever, but if your camera was off-kilter when you snapped the shot, then your subjects lean like a certain tower in Pisa. Elements has planned for this problem too, by including a nifty Straighten tool that makes adjusting the horizon as easy as drawing a line.

> **TIP** About 95 percent of the time, the Straighten tool does the trick, But for the few cases where you can't get things looking perfect, you can still use the old school Elements method—the Free Rotate command, which is described on the next page.

Straighten Tool

Ever since Elements first came out, people have been asking Adobe for an easier way to straighten the content of their photos. Starting with Elements 4, Adobe came through in a big way with its Straighten tool. If you can draw a line, you can straighten a photo with this tool.

To straighten your photo:

1. **Open a crooked photo, and then activate the Straighten tool.**

 The Straighten tool lives just below the Cookie Cutter tool in the toolbox. Its icon is two little photos, one crooked and one not. To activate the Straighten tool, click the icon or press P.

2. **Use the Options bar to choose how you want the Straighten tool to handle the edges of your photo.**

 Once your picture's straightened, the edges are going to be a bit ragged, so you can choose what you want Elements to do about that:

 Grow Canvas to Fit. Elements adds extra space around the edges of your photo to make sure that every bit of the original edges still show. It's up to you to crop your photo afterward (page 221).

 Crop to Remove Background. Elements chops off the ragged edges to give you a nice rectangular image.

 Crop to Original Size. Elements makes sure that the dimensions of your photo stay exactly the same, even if that means including some blank spaces along parts of the edge where straightening has moved the contents of the photo away from the edge of the image.

3. **Drag a line in your photo to show Elements where horizontal should be.**

 As shown in Figure 10-6, you draw your line at an angle. Elements automatically levels out your photo, making your line the true horizontal plane in the image. If the rotation moves parts of your image outside the frame, Elements either trims or leaves them, depending on what you chose in the Options bar.

 TIP If you have a photo of trees, sailing ships, skyscrapers, or any other subject where you'd rather straighten *vertically* than horizontally, then just hold down Ctrl while you drag. The line you draw determines the vertical axis of your photo.

If you don't like what Elements did, press Ctrl+Z to undo it and draw another line. If you're happy, then you're all done, except for saving your work (Ctrl+S).

Free Rotate

You can also use the Rotate commands to straighten your photos, or to turn them at angles for use in scrapbook pages or album layouts you create. The rotate command that's best for this use is Free Rotate Layer, which lets you grab your photo and spin it to your heart's content.

NOTE You don't have to understand layers—an advanced Elements feature that lets you slice up your image into stackable components—to use the Free Rotate Layer command. See the tutorial within Elements (Help → Tutorials → Using Layers) or *Photoshop Elements: The Missing Manual* for more on how Layers work.

Figure 10-6:
Left: To correct the crooked horizon in this photo, just draw a line along the part that should be level. It's easiest to do this by choosing a clearly marked area like the horizon in this photo. But you could also draw a line across the middle of a lawn, for instance, and Elements would straighten the photo to that line.

Right: Elements automatically rotates the photo to straighten its contents. As shown here, you see the results of selecting "Grow Canvas to Fit," which automatically trims off the ragged edges of your straightened photo.

If you aren't sure where straight is, Elements gives you some help figuring it out, as shown in Figure 10-7.

Figure 10-7:
If you need some help figuring out where straight is, then choose View → Grid to toggle these handy guidelines on and off. You can adjust the grid spacing in Edit → Preferences → Grid.

To use Free Rotate Layer:

1. **Choose Image → Rotate → Free Rotate Layer.**

 Elements asks if it should "make this background a layer." Say Yes.

2. In the dialog box that appears, type a name for the layer, if you wish. Then click OK.

Small boxes appear at the corners of your photo (Figure 10-8).

3. **Drag one of these corners with your mouse to tilt your photo to the proper angle.**

Your picture may look kind of jagged while you're rotating. Don't worry about that—Elements smoothes things out once you're done.

Figure 10-8:
To straighten the contents of your photo, or even to spin it around in a circle, grab these little arrows (circled here in red) and start turning. Just reach for the corner and adjust your photo the way you'd straighten a crooked picture on your wall. The arrows appear when you move your mouse near a corner of the photo.

4. When you've got your image positioned where you want it, press Enter.

Now you've got a nice straight picture, but the edges are probably pretty ragged since the original had slanted, unrotated sides. You can take care of that by cropping your photo, as explained later in the chapter.

Straightening Scanned Photos

Everyone with a scanner knows the frustration of carefully placing a photo on the glass, only to have it come out crooked. Elements includes a wonderful command—Divide Scanned Photos—that solves this problem. Furthermore, you can scan *several* photos at once (Figure 10-9), and then use this command to simultaneously straighten and separate the individual images.

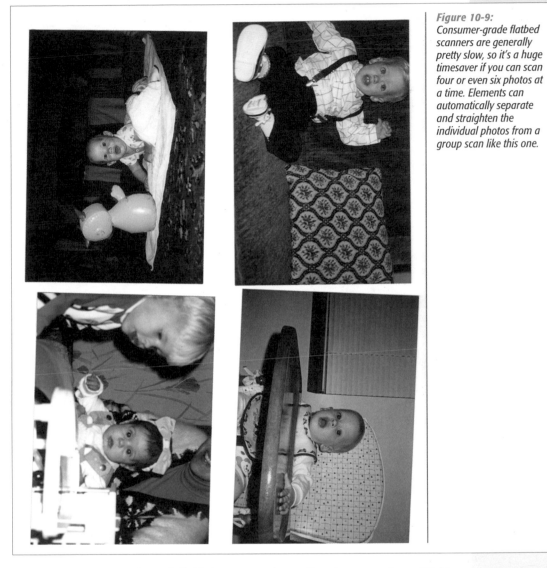

Figure 10-9:
Consumer-grade flatbed scanners are generally pretty slow, so it's a huge timesaver if you can scan four or even six photos at a time. Elements can automatically separate and straighten the individual photos from a group scan like this one.

If you have any intention of digitizing generations of ancient snapshots, Divide Scanned Photos is worth the whole price of Elements. The only limit on the number of photos is how many you can fit on your scanner. It doesn't matter whether you scan directly into Elements or use your scanner's own software, and it doesn't matter what file format you save the scanned image in. (See Chapter 4 for more about scanning images into Elements.)

> **NOTE** Sometimes it pays to be crooked. Divide Scanned Photos does its best work if your photos are fairly crooked, so don't waste time trying to be precise when placing your pictures on the scanner.

Once you've scanned a batch of photos, follow these simple steps:

1. **Open your scanned image file. Then, in the Editor, choose Image → Divide Scanned Photos.**

 Sit back and enjoy the show as Elements carefully calculates, splits, straightens out, and trims each image. The individual photos appear and disappear as Elements works through the group.

2. **When prompted by Elements, name and save each separated image.**

 You end up with the original group scan as one file, plus you have a separate file for each photo Elements has carved out.

Once you're done, you can import the cut-apart photos into the Organizer. Just make sure that "Include in Organizer" is turned on in the Save As dialog box.

> **TIP** Elements can also straighten out and crop a single scanned image. After you've scanned in your photo, Choose Image → Rotate → Straighten and Crop Image, and Elements tidies things up for you. You can also choose just Straighten Image if you'd rather crop the edges yourself.

Cropping Photos

Whether or not you straightened your photo, you'll probably need to *crop* it—trim it to a certain size. There are two main reasons for cropping your photos. If you want to print on standard sizes of photo paper, you usually need to trim off part of your image so it fits onto the paper. You also might want to crop away distracting objects in the background or people you don't want in the picture, for instance.

A few cameras produce photos that are proportioned exactly right for printing to a standard size like 4×6. But most cameras give you photos that aren't the same proportions as any of the standard paper sizes like 4×6 or 8×10. (The width-to-height ratio is also known as the *aspect ratio*.)

The extra area most cameras provide gives you room to crop wherever you like. You can also crop out different areas for different size prints (assuming you save your original photo). Figure 10-10 shows an example of a photo that had to be cropped to fit on a 4×6 piece of paper. If you'd like to experiment with cropping or changing resolution (explained on page 225), then download the image in the figure (waterfall.jpg) from the "Missing CD" page at *www.missingmanuals.com.*

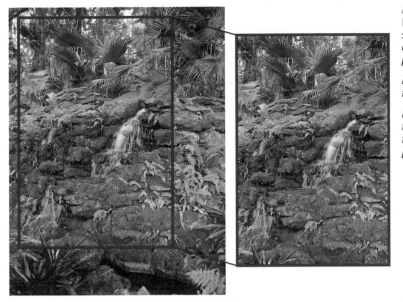

Figure 10-10:
When you print onto standard sized paper, you may have to choose the part of your digital photo you want to keep.

Left: The photo as it came from the camera.

Right: The results of cropping the image down to make it the right shape for a 4×6 print.

Using the Crop Tool

The Crop tool includes a helpful list of preset sizes to make cropping easier (details on how fixed size cropping works are in the next section). But if you don't need to crop to an exact size, here's how you perform basic freehand cropping:

1. **In the Toolbox, click the Crop icon (or just press the C key). Then drag anywhere in your image to select the area you want to keep.**

 The area outside the boundaries of your selection is covered with a dark shield. The dark area is what you're discarding. To move the area you've chosen, just drag the selection box to wherever you want it.

 NOTE You may find the Crop tool a little crotchety sometimes. See the box on page 223 for help in making it behave.

2. **To resize your selection, drag one of the little handles on the sides and corners.**

 They look like little squares as shown in Figure 10-11. You can drag in any direction, so you can also change the proportions of your crop if you want to.

3. **If you change your mind, click Cancel (the "no" symbol) on the photo, or press the Esc key.**

 That undoes the selection so you can start over or switch to another tool if you decide you don't want to crop after all.

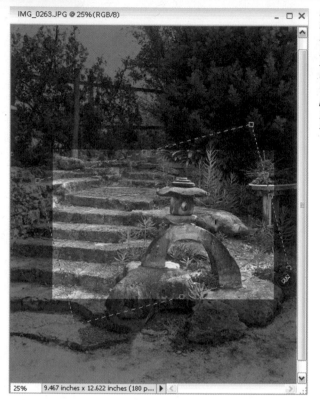

IMG_0263.JPG @ 25%(RGB/8)

25% 9.467 inches x 12.622 inches (180 p...

Figure 10-11:
If you want to change your selection from horizontal to vertical, or vice versa, then just move your cursor outside the cropped area and you'll see the rotation arrows (circled). Grab and rotate them, the same way you would an entire photo. Changing your selection doesn't rotate your photo—just the boundaries of the crop. When you're done, press Enter to tell Elements you're satisfied.

4. **When you're sure you've got the crop you want, press Enter.**

 Alternatively, click the OK (checkmark) symbol on the photo, or double-click inside the cropping mask. You're done!

Cropping Your Image to an Exact Size

You don't have to eyeball things when cropping a photo. You can enter any dimensions you want in the width and height boxes in the Options bar, or, from the Aspect Ratio menu, you can choose one of the Presets, which automatically enters a set of numbers for you. The Aspect Ratio menu offers you several standard photo sizes, like 4×6 or 8×10, to choose from. The "Use Photo Ratio" choice in the Presets list lets you crop your image using the same width/height proportions (aspect ratio) as in the original.

> **WARNING** If you enter a number in the Resolution box that's different from your image's current resolution, then the Crop tool resamples your image to match the new resolution, as you'll see when you learn about resizing later in this chapter. See "Resampling" on page 231 to understand why resampling isn't always a good thing.

Crop Tool Idiosyncrasies

The Crop tool is crotchety sometimes. People have called it "bossy," and that's a good word for it. Here are some settings that may help you control it better:

- **Snap to Grid**. You may find that you just can't get the crop exactly where you want it. Does the edge keep jumping slightly away from where you put it? Like most graphics programs, Elements uses a grid of invisible lines—called the *autogrid*—to help position things exactly. Sometimes a grid is a big help, but in situations like this, it's a nuisance.

If you hold down Ctrl, you can temporarily disable the autogrid. To get rid of it permanently, or to adjust the spacing on it, go to the View menu and turn off Snap to Grid. You can adjust the grid settings in Preferences → Grid.

- **Clear the Crop Tool**. Occasionally you may find that the Crop tool won't release a setting you entered, even after you clear the Options bar boxes. If the Crop tool won't let you drag where you want and keeps insisting on creating a particular sized crop, click the Crop icon on the left side of the Options bar, and then choose "Reset tool" from the pop-up menu.

Cropping with the Marquee Tool

The Crop tool is very handy, but it wants to make the decisions for you about several things you may want to control yourself. For instance, the Crop tool may decide to resample (page 231) the image whether you want it to or not. The Crop tool gives you no warning that it's resampling. It just does it.

For better control, and also for making elliptical crops (great for oval vignettes), you may prefer to crop by using the Marquee tool. It's no harder than using the Crop tool, but you get to make all the choices yourself this way.

There's one other big difference between using the Marquee tool and the Crop tool: with the Crop tool, all you can do with the area you selected is crop it. The Marquee tool, in contrast, lets you do anything else you want to your selected area, like adjust the color, which you may want to do before you crop.

To make a basic crop with the Marquee tool:

1. **In the Toolbox, click the Marquee tool (the little dotted square), or just press M.**

 Figure 10-12 shows you the shape choices you get with the Marquee tool.

Figure 10-12:
Click the Marquee tool, and you can choose the marquee's shape from this menu, or click your choice in the Options bar when the tool is active. They both do the same thing.

2. **Drag the selection marquee across the part of your photo you want to keep.**

 When you let go, your selected area is surrounded by the dotted lines, sometimes called "marching ants," shown in Figure 10-13. The area inside the marching ants is the part of your photo you're keeping.

 If you make a mistake, press Ctrl+D to get rid of the selection and start over.

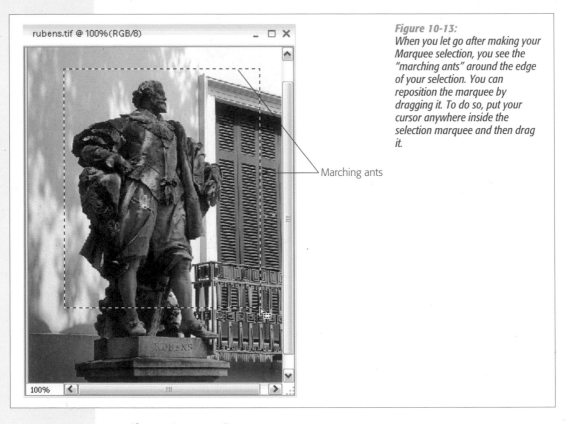

rubens.tif @ 100%(RGB/8)

Marching ants

100%

Figure 10-13:
When you let go after making your Marquee selection, you see the "marching ants" around the edge of your selection. You can reposition the marquee by dragging it. To do so, put your cursor anywhere inside the selection marquee and then drag it.

3. **Choose Image → Crop.**

 The area outside your selection disappears, and your photo is cropped to the area you selected in step 2.

 TIP If you want your selection marquee to be a particular size, then in the Options bar, choose Mode → Fixed Aspect Ratio. Next, enter the proportions you want in the Width and Height boxes. The Marquee will maintain those proportions as you drag.

 You can also crop to exact measurements with the Marquee tool. For example, say you want to print a photo to fit perfectly into a 3×5 frame, or someone asks you to supply a headshot that's exactly one inch square. Here's what to do:

1. **At the bottom of the image window, check your photo's resolution.**

 Make sure the pixels per inch (ppi) number is somewhere between 150 and 300. 300 is best, for reasons explained on page 228.

 TIP If the ppi is too low, choose Image → Resize → Image Size. Change the number in the Resolution box to what you want. Make sure that the checkbox in the Resize dialog box that says "Resample Image" is turned off, and then click OK. See page 231 for more on resampling.

2. **Click the Marquee tool or press M and then choose the Rectangular Marquee tool.**

 Before dragging your cropping marquee, you must tell Elements what size photo you want to end up with.

3. **In the Options bar, choose Mode → Fixed Size. Then, in the Width and Height boxes, enter your dimensions.**

 When you drag, you get a selection the exact size you chose in the Options bar. You can move the marquee around, but you can't resize it.

4. **Drag anywhere in your image. Then choose Image → Crop.**

 Elements crops your photo, exactly as with a marquee you dragged freehand. Difference is, this method gives you total control over the finished size.

 NOTE If you're doing your own printing, there's really no reason to tie yourself down to standard photo sizes unless you need the image to fit in a frame or album that accommodates only that size. You can make your image whatever size and shape looks attractive—square, tall and skinny, or whatever—and cut the paper later. And when sizing images for the Web, you can be truly inventive.

Changing the Size of Your Photos

Resizing your photo brings you up against a pretty tough concept in digital imaging: *resolution*, which measures, in pixels, the amount of detail your image can show. Especially confusing is the fact that the resolutions you want for printing and for onscreen use (like email and the Web) are quite different. That's because it takes many more pixels to create a good-looking print than you need for a photo that's going to be viewed only onscreen. A photo that's going to print well almost *always* has too many pixels in it for onscreen display, and as a result, its file size is usually pretty hefty for emailing. Often, you need to make *two* copies of your photo for the two different uses.

This section gives you a brief introduction to both screen and print resolution and explains the decisions you need to make when using the Resize Image dialog box. You'll also learn how to add more *canvas* (blank space) around your photos (to make room for a caption below a picture, for instance).

 TIP If you want to know more about resolution, a good place to start is *www.scantips.com*.

Resizing Images for Email and the Web

When your photo is destined for viewing onscreen, it should have enough resolution to be clear and easy to view without being oversized. Have you ever gotten an emailed photo that was so huge you could see only a tiny bit of it at once? That happens when an image isn't optimized for viewing on a monitor. Today's multimegapixel digital cameras spew out high-resolution images that look great when printed, but you need to reduce them for comfortable onscreen viewing. Fortunately, Elements makes it easy.

> **NOTE** It's much easier to get good results making a photo smaller than larger. Elements lets you *increase* the size of your image, but you may get mediocre results. See "Resampling" on page 231 for the explanation.

To resize photos, you use the Image Size dialog box (Image → Resize → Image Size). As shown in Figure 10-14, this box has two main sections. The top one says Pixel Dimensions, and below that is Document Size. You'll use the Pixel Dimensions settings when you know your image is going to be viewed only onscreen. (Document Size is for printing.)

Figure 10-14:
The Pixel Dimensions section of the Image Size dialog box contains the settings you'll need when preparing a photo for onscreen viewing. The number immediately to the right of Pixel Dimensions (14.1 M) indicates the current size of your file in megabytes. The Document Size section has the settings you'll use when you want to prepare photos for printing.

A monitor is concerned only with a photo's *pixel dimensions*. On a monitor, a pixel is always the same size (unlike a printer, which can change the size of the pixels it prints out). Your monitor doesn't know anything about pixels per inch (ppi), and it can't change the way it displays a photo even if you change the photo's ppi settings, as shown in Figure 10-15. (It's true that graphics programs like Elements can change the size of your onscreen view by, say, zooming in, but most programs, like your Web browser, can't.) All you have to decide is how many pixels long and how many pixels wide you want your photo to be. You control those measurements in the Pixel Dimensions section of the Image Size dialog box.

The dimensions you choose may vary, depending on who's going to be seeing your photos, but as a general rule, small monitors today are 1024 × 768 pixels. Of course, some monitors, like the largest Dell and NEC models, have many more pixels than that. Still, if you want to be sure that everyone who sees your photo won't have to scroll, then a good rule of thumb is to choose no more than 650 pixels for the longer side of your photo, whether that's the width or the height.

Figure 10-15:
This screenshot demonstrates how your monitor doesn't care about the ppi settings you enter. One of these photos was saved at 100 ppi, the second at 300 ppi, and the last at 1000 ppi. Can you tell which? No. They all display at exactly the same size on your monitor, because they all have exactly the same pixel dimensions, which is the only resolution setting your monitor understands.

NOTE To get the most accurate look at how large your photo truly displays on a monitor, choose View → Actual Pixels.

Also, although a photo is always the same pixel dimensions, you really can't control the exact inch dimensions at which those pixels display on other people's monitors. A pixel is always the same size on any given monitor, but different monitors have different sized pixels these days. Figure 10-16 illustrates this concept.

To resize your photos, start by making sure you're not resizing your original. You're going to be shedding pixels that you can't get back again, so resize your photos on a copy (File → Duplicate). Then follow these steps:

1. **Call up the Image Size dialog box.**

 Go to Image → Resize → Image Size.

2. **In the Pixel Dimensions area, enter the dimension you want for the longer side of your photo.**

 Usually you'd want 650 pixels or less. Be sure that pixels show as the unit of measurement. You just need to enter the number for one side. Elements figures it out for the other side as long as "Constrain Proportions" is turned on down

near the bottom of the dialog box. (You need to turn on "Resample Image" before you can change the pixel dimensions.)

Figure 10-16:
Both these computers have a screen resolution of 1024 × 768 pixels, and the photo they're displaying takes up exactly the same percentage of each screen. But the picture on the left is larger because the monitor is physically larger–in other words, the pixels are bigger.

3. **Check the settings at the bottom of the dialog box.**

 Constrain Proportions should be turned on. (Scale Styles doesn't matter. Leave it on.) Resample Image should be turned on; see page 231 for more on how resampling works. Choose Bicubic Sharper from the pull-down menu. Adobe recommends Bicubic Sharper when you're making an image smaller, but you may want to experiment with the other menu options if you don't like the results you get when using Bicubic Sharper.

4. **Click OK.**

 Your photo is resized, although you may not immediately see a difference onscreen. Choose View → Actual Pixels, before and after you resize, and you can see the difference.

5. **Save your resized photo to make your size change permanent.**

 If you're concerned about file size, use Save for Web (File → Save for Web), which helps you create even smaller files.

 TIP Sometimes Elements resizes for you–for example, when you use Attach to E-mail or the Organizer's E-Mail command (see page 330). But the method described here gives you more control over your results than letting Elements make your decisions for you.

Resizing for Printing

If you want great prints, you need to think about your photo's resolution quite differently than you do for images that you're emailing. For printing, as a general rule, the more pixels your photo has, the better. That's the reason camera manufacturers keep packing more megapixels into their new models—the more pixels you have, the larger you can print your photo and still have it look terrific.

NOTE Even before you take your photos, you can do a lot toward making them print well if you always choose the largest size and the highest quality setting (typically extra fine, superfine, or fine) on your camera.

When you print your photo, you need to think about two things: the size of your photo in inches (or whatever your preferred unit of measurement is) and the resolution in pixels per inch (ppi). Those settings work together to control the quality of your print.

Your printer is a virtuoso that plays your pixels like an accordion. Your printer can squeeze the pixels together and make them smaller, or spread the pixels out and make them larger. Generally speaking, the denser your pixels, the higher your ppi. The higher the resolution of your photo is, the better it looks.

If you don't have enough pixels in your photo, the print appears pixelated—very jagged and blurry looking. The goal is to have enough pixels in your photo so that they'll be packed fairly densely—ideally at about 300 ppi.

The ppi setting is critical for getting a good print. If you try to print a photo at 72 ppi it usually looks terrible, because the pixels just aren't dense enough. 300 ppi is considered optimum. You usually don't get a visibly better result if you go over 300 ppi, just a larger file size. Depending on your tastes, you may be content with your results at a lower ppi. For instance, some Canon camera photos come into Elements at 180 ppi, and you may be happy with how they print. Figure 10-17 demonstrates why it's so important to have a high ppi setting.

NOTE Your printer has its own resolution settings, which are measured in dots per inch (dpi). The printer's resolution setting isn't the same as your image resolution. Your 300 ppi photo will usually look much better at a very high dpi, but dots don't directly equate to pixels in your image. If your printer prints at 2400 dpi, you still need only a 300 ppi image to start with.

To set the size of an image for printing:

1. **Call up the Image Size dialog box.**

 Go to Image → Resize → Image Size.

2. **Check the resolution of your image.**

 You want to look at the Document Size section of the dialog box. Start by checking the ppi setting. If it's too low, like 72 ppi, then go to the bottom of the dialog box and turn off Resample Image. Then, in the Document Size area, enter the ppi you want. The dimensions should become smaller to reflect the greater density of the pixels. If they don't, click OK and then open the dialog box again.

3. **Check the physical size of your photo.**

 Look at the numbers in the Document Size area. Are they what you want? If so, then you're all done. Click Okay.

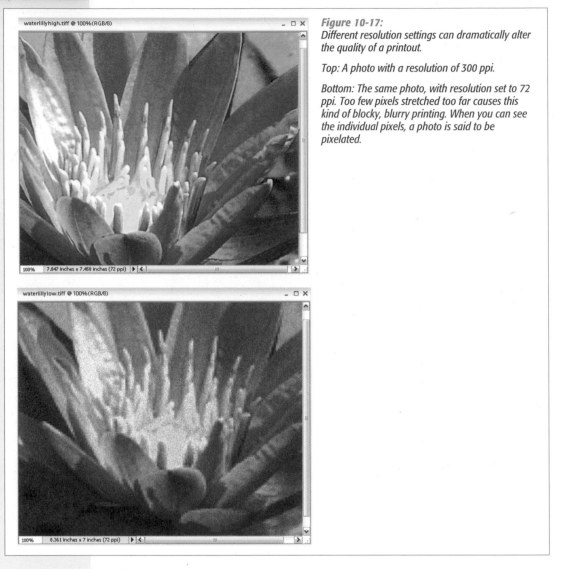

Figure 10-17:
Different resolution settings can dramatically alter the quality of a printout.

Top: A photo with a resolution of 300 ppi.

Bottom: The same photo, with resolution set to 72 ppi. Too few pixels stretched too far causes this kind of blocky, blurry printing. When you can see the individual pixels, a photo is said to be pixelated.

4. **If your size numbers aren't right, resize your photo.**

If the proportions of your image aren't what you want, crop the photo using one of the methods described earlier, and then come back to the Image Size dialog box. Don't try to reshape an image using the Image Size dialog box.

Once you've returned to the Image Size dialog box, go to the bottom of the window and turn on Resample Image. Choose Bicubic Smoother in the menu. (This menu choice is Adobe's recommendation, but you may find that you prefer one of the other resampling choices.)

Now enter the size you want for the width or height. Make sure that Constrain Proportions is turned on. If it is, Elements calculates the other dimension for you. (Scale Styles doesn't matter. Leave it on.)

5. **Click OK.**

Your photo is resized and ready for printing.

Resampling

Resampling means changing the number of pixels in an image. When you resample, your results are permanent, so you want to avoid resampling an original photo if you can help it. As a rule, it's easier to get good results when you *downsample*, that is, make your photo smaller, than when you *upsample*, which you do when you want to make your photo larger.

When you upsample, you're *adding* pixels to your image. Elements has to get them from somewhere—so it makes them up. All things considered, Elements is pretty good at filling in the blanks, but these pixels are never as good as the pixels that were in your photo to begin with, as you can see from Figure 10-18. You can download the photo file (russian_box.jpg) from the "Missing CD" page at *www.missingmanuals.com* if you'd like to try resampling for yourself. Zoom in very closely so you can see the pixels.

Figure 10-18:
Here's a close-up look at what you're doing to your photo when you resample it.

The photo as it came from the camera.

Downsampled to 72 ppi.

Upsampled back to the original resolution. See how soft the pixels look compared to the original?

When you enlarge an image to more than 100 percent of its original size, you'll definitely lose some of the original quality. So, for example, if you try to stretch a photo that's 3" wide at 180 ppi to an 8×10 print, then chances are you won't like the results.

Elements offers you several resampling methods, and they do a very good job when you find the right one for your situation. You select them in the Resample Image menu in the Image Size dialog box. Adobe recommends choosing Bicubic Smoother when you're upsampling (enlarging) your images and Bicubic Sharpener

when you're downsampling (reducing) your photos, but you may prefer one of the
others. Experiment with them all to see which you prefer.

UP TO SPEED

Finding a Size that Fits

Here's a brief list of resolutions you may want to use for different projects. Of course, you're not bound to them, but a good guiding principle to keep in mind is that you can always dump extra pixels if you decide you don't need them. Once you've cut pixels, however, they're gone forever.

- **Scans that will be viewed only onscreen (and not printed)**. 72 ppi is generally considered enough for onscreen viewing. Just remember that when you scan at this low resolution, you won't get a good print at a decent size if you change your mind later on. If there's any chance you'll want to print your image, then you're better off scanning at a print resolution (see the next bullet list item) and then creating a separate, downsized copy for onscreen viewing. Better yet, just look at the pixel dimensions of your scan and forget the ppi entirely.

- **Scans for printing**. 300 ppi is pretty standard, unless you're going to enlarge the image or you need to do a lot of really close editing work on it.

- **Scans to make very large prints**. Try 600 ppi for these.

- **Scans for detailed closeup retouching**. 600 ppi, and then downsample to 300 ppi before you make your final print. The extra pixels give you a more detailed view when zooming way in, but add little or nothing to the print quality.

- **Digital photos to email**. You can get away with the lowest image quality settings on your camera when emailing photos, but you risk kicking yourself later if you happen to get a shot that you want to print.

- **Digital photos for printing**. Use the fine or super-fine settings on your camera and the largest photo size available. You can always size them down later if you don't need all those pixels.

Adding Canvas

Just like the works of Monet and Matisse, your photos appear in Elements on a digital "canvas." Sometimes you may want to add more canvas to make room for text or if you're combining photos into a collage.

To make your canvas larger, choose Image → Resize → Canvas Size. You can change the size of your canvas using a variety of measurements. If you don't know exactly how much more canvas you want, choose Percent. Then you can guesstimate that you want, say, 2 percent more canvas or 50 percent more. Figure 10-19 shows how to get your photo into the right place on the new canvas.

> **NOTE** Changing the size of your canvas doesn't change the size of your picture any more than pasting a postcard onto a full-sized sheet of paper changes the size of the postcard. In both cases, all you get is more empty space around your picture.

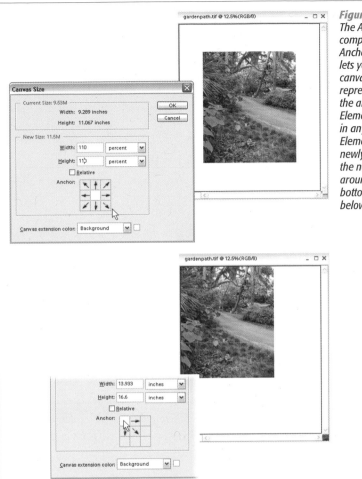

Figure 10-19:
The Add Canvas dialog box isn't as complicated as it looks. The strange little Anchor grid with arrows pointing everywhere lets you decide exactly where to add new canvas to your image. The white Anchor box represents your photo's current position and the arrows surrounding it show where Elements will add the new canvas. By clicking in any of the surrounding boxes, you tell Elements where to position your photo on the newly sized canvas. In the top pair of images, the new canvas has been added equally around all sides of the existing image. In the bottom pair, the new canvas has been added below and to the right of the existing image.

Elements' Quick Fix Tools

Photoshop Elements gives you the same tools to edit your digital photographs that the pros use—but you don't have to be a pro to use them. If you've been envying the one-click fixes available to folks who use free programs like EasyShare and Picasa (covered in Chapter 9) here's some great news: Elements has a Quick Fix window.

With Quick Fix, you can dramatically improve the appearance of a photo with just a click or two. The Quick Fix window gathers together easy-to-use tools that adjust the brightness and color of your photos, make them look sharper, fix red eye, and so on. It's also the only place in Elements that gives you a before-and-after view as you work, just like EasyShare and Picasa. That may keep you coming back to the Quick Fix window even after you master the advanced editing techniques coming up in Chapter 12.

A Tour of the Quick Fix Window

Getting to the Quick Fix window is easy. If you're in the Editor, go to the Shortcuts bar and click the Quick Fix button. If you're in the Organizer, on the Shortcuts bar, click the Edit button's drop-down triangle, and choose "Go to Quick Fix." The Quick Fix window looks like a stripped-down version of the Standard Edit window (Figure 11-1).

> **TIP** If you have several photos open when you come into the Quick Fix window, they appear at the bottom of the screen in an area called the Photo Bin. Just click a thumbnail at the bottom of your screen to choose the one you want to edit. That photo becomes the active image: the one you see in the Quick Fix preview area in the center of your screen.

The Quick Fix Toolbox

The Toolbox holds an easy-to-navigate subset of the larger tool collection that's in the Standard Edit window. All the tools work the same way in both modes, and you can also use the same keystrokes to switch tools here, too.

Three of the tools—Zoom, Hand, and Crop—are the same ones described in Chapter 10. Two others—Magic Selection and Red Eye—are unique to the Quick Fix window. From top to bottom, the Quick Fix Toolbox holds:

- **The Zoom tool** lets you telescope in and out on your image so that you can get a good close look at details or pull back to see the whole photo. See Chapter 10 for full instructions on using this tool. You can also zoom by using the Zoom pull-down menu below the image preview area.

- **The Hand tool.** also covered in Chapter 10, helps move your photo around in the image window—just like grabbing it and moving it with your own hand.

- **The Selection Brush tools** let you apply Quick Fix commands to only a part of your image by selecting the portion you want to work on. You get two options here: Elements' regular Selection brush and the Magic Selection brush. The difference between the two tools is that the Selection brush lets you paint a selection exactly where you want it (or mask out part of your photo to keep it from getting changed), while the Magic Selection brush makes Elements figure out the boundaries of your selection based on your much less precise marks on the image. The Magic Selection brush is much more automatic than the regular Selection brush.

- **The Crop tool** lets you change the size and shape of your photo, by cutting off the areas you *don't* want. See Chapter 10 for a refresher course on cropping.

- **The Red Eye tool** is specially designed to do one thing: take the red out of your subjects' eyes when you click them. Read full details on using it later in this chapter.

The Quick Fix Control Panel

The Control Panel, on the right side of the Quick Fix window, is where you make most of your adjustments. Elements helpfully arranges everything into four palettes—General Fixes, Lighting, Color, and Sharpen—listed in the order you typically use them. In most cases, it makes sense to start at the top and work your way down until you get the results you want. (See page 238 for more suggestions on what order to work in.)

The Control Panel always fills the right side of the Quick Fix screen. There's no way to hide it, but you can expand and collapse the panels, as explained in Figure 11-2.

> **NOTE** If you go into Quick Fix mode *before* you open a photo, you won't see the pointers in the sliders, just empty tracks. Don't worry—they'll automatically appear as soon as you open a photo and give them something to work on.

Figure 11-2:
Clicking any of these triangles collapses or expands that section of the Control Panel. If you have a small monitor and you're bothered by the way the Sharpen slider (not shown here) scrapes the bottom of the window, then close one of the upper sections to bring the Sharpen slider up onto your screen when you need to reach it.

Different Views: After vs. Before and After

When you open an image in Quick Fix, your picture first appears by itself in the main window with the word *After* above it. Elements keeps the Before version—your original photo—tucked away, out of sight. But you can pick from three other different layouts, which you can choose at any time: Before Only, Before and After (Portrait), and Before and After (Landscape). The Before and After views are especially helpful when you're trying to figure out if you're improving your picture—or not—as shown in Figure 11-3. Switch between views by picking the one you want from the pop-up menu just below your image.

> **NOTE** Quick Fix limits the amount of screen space available for your image. If you want a larger view while you work, then click over to Standard Edit. In fact, whenever you're in Quick Fix mode, you can always switch back to the Standard Editor at any point if you want tools or filters not available in Quick Fix. See the next chapter for more details.

Figure 11-3:
*The Before and After
view in the Quick Fix
window makes it easy to
keep an eye on just how
you're changing your
photo. You can use the
Zoom tool to focus in on
just a portion of your
picture.*

Quick Fix Suggested Workflow

The tools in the Quick Fix window are pretty simple to use. You can try one or all of them—it's up to you. And whenever you're happy with how your photo looks, you can leave Quick Fix and go back to the Standard Editor or the Organizer.

No hard and fast rules exist for what order you need to work in when using the Quick Fix tools. But if you're the type of person who likes a set plan for fixing photos, then here's one order in which to apply the commands the Quick Fix has to offer:

1. **Rotate your photo, if necessary.**

 No sense trying to edit an upside down or sideways photo, right? Use the rotate buttons below the image preview, which you can see in Figure 11-3.

2. **Fix red eye, if necessary, as described on page 239.**

 In people pictures, red eye is the most important fix, and sometimes it's the only one necessary. Take care of it now, so if you adjust the color or sharpness later, you'll be starting from eyes that are already the right color.

3. **Try the Auto Smart Fix and/or the Smart Fix slider.**

 See page 240 for detailed instructions on how the Smart Fix works.

4. **If Smart Fix wasn't smart enough, work your way down through the other commands until you like the way your photo looks.**

 See the sections on Lighting (page 242) and Color (page 245) later in this chapter.

5. Sharpen (page 246).

Try to perform sharpening as your last adjustment, because other commands can give you unpredictable results on already-sharpened photos.

6. Crop.

You may also want to crop as a first step sometimes, depending on the photo. If you've got a lot of overexposed sky that you plan to cut out anyway, then you may get better results from the Lighting and Color tools if it's gone already.

NOTE When you click the Quick Fix Reset button, just above your image, your photo returns to the way it looked *before* you started working in Quick Fix. This button undoes *all* Quick Fix edits, so don't use it if you want to undo only a single action. For that, just use the regular undo command: Edit → Undo or Ctrl+Z.

GEM IN THE ROUGH

The Other Red Eye Tool

Elements gives you a totally automatic Red Eye fix right in the Organizer. Just click once on your photo to select it, and then do one of the following:

- Press Ctrl+R.

- Right-click the thumbnail and choose "Auto Red Eye Fix" from the pop-up menu.

- Choose Edit → "Auto Red Eye Fix."

That's it. Elements automatically analyzes your photo to find red eyes, and fixes them without any additional input from you. You may be delighted with the end result, but you're about equally likely to find that Elements also blackened the white teeth in an open mouth or put out any bright streetlights.

In that case, just press Ctrl+Z to undo the fix and go on to the Editor's Quick Fix tool, which is almost as easy and much more accurate.

You can also apply the Auto Red Eye Fix in the Quick Fix window or the Standard Editor. In the Quick Fix window, look for the Auto button in the Red Eye area of the Control Panel. In the Editor, activate the Red Eye tool and click the Auto button in the Options bar.

The advantage to using the Auto Red Eye Fix tool in the Organizer, though, is that you save your corrected photo in a *version set*—a collection of the same photo. If you don't like the correction, just right-click the Organizer thumbnail, and then choose Version Set → Reveal Photos in Version Set, and delete the new version.

Fixing Red Eye

Everyone who's ever taken a flash photo has run into the dreaded problem of *red eye*—those glowing, demonic pupils that make your subject look like someone out of an Anne Rice novel. Red eye is even more of a problem with digital cameras than with film, but luckily, Elements has a simple and terrific Red Eye tool for fixing it. All you need to do is click the red spots with the Red Eye tool, and your problems are solved.

TIP You can try to fix red eye automatically right in the Organizer (see the box above). You'll probably find that the Quick Fix Red Eye tool is much more reliable, though.

To use the Quick Fix Red Eye tool:

1. **Find the photo you want to fix, and then open it in the Quick Fix window, or in the Editor.**

 The Red Eye tool works the same whether you get to it from the Quick Fix Toolbox or the main Toolbox in the Standard Editor.

2. **Use the Zoom tool to magnify the eyes.**

 You can also switch to the Hand tool if you need to drag the photo so that the eyes are front and center.

3. **In the Toolbox, click the Red Eye icon (or press Y).**

 If you need to adjust how the Red Eye tool works, the Options bar gives you two controls, although 99 percent of the time you can ignore them:

 Darken Amount. If the result is too light, then increase the percentage in this box.

 Pupil Size. Increase or decrease the Pupil Size number to tell Elements how much area to consider part of a pupil.

4. **Using the Red Eye tool in Figure 11-4, click in the red part of the pupil.**

 That's it. Just one click should fix it. If a single click doesn't fix the problem, you can also try dragging over the pupil with the Red Eye tool. Sometimes one method works better than the other.

5. **Repeat the process on the other eye.**

Figure 11-4:
Zoom in when using the Red Eye tool so you get a good look at the pupils. The eye on the left side of this picture has already been fixed. Don't worry if your photo looks so magnified that it loses definition—just make the red area large enough for a bulls-eye. Notice what a good job the Red Eye tool does of keeping the highlights (called catchlights) in the eye that's been treated.

The Smart Fix

The secret weapon in the Quick Fix window is the Smart Fix command, which automatically adjusts a picture's lighting, color, and contrast, all with one click. You don't have to figure anything out. Elements does it all for you.

You'll find the Smart Fix in the General Fixes palette, and it's about as easy to use as hitting the speed dial button on your phone: Click the Auto Smart Fix button, and if the stars are aligned, then your photo looks considerably better. Figure 11-5 gives you a glimpse of the Smart Fix's capabilities. You can download this photo—*finch.jpg*—from the "Missing CD" page at *www.missingmanuals.com* if you want to try these fixes yourself.

Figure 11-5:
Top: This photo is so dark you may think it's beyond help.

Bottom: The Auto Smart Fix button did all this with just one click. (A click of the Auto Sharpening button, explained on page 246, was added to make it look really spiffy.)

If you're happy with the Auto Smart Fix button's changes, you can move onto a new photo, or try sharpening your photo a little (page 246) if the focus appears a little fuzzy. You don't need to do anything to accept the Smart Fix changes.

But if you're not ecstatic with your results, take a good look at your photo. If you like what Auto Smart Fix has done, but the effect is too strong or too weak, press Ctrl+Z to undo it, and try playing with the Smart Fix Amount slider instead. The

Other Red Eye Fixes

The Red Eye tool does a great job most of the time, but it doesn't always work and it doesn't work on animals' eyes (which actually end up looking green in many photos). Elements gives you a couple of other ways you can fix red eye that work in almost any situation. Here's one:

1. From the Editor, zoom way, way in on the eye. You want to be able to see the individual pixels.

2. Use the Eyedropper tool (fourth from the top in the toolbox) to sample the color from a good area of the eye, or from another photo.

3. From the Toolbox, get out the Pencil tool (nested with the Brush tool) and set its size to 1 pixel.

4. Now click in the bad or empty pixels of the eye to replace the color with the correct shade. Remember to leave a couple of white pixels for a catchlight.

This solution works even if the eye is *blown out* (that is, all white with no color information left).

Amount slider does the same thing the Auto Smart Fix does, only *you* control the degree of change.

Watch the image as you move the slider to the right. If your computer is slow, there's a certain amount of lag time, so go slowly to give it a chance to catch up. If you happen to overdo it, sometimes it's easier to press the Reset button above your image and start again. Figure 11-6 explains how to use the checkmark and the cancel button (which appear next to the General Fixes label) to accept or reject your changes.

> **TIP** Usually you get better results with a lot of little nudges to the Smart Fix slider than by moving it way over in one direction.

Sometimes Smart Fix just isn't smart enough to do everything you want it to do, and sometimes it does things you don't want it to do to your photos. The Smart Fix is better with photos that are underexposed than photos that are overexposed, for one thing. Fortunately, you still have several other editing choices to try, and they're covered in the following sections. If you don't like what Smart Fix has done to your photo, then undo it before going on to make other changes.

> **NOTE** In the Standard Editor, you can find the Smart Fix commands in the Enhance Menu: Enhance → Auto Smart Fix (Ctrl+M), and Enhance → Adjust Smart Fix (Ctrl+Shift+M). In the Organizer, select a photo and choose Edit → Auto Smart Fix (Ctrl+Alt+M), or right-click it and choose Auto Smart Fix from the shortcut menu.

Adjusting Lighting and Contrast

The Lighting palette lets you make very sophisticated adjustments to the brightness and contrast of your photo. Sometimes problems that you thought stemmed from exposure or even focus may right themselves with these commands.

Figure 11-6:
When you move a slider in any of the Quick Fix palettes, the cancel and checkmark buttons appear in the palette you're using. Click the Cancel symbol to undo the last change you made, or click the checkmark (Accept) to apply the change to your image. If you make multiple slider adjustments, then clicking the Cancel symbol undoes everything you've done since you clicked Accept. So, once you click Accept, the only way to back out is to click Reset (or press Ctrl+Z) and start over.

Levels

If you want to understand how Levels really works, you're in for a long technical ride. On the other hand, if you just want to know what it can do for your photos, the short explanation is that it adjusts the brightness of your photo by redistributing the color information; Levels changes (and hopefully fixes!) both brightness and color at the same time.

If you've never used any photo-editing software before, this may sound rather mysterious, but photo-editing pros can tell you that Levels is one of the most powerful commands for fixing and polishing up your pictures. To find out if its magic works for you, click the Auto Levels button. Figure 11-7 shows what a big difference Levels can make to your photo. Download this photo (*squirrel.jpg*) from the "Missing CD" page at *www.missingmanuals.com*, if you'd like to try this out yourself.

Figure 11-7:
A quick click of the Auto Levels button can make a very dramatic difference in how vivid your photo is.

Left: The original photo of the squirrel isn't bad, so you may not realize how much better the colors could be.

Right: This image shows how much more effective your photo is once Auto Levels has balanced the colors.

What Levels does is very complex. See Chapter 12 for lots more information about what's going on behind the scenes with Levels and how you can apply this command much more precisely.

Contrast

The main alternative to Auto Levels in Quick Fix is Auto Contrast. Most people find that their images tend to benefit from one or the other of these options. Contrast adjusts the relative darkness and lightness of your image without changing the color, so if Levels made your colors go all goofy, try adjusting the contrast instead. You activate Contrast just as you do the Levels tool: simply click the Auto button next to its name.

Shadows and Highlights

The Shadows and Highlights tools do an amazing job of bringing out the details that are lost in the shadows or bright areas of your photo. Figure 11-8 shows what a difference these tools can make.

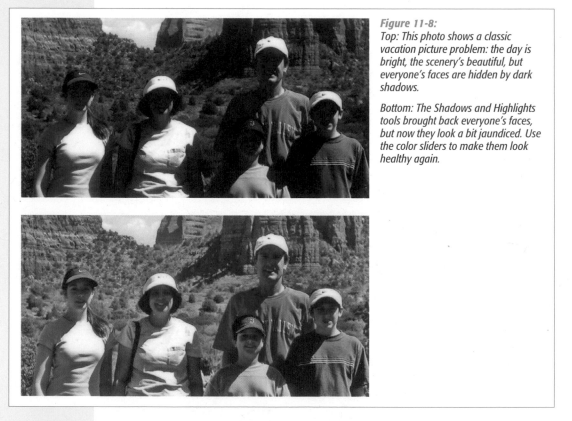

Figure 11-8:
Top: This photo shows a classic vacation picture problem: the day is bright, the scenery's beautiful, but everyone's faces are hidden by dark shadows.

Bottom: The Shadows and Highlights tools brought back everyone's faces, but now they look a bit jaundiced. Use the color sliders to make them look healthy again.

Go easy. Getting overenthusiastic can give your photos a very washed out, flat look. The Shadows and Highlights tools are a collection of three sliders, each of which controls a different aspect of your image:

- **Lighten Shadows**. Nudge the slider to the right and you'll see details emerge from murky black shadows.

- **Darken Highlights**. Use this slider to dim the brightness of overexposed areas.

- **Midtone Contrast**. After you've adjusted your photo's shadows and highlights, your photo may be very flat looking with not enough contrast between the dark and light areas. This slider helps you bring a more realistic look back to your photo.

> **TIP** You may think you only need to *lighten* shadows in a photo, but sometimes just a smidgen of Darken Highlights may help, too. Don't be afraid to experiment by using this slider even if you've got a relatively dark photo.

Correcting Color

The Color palette lets you—surprise, surprise—play around with the colors in your image. In many cases, if you've been successful with Auto Levels or Auto Contrast you won't need to do anything here.

Auto Color

Once again, there's another one-click fix available—Auto Color. Actually, in some ways Auto Color should be up in the Lighting section. Like Levels, it simultaneously adjusts color and brightness, but it looks at different information in your photos to decide what to do with them.

When you're first learning to use Quick Fix, you may want to try all three—Levels, Contrast, and Auto Color—to see which generally works best for your photos. Undo between each change and compare your results. Most people find that they like one of the three most of the time, but you don't usually need to apply all three to the same photo.

Auto Color may be just the ticket for your photos, but you may also find that it shifts your colors in strange ways. Give it a click and see what you think. Does your photo look better or worse? If it's worse, just click Reset or press Ctrl+Z to undo it, and go back to Auto Levels or Auto Contrast. If they all make your colors look a little off, or if you want to tweak the colors in your photo, then move on to the Color sliders, which are explained in the next section.

Using the Color sliders

If you want to adjust the colors in your photo without changing the brightness, then check out the Color sliders. For example, your digital camera may produce colors that don't quite match what you saw when you took the picture, or you may have scanned an old print that's faded or discolored, or you may want to change the colors in a photo just for the heck of it. If so, the sliders below the Auto Color button are for you.

You get four ways to adjust your colors here:

- **Saturation** controls the intensity of the color in your photo. For example, you can turn a color photo to black and white by moving the slider all the way to the left. Move it too far to the right and everything glows with so much color that it looks radioactive.

- **Hue** changes the color from, say, red to blue or green. If you aren't looking for realism, you can have some fun with your photos by really pushing this slider to create funky color changes.

- **Temperature** lets you adjust color from cool (bluish) on the left to warm (orange-ish) on the right. Use Temperature for things like toning down the warm glow you see in photos taken in tungsten lighting, or just for fine-tuning your color balance.

- **Tint** adjusts the green/magenta balance of your photo, as shown in Figure 11-9.

You probably won't use all these sliders on a single photo, but you can use as many of them as you like. Remember to click the checkmark that appears in the Color palette if you want to accept your changes. Chapter 12 has much more information about how to use the full-blown Editor in Elements to really fine-tune your image's color.

> **TIP** When you look at the color of the slider's track, it shows you what happens if you move in that direction. So there's less and less color as you go left in the Saturation track, and more and more color to the right. Looking at the tracks can help you know where you want to move the slider.

Sharpening

Now that you've finished your other corrections, it's time to *sharpen*, or improve the focus, of your photo. Most digital camera photos need some sharpening, since the sharpening your camera applies is usually deliberately conservative. Once again, a Quick Fix Auto button is at your service. Give the Auto Sharpen button a try to get things started.

You should understand, though, that the sad truth is that there's really no way to improve the focus of a photo once it's taken. Software sharpening just increases the contrast where the program perceives edges, so using it first can have strange effects on other editing tools and their ability to understand your photo.

If you don't like what Auto Sharpening does (and you very well may not), you can undo it by clicking the Cancel button on the Sharpen palette. Try the slider instead. If you thought the Auto button overdid things, then go very gently with the slider. Changes vary from photo to photo, but usually Auto's results fall at around the 30 to 40 percent mark on the slider.

Figure 11-9:
Top: The greenish tint in this photo is a drastic example of a very common problem caused by many digital cameras.

Bottom: A little adjustment of the Tint slider clears it up in a jiffy. It's not always as obvious as it is here that you need a tint adjustment. If you aren't sure, the sky is often a dead giveaway. Is it robin's egg blue? If the photo's sky is that color and the real sky was just plain blue, then tint is what you need.

NOTE If you see funny halos around the outlines of objects in your photos, or strange flaky spots (making your photo look like it has eczema), those are artifacts from too much sharpening.

Always try to view Actual Pixels (View → Actual Pixels) when sharpening, because that gives you the clearest idea of what you're actually doing to your picture. If you don't like what the button does, undo it, and then try the slider. Zero sharpening is all the way to the left. Moving to the right increases the amount of sharpening applied to your photo. As a general rule, you want to sharpen more for photos you plan to print than for images for Web use.

Advanced Photo Retouching with Elements

You may be perfectly happy for a very long time using Elements only in Quick Fix mode (Chapter 11). And that's fine, as long as you understand that you've hardly scratched the surface of what Elements can do for you. Sooner or later, though, you're probably going to run across a photo where your best Quick Fix efforts just aren't good enough. Or you may just be curious to see what else Elements has under its hood.

When you graduate from the Quick Fix to Elements' Standard Edit window, you gain the power to fix everything from exposure problems to those inevitable little blemishes that you—not to mention your subjects—would love to zap away.

Even more important is how Elements can improve your photos' color. Next to resolution and exposure, color is the most important concept in Elements. If you want to get the best possible results from Elements, you need to understand a little about how your camera, computer, and printer think about color. So you'll also learn in this chapter about how Elements—and by extension, you—can manipulate your image's color.

> **NOTE** One chapter can't give all these topics the complete coverage they deserve. It takes a book to do that, and as a matter of fact, there is one: *Photoshop Elements: The Missing Manual*.

Fixing Exposure Problems

Exposure, as you learned in Part 1, refers to the amount of light the sensor in your digital camera receives when you click the shutter. A well-exposed photo shows the largest amount of detail in *all* parts of your image—light and dark. In a properly

exposed photo, shadows aren't just pits of blackness, and bright areas show more than washed-out splotches of white.

Incorrectly exposed photos are *the* number one problem all photographers face. No matter how carefully you set up your shot and how many different settings you try on your camera, it always seems like the picture you really, really want to keep is the one whose exposure is out of whack.

The Quick Fix commands covered in Chapter 11 can really help, but if you've tried to bring back a picture that's badly over- or underexposed, you've probably run into the limitations of what Quick Fix can do. Enter the Shadow/Highlights command.

<div style="border:1px solid black;padding:8px;">

IN THE FIELD

Avoiding Blowouts

An area of a photo is *blown out* when it's so overexposed that it appears as just plain white—in other words, your camera didn't record any data at all for that area. (Elements isn't all that great with total black, either, but that doesn't happen quite so often.

Most underexposed photos have some tonal gradations in them, even if you can't see them very well.) So when you're taking pictures, remember that it's generally easier to correct underexposure than overexposure.

</div>

The Shadows/Highlights Command

The Shadows/Highlights command is one of Elements' best features. With it, you can zip through corrections that would have been darned near impossible without it. Shadows/Highlights is an incredibly powerful tool for adjusting only the dark or light areas of your photo without messing up the rest of it. Figure 12-1 shows what a great help it can be.

NOTE The Shadow/Highlights dialog box, like most of Elements' advanced fixes dialog boxes, has a preview checkbox, which lets you watch what's happening to your image as you adjust the settings. It's a good idea to keep these checkboxes turned on so you can make sure you like the changes you're making.

The Shadows/Highlights tool is very easy to use, because you just go by what you're seeing. Here are the specifics:

1. **Open your poorly lit photo in the Editor, and then choose Enhance → Adjust Lighting → Shadows/Highlights.**

 Your photo immediately becomes about 30 shades lighter. Don't panic. As soon as you select the command, the Lighten Shadows setting automatically jumps to 25 percent, which is way too much for about 80 percent of your photos. Just shove the slider back to 0 to undo this change before you start making your corrections.

Figure 12-1:
Shadows/Highlights can bring back details from photos where you were sure there was no information at all.

Top: The original photo suffers from a severe case of extreme backlighting.

Bottom: The Shadows/Highlights tool brings out the hidden detail and reduces the background glare. If you look closely at the mouths of the bells and the wooden supports just below them, you can see the kind of noise (graininess) that often lurks in underexposed areas. To fix those problems, try tweaking the saturation (page 268).

2. **Move the Lighten Shadows and Darken Highlights sliders around until you like what you see.**

Lighten Shadows makes the dark areas of your photo lighter, and Darken Highlights makes the light areas darker. Dragging the slider to the right increases the effect for either one.

NOTE You may to want to add a smidgen of the opposite tool to balance things out a little. In other words, if you're lightening shadows, you may get better results by giving the Darken Highlights slider a teeny nudge, too.

3. **After adjusting the shadows and highlights, move the Midtone Contrast slider to the right, if necessary, to increase the contrast in your photo.**

 Midtone Contrast is there because your photo may look kind of flat after you're done with Shadows/Highlights, especially if you've made big adjustments.

4. **Click OK when you're happy.**

NOTE If your photo's colors look a bit washed out after you use the Shadows/Highlights tool (making everyone look like they've been through the laundry too many times) you can adjust the color saturation. You can do so either in Quick Fix (Chapter 11) or in the Standard Editor (see "Making Your Colors More Vibrant" later in this chapter).

Sharpening Your Images

Digital cameras are wonderful, but often it's hard to tell how well you've focused until you download the photos to your computer. And due to the way digital sensors process information, most digital pictures can usually be improved with a little dose of *sharpening*—a tricky maneuver whereby Elements appears to improve your image's focus. Understand, when Elements sharpens your photo, it doesn't magically correct the focus. Instead, it deepens the contrast where colors meet, giving the image a crisper appearance.

Most of the time, the best way to sharpen an image is by using the sharpening *filters.* (Filters are high-powered, but easy to use Elements tools which changes a specific aspect of a photo's appearance.) If you go to Filter → Sharpen, your choices are Sharpen, Sharpen Edges, Sharpen More, and Unsharp Mask. As well as having the most counterintuitive name in all of Elements, the Unsharp Mask (Figure 12-2) is actually by far the most capable and versatile of the sharpening tools. (See the box on page 253 for more information.)

The other sharpen filters aren't complete slouches—they're just not as good as the mighty Unsharp Mask. Here's what they do:

- **Sharpen**, just as the name says, sharpens your image, but you have no control over anything. It's a take-it-or-leave-it command with no adjustments. You can apply it repeatedly to build up the effect.

- **Sharpen Edges** finds areas where significant color changes occur and sharpens the adjacent pixels. This filter tries to work only on edges (that is, where two contrasting colors meet), without affecting the overall smoothness of the photo. Once again, there are no controls to let you tweak its effects.

Figure 12-2:
Left: This photo was sharpened with the Sharpen filter. It's not bad, but it's not much different from the way the photo came from the camera, either.

Right: This photo was treated with a dose of Unsharp Mask. Notice how much clearer the individual hairs in the dog's coat are and how much better defined its eyes and mouth are.

- **Sharpen More** applies a more intense filter than the Sharpen filter. It's basically pretty similar to the Sharpen filter with the settings raised a bit. Depending on your photo, it may not make much difference, or it may sharpen it to the point where you start to see *artifacts* (tiny colored specks).

TIP For best results, do all your other corrections and changes before applying any of Elements' sharpening tools. Sharpening can cause unpredictable results in subsequent adjustments, so always sharpen as the very last step. A good rule to remember is "last and once." Applying sharpening repeatedly degrades your image's quality.

FREQUENTLY ASKED QUESTION

The Sharp Unsharp Mask

Why, oh why, is Unsharp Mask on the same menu with the sharpening tools? It sounds exactly like what I don't *want to do to my photos.*

To be fair, it's not Adobe's fault: *Unsharp mask* is an old photographer's term. Elements' Unsharp Mask is a digital replication of an ingenious darkroom technique. To sharpen film prints, photographers would create a blurred negative, and then lay it over the original negative. When light passed through the layered negatives onto photo paper, the images combined to create a single image with more clearly defined lines and edges.

Thus, placing an unsharp mask over the original image actually creates a *sharper* image.

Behind the scenes, Elements' Unsharp Mask feature does the very same thing—digitally. It creates a slightly blurred image of your photo and then compares that image to the original. The extra information generated by comparing two slightly different images helps Elements calculate where the lines and edges in your photo should fall. This technique sharpens photos better and more realistically, so stop worrying about the name and just use it.

Applying the Unsharp Mask

While there's nothing wrong with the other sharpening tools, the Unsharp Mask is so powerful that you can get by without ever trying the others. It ranks right up there with Levels (covered later in this chapter) as a contender for most useful tool in Elements. The Unsharp Mask is the only sharpening tool that gives you any control over how much it sharpens, and that's crucial.

When you're ready to apply the Unsharp Mask:

1. **Open your photo in the Editor, and then choose Filter → Sharpen → Unsharp Mask.**

 In the Preview window, you can zoom in and out and grab the photo to get a good view of the part you're most worried about sharpening.

2. **Move the sliders until you like what you see.**

 The Unsharp Mask window gives you three sliders. You'll probably need to do a bit of experimenting to find out which settings work best for you:

 Amount tells Elements how much to sharpen, in percent terms. A higher number means more sharpening.

 Radius tells Elements how far from an edge Elements should look when increasing the contrast.

 Threshold controls how different a pixel needs to be from the surrounding pixels before Elements should consider it an edge and sharpen it. If you leave the threshold at zero, the standard setting, Elements sharpens all the pixels in an image.

3. **When you're satisfied, click OK.**

Fixing Blemishes: An Introduction

It's an imperfect world, but in your photos, it doesn't have to be. Elements gives you some amazing tools for fixing the flaws in your subjects. You can erase crows' feet and blemishes, eliminate power lines in an otherwise perfect view, or even hide objects you wish weren't in your photo. Not only that, but these same tools are great for fixing problems like tears, folds, and stains. With a little effort, you can bring back photos that seem beyond help. Figure 12-3 shows an example of the kind of restoration you can accomplish with a little persistence and Elements.

Elements gives you three main tools for this kind of work: The Spot Healing brush, the Healing brush, and the Clone Stamp. You can find all of them in the toolbox.

Spot Healing brush

The Spot Healing brush is the easiest way to repair your photo. Just drag over the area you want to fix. Elements searches the surrounding area and blends that

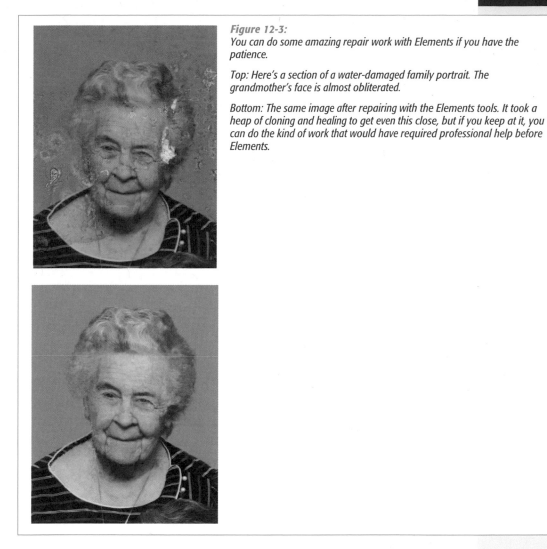

Figure 12-3:
You can do some amazing repair work with Elements if you have the patience.

Top: Here's a section of a water-damaged family portrait. The grandmother's face is almost obliterated.

Bottom: The same image after repairing with the Elements tools. It took a heap of cloning and healing to get even this close, but if you keep at it, you can do the kind of work that would have required professional help before Elements.

information into the bad spot, making it indistinguishable from the background. It usually works best on small areas, because if there's contrasting material too close to the area you're trying to fix, it can unintentionally get pulled into the repair.

To use the Spot Healing brush:

1. **In the toolbox, click the Healing brush icon (the band-aid), and choose the Spot Healing brush from the pop-up menu.**

 Alternatively, press J and choose the Spot Healing brush in the Options bar.

2. **In the Options bar, you can choose a brush size (the number of pixels the brush covers).**

 Choose a size that's the minimum width you need to cover the flaw.

3. **Click the bad spot.**

If the brush doesn't quite cover the flaw, drag over the area.

4. **When you release the mouse button, Elements repairs the blemish.**

You won't see any change to your image while you drag; only after you let go.

Healing brush

The Healing brush works similarly to the Spot Healing brush, only you tell the Healing brush the part of your photo to use as a source for the material you want to blend in. The Healing brush is more flexible than the Spot Healing brush, and better suited to large areas, because you don't have to worry about inadvertently dragging in contrasting details that are near to the area you're fixing.

To use the Healing brush:

1. **In the toolbox, click the Healing brush icon (the band-aid).**

Alternatively, press J and choose it from the Options bar. When you activate the Healing brush, you see a number of doodads in the Options bar. For most retouching purposes, the only one you have to worry about is the Mode menu.

2. **In the Options bar, choose Normal or Replace from the Mode menu.**

Normal is usually the best choice. Sometimes, though, your replacement pixels may make the area you work on a visibly different texture than the surrounding area. In that case, choose Replace, which preserves the grain of your photo.

3. **Find a good spot in your photo to use for the repair. Alt-click it to tell Elements to use this spot as a sample.**

When you click the good spot, your cursor temporarily turns into a circle with crosshairs.

4. **Using the circle cursor, drag over the area you want to repair.**

You can see where Elements is sampling the repair material from: It's marked with a cross.

5. **When you release the mouse button, Elements blends the sampled area into the problem area.**

You may not see anything happen after you let go. Be patient. It takes Elements a few seconds to perform its magic. If you don't like the results, press Ctrl+Z and start over.

The Clone Stamp

The Clone Stamp offers another way to make repairs. It works like the Healing brush in that you sample a good area and apply it to the area you want to fix. But instead of *blending* the repair in, the Clone Stamp *covers* the bad area with the

replacement. The Clone Stamp is best for situations when you want to completely hide the underlying area, as opposed to letting any of what's already there blend into your repair (which is how things works with the Healing brushes). The Clone Stamp is also your best option when you want to create a realistic copy of detail that's elsewhere in your photo. You can clone over some leaves to fill in a bare branch, or replace a knothole in a fence board with good wood, for instance.

To use the Clone Stamp:

1. **In the toolbox, click the rubber stamp icon.**

 Be careful not to choose the Pattern Stamp (the checkerboard), which is on the Clone Stamp's pop-up menu.

2. **On the Options bar, choose a brush size that's just big enough to get a sample without picking up any details you don't want to use in your repair.**

 It's the same deal as picking a size for the Spot Healing brush, described on page 254.

3. **Find the spot in your photo you want to repair.**

 You may have to zoom in close.

4. **Find a good spot to clone as a replacement for the bad spot. Alt+click it.**

 You want an area that's the same tone as the area you're fixing. Unlike the Healing brush, the Clone Stamp doesn't do any blending, so it pays to be precise.

5. **Using the circle cursor, click the spot you want to cover.**

 A cross remains behind on the spot you cloned from.

6. **Keep clicking until you've covered the flaw.**

 What you see as you click is what you get. Elements doesn't do any blending for you, so you have more control than with the Healing brush tools.

Correcting the Colors on Your Screen

You want your photos to look as good as possible and to have beautiful, breathtaking color, right? That's probably one of the reasons you bought Elements. But now that you've got the program, you're having a little trouble getting things to look the way you want. Do either of these situations sound familiar?

- Your photos look great onscreen but your prints are washed out, too dark, or the colors are all a little wrong.

- Your photos look just fine in other programs like Word or Windows Explorer, but they look just awful in Elements.

To paraphrase that old romantic chestnut: It's not you, it's Elements. As a *color-managed* program, Elements uses your monitor for guidance when displaying the

Dust and Scratches

Scratched, dusty prints can create giant headaches when you scan them. Cleaning your scanner's glass helps, but lots of photos come with plenty of dust marks already in the print. A similar problem is caused by *artifacts*, blobbish areas of color caused by JPEG compression. For instance, if you take a close look at the sky in a JPEG photo, you may see lots of little distinct clumps of each shade of blue.

The Healing brushes are usually your best first line of defense for fixing these problems, but if the specks are very widespread, Elements offers a couple of other options you may want to try.

The first is the JPEG artifacts option in the Reduce Noise filter (Filter → Noise → Reduce Noise).

Hopefully, that should take care of things.

If it doesn't, other possible solutions include the Despeckle filter (Filter → Noise → Despeckle), which is sometimes effective for JPEG artifacts. If that doesn't get everything, you can undo it and try the Dust and Scratches filter (Filter → Noise → Dust and Scratches), or the Median Filter (Filter → Noise → Median). The Radius setting for these last two filters tells Elements how far to search for dissimilar pixels for its calculations. Keep that number as low as possible. The downside to the filters in this group is that they smooth things out in a way that can make your image look blurred. Generally, Despeckle is the filter that's least destructive to your image's focus.

colors in your photos. Most programs pay no attention to what your monitor thinks, but a color-managed application like Elements relies on the *profile*—the information your computer stores about your monitor's settings—when it decides how to print or display a photo onscreen. If that profile isn't accurate, then neither is the color in Elements.

So you may need to *calibrate* your monitor, which is a way of adjusting its settings. Before you fine-tune the colors in your photos, it pays to make sure what you see onscreen accurately reflects the colors in your final print. A properly calibrated monitor makes all the difference in the world for getting great-looking results.

Getting Started with Calibrating

Calibrating a monitor sounds horribly complicated, but it's actually not that difficult and it's even kind of fun. You get an added benefit in that your monitor may look about a thousand times better than you thought it could. Calibrating may even make it easier to read text in Word, for instance, because the contrast is better.

When you install Elements, Adobe gives you the Adobe Gamma Utility to calibrate your monitor. To get to it, choose Start → Control Panel → Appearance and Themes → Adobe Gamma. Click the utility and follow the onscreen directions. Figure 12-4 shows you the Adobe Gamma window.

Figure 12-4:
Despite its intimidating name, the Adobe Gamma Utility is actually fairly easy to use, as you can see from this straightforward first screen. Choose the wizard if you've never calibrated your monitor before. If you want a step-by-step guide to using the Adobe Gamma Utility, Photoshop guru Ian Lyons has an excellent tutorial on his Web site at www.computer-darkroom.com/ps8_colour/ps8_2.htm. (It was written for Photoshop, but Adobe Gamma works the same no matter which program you use.)

NOTE If you have an LCD (flat panel) monitor, here's a bit of bad news: Adobe didn't design Adobe Gamma to work with your type of monitor. The good news is that sometimes Adobe Gamma does help (despite Adobe's claims). It's certainly worth a try, and the odds are that you can improve your view at least a little, even if you can't make it perfect. If that doesn't help, you may want to try (read: buy) a third-party monitor-calibrating solution.

Taking Control with Levels

People who've used Elements for a while will tell you that the Levels command goes right at the top of any list of the program's most essential tools. You can fix an amazing array of problems simply by adjusting the level of each *color channel*. Here's how color channels work: On your monitor, each color you see is composed of red, green, and blue. In Elements, you can make very precise adjustments to your images by adjusting these color channels separately.

Just as its name suggests, Levels adjusts the level of each color within your image. There are several different adjustments you can make using Levels, from general brightening of your colors to fixing a color cast. Most digital photo enthusiasts treat every picture they take to a dose of Levels, because there's no better way to polish up the color in your photo.

The way Levels works is fairly complex, but here's a brief overview: Start by thinking of the possible range of brightness in any photo on a scale from 0 (black) to 255 (white). Some photos may have pixels in them that fall at both those extremes, but most photos don't. And even the ones that do may not have the full range of brightness in each individual color channel. Most of the time, there's going to be some empty space at one or both ends of the scale.

When you use Levels, you tell Elements to consider the range of colors available in *your* photo as the *total* tonal range it has to work with. Elements redistributes your colors accordingly. Basically, you just get rid of the empty space at the ends of the

Choosing a Color Space

A color space is a standard set of color definitions. For example, when someone says "green," what do you envision: a lush emerald color, a deep forest, or a bright lime? Choosing a color space ensures that everything—Elements, your monitor, your printer—sees the same colors the same way. When you choose a color space, you tell Elements which set of standards you want it to apply to your photos. There are only two color spaces that you need to concern yourself with in Elements: sRGB and Adobe RGB.

If you're perfectly happy with the color you see on your monitor in Elements and you like the prints you're getting, you don't need to make any changes. Otherwise, you can modify your color space in the Color Settings dialog box. Choose Edit → Color Settings, or press Ctrl+Shift+K, and select one of the following

- **No Color Management**. Elements ignores any information that your file already contains, like color space information from your camera, and doesn't attempt to add any color info to the file data. For general use, you're probably best off starting with No Color Management. Then try the others if it doesn't work well for you. By the way, when you do a Save As [File → Save As], don't turn on the checkbox that embeds your monitor's profile into the photo file.

Your monitor profile is best left for the monitor's own use, and it can cause trouble when you try to print the photo.

- **Always Optimize Colors for Computer Screens**. Choose this option and you're looking at your photo in the sRGB color space, which is what most Web browsers use, so this is a good choice for when you're preparing graphics for the Web.

- **Always Optimize for Printing**. This option uses the Adobe RGB color space, which is a wider color space than sRGB. In other words, it allows more gradations of color than sRGB. Many home inkjet printers actually cope better with sRGB or no color management than with Adobe RGB, so despite the note you'll see in the Color Settings dialog box about "best for printing," don't be afraid to try one of the other two settings instead.

- **Let Me Choose.** This option assumes that you're using the sRGB space, but each time you open a file, you see a message box where you can switch to any of the above options on the fly

scale of possibilities. This can dramatically readjust the color distribution in your photo, as you can see in Figure 12-5.

It's much, much easier to use Levels than to understand it, as you know if you've already tried Auto Levels in the Quick Fix window (page 243). That command's great for, well, quick fixes. But if you really need to massage your image, Levels has a lot more under the hood than you can see there. The next section shows you how to get at these settings.

Understanding the Histogram

Before you can get started adjusting Levels, you first need to understand the heart, soul, and brain of the Levels dialog box: the Histogram, as shown in Figure 12-6.

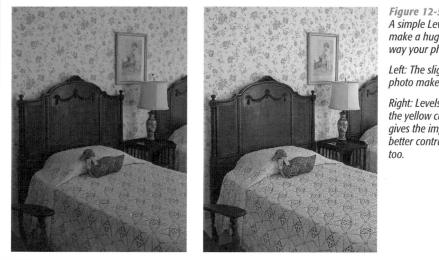

Figure 12-5:
A simple Levels adjustment can make a huge difference in the way your photo looks.

Left: The slight yellow cast to this photo makes everything look dull.

Right: Levels not only got rid of the yellow cast, but the photo also gives the impression of having better contrast and sharpness, too.

Figure 12-6:
One of the scariest sights in Elements, the Levels dialog box is actually your very good friend. If it frightens you, take comfort in knowing that you've always got the Auto button here, which is the same Auto Levels command as in the Quick Fix. But it's worth persevering: the other options here give you much better control over the end results.

The Histogram is the black bumpy mound in the window. It's really nothing more than a bar graph indicating the distribution of the colors in your photo. (It's a bar graph, but there's no space between the bars, which is what causes the mountainous look.)

From left to right, the Histogram shows the brightness range from dark to light (the 0 to 255 mentioned earlier in this section). The height of the "mountain" at any given point shows how many pixels in your photo are that particular brightness. You can tell a lot about your photo by where the mound of color is before you adjust it, as demonstrated in Figure 12-7.

If you look above the Histogram, you can see that there's a little menu that says RGB. If you pull that down, you can also see a separate Histogram for each

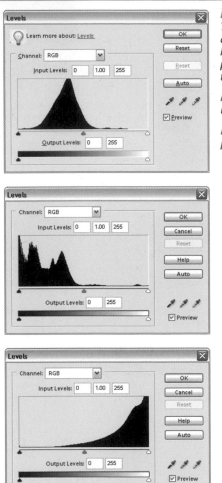

Figure 12-7:
Top: If the bars in your Histogram are all smushed together, your photo doesn't have a lot of tonal range. As long as you like how the photo looks, that's not important. But if you're unhappy with the color in the photo, it's usually going to be harder to get it exactly right than a photo that has a wider tonal distribution.

Middle: If all your colors are bunched up on the left side, your photo is underexposed.

Bottom: If you just have a big lump that's all on the right side, your photo is overexposed.

individual color. You can adjust all three channels at once in the RGB setting (which those in the know call the *luminosity*), or change each channel separately.

The Histogram contains so much information about your photo that Adobe also makes it available in the Editor in its own palette so that you can always see it and use it to monitor how you're changing the colors in your image. The Histogram palette is shown in Figure 12-8. Once you get fluent in reading Histogram-ese, you'll probably want to keep this palette around.

The Histogram is just a graph, and you don't do anything to it directly. What you do when you use Levels is to use the Histogram as a guide so that you can tell Elements what to consider as the white and black points—that is, the darkest and lightest points, in your photo. (Remember, you're thinking in terms of brightness values, not shades of color, for these settings.)

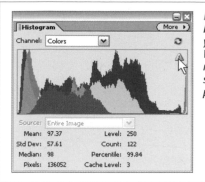

Figure 12-8:
*If you keep the Histogram on your desktop, you can always see what effect
your changes are having on the color distribution in your photo. Choose
Window → Histogram and, if you wish, choose Colors from the pull-down
menu on the palette. (You can't see it here, but this window graphs each color
separately.) To update a Histogram, click the triangle as shown. If you're not a
pro, you can safely ignore the statistical numbers at the bottom of the box.*

Once you've set the dark and light end points, you can adjust the *gamma*—the
tones in between that would appear gray in a black-and-white photo. If that
sounds complicated, it's not—not when you're actually doing it. Once you've
made a Levels adjustment, the next time you open the Levels dialog box, you'll see
that your Histogram now runs the entire length of the scale, because you've told
Elements to redistribute your colors so that they cover the full dark-to-light range.

The next two sections show you—finally!—how to actually adjust your image's
Levels.

> **TIP** Once you learn how to interpret the Histograms in Elements, you can use your knowledge
> out in the field. If your camera has its own histogram display it's the best exposure meter going. To
> avoid blowouts, all you have to do is make sure there's a wee bit of space at the right (highlight)
> end of the histogram. If the histogram has pixels stacked up on the right side, you've blown out a
> bunch of highlights.

Adjusting Levels: The Eyedropper Method

One way to adjust Levels is to set the black, white, and/or gray points by using the
eyedroppers on the right side of the Levels dialog box. It's pretty easy—just follow
these steps:

1. **Choose Enhance → Adjust Lighting → Levels (or press Ctrl+L instead).**

 The Levels dialog box loves to plunk itself down smack in the middle of the
 most important part of your image.

2. **Move the Levels dialog box out of the way so that you get a good view of your
 photo.**

 Just grab it by the top bar and drag it to where it's not covering up a crucial part
 of your photo.

3. **In the Levels dialog box, click the black eyedropper.**

 From left to right, the eyedroppers are black, gray, and white. You can kind of
 see the colors if you look closely.

4. **Move your cursor back over your photo and click an area of your photo that should be black.**

Should be, not *is*. That's a mistake lots of people make the first time they use this tool. They get the gray eyedropper, say, and click a spot that appears gray rather than one that *ought to be* gray.

5. **Repeat with the other eyedroppers for their respective colors.**

In other words, now find a white point and a gray point. That's the way it's supposed to work, but it's not always possible to use all of them in any one photo. Experiment to see what gives you the best-looking results.

> **NOTE** You don't always need to set a gray point. If you try to set it and you think your photo looked better without it, just skip that step.

6. **When you're happy with what you see, click OK.**

When you adjust Levels, you can make sweeping changes to your photo's overall appearance, but don't let that intimidate you. If you mess up, just click the Reset button, and you can start over again.

Adjusting Levels: The Slider Controls

The eyedropper method works fine if your photo has spots that should be black, white, or gray, but a lot of the time, your picture may not have any of these colors. Fortunately, the Levels sliders give you yet another way to apply Levels, and it's by far the most popular method. Using the sliders gives you maximum control over your colors, and it works great even for photos that don't have a white, black, or gray point to click.

If you look directly under the Histogram, you'll see three little triangles, called the Input sliders. The left triangle is the slider for setting the black point in your photo, the right slider sets the white point, and the middle slider adjusts your gamma (gray). You just drag them to make changes to the color levels in your photo, as shown in Figure 12-9.

When you move the left Input slider, you tell Levels, "Take all the pixels from this point down and consider them black." With the right slider, you're saying, "Make this pixel and all higher values white." The middle slider, the gamma slider, adjusts the brightness value that's considered medium gray. All three adjustments improve the contrast of your image.

> **NOTE** If there are small amounts of data—like a flat line at the ends or if all your data's bunched in the middle of the graph—watch the preview in your photo to decide how far toward the mountain you should bring the sliders. Moving it all the way in may be too drastic. Your own taste should always be the deciding factor when you're adjusting a photo.

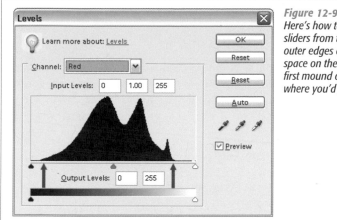

Figure 12-9:
Here's how to use the Levels sliders. You want to move the sliders from the ends of the track until they're under the outer edges of the color data in the graph. If there's empty space on the end, just move the slider until it's under the first mound of data. The red arrows in this figure show where you'd position the outer sliders for this photo.

The easiest way to use the Levels sliders is to:

1. **Choose Enhance → Adjust Lighting → Levels (or press Ctrl+L instead).**

 Drag the Levels dialog box out of the way so that you get a good view of your photo.

2. **On the left side of the Histogram box, drag the Black input slider to the right—if necessary.**

 Move it over until it's under the left-most part of the Histogram that has a "mound" of color in it. If you glance back at Figure 12-9, you'd move the left slider to where the left red arrow is. (Incidentally, although you're adjusting the colors in your image, the Levels Histogram stays black and white no matter what you do—you don't get any color in the dialog box itself.)

 You may not need to move the slider at all if there's already a good bit of data at the end of the Histogram. It's not mandatory to adjust everything every time.

3. **Grab the White slider (the one on the right side) and drag it toward the left.**

 Bring it under the farthest right area of the Histogram that has a mound of data in it.

4. **Now adjust the gray slider.**

 This is called the *gamma* slider and it adjusts the midtones of your photo. Move it back and forth while watching your photo until you like what you see. Gamma makes the most impact on the overall result, so take some time to play with this slider.

5. **Click OK.**

You can adjust your entire image or adjust each color channel individually. The most accurate way is to first choose each color channel separately from the Channel drop-down menu in the Histogram dialog box. Adjust the end points for each channel by itself, and then go back to RGB and tweak just the gamma slider.

The last control you may want to use in the Levels dialog box is the Output Levels slider. Output Levels work roughly the same way as your brightness and contrast controls on your TV. Moving these sliders makes the darkest pixels darker and the lightest pixels lighter. Among pros, this is known as adjusting the *tonal range* of a photo.

Adjusting Levels will improve almost every photo you take, but if your photo has a bad *color cast*—if it's too orange or too blue—you may need something else. The next section shows you how to get rid of unwanted color.

Removing Unwanted Color

It's not uncommon for an otherwise good photo to have a *color cast*—that is, to have all the tonal values shifted so that the photo's too blue, like Figure 12-10, or too orange. You may wind up with a photo like this every once in a while if you forget to change the white balance (page 50), your camera's special setting for the type of lighting conditions you're shooting in (common settings are daylight, fluorescent, and so on).

Figure 12-10:
Left: In an outdoor photo taken with the camera set for tungsten indoor lighting, you get a bluish cast. You can tell the color cast is off because the whole photo appears dark and dingy.

Right: Elements fixes that wicked color cast in a jiffy. This section gives you a complete rundown of all of Elements color cast-fixing tools.

Elements gives you several ways to correct color cast problems:

- **Auto Color Correction** doesn't give you any control over how Elements works, but it often does a good job. To use it, choose Enhance → Auto Color Correction, or press Ctrl+Shift+B.

- **Levels,** as explained earlier, give you the finest control of the methods in this list. You can often eliminate a color cast by adjusting the individual color channels till the extra color's gone (as explained in the previous section). The downside is that Levels can be very fiddly for this sort of work, and one of the other ways may be much faster at getting you the results you want.

- **Remove Color Cast** is the special command for correcting a color cast with one-click ease. The next section explains how to use this tool.

- **The Color Variations** dialog box is helpful in figuring out which colors you need more or less of, but it has some limitations. It's covered later, starting below.

- **The Photo Filter command** gives you much more control than the Color Cast tool, and you can apply Photo Filters as Adjustment layers, too (see page 285).

All these tools are useful for fixing a color cast, depending on exactly what your problem is. Usually you'd start with Levels and then move on to the Color Cast tool or the Photo Filter. (To practice any of the fixes you're about to learn, download the photo heron.jpg from the "Missing CD" page at *www.missingmanuals.com*.)

Using the Remove Color Cast Tool

The Remove Color Cast tool is another eyedropper sampling tool that adjusts the colors in your photo based on the pixels you click. In this case, you show Elements where a neutral color should be. The tool works pretty well when your image has areas that should be black, white, or gray, even if they're very tiny. It may not work if you have an image that doesn't have a good area to sample.

As you saw with the heron in Figure 12-10, the Remove Color Cast command can make a big difference with just one click. To use it:

1. **Choose Enhance → Adjust Color → Remove Color Cast.**

 Your cursor should change to an eyedropper when you move it over your photo. If it doesn't change, go to the dialog box and click the Eyedropper icon.

2. **Click an area that should be plain gray, white, or black.**

 You only have to click once in your photo for this tool to work. As with the Levels eyedropper tool, click an area that *should be* gray, white, or black (as opposed to looking for an area that's currently one of these colors).

3. **Click OK.**

 TIP After using the Remove Color Cast tool, try using the Auto Color Correction command from the Enhance menu. Often this helps put the final touch on color cast removals. If you don't like what it does, just press Ctrl+Z to undo it.

Using Color Variations

The Color Variations window (Figure 12-11) is very appealing to many Elements beginners, because it gives you a visual clue about what to do to fix the color in your photo. You just click the little preview thumbnail that shows the color balance you like best, and Elements applies the necessary change to make your photo look like the thumbnail.

However, Color Variations has some pretty severe limitations, most notably, the microscopic size of the thumbnails. It's very hard to see accurately what you're doing, and even newcomers can usually get better results in Quick Fix (Chapter 11).

Still, Color Variations is useful for those times when you know something's not quite right with your photo's color but you can't figure out exactly what to do about it. And since it's adjustable, Color Variations is good for when you do know what you want but want to make only the tiniest sliver of a difference to the color of your photo.

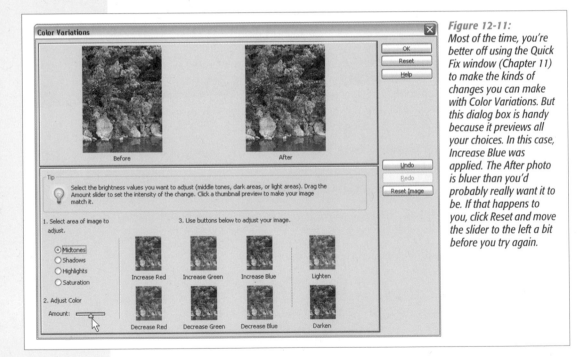

Figure 12-11:
Most of the time, you're better off using the Quick Fix window (Chapter 11) to make the kinds of changes you can make with Color Variations. But this dialog box is handy because it previews all your choices. In this case, Increase Blue was applied. The After photo is bluer than you'd probably really want it to be. If that happens to you, click Reset and move the slider to the left a bit before you try again.

Making Your Colors More Vibrant

Do you drool over the luscious photos in travel magazines—the ones that make regular, non-vacation life seem pretty drab in comparison? What *is* it about those photos that makes things look so dramatic?

A lot of the time the answer is the *saturation*, or the intensity, of the colors. Super-saturated colors make even ordinary landscapes and objects really pop (to use the technical term).

It's not necessary to work on an entire photo when changing its saturation. By increasing the saturation of your subject and decreasing the saturation in the rest of the photo, for example, you can call attention where you want it, even in a crowded picture. Figure 12-12 shows a somewhat exaggerated use of this technique, and you can download the photo (*shelfsitter.jpg*) from the "Missing CD" page at *www.missingmanuals.com* to try it out for yourself.

Figure 12-12:
Top: In this photo, all the little shelfsitter figures are about equal in brightness.

Meanwhile, the rest of the photo was desaturated. The effect is exaggerated here, but a subtler use of this technique can help call attention to the part of a photo where you want people to focus their attention.

It's quite easy to change saturation. You can use either the Hue/Saturation dialog box or the Sponge tool, which are explained in the following sections. For big areas, or when you want a lot of control, use Hue/Saturation. If you just want to quickly paint a different saturation level (either more or less saturation) on a small spot in your photo, the Sponge tool is faster.

NOTE Many consumer-grade digital cameras are set to crank the saturation of your JPEG photos into the stratosphere. That's great if you love all the color. If you prefer not to live in a Technicolor universe, you may wish to desaturate your photos in Elements to remove some of the excess color.

Using the Hue/Saturation Dialog Box

Hue/Saturation is one of the most popular commands in Elements. If you aren't satisfied with the results of a simple Levels adjustment, you may want to work on the hue or saturation as the next step toward getting really eye-catching color.

Hue simply means the color of your image—whether it's blue, brown, purple or whatever. Most people use the saturation adjustments more than the hue controls, but both hue and saturation are controlled from the same dialog box.

When you use Hue/Saturation, it's a good idea to make most of your other corrections, like Levels or exposure corrections (see page 242), first. When you're ready to use the Hue/Saturation command, just follow these steps:

1. **Choose Enhance → Adjust Color → Adjust Hue/Saturation.**

 The Hue/Saturation dialog box appears.

2. **Move the sliders until you see what you want.**

 If you want to adjust only saturation, you can probably ignore the Hue slider. (Hue changes the colors in your photo.)

3. **Move the Saturation slider to the right to increase the amount of saturation (more color) or to the left to decrease it. If necessary, move the Lightness slider to the left to make the color darker or to the right to make the color lighter.**

 Incidentally, you don't have to change all the colors in your photo equally. See Figure 12-13 for how to focus on individual color channels.

 TIP Generally speaking, if you want to change a pastel to a more intense color, you'll need to reduce the lightness in addition to increasing the saturation—if you don't want your color to look radioactive.

Adjusting Saturation with the Sponge Tool

You can also adjust saturation with the Sponge tool. The Sponge tool is very handy for working on small areas, but all that dragging gets old pretty fast when you're working on a large chunk of your image. For those situations, use Hue/Saturation instead.

To use the Sponge tool, drag over the area you want to change. Figure 12-14 shows an example of the kind of work the Sponge does.

1. **In the toolbox, click the Sponge tool (or press O and choose the Sponge icon). Then, in the Options bar, choose the mode or flow settings you want.**

Figure 12-13:
The Hue/Saturation dialog box has a pull-down menu so you can adjust individual color channels. If only the reds are excessive (a common problem with digital cameras), you can choose to lower the saturation only for the reds without changing the other channels.

Figure 12-14:
Here, the Sponge tool has been applied to the left side of the window frame and the roof beside it, increasing the color saturation in those areas. Approach the Sponge tool with some caution. It doesn't take much to cause degradation in your image, especially if you've made many previous adjustments to it. If you start to see noise (graininess), undo your sponging and try it again at a reduced setting.

Although it's called a sponge, the Sponge tool works like any other brush tool in Elements. The Sponge has a couple of unique settings of its own as well:

Mode. Choose here whether to saturate (add color) or desaturate (remove color).

Flow. Flow governs how intense the effect is. A higher number means more intensity.

2. **Drag in the area of your photo you want to change.**

Creating Special Effects

As you've seen in the past few chapters, editing and retouching photos often involves making subtle changes. The goal is to make your photos look better, yet still completely natural, which requires a light hand and a sense of moderation.

Get ready to rock and roll. When you use special effects, you can toss moderation out the window. With a little help from your computer, you can make your photos look like, well, a psychedelic rock and roll poster from the 1960s. You can transform a color photo to black and white or even give it the sepia tones of an antique print. You can make a bright midday image look like you shot it at sunset, or add a grainy texture that makes a digital photo look like you took it on actual film.

This chapter shows you how to create special effects in three programs: EasyShare, Picasa, and Photoshop Elements. EasyShare and Picasa offer some of the same effects, like converting color photos to black and white, but their effects lists aren't identical (see Table 13-1 for a full comparison). EasyShare focuses on fun effects that completely alter a photo's appearance with a single click—making a photo look like a drawing, for example. Picasa's also easy to use, but it leans toward more realistic effects, and gives you more tools (like sliders) to help control the results.

While EasyShare offers 10 effects and Picasa 12, Elements gives you more than *90*. (Well, for $100, it darn well should.) In Elements, you create effects by layering various *filters*, each of which changes a specific aspect of a photo's appearance. With the extra flexibility comes a longer learning curve, but with a little practice you can go way, way beyond the capabilities of EasyShare or Picasa, as you can see in the table. In addition, Elements lets you stitch several photos together into a panoramic view (page 290).

NOTE This chapter covers all the effects provided by EasyShare and Picasa, but it just scratches the surface when it comes to Photoshop Elements. If you're using Elements and want to really delve deep into special effects, pick up a copy of *Photoshop Elements: The Missing Manual*.

Table 13-1. *If you're interested in a specific effect, check this table to see which program has it. With Elements, you can duplicate almost all of the effects offered by the other two programs, but it may take more than a single click.*

	EasyShare	Picasa	Elements
Number of Effects or Filters	10	12	90+
Cartoon, Drawing Effect	Yes	*No*	Yes
Coloring Book Effect	Yes	*No*	Yes
Colorize Black & White Photos	*No*	*No*	Yes
Convert to Black & White	Yes	Yes	Yes
Film Grain Effect	*No*	Yes	Yes
Filtered Black & White	*No*	Yes	Yes
FishEye, Spherize Distortion	Yes	*No*	Yes
Focal Black & White	*No*	Yes	Yes
Glow	*No*	Yes	Yes
Graduated Tint	*No*	Yes	Yes
Increase Grain	*No*	Yes	Yes
Panorama Photos	*No*	*No*	Yes
Saturation	*No*	Yes	Yes
Sepia Tone	Yes	Yes	Yes
Soft Focus, Blur	*No*	Yes	Yes
Spotlight (Vignette) Effect	Yes	*No*	Yes
Spotlight Effect	Yes	*No*	Yes
Tint (DuoTone)	*No*	Yes	Yes
Warm Up Colors (add orange cast)	Yes	Yes	Yes

Adding Effects with EasyShare

EasyShare gives you ten different special effects, organized in two groups: Scene Effects and Fun Effects. In general, the Scene Effects are more subtle and primarily alter a photo's overall coloring. Fun Effects are more dramatic, distorting the photo or changing it in non-photorealistic fashion.

Adding an Effect

You apply effects in EasyShare's Edit view (page 192). Here's how:

1. **Select the photo you want to work on and then go to Edit view.**

 For example, choose Edit → Edit View, or click the Edit button at the top of the My Collection window.

2. **At the top of the Edit window, click either the Scene Effects button or the Fun Effects button.**

 To the left of your photo, a list of effects appears. See below for a full description of all EasyShare's Scene Effects; page 276 for the Fun Effects.

3. **In the list at left, choose an effect by clicking its radio button.**

 EasyShare applies the effect to your photo and shows you a preview right there in the Edit window.

4. **If you like what you see, click Accept.**

 Click Cancel to revert to the original photo. Before you leave Edit view and go back to look at your photos in EasyShare albums, you need to decide whether or not to save your photo with its new special effects.

5. **At the bottom of the window, click one of the buttons to either save or revert your edited photo.**

 If you choose Revert, you lose all the edits and effects and you're back at square one. Choose Save As to save your picture with the effects as a *new* photo; you'll have both the original and your special effects photo in your album. Click the Save button to save the photo with special effects as your *only* copy. (If you click the Close button, EasyShare asks whether you want to save the changed photo before it lets you close.)

 NOTE You can successfully select two or more Fun Effects and then click Accept to apply them all to a single photo. With Scene Effects, when you want to create multiple effects, you need to apply one effect, click the Accept button, and then apply another.

Scene Effects

Scene Effects each change a photo's overall appearance with a single click. Unlike Picasa and Elements, EasyShare doesn't give you any settings to tinker with.

- **No Effect** exists primarily to cancel out any effect you've already added.

- **Black and White** makes your color photo black and white. Technically, this effect translates the image's color information into grayscale.

- **Sepia Tone** makes your photo look like an old-fashioned daguerreotype. It does the same thing as the Black and White effect, but gives the photo a brown tint.

- **Forest** brightens and enhances the greens in the image, giving plants and foliage a richer appearance. It's designed to enhance nature shots, but you can use it on any photo.

- **Scenic** is similar to the Forest effect above. It enhances specific colors in your photos. For example, Scenic darkens and enhances the sky, while lightening the greens and foliage in the photo.

- **Portrait** warms up the photo and provides a soft, pleasant look.

- **Sunset** is known among photographers as the "golden hour" because of the beautiful quality of the light. The Sunset effect simulates that look by warming up the colors in the photo, giving your photo the golden look of a sunset. (The other important feature of the golden hour is the angle of the sunlight, but that's not something EasyShare can recreate.)

Fun Effects

Like Scene Effects, you apply Fun Effects with a single click. As the name implies, these effects don't make any claims about realism, but you'll find they're great for preparing photos for use on things like greeting cards, coffee mugs, mouse pads, and so on.

- **Spotlight.** This is a great effect for portraits, but you need to start with your model in the middle of the photo. Spotlight darkens the edges of the photo, focusing attention on a center point (Figure 13-1).

Figure 13-1:
EasyShare's Spotlight effect darkens the edge of the photo and focuses light on the center. This dramatic vignette effect is reminiscent of old time photography. Unfortunately, EasyShare doesn't let you move the center of the vignette around on the image, so you may have to crop your photo before applying the effect to get the spotlight lined up just right.

- **Coloring Book.** True to its name, this effect changes your photo so it looks like a page from a coloring book: It outlines the edges of objects in the picture and removes the fill-in colors (Figure 13-2).

Figure 13-2:
The Coloring Book effect works best on relatively simple photos with sharply defined edges where colors meet. If a photo's too complicated, the result of the Coloring effect may be confusing and hard to identify.

- **Cartoon.** Similar to the Coloring Book effect above, Cartoon outlines the objects in your picture, but fills it in with saturated color, the way a cartoonist would draw it. Cartoon works great on some photos, but not others, and the only way to find out is to experiment with different photos. But when you get the right photo, the Cartoon effect is a winner.

- **Fisheye.** This effect distorts the picture as if you're viewing it through an extremely wide-angle lens. Adding the Fisheye effect to a close-up of someone's face always gets a laugh. EasyShare doesn't let you adjust the size or angle of the distortion, so if you really get into distorting your friends' faces for fun (or revenge), you need to turn to Photoshop Elements filters (page 285).

Undoing an Effect

EasyShare makes sure you don't lose your original photos when you're playing around with special effects. You have several ways to undo your experiments:

- **Cancel.** While you're working with the photos, there's the handy Cancel button at the bottom of the screen. Clicking Cancel while you're previewing an effect puts you back at square one.

- **Undo.** If you've gone beyond the preview stage and clicked the Accept button, you can still undo your work using two of the buttons at the bottom of the Edit screen. The Undo button removes the last effect that was applied to the photo. Using Undo, you can step backward through any effects that have been applied to the photo.

- **Revert.** If you want to remove all the effects more quickly, use the Revert button. With one click, the Revert button removes *all* the effects that have been applied to the photo since the last save.

• **Restore.** Finally, there's the ultimate Undo that you can apply days or even years later. While you're viewing your photos under the My Collection tab, you can choose to restore your original photo by selecting your photo and then going to File → Restore Original (Figure 13-3). This removes all effects and edits you've made to your photo.

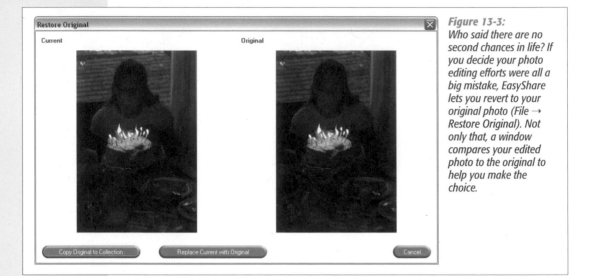

Figure 13-3:
Who said there are no second chances in life? If you decide your photo editing efforts were all a big mistake, EasyShare lets you revert to your original photo (File → Restore Original). Not only that, a window compares your edited photo to the original to help you make the choice.

Adding Effects with Picasa

Picasa's special effects collection ranges from the practical to the whimsical. For example, many photos benefit from a gentle application of Sharpen (improves focus) or Saturation (deepens color) and they still resemble the original shot. Apply Soft Focus or Focal Black and White and you're moving into the realm of drama and special effects.

Effects, like most of Picasa's tools, are intuitive and clearly labeled. For example, the Effects panel shows you thumbnail previews of each effect (Figure 13-4). And if that's not clear enough, you can read a brief text description when you move your cursor over each effect.

Applying an Effect

You apply many of the effects with the click of a button. With others, you can control the effect by dragging a slider or two. Here are the basics:

1. **In the Lightbox (page 112), double-click a photo to open it in Edit View (or choose Edit → Edit View).**

 Picasa shows you a full-size preview of your photo in the middle of the screen. To its left are three tabs: Basic Fixes, Tuning, and Effects.

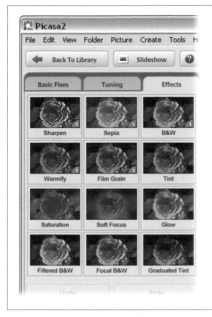

Figure 13-4:
Picasa's Effects palette gives you access to all twelve effects and provides a mini-preview of the effect applied to the photo in your Edit view. In many cases, applying the effect is simply a matter of clicking on the palette option.

2. **Click the Effects tab.**

 The panel reveals a palette of effects to transform your photos (Figure 13-4). The options run the gamut from subtle to dramatic, as you'll see in the next section.

3. **Click an effect's thumbnail to apply it to your photo.**

 Picasa instantly shows you the results. If it's possible to edit the effect, you'll see sliders for doing so in the Effects panel.

4. **If you want, edit the result. When you're satisfied, click Apply.**

 With your edited photo now in the middle of the screen, Picasa once again displays the Effects panel. Only now, the thumbnail buttons show you how your photo would look if you added *another* effect to the one you just applied. (You can even re-apply some effects.)

 And, at the bottom of the panel, an Undo button lets you remove the effect you just applied.

 TIP If you've applied multiple effects, you can click the Undo button repeatedly to step back through them. Its text changes to show you what effect you're about to remove: "Undo Saturation," for example.

The Effects Panel: A Tour

A few of Picasa's effects are subtle and suitable for realistic retouching work—like Sharpen and Saturation. Then there are the more dramatic effects, such as Focal

Black and White and Graduated Tint, which give your photos an otherworldly look. Some of the effects are cumulative; you can apply them more than once by repeatedly clicking the mini-preview. Here's a brief tour through all your choices:

- **Sharpen.** If your photo looks a little soft or out of focus, use the Sharpen effect to make it look crisper. The Sharpen effect can't really change the focus of an image, but it enhances the edges where colors meet, making the photo *appear* to be in better focus. To sharpen your photo, click the Sharpen option on the effect palette. You can click more than once, and Picasa continues to sharpen the image.

 > **TIP** It's usually best to make color and exposure changes *before* you sharpen your image. Properly used, Sharpen brings a photo to life. But if you sharpen too much, you can degrade the photo, making it look blotchy.

- **Sepia.** Clicking the Sepia effect gives photos an antique look by converting the colors to shades of reddish brown.

- **B&W.** This effect converts a color photo to grayscale, making it appear to be shot with black-and-white film.

- **Warmify.** Select Warmify, and Picasa boosts the warm tones in your image, reducing the blues and increasing the yellows and reds.

- **Film Grain.** Back in the olden days when photographers shot with film, the grain size of competing brands and types of film produced noticeable differences. Picasa's Film Grain effect simulates the appearance of grainy film. You can increase the graininess by repeatedly clicking on the Film Grain palette option.

- **Tint.** When you choose the Tint effect (Figure 13-5), Picasa removes the color from you photo and gives you tools for choosing a tint color. Hold your cursor over the color palette icon, and a larger color palette appears. You can preview different tint options by moving the cursor over the colors in the palette. When you find the right tint, click it.

- **Saturation.** Some photos with dramatic colors come to life when you increase the color saturation. Other photos, like rainy day pictures, can get even moodier if you carefully tone down the color. Picasa lets you control color saturation with a slider. Drag the slider all the way to the left and you remove all the color from your image—it looks like a black and white photo. Drag the slider all the way to the right, and your photo starts to look psychedelic (Figure 13-6). With minor adjustments of color saturation in between those extremes, you can create enhanced but realistic effects.

- **Soft Focus.** In Hollywood, glamour photographers would shoot through cheesecloth or apply Vaseline to the edges of a filter to get a romantic, soft focus effect. Picasa lets you do the same thing and gives you control over how to apply the effect (Figure 13-7).

Figure 13-5:
Picasa gives you two ways to control the Tint effect. First, you can choose the tint color. Second, you can control the amount of the original colors that show through by adjusting the Color Preservation slider at the top of the panel (not shown here). For example, you can add a blue tint while maintaining some of the photo's original red color, and make everyone think you've discovered the elusive purple rose.

Figure 13-6:
Used moderately, the Saturation effect can enliven the colors in a picture, or it can be used to the extreme as shown here. The bowl and watermelon are both so vivid they no longer look realistic. They've lost their highlights and most of their definition.

- **Glow.** To give your photos a gauzy, glow effect, click the Glow option. Sliders control the intensity and radius of the glow.

- **Filtered B&W.** Film photographers sometimes shoot black-and-white film with different colored filters on the lens. This effect mimics that shooting technique by changing the contrast and highlights of an image.

Figure 13-7:
Top: This rose is getting Picasa's soft focus treatment including three manual adjustments. The focal point is selected, as indicated by the small crosshair symbol in the center of the rose.

Bottom: A slider shrinks or expands the size of the area that's in focus, keeping the rose relatively sharp while the leaves are blurred. A second slider controls the degree of the blurring.

- **Focal B&W.** With Focal Black & White, you can create a photo that's part color and part black and white (Figure 13-8). It's a powerful effect because it actually lets you direct the viewer's eye to the colored part of the image. Picasa gives you quite a bit of control over this effect. First, click in the center of the area where you want color. Picasa removes the color from the edges of the image. Use the Size slider to adjust the size of the area that's in color. The Sharpness slider lets you control the transition area between color and black and white. It can be very distinct or feathered out.

Figure 13-8:
Focal B&W creates a dramatic effect that's particularly suited to portraits. You can create that Wizard of Oz magic all in one photo.

- **Graduated Tint.** This effect simulates the use of a graduated color filter (Figure 13-9), where a specific color increases over a range within the photo. To use this effect, select a point in the middle of your photo where you want the color to begin and then choose a color with the color picker from the Effects tab on left. Control the sharpness of the color's edge with the Feather slider. Control the darkness of the tint with the Shade slider.

Figure 13-9:
Picasa's graduated tint always works from bottom to top; it's lighter at the bottom and gets darker toward the top. You can add a heavy tint for artistic effect, as shown here, or use the graduated tint in a more natural way. For example, you can add a blue tint to carefully enhance the color of a sky.

Copying and Pasting Picasa's Effects

Once you've got an effect or series of effects you like, Picasa lets you copy it to other photos. For example, say you return home from a day at the beach and, looking at your photos, realize that every one needs similar adjustments. Perhaps you want to tweak the saturation a bit and then sharpen the photos. Or maybe the changes you have in mind are even more extensive.

It can get a little tedious to apply the same effects to photo after photo, so Picasa gives you a fabulous timesaver.

It's a pretty straightforward cut-and-paste operation: Select the photo that already has the perfect effect. Then go to Edit → Copy All Effects. Next, choose the photo or group of photos you want to transform and go to Edit → Paste All Effects. That's all there is to it.

Undoing Picasa's Effects

In Picasa, there's nothing you can do that can't be undone. Here are your options:

- **Cancel.** When you're editing an effect, click the Cancel button at the bottom of the panel. Picasa undoes any work you've done in that window and returns you to the regularly scheduled Effects panel.

- **Undo/Redo.** Down at the bottom of the Effects panel (in Edit View) is Picasa's Undo button. It has a great memory, but it's very forgiving. The Undo button remembers the edits or effects you've applied, and it even tells you right there on the button. If the last thing you did was apply the Tint effect, the button is labeled Undo Tint. Click the button and the Tint is gone. Now the button may read Undo Crop or Undo Auto Contrast—whatever you last did before applying Tint. The button lets you step backwards through every change you've made. (Ah, if only real life had an undo button as understanding as Picasa's.)

 Furthermore, to the right of the Undo button is a Redo button that lets you step back through the changes you've undone. You can keep undoing and redoing until you get it right.

- **Undo All Edits.** If you want to undo all the changes you've made to a photo in one fell swoop, go to Picture → Undo All Edits. Picasa puts up a box to make sure you want to remove all the edits. Click Yes and you see the photo as it looked when it was first added to Picasa.

Adding Effects with Elements

When it comes to effects, comparing EasyShare and Picasa to Photoshop Elements is like pitting mopeds against Maseratis. While EasyShare and Picasa each provide about a dozen effects, Elements has over 90 different *filters*—its name for the image-modifying tools that can change your picture's appearance in all sorts of neat ways. You can tweak and tune each filter to create truly original effects. An individual filter may have a dozen different options, and then there are the effects that you can create by applying more than one filter.

If that sounds too complicated, relax. Using filters isn't difficult. Although Elements gives you a lot of options, applying a filter is often as easy as double-clicking a button. And even though there are a huge number of filters, they're grouped into categories to help you find one that does what you need. This section offers a quick tour through the filter categories as well as instructions on how to actually apply the filters. Once you learn to use a couple of filters, it isn't hard to experiment with the others.

NOTE If you end up really liking filters, hold onto your hat: Elements offers dozens of other filter-like tools, called Effects and Layer Styles. You'll only learn about filters in this book, but if you're interested in Effects and Layer Styles they both work pretty similarly to filters.

Applying Filters

You can choose to apply any filter from either the Filter menu or the Styles and Effects palette (Window → Style and Effects); the filters do exactly the same thing no matter which way you choose them. Here's how to get started:

1. In the Editor, open the photo you want to work on.

2. In the Filter menu, choose a filter by name from the list. Or, in the Styles and Effects palette, select Filters from the left-side drop-down menu and click a filter thumbnail button.

 The thumbnail images give you a preview of what the filters do. The Styles and Effects palette is usually one of the three palettes in the Palette bin the first time you launch Elements. If it's not there waiting for you, choose Window → Styles and Effects to call it up.

3. If necessary, to see a full-size preview, choose Filter → Filter Gallery.

 The Gallery window opens a full screen, giving you a large preview of what you're doing to your photo.

 Some filters automatically open the Filter Gallery when you choose them from the menu or the palette. The next section goes into more detail about using Elements' Filter menu. For the skinny on the Styles and Effects palette, see page 286.

TIP Elements makes it easy to apply the same filter repeatedly. Press the Ctrl+F keyboard shortcut, and Elements applies the last filter you used, with whatever settings you last used. The top listing in the Filter menu also shows the name of this same filter (selecting it works the same way as the keyboard shortcut: you get the same settings you just used).

Choosing Filter Menu Commands

If you find it easiest to find a filter by looking at a list of names, the Filter menu is the method you'll probably want to use. The filters are grouped into 14 main

categories, with many individual filters in each group. When you choose a filter from the list, one of three things happens:

- **Elements applies the filter automatically.** This happens if the filter's name in the list doesn't have an ellipsis (...) after it. Just look at the result in your photo and undo it (Ctrl+Z) if you don't like its effect. If you do like it, you don't have to do anything else.

- **You see a dialog box.** The Elements filters that have adjustable settings have an ellipsis (...) after their names. Some of them (mostly correctional filters) open a dialog box where you can tweak the settings. Set everything as you want it, watching the small preview in the dialog box to see what you're doing. Then click OK.

- **You see the Filter Gallery.** Some of the more artistic, adjustable filters call up the Filter Gallery so that you can get a nice large preview of what you're doing and also so you can rearrange the order of multiple filters before applying them. Applying filters from the Gallery is explained later.

Regardless of how you've applied the filter, once you're done, you can always undo it (Ctrl+Z) if you're not happy with the effect. If you like it, there's no need to do anything else, except of course to eventually save your image.

Navigating the Styles and Effects Palette

If you're more comfortable with visual clues, you can also find most filters in the Styles and Effects palette (Figure 13-10). You'll see a little pull-down menu on the left side. Choose Filters there, and then you can use the menu on the right to limit your viewing options to filters in any particular category, if you like. The categories are the same ones you see in the Filter menu.

Figure 13-10:
The Styles and Effects palette gives you a preview of what every filter looks like when applied to the same picture of a green apple. If you know what you want a filter to do but don't know what name to look for, scrolling through these thumbnail images should help you find the one you want.

To apply a filter from the palette, double-click its thumbnail. If the filter has settings, you get the same dialog box or Filter Gallery you'd see if you'd applied the filter from the Filter menu, as described earlier.

> **NOTE** One small drawback to applying filters from the palette is that you can't tell from the thumbnail whether a filter is one that applies automatically. Unlike the Filter menu, there's no clue like the ellipsis (…) to tell you which group a filter falls into.

A Tour of the Filter Gallery

The Filter Gallery, shown in Figure 13-11, is one of Elements' more popular features. It gives you a large preview window, plus thumbnails so you have a visual guide to what your filter will do. If you want an even larger preview, you can click the arrow that the cursor is over in the figure to collapse the thumbnails and regain that entire section for preview space.

The Gallery is more for artistic filters than for corrective filters. You can't apply the Sharpening or Noise filters from the Gallery, for instance. All the Gallery filters are in the artistic, brush stroke, distort, sketch, stylize, and texture categories. (See the next section for an overview of all the filter categories Elements offers.)

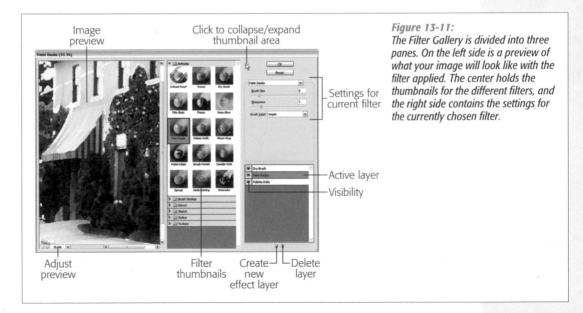

Figure 13-11:
The Filter Gallery is divided into three panes. On the left side is a preview of what your image will look like with the filter applied. The center holds the thumbnails for the different filters, and the right side contains the settings for the currently chosen filter.

The Filter Gallery also lets you apply filters on top of each other—you can stack them up and change the order in which they're applied to your image. Changing the order of filters can make some big differences in how they affect your image. For example, you get very different results if you apply Ink Outlines *after* the Sprayed Strokes filter compared to what happens if you apply Ink Outlines first. The Gallery lets you play around and experiment to see which order gives you the exact look you want.

In addition to letting you adjust the settings for a given filter, the Filter Gallery lets you perform a few other tricks:

- **Adjust the preview of your image.** In the lower-left corner of the Gallery, click directly on the percentage listing or click the arrow next to it for a list of preset sizes to choose from. You can also click the + and – buttons to zoom the view in or out. Easier still, use the Ctrl+= and Ctrl+– (the Ctrl key plus the – key) shortcuts to zoom in and out from the keyboard.

- **Choose a new filter.** Just click a filter's thumbnail once and you get the settings for the new filter and the preview image updates right away—usually (see the box on page 290).

- **Add a new filter layer.** You can stack up filters in layers in the Filter Gallery. Each time you click the New Filter Layer icon (see Figure 13-12), you add another filter layer to the ones you already have.

Figure 13-12:
At the bottom of the Filter Gallerys settings pane, you can see what filters you've applied, and add, subtract, or rearrange their order. To add new filter layers just click the New Filter Layer button (circled).

- **Change the position of filter layers.** Just drag them up and down in the stack to change the order in which they'll get applied to your image.

- **Hide filter layers.** In the filter layer palette, click the eye next to a filter layer to turn off the filter's visibility.

- **Delete filter layers.** Highlight any filter layer by clicking it and then click the Trash icon to delete it.

- **Change the content of a layer.** You can change what kind of filter is in a particular layer. For instance, if you applied, say, the Smudge Stick, but wish you had used the Glass filter instead, you don't have to delete the Smudge Stick layer. Instead, just highlight the Smudge layer and click the Glass filter button to change the layer's contents.

TIP Ctrl+F reapplies all the filters that were in your last gallery set if you press it again after using the Filter Gallery.

Filter Categories

Elements divides the filters into categories to help make it easier for you to track down the filter you want. Some of the categories, like Distort, contain filters that vary hugely in what they do to your photo. Other categories, like the Brush Stroke filters, contain filters that are all pretty obviously related to one another. Here's a quick breakdown of the categories:

- **Adjustments.** These filters apply some photographic, stylistic, and artistic changes to your photo.

- **Artistic.** This is a huge group of filters that do everything from making your photo look like it was cut from paper (Cutout) to making it look like a quick sketch (Rough Pastels). You generally get the best effects with these filters by using multiple filters or applying the same one multiple times.

- **Blur.** The blur filters let you soften the focus of your photo and add artistic effects.

- **Brush Strokes.** These filters apply brush stroke effects to your photo to give it a hand-painted look.

- **Distort.** These filters warp your image in a great variety of ways. The Liquify filter is the most powerful of the group.

- **Noise.** Use these filters to add or remove grain from your image.

- **Pixelate.** The Pixelate filters break your image up in different ways, making it show the dot pattern of a magazine halftone, or the fragmented look you see on television where they're concealing someone's identity.

- **Render.** This group includes a pretty diverse bunch of filters that let you do things like create a lens-flare effect (Lens Flare), transform a flat object so it looks three dimensional (3D Transform), and make fibers (Fibers) or clouds (Clouds).

- **Sharpen.** These filters give your photo an impression of improved focus.

- **Sketch.** These filters not only make your photo look like it was drawn with different instruments (like charcoal, chalk, and crayon), you can also make your photo look like it was embossed in wet plaster, photocopied, or stamped with a rubber stamp.

- **Stylize.** These filters create special effects by increasing the contrast in your photo and displacing pixels. You can make your photo look radioactive, reduce it to outlines, or make it look like it's moving fast with the Wind filter.

- **Texture.** These filters change the surface of your photo to look like it was made from another material. Use them to create a crackled finish (the Craquelure filter), stained glass (Stained Glass), or a mosaic effect (Mosaic Tiles).

- **Video.** These filters are for use in creating and editing images for videos.

- **Other.** This is a group of fairly technical filters that you can highly customize to do things like create your own filter.

- **Digimarc.** Use this filter to check for Digimarc watermarks in photos. Digimarc is a company that lets subscribers enter their information in a database so that anyone who gets one of their photos can find out who the copyright holder is.

POWER USERS' CLINIC

Filter Plug-Ins

You're not limited to the dozens of filters that come with Photoshop Elements. You can add filters created by professional developers and other Photoshop experts. You get the filters online, in the form of *plug-ins* (little programs that you install on your PC to add capabilities to Elements). Any new filters you install appear at the bottom of the list in the Filter menu.

You can find a number of filter plug-ins online, ranging from free to very expensive. A good place to start your search is on the Adobe Studio Exchange (*http://share. studio.adobe.com*). About 99 percent of what you'll see listed is made specifically for the full version of Photoshop, but these filters all work with Elements, too.

Creating Panoramas with Elements

Everyone's had the experience of trying to photograph an awesome view—a city skyline or a mountain range, for instance—only to find the whole scene won't fit into one picture, because it's just too wide. Elements, once again, comes to the rescue. With Elements' Photomerge command, you can stitch together a group of photos that you've taken while panning across the horizon. You end up with a panorama that's much larger than any single photo your camera can take. Panoramas can become addictive once you've tried them, and they're a great way to get those wide, wide shots that are beyond the capability of your camera lens.

> **TIP** Some digital cameras have a built-in Panorama feature (page 29). If yours does, you may have to install software from the CD that came with your camera to merge the shots instead of using Elements. See your camera's instructions for details. But if your camera doesn't do panoramas, this section's for you.

The general procedure for creating a panorama in Elements is straightforward, but the devil's in the details. First, you'll learn how to use the Photomerge command to make panoramas. Since the angle of your image may need a little correcting afterwards, you also need to learn how to use Elements' Transform commands to adjust the images you've created.

Figure 13-13 shows a three-photo panorama and the photos that went into it. You can download these photos (pavillion1.jpg, pavillion2.jpg, and pavillion3.jpg) from the "Missing CD" page at *www.missingmanuals.com*, if you'd like to give panorama-making a try.

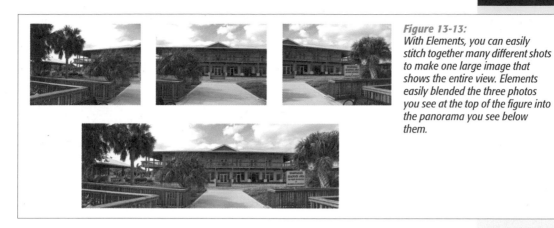

Figure 13-13:
With Elements, you can easily stitch together many different shots to make one large image that shows the entire view. Elements easily blended the three photos you see at the top of the figure into the panorama you see below them.

Selecting Photos to Merge

The first part of creating a panorama is selecting the photos you want to include. You can save yourself a lot of time and trouble if you go through your photos first, to be sure the color in all the photos matches, *before* you start your panorama. Figure 13-14 shows why you need to take this step.

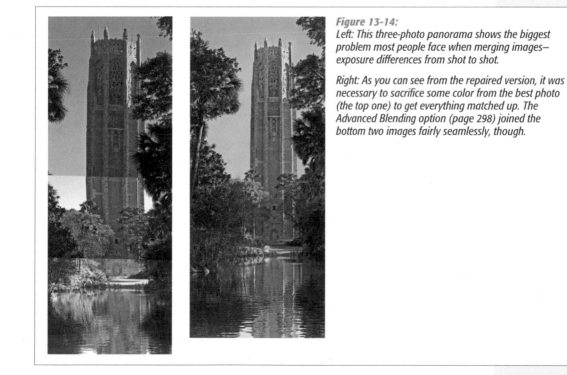

Figure 13-14:
Left: This three-photo panorama shows the biggest problem most people face when merging images—exposure differences from shot to shot.

Right: As you can see from the repaired version, it was necessary to sacrifice some color from the best photo (the top one) to get everything matched up. The Advanced Blending option (page 298) joined the bottom two images fairly seamlessly, though.

Your starting point is a group of photos you've taken that can fit together side by side to show a more complete view of your subject in one image. When choosing photos to merge, keep these facts in mind:

- **Elements can merge together as many photos as you want to include in a panorama.** The only real size limitation comes when you want to print out your merges. If you have only letter-size paper and you create a five-photo horizontal panorama, it's going to be only a couple of inches high, even if you rotate your panorama to print lengthwise.

- **You'll get the best results creating a panorama if you plan ahead when shooting your photos.** The pictures should be side by side, of course, but you get much better results if they overlap each other by at least 30 percent. (See the box on page 297 for more shooting advice.)

- **The biggest panorama problem is matching the color of your photos.** If possible, when you take the pictures, make sure they all have identical exposures.

- **You can also create vertical panoramas.** Elements automatically figures out which way your photos fit together.

Merging Photos into a Panorama

When you use the Photomerge command, you start by telling Elements which photos to combine (more on how to do that in a moment). Elements responds by doing the heavy lifting of actually merging the photos into one, but you still have to go in and do the clean-up work (trimming, correcting the blending, and so on) if you want stellar results.

When you're ready to create a panorama, just follow these steps:

1. **Go through the photos you want to use and make sure the colors match as closely as possible.**

 Use any of the editing tools in the Quick Fix (Chapter 11) or the more advanced editing options (Chapter 12) to modify colors and exposure levels. Figure 13-15 demonstrates how to compare the color in your photos as you work.

2. **Choose File → New → Photomerge Panorama.**

 The Photomerge Browse window appears (Figure 13-16), which is where you choose the photos you want to combine.

 NOTE The Photomerge Browse window doesn't give you thumbnail views—only a list of file names. Make a note of your files' names or rename them so that you'll know which ones are the ones you want.

3. **Choose the photos you want to include.**

 Click the Browse button in the window to see a list of the folders and files on your hard drive. Navigate to the one you want and click Choose. If you can't select all the photos at once because they aren't all in the same folder, you can

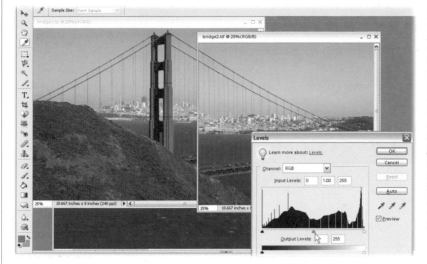

*Figure 13-15:
It helps to prepare your
photos for merging by
adjusting them side by
side so that you can
compare the colors.
Here, a combination of
Levels and a little
tweaking with the Tint
slider (in the Quick Fix,
see page 245) gets the
photos close enough to
get started. You can also
get good results
sometimes by using the
Hue/Saturation controls
(page 270) to adjust the
individual color channels.*

click Browse as many times as you want, and the new files get added to the list
in the window.

If you have open photos, they're automatically loaded in the Browse window.
So if you want to merge photos from several different folders, opening all of
them is one way to get them into the mix faster than by navigating to each
folder separately.

NOTE Photomerge copies each file as it adds it to the panorama and doesn't change your orig-
inals. You don't need to worry about making copies especially for your panoramas.

4. **Add more photos if necessary.**

If you need files from several folders and you didn't get them ahead of time, just
keep going back until you've rounded them all up. Just click the Browse button
again. If you inadvertently have more photos than you want, highlight the
unwanted photo(s) in the list and click the Remove button.

5. **When you've got all the images you want, click OK.**

If your photos weren't already open, you see them open one by one as Ele-
ments starts performing its merge magic.

Adjusting Your Photos

Once your photos appear in the Photomerge window, you see Elements' best-guess
effort at combining them. Elements' first pass isn't always perfect. Now your part
of the work begins, since you usually need to do a fair bit of tweaking here to get
the best results.

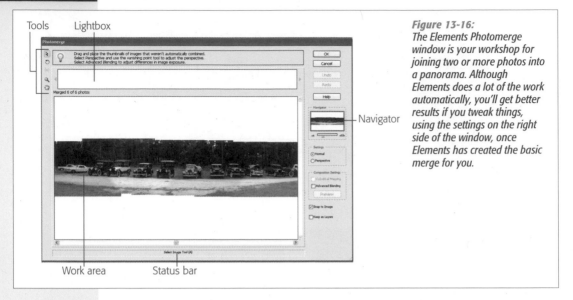

Tools Lightbox

Navigator

Work area Status bar

Figure 13-16:
The Elements Photomerge window is your workshop for joining two or more photos into a panorama. Although Elements does a lot of the work automatically, you'll get better results if you tweak things, using the settings on the right side of the window, once Elements has created the basic merge for you.

Sometimes, for example, as shown at top in Figure 13-17, Elements just gets confused and combines your photos randomly. In other cases, it just can't figure out where to put a photo at all. When that happens, Elements leaves the photos it can't place up at the top of the window, in the area called the *lightbox.*

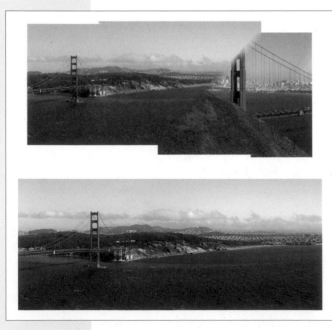

Figure 13-17:
Elements valiantly tries to combine your photos, but sometimes it has trouble lining up images exactly or figuring out how to fit a particular photo into the merge.

Top: Here, Elements guesses more wildly than a 10th-grader on a pop quiz.

Bottom: Here's the final result, showing the end product of a five-photo merge. As you can see, with a little help, Elements can usually do a fine job of combining images—even when it doesn't know where to start.

You can manually drag files into the merge and also reposition photos already in your panorama. Just grab them with the Select Image tool (explained in the following list) and drag them to the correct location in the merge.

If you try to nudge the position of a photo and it keeps jumping away from where you've placed it, turn off "Snap to Image" on the right side of the Photomerge window. Then you should be able to put your photo exactly where you want it. However, Elements isn't doing the figuring for you anymore, so use the Zoom tool to get a good look at the alignment afterwards. You may need to micro-adjust the photo's exact position.

At the top left of the Photomerge window is a little toolbox. Some tools are familiar; others are special tools just for panoramas.

- **Select Image.** Use this tool to move individual photos into or out of your merge or to reposition them within it. Press the A key, or click the tool, to activate it.

- **Rotate Image.** Elements usually rotates images automatically when merging them, but if it doesn't, or guesses wrong, press R to activate this tool and then click the photo you want to rotate. You see handles on the image, just the way you would with the regular Rotate commands (page 214). Then just grab a corner and turn the photo until it fits in properly. Usually, you won't need to drastically change a photo's orientation, but this tool helps make the small changes often needed to line things up better.

- **Vanishing Point.** To understand what this tool does, think of standing on a long, straight, country road and looking off into the distance. The point at which the two parallel lines of the road seem to converge and meet the horizon is called the *vanishing point*.

 The Vanishing Point tool in Elements just tells Photomerge where you want that point to be in your finished panorama. Knowing the vanishing point helps Elements figure out the correct perspective. Press V to activate the Vanishing Point tool. Figure 13-18 shows an example of how it can change your results.

- **Zoom tool.** This is the same Zoom tool you meet everywhere else in Elements. Click the magnifying glass in the toolbox or press Z to activate it.

- **Hand tool.** Use the Hand tool here when you need to scoot your *entire* merged image around to see a different part of it. Click the Hand icon in the toolbox or press H to activate it. When moving an individual photo within your panorama, use the Select Image tool.

You have a few other aids on the right side of the window. Some, like Advanced Blending, adjust the way your photos blend together. Others, like Cylindrical Mapping, adjust the camera's-eye view angle.

To control your onscreen view of your panorama, Elements gives you the Navigator on the right side of the Photomerge window. Move the slider to resize the view of your panorama. Drag to the right to zoom in on one area or to the left to shrink the

view so that you can see the whole thing at once. When you want to target a particular spot in your merge, drag the red rectangle to control the area that's onscreen.

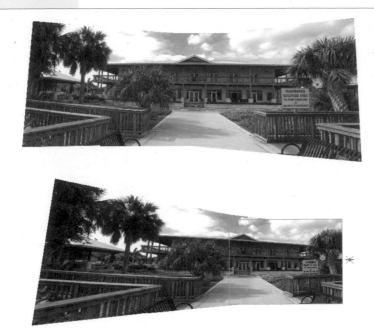

Figure 13-18:
You can radically alter the perspective of your panorama by selecting a vanishing point.

Top: Here you see the result of clicking in the center.

Bottom: Here you see the result of clicking on the right-hand image. Note that the tool selects only the image, not the actual point—you can click any photo to put your vanishing point there, but if you subsequently try to tweak it by clicking at a higher or lower point within the same photo, nothing happens.

Fine-Tuning Your Panorama

Once you get all your photos positioned to suit you, you may want to adjust the result to make things look a bit smoother. Elements has several other commands to help you do so.

On the right side of the Photomerge window, you see several rows of buttons and checkboxes. You'll usually want to try at least a couple of these settings to improve your panorama. At the top, you see the usual OK and Cancel buttons for when you're ready to create your panorama or when you change your mind about the whole process.

Next are the Undo and Redo buttons. If you Undo something and change your mind again, click Redo. Both Undo and Redo are grayed out until you do something they can change. The Help button takes you straight to the Photomerge section of the Elements Help files.

Below the Navigator box you see two radio buttons—Normal and Perspective—that adjust the viewing angle of your panorama. You can choose one or the other, but not both.

- **Normal.** This radio button gives you your photomerge as Elements combined it, with no changes to the perspective. If you don't like the way the angles in your panorama look, try clicking Perspective instead.

- **Perspective.** When you click this button, Elements attempts to apply perspective to your panorama to make it look more realistic. Sometimes Elements does a bang-up job, but usually you'll get better results if you help it out by setting a vanishing point, as explained earlier. Sometimes adding cylindrical mapping, explained later, can help. If you still get a totally weird result, go ahead and just create the merge anyway. Then correct the perspective yourself afterward using one of the Transform commands.

The Composition settings farther down the window aren't mutually exclusive. You can add either (or both) of them—Cylindrical Mapping or Advanced Blending—to your panorama if you think it needs their help. Just turn on their checkboxes to use them.

IN THE FIELD

Shooting Tips for Good Merges

The most important part of creating an impressive and plausible panorama starts before you even launch Elements. You can save yourself a lot of grief by planning ahead when shooting photos for a panorama.

Most of the time, you know *before* you shoot that you'll want to try to merge your photos. You don't often say, "Wow, I can't believe I've got seven photos of the Dr. Dre balloon at the Thanksgiving Day parade that just happen to be exactly in line and have a 30 percent overlap between each one! Guess I'll try a merge."

If you know you want to create a panorama, when you're taking pictures, set your camera so it's as much in manual mode as possible. The biggest headache in panorama-making is trying to get the exposure, color, brightness, and so on to blend seamlessly. Elements is darned good about blending the outlines of the physical objects in your photos. Lock your camera settings so that the exposure of each image is as identical as possible.

Even on small digital cameras that don't have much in the way of manual controls, you may have some kind of panorama setting, like Canon's Stitch Assist mode, that does the same thing.

(To be honest, your camera may make merges itself that work better than what Elements can do, because the camera's doing the image-blending internally. Check out whether your model has a panorama feature.)

The more your photos overlap, the better. Elements does what it can with what you give it, but it's really happy if you can arrange a 30 or 40 percent overlap between images.

It's helpful to use a tripod if you have one, and *pan heads*–tripod heads that let you swivel your camera in an absolutely straight line–were made for panoramas. Actually, as long as your shots aren't wildly out of line, Elements can usually cope. But you may have to do quite a bit of cropping to get even edges on the finished result if you don't use a tripod.

Whether you use a tripod or not, keep the camera level, rather than the horizon, to avoid distortion. In other words, focus your attention more on leveling the body of the camera than what you see through the viewfinder. Use the same focal length for each image, and try not to use the zoom, unless it's manual, so that you can keep it exactly the same for every image.

To see what they do to your photo, you need to click the Preview button after turning on their checkboxes (both features are explained in the following list). While you're looking at the preview, you can't make any other changes to your panorama. You have to click "Exit Preview" before you can tweak your panorama

any further. You won't see the effect of these settings again until you click OK to tell Elements you're ready for a finished panorama.

> **NOTE** If you use the preview, take a good look at the joined seams of your merge when Elements is finished. Once in a while it has trouble getting things put back exactly where they were before previewing. In that case, just close the merge without saving and try again.

- **Cylindrical Mapping.** When you apply perspective to your panorama, you may wind up with an image that looks like a giant bow tie. Cylindrical mapping helps put your images back into a more normal perspective by vertically stretching the middle section to make everything the same height. It's called "cylindrical" because it gives an effect like that of looking at a label on a bottle—the middle seems largest, and the image gets smaller as it fades into the distance (on the sides around the back of the bottle). This setting's available only if you select Perspective in the settings above it. If you choose Normal, it's grayed out.

- **Advanced Blending.** It's very rare to get photos with colors that match exactly. Advanced blending tries to smooth out the differences by averaging the color between the photos, and it does help some, but usually not enough.

The following two settings really should be at the top of the list, since they're the ones you'd use first when making a panorama.

- **Snap to Image.** Elements automatically places your photos in the panorama exactly where it thinks they should go. If you want to override Elements and position your photos yourself, turn off Snap to Image.

- **Keep As Layers.** When you create a panorama, Elements ordinarily combines all your photos into an image that has only one layer in it. (Layers are an advanced Elements feature that lets you slice up your image into stackable components; see the tutorial within Elements [Help → Tutorials → Using Layers] or *Photoshop Elements: The Missing Manual* for more on how Layers work.) If you turn on "Keep as Layers," you get a multi-layered panorama in which each photo is on its own layer. This makes it a bit easier to go back and apply corrections to one of the photos after the merge, but it also makes for a hugely larger file. Generally, you're better off canceling a merge and working on the photo by itself and then remerging.

Finishing Up: Creating Your Panorama

Once you're happy with your panorama, click OK and wait while Elements puts everything together for you. You may need to wait awhile, especially on a memory-challenged computer, so don't worry if it seems like nothing's happening—Elements is calculating like mad.

Usually, you have to crop (page 220) your panorama to get rid of the ragged edges, but once you do, it's quite remarkable how much it looks like a single photo. At this point, it's a single image, so you can edit it as you'd edit a normal photo. You need to name and save it, also.

Part Four: Sharing Your Photos

4

Sharing Your Photos Online

Showing off your photos has always been a source of great joy and—in pre-digital days—major pain. Friends and relatives passed your prints around the room, craning their necks to see over each other's shoulders. By the time you got them back, your photos were dog-eared, smudged, and out of order, making it even harder to order copies for folks who wanted them. Sending those copies required expensive mailing envelopes and a special trip to the post office.

With digital photography, you can avoid the expense of reprints and postage stamps by emailing your shots. The next chapter shows you how easy it is (using the programs covered in this book), to email shots that look great on a PC screen. But digital photos are big files—and email systems prefer small files. When you email photos with enough resolution to make good quality prints, you can send only a few at a time—and you risk crippling your loved ones' inboxes. Email is still a limited solution.

Web sites like the ones covered in *this* chapter are the wave of the future. Sharing photos online is similar to organizing them online for your own use. In fact, this chapter assumes you're already familiar with uploading photos to the Web, as described in Chapter 6. Once you've set up an online photo collection, you simply give viewing privileges to anyone you like. This chapter shows you how.

The benefits of sharing your photos online include:

- **Instant gratification.** Minutes after you upload photos, impatient friends and family members can see them online.

- **No emailing huge files.** When you share photos online, you're emailing only a *link* to your photo gallery, not the photos themselves. The sharing Web site even creates the link and email message for you.

- **Letting people print their own photos.** That's right—the people you're sharing the photos with can take over most of the work. If Aunt Mildred just *has* to have an 8×10 enlargement of that adorable shot of Fifi, then she can buy it online and have it sent right to her home.

- **Sharing photos with friends you didn't know you had.** The Web makes it easy for people who have similar hobbies and interests to find each other, share photos, and compare notes. The photos stuffed in that shoebox in your closet never dreamed of such adventure.

- **Improving your picture-taking prowess.** When you join the online community of digital photographers, a wealth of professional knowledge is yours for free. If you show that you're serious about photography, experienced photographers are glad to critique your photos and help you make them even better.

As you can imagine, photo-sharing sites come in different flavors for different kinds of photographers. This chapter covers five popular ones: EasyShare, Shutterfly, and Snapfish, which make sharing easy for everybody; Flickr, where photographs are an adjunct to special interest groups; and Photo.net, a sophisticated site where serious photographers hone their craft.

Choosing a Photo-Sharing Service

If you're already using EasyShare, Shutterfly, or Snapfish to organize your online albums, your decision's easy: stick with the same service. All of them offer more or less the same features, including print ordering and photo merchandise, email invites to friends, Web-based slideshows, and the ability to limit who sees your pictures (Figure 14-1). If you're just getting started, see the list below for a few key differences that might tip the balance for you. And if the community-oriented Flickr or Photo.net appeal to you, then you can always post some of your photos there as well. Here's a quick summary of highlights for each service:

- **EasyShare.** Kodak's EasyShare Gallery (*www.kodakgallery.com*) is the most flexible when it comes to mixing and matching photos from different albums into one slideshow. On the downside, preparing slideshows takes a few more steps than the other services, even if you're sharing photos from only one album.

- **Shutterfly.** Quicker and a bit simpler to use than EasyShare, Shutterfly (*www.shutterfly.com*) also offers one cool feature you won't find on any of the other consumer-oriented sites: *Collections.* A Collection is like a collaborative album, with its own Web address, where members can view each other's photos and comments. It's a perfect tool for sharing photos after a group vacation. And if you use the optional Shutterfly Express program (page 143) on your PC, you're in for a big timesaver: you can share your photos as you upload them.

- **Snapfish.** Hewlett-Packard's Snapfish (*www.snapfish.com*) has a no-frills design that gives your visitors especially easy access to print ordering. With 19 million members and 350 million photos stored online, it claims to be the Internet's largest photo site. It also offers the lowest print prices. Snapfish also has the most convenient address book feature—it remembers your email addresses automatically.

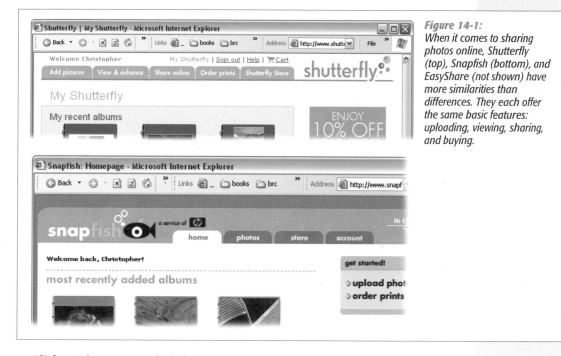

Figure 14-1:
When it comes to sharing photos online, Shutterfly (top), Snapfish (bottom), and EasyShare (not shown) have more similarities than differences. They each offer the same basic features: uploading, viewing, sharing, and buying.

- **Flickr.** Yahoo acquired Flickr in 2005 to add more photo-sharing features to Yahoo's popular Groups service (where fans of topics ranging from alfalfa to zoantharia gather to gab about their interests). Accordingly, Flickr offers the widest variety of options for choosing *how* to share your photos, and with whom. You can share pictures publicly, and easily search the public collection for photos on various topics. For sharing with a few friends and relatives, however, Flickr is less helpful than EasyShare, Shutterfly, or Snapfish. On the other hand, where else can you hook up with people who love taking pictures of their cars (Figure 14-2) as much as you do?

- **Photo.net.** Philip Greenspun, a writer and MIT instructor, founded Photo.net (*www.photo.net*) in the early 90's as a showcase for his own writing and photography. Since then, the site has evolved into a comprehensive resource for film and digital photographers. Photo.net's coolest feature? It lets you share your pictures with other photo jocks, who'll let you know what's working…and what they would've done to improve your photo. The site's also packed with equipment, camera shop, and developing lab reviews; classified ads and stolen gear notices; discussion forums; online tutorials; online shopping and product

evaluations; photographic travelogues; and more. What you *won't* find is an easy way to share photos with family and friends or order prints. So pick a different site for general sharing, and when you're ready to advance your photography skills, start submitting a few of your best shots to Photo.net.

Figure 14-2:
Flickr's special interest groups, like the Porsche club shown here, all work the same way, so once you learn to navigate through one, you can easily explore other collections. To the right of the full-size photo are thumbnails showing the previous and next photos in the set. Click the thumbnails to step forward or backward, displaying the current photo in the middle of the window.

Sharing Photos with EasyShare

Kodak's photo service has two parts. There's the EasyShare software (page 104) that runs on your computer, where you organize and edit your photos, and there's EasyShare Gallery (*www.kodakgallery.com*) where you share your photos online and order prints. Once you've created your online photo album(s) you pick the photos you want to share. Then, with the Gallery's help, you send out email invitations. When your friends receive the invites, all they have to do is click a link and they're taken right to your pictures.

Selecting Photos to Share

To share photos via the EasyShare Gallery, you first need to upload your pictures to the Gallery (see page 123 for full details on how to do that). Once your photos are online, you can share entire albums, or combine photos from one or more albums into a slideshow. Log into the EasyShare Gallery, and then follow these steps:

1. **At the top of any Gallery page, click the Share Photos tab (Figure 14-3).**

 You see a new page with your albums listed in a column on the left. At right, a heading says Your Slideshow. At first it's empty, but you'll fill it up as you add photos for your show.

2. **In the albums list, select the albums you want to share.**

 The words "This album will be shared" appear under each album you select. The selected albums also show up in the Your Slideshow list (Figure 14-3).

 If you don't make any changes, EasyShare creates a slideshow that starts with the album at the top of your list. However, EasyShare gives you a couple of ways to tweak your slideshow.

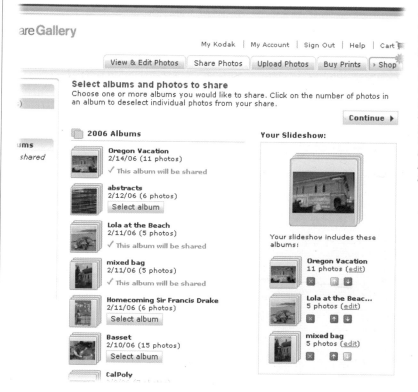

Figure 14-3:
EasyShare creates a slideshow from the photos you choose. You can change the order of your albums, and you can choose which photos from your albums go into the slideshow, but at this stage you can't rearrange photos within albums. You need to do that on the View & Edit Photos tab before creating the slideshow.

3. **To rearrange the order of the albums, click the up and down arrows.**

 If you want to remove an album from the list, click the X button.

4. **To choose which photos are used in your slideshow, click the Edit link under the album name.**

 A small window opens, containing thumbnails of the album's photos. To select or remove photos, click the thumbnails. Deselected photos appear faded; click

again to add the photo back in. When you're done, click Save to return to the Select Albums page.

5. **If you're happy with your slideshow, click Continue.**

Your slideshow is complete. The next screen lets you send out an invitation.

Sharing a Slideshow

EasyShare lets you send invitations when you first create a slideshow. If you don't send your invites right away, Gallery keeps your slideshow until you log off; so you can go and buy prints or view your albums. When you want to send out invites for your slideshow, just click the Share Photos tab and you'll see your slideshow ready to go. But if you leave EasyShare Gallery and come back, you'll have to start over from scratch.

The first time you send someone an invitation, you must type a full email address. But you can save keystrokes and brain cells by adding invitees to your EasyShare address book. In the future, you can invite them simply by choosing their names. You can also combine folks in your address book into *groups* for even greater time-savings. For example, you might put your twelve brothers and sisters in a group called "Siblings." Then just choose the Siblings group to invite the whole clan.

Follow these steps to create and email invitations:

1. **On the "Invite your friends to view this slideshow" page (Figure 14-4), type email addresses into the "To:" field (***mickjagger@rollingstones.com,*** for example).**

Invite as many people as you like. Simply separate the email addresses by semicolons.

2. **To add someone to your address book, click the "Friends & Groups" link just below the "To:" box.**

On the next page, two links in the upper-right corner let you Add a Friend or Add a Group. If you click Add a Friend, then you can enter an email address and a person's real name. When you click Add a Group, EasyShare shows you a list of Friends you've already added. Turn on checkboxes to add Friends to the group. To add new people to the group, type their email addresses in the fields below. (Folks you add this way also show up on your Friends list.)

3. **When you're done entering email addresses, click Continue to return to the screen shown in Figure 14-4. Fill in the email subject and body.**

EasyShare starts the email with a generic subject and message, but you can come up with something more enticing.

4. **Under your slideshow's image, type a title.**

This text box is easy to overlook, tucked over there on the right. Your guests see this title when they're viewing the slideshow.

5. **If you wish, turn off the "Require friends to sign in to view and save your photos" checkbox.**

EasyShare automatically turns on this option, which means your friends must create their own EasyShare accounts before they can view your photos. This blatant Kodak recruiting ploy actually has a benefit for you, too: When you leave this option turned on, you get a record of who's viewed your photos. Furthermore, if your guests want to order prints, then they *must* have an EasyShare account. Requiring them to sign up at the outset saves them time later.

Figure 14-4:
You don't even have to fire up Outlook to send an email invitation. EasyShare creates and sends the invite for you. All you have to do is fill in the blanks and click Send.

6. **When you're done, click Send Invitation.**

EasyShare sends your recipients an attractive email message displaying the first picture of your slideshow and a View Photos button. Kodak adds a sales pitch to the bottom of the email, letting your friends know they can join EasyShare Gallery, print photos, create photo mugs, and so on.

Sharing Photos with Shutterfly Express

Shutterfly (*www.shutterfly.com*) gives you a few ways to share photos. You can take the conventional route—choosing photos to share and emailing invitations using the Shutterfly Web site—which works much like EasyShare and Snapfish, as described elsewhere in this chapter. Or you can do it the easy way: Share your photos at the same time you're uploading them using the Shutterfly Express program on your PC (Figure 14-5).

NOTE At this writing, Shutterfly was testing out a new program—currently saddled with the ungainly name "Shutterfly Photo Organization Client"—that will eventually replace Shutterfly Express. The new program will help you with much more than simply uploading and sharing photos: You'll be able to edit and organize your photos right on your PC.

Last but not least, you can also share your photos using Shutterfly's *Collections,* which are a little different than anything EasyShare or Snapfish offers. Collections are collaborative photo albums which get their own unique Web address like BradAndAngelinapix.shutterfly.com. You get to create the name—the "Brad-AndAngelinapix" part in the example. Visitors don't have to be Shutterfly members to see your photos, but if they are, they can log in and then add their *own* pictures, leave comments, and buy prints. You can use Collections for anything from sharing photos with family to working on a project with colleagues.

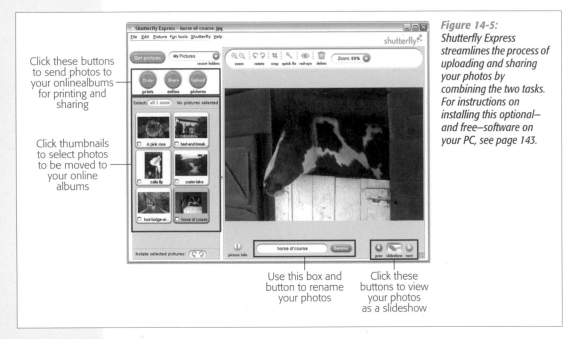

Click these buttons
to send photos to
your onlinealbums
for printing and
sharing

Click thumbnails
to select photos
to be moved to
your online
albums

Figure 14-5:
Shutterfly Express streamlines the process of uploading and sharing your photos by combining the two tasks. For instructions on installing this optional–and free–software on your PC, see page 143.

Use this box and
button to rename
your photos

Click these
buttons to view
your photos
as a slideshow

Uploading and Sharing with Shutterfly Express

If you've already uploaded the photos you want to share to Shutterfly, you may as well skip Shutterfly Express. Simply sign into the Shutterfly Web site and then click the "Share online" tab. Creating shared albums works just like organizing your photos in Shutterfly, as described in Chapter 6. Select the photos you want to share as if you were moving them to a new album. When you click the Next button you see a screen to create your email invitations. For help with that, skip to step 5 on the next page for advice on emailing invitations.

If the photos you want to share are still sitting on your PC, this section's for you. Start up Shutterfly Express, and then follow these steps:

1. **In the Shutterfly Express window's upper-left corner, click the Get Pictures button.**

 Shutterfly shows you photos stored on your computer, one folder at a time.

2. **To share a photo, turn on the checkbox next to its name.**

 Shutterfly Express doesn't give you albums or any other way to organize your photos; it simply helps you find photos to upload and share.

3. **Above the thumbnail images, click the "Share online" button.**

 Truth is, when you click *any* of these buttons, Shutterfly Express uploads the selected photos to your Shutterfly online account. But when you click "Share online," Shutterfly whisks you straight to the page where you create your invitations.

4. **When the sign in box appears, enter your email address and the password you created when you signed up for Shutterfly.**

 Next you see the form where you create your email invitation (Figure 14-6).

*Figure 14-6:
Shutterfly's invitation form is the same whether you use the Shutterfly Express program or the online site.*

5. **Type your email addresses, a subject, and a message for the invitation. Then click Next to upload your photos and send the invitation.**

 A box appears, showing you the progress in uploading your photos. After the upload is complete, you see a window that thanks you for using Shutterfly and includes a link to the page that shares your photos. Meanwhile, your friends receive an attractive invitation by email (Figure 14-7).

TIP The Thank You window also offers to add your email recipients to your Shutterfly address book, so that in the future you can just select them instead of manually typing out their addresses.

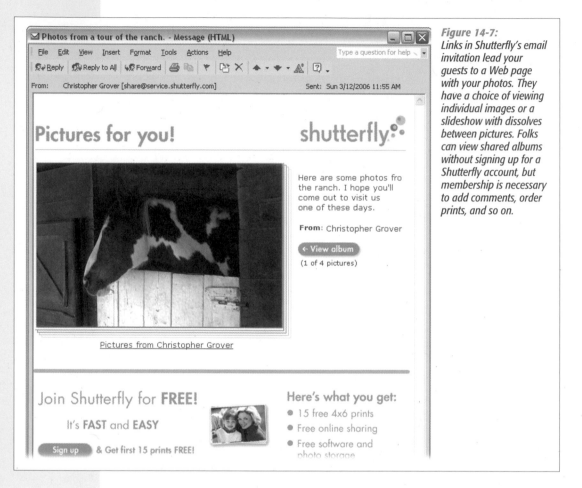

Figure 14-7:
Links in Shutterfly's email invitation lead your guests to a Web page with your photos. They have a choice of viewing individual images or a slideshow with dissolves between pictures. Folks can view shared albums without signing up for a Shutterfly account, but membership is necessary to add comments, order prints, and so on.

Sharing Photos with Snapfish

Like Shutterfly, Snapfish (*www.snapfish.com*) makes photo sharing simple. You can share more than one album at once, but you can't pick and choose photos from different albums as you can with EasyShare.

TIP To mix and match photos from different albums, you need to create a new album, copy photos to it, and then share that new album. For details on copying photos between albums, see page 152.

Once you've uploaded photos into Snapfish albums (page 149), sharing them is a breeze:

1. **Log into Snapfish. On the Home page, in the Get Started box at upper right, click "share."**

 On the "Share albums" page, you see thumbnail icons of all your albums.

2. **Turn on the checkbox next to the album(s) you want to share. Then click "choose these albums."**

 The "Share an album" screen appears.

3. **In the "addresses" box, type the email addresses of all the people you want to show your album to, separated by commas.**

 Snapfish automatically saves your guests' addresses in an online address book for you. In the future, you can click the "address book" link and eliminate all that typing.

4. **Type a subject line and a message for your email invitation.**

 If you leave it to Snapfish, you end up with a message that tells your friends how much it costs to order prints. You can delete this message with impunity. Your guests will have no trouble finding the "order prints" link on every Snapfish page.

5. **Click the Share Album button to send your invitation.**

 Your friends receive an email with the name of your album, a representative picture, and a nice big "view my photos" button (Figure 14-8).

Sharing Photos and Hobbies: Flickr

As an adjunct to Yahoo Groups, Flickr (*www.flickr.com*) is a place where photo buffs, dog buffs, Porsche buffs, and just about every other imaginable kind of buffs share their photos and passions. You can use Flickr to share photos with your family, but be warned: Technophobic relatives won't find Flickr as easy to use as, say, EasyShare or Snapfish. Flickr originated as the digital brainchild of photo-snapping computer geeks, and it still falls short in user-friendliness.

Flickr's Many Ways to Share

Before you can share photos on Flickr, you must upload them, as described on page 153. Once you upload a photo, you have a bunch of ways to decide *who* gets to see it online. Your options, in order from most paranoid to let-it-all-hang-out, are as follows:

- **Private.** You, and only you, can see this photo on Flickr, unless you grant access to specific people (from your Contacts list, as described in the next section). You can make photos private if you're just using Flickr to temporarily store photos so you can clear your memory card (or if you're not sure you want Web-surfing co-workers to stumble upon a shot of you in a swimsuit).

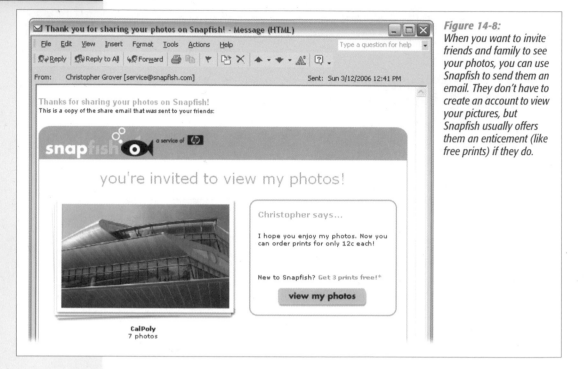

Figure 14-8:
When you want to invite friends and family to see your photos, you can use Snapfish to send them an email. They don't have to create an account to view your pictures, but Snapfish usually offers them an enticement (like free prints) if they do.

NOTE Unfortunately, you can apply the Private designation only to photos you've uploaded.

- **Contacts.** You can add any fellow Flickr members to your Contacts list. Or invite folks to sign up for a Flickr membership so you can have them as contacts. Flickr lets you further subdivide your contacts into Family and Friends, giving you more control over who gets to see which photos and *photo sets* (photo collections).

- **Groups.** If you're uploading photos for the viewing pleasure of a Flickr group that you've joined, then you can make them available only to group members. You can even create groups for the express purpose of sharing photos.

- **Public.** Anybody surfing around Flickr can view photos you designate as Public. Your photos may come up when folks search for photos by tag (page 156). For example, if you upload some shots of your dogs and tag them Daisy and Duke, then you may get some Jessica Simpson fans visiting your *photo stream* (the history of all the photos you've uploaded to Flickr).

The easiest way to use Flickr is to make all your photos Public and tell your friends and family to look you up by your Flickr ID. But you sacrifice some privacy that way. To limit who can ogle your pictures, make them available only to people on your Contact list, as described next. The catch: To be on the list, your contacts must have (or create) Flicker IDs of their own.

Creating Contacts

When you first sign up with Flickr, your Contacts list, like your photostream, is empty. To fill it up, just follow these steps:

1. **Sign into Flickr. At the top of any Flickr screen, click Your Contacts.**

 On the "Photos from your contacts" screen, you can see your existing contacts (if any) and add new ones.

2. **Click either "search for people" or "invite some of your friends."**

 If you choose the first option, you can look up Flickr members by ID (if you know it), or just by email address. This option also lets you add total strangers to your contact list by searching for others who share your interests (breeding zebra finches, for example).

 If you choose the second option, you don't have to know whether folks have a Flickr ID (and you can skip the rest of these steps). Flicker emails your guests invitations to view your photos. When they click the link in the email, they can enter Flickr using an existing ID, or create one on the spot.

3. **On the "Find people" page, enter a Flickr ID, email address, or topic of interest.**

 Flickr lets you search by all kinds of information in member profiles, like favorite books and movies. When you find who you're looking for, Flickr takes you to the member's photo page.

4. **At the top of the member's photo page, click the "Add as a contact" link.**

 Flickr shows you a confirmation screen, where you can also designate the new contact as either Friend or Family.

5. **Click OK when you're done.**

 From now on, this person's recent photos show up whenever you visit Your Contacts page. You can even sign up for an RSS or Atom feed. (RSS is a terrible name for a great technology; it can stand for either Rich Site Summary or Really Simple Syndication. It's a system of signing up for free "subscriptions" to Web sites so you don't have to check them for updates. Atom works the same way.) If your browser offers one of these features, then it can alert you when your contact has uploaded new shots.

 TIP If the Your Contacts page gets too crowded, click the self-explanatory link that says "only show photos from your family and friends."

Now that you've set up some contacts, you can reveal your Private photos to them, as described next.

Setting Up Photos for Sharing

You can choose sharing settings during the uploading process, or add or change them anytime later, as long as you're signed into Flickr. Here's how:

1. **Go to the Your Photos page. (For example, click the "Photos: Yours" link at the top of any Flickr screen.)**

 Your albums are listed at left. Click an album to view its photos in the middle part of the screen.

 TIP If you have lots of photos in Flickr, then they may take up several pages. If so, you'll see page numbers under the last photo on the current page. Click the numbers to navigate from page to page.

2. **Browse through your photos until you find the one you want to share, and then click the "change" link.**

 The link is under the photo in the main part of the screen (Figure 14-9).

lola-brief-nap

One of the few moments Lola wasn't in motion.

(5 comments / 75 views)

This photo is **public** (change)

Uploaded on Feb 10, 2006 | Delete

Figure 14-9:
Under each photo on Flickr, you can review a number of details about it. For example, you can read the caption you supplied, how many people have commented on or viewed the photo, and the date you uploaded it. You can also see whether your photo is public or private. To edit your sharing options, click "change."

3. Select either Private or Public.

 As far as sharing photos on Flickr goes, the great divide is whether your photos are Private or Public (Figure 14-10). Choosing Private doesn't mean you can't share photos with others, it just means you have more control over who you share them with. You can choose to share your photos with Friends, Family, or both, by turning on the checkboxes.

 NOTE To Flickr, Friends and Family have no literal meaning. You can assign these designations to anyone on your Contacts list. For example, you can use Family for anyone you want to show personal photos to, and use Friends for sharing work-related images with your co-workers.

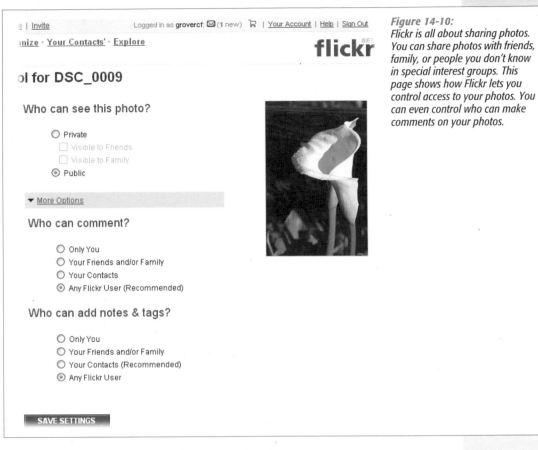

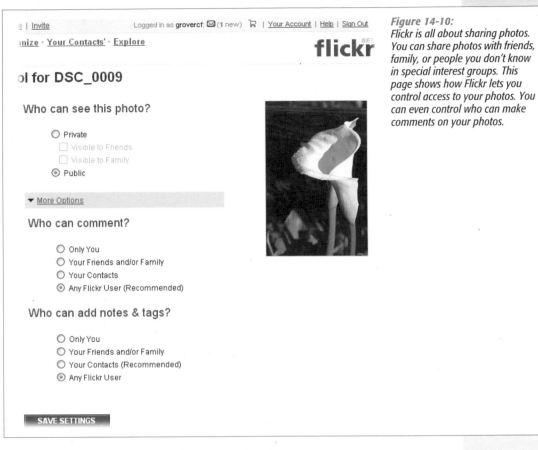

Figure 14-10:
Flickr is all about sharing photos. You can share photos with friends, family, or people you don't know in special interest groups. This page shows how Flickr lets you control access to your photos. You can even control who can make comments on your photos.

4. Save the changes by clicking the Save Settings button.

When you're happy with the new sharing settings, click Save Settings, and Flickr takes care of the rest.

NOTE Adding Flickr members to your Contacts list doesn't put you on *their* lists. It's up to them to add you. Fortunately, on all Flickr Profile pages, there's a "send message" link, so you can ask nicely.

Sharing with Groups

In a Flickr Group, photos from all group members get thrown into one communal photostream called a *Pool*. Groups give you instant sharing. Just choose a group, and all members have access. You don't have to mess with invitations or contact-list management. Some groups bring together people with a common interest, like flower arranging or black-and-white photography. But a group can also consist of students working on a joint project, a far-flung family with wedding pictures to share, and so on.

Sharing photos with people in Groups isn't difficult, but the first thing you need to do is join a group. So sign into Flickr and follow these steps:

1. **Click the Groups link at the top of any Flickr page.**

 The next page lists some popular and recently created Flickr groups. On the off chance that one of these groups is exactly what you're looking for, click its link to go to the group's home page and join up.

2. **Click "browse around" or "create your own group."**

 The "Browse for a group" page shows you a list of broad categories: Computers & Internet, Life, Nature, and so on. Click a category to drill your way down to more specifically focused groups.

 If you're creating a new group, you get three choices: Public–Anyone Can Join, Public–Invite Only, and Private. The Private option's good for co-workers or family groups, but you can't change a Private group to Public later.

 Once you've joined or created a group, you can send any of your Flickr photos to it.

3. **On the Your Photos page, click the photo's thumbnail to display the full-size image. Above the photo, click Send To Group, and then choose a group from the drop-down menu (Figure 14-11).**

 If a group name is grayed out, you've already added the photo to the group.

Sharing with the Pros: Photo.net

Sharing photos with friends and family is a lot of fun, but if you want to become a better photographer, then the best way to learn is by conferring with experienced photographers. Photo.net (*www.photo.net*) is a community of professional and avid amateur photographers who provide mutual support by rating and critiquing each other's work (Figure 14-12).

The quality of the photography on Photo.net is generally good to excellent, and the topics are geared toward professionals. For example, you'll find portrait and nature photography, but not family and pet snapshots. If you're thin-skinned, then you may not want to hear what pros and serious amateurs have to say about your photos. On the other hand, when you want to learn how to take great pictures, this is a good place to begin your education.

NOTE Photo.net is a subscription-based site. Frequent visitors who post photos are expected to pay the $25 per year subscription fee, enforced by the guilt-inducing honor system. Until you subscribe, you can use a trial/guest membership. About half of the site's revenue comes from subscriptions and the other half comes from advertising. Subscribers enjoy benefits such as unlimited submissions, critiques, and gallery folders.

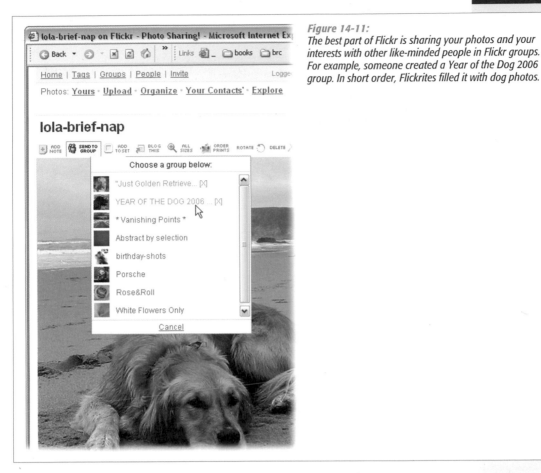

Figure 14-11:
The best part of Flickr is sharing your photos and your interests with other like-minded people in Flickr groups. For example, someone created a Year of the Dog 2006 group. In short order, Flickrites filled it with dog photos.

Your Photo.net Portfolio

When you join Photo.net, you create a portfolio, which serves as your online photo repository, personal information file, and launching pad to the online community. It includes:

- **Folders.** Your folders hold the photos that you upload.

- **Presentations.** You can copy photos from your folder into presentations that you share with other Photo.net members. If other members create presentations and send them to you, then you'll find them in your portfolio.

- **Your photo equipment.** This listing makes it easier to add camera and equipment information to your photos as you submit them.

 TIP Using Photo.net to keep track of purchase dates and serial numbers can come in handy if your equipment ever disappears.



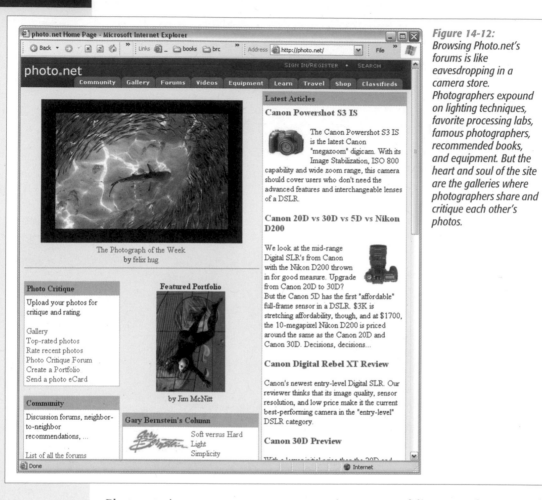

Figure 14-12:
Browsing Photo.net's
forums is like
eavesdropping in a
camera store.
Photographers expound
on lighting techniques,
favorite processing labs,
famous photographers,
recommended books,
and equipment. But the
heart and soul of the site
are the galleries where
photographers share and
critique each other's
photos.

Photo.net gives you many ways to customize your portfolio to match your needs. For example, if you view or critique a photo, you can then ask Photo.net to send you alerts when other people comment on the same photo.

Uploading Pictures to Photo.net

To submit to Photo.net, you must first become a member. Go to *www.photo.net*, admire the Photograph of the Week, and then click the "Sign in/Register" link in the upper-right corner. Type your name, email address, country of residence, and optional demographic information. When you click Register, Photo.net emails you your password and instructions for your first login.

When you're in, here's how to submit photos:

1. **Under the Gallery tab on any Photo.net page, choose My Portfolio.**

 The My Portfolio page is divided into different sections: Your Folders, Your Presentations, Your Settings, and so on.

2. Under Your Folders, click the "upload a single photo" link.

 Photo.net shows you the Add Photo page, which is a fairly detailed form (Figure 14-13).

3. **At the top of the form, click Browse, and then navigate to the photo file on your PC that you want to upload.**

 Fill out as much of the rest of the form as you like. Include any information you think will be helpful to other photographers viewing (or critiquing) your photo.

4. **When you're done, click "Add this photo" to submit the photo.**

Figure 14-13:
The Add Photo form gives you plenty of ways to provide details about your picture. The camera film and equipment details come from your Photo.net equipment listing. Fill in the other details such as the date and location of the shot. At the bottom of the form, you can add technical information.

Viewing Photos and Critiques

Once your photo is added to your gallery, other members can view it, rate it, and provide critiques. You can find all pictures uploaded to Photo.net, including your own, by clicking the Gallery tab. To get an idea of what other members are shooting, choose from links like Browse Portfolios, Top Photos, and so on. To see your own work, click Your Portfolio on any page. Click any thumbnail photo to view it (and its accompanying details) on a separate page (Figure 14-14). When you view photos in your portfolio, you can see how many times fellow photographers have viewed your pictures as well as any ratings and critiques they've provided.

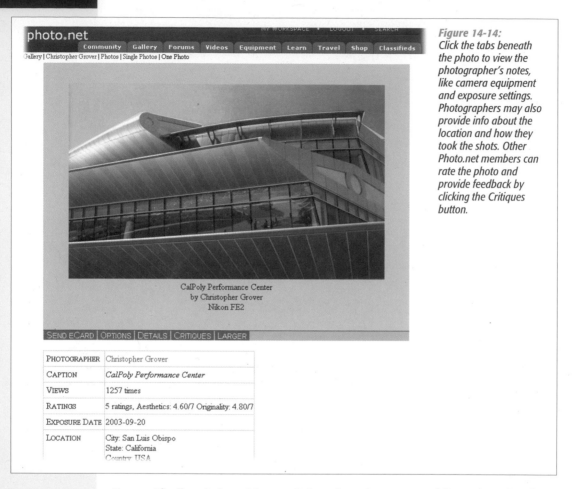

Figure 14-14:
Click the tabs beneath the photo to view the photographer's notes, like camera equipment and exposure settings. Photographers may also provide info about the location and how they took the shots. Other Photo.net members can rate the photo and provide feedback by clicking the Critiques button.

To specifically ask for critiques, click a photo in your portfolio. When the photo page appears, click the Options tab below your photo, and then click the Request Critique link. Your photo appears in the Critique Forum, where other members can provide comments and rate your photo on a scale from 1 to 7. By and large, critiques on Photo.net are supportive and helpful.

Trek the World Through Photography

If you've ever dreamed of visiting faraway lands and photographing your adventures, TrekEarth is for you. This site (*www.trekearth.com*) is devoted to exploring the planet's places and peoples through pictures. As befitting a site named TrekEarth, the home page displays a world map. Just click a continent to begin browsing for pictures. You can choose from categories like daily life, festivals, nature, and architecture. For your reading (and writing) pleasure, the site also hosts travelogues and discussion boards.

Unlike, say, Flickr, TrekEarth isn't a place to share snapshots of family, friends, and pets. The rule of thumb is: If you can't explain how the photo helps others learn about the world, then it probably doesn't belong on TrekEarth. Members can post only one photo every 24 hours, which also helps keep the content true to the theme and the quality high.

In addition to providing world tours on the cheap, TrekEarth serves as a forum for photographers who want to improve their skills. On TrekEarth, there's a difference between *comments* and *critiques*.

A comment is a general remark, usually about the place or the subject of the photo. A critique contains specific information as to why the photo is good or not and provides constructive advice for improvement. To further encourage helpful critiques, TrekEarth provides a way for photographers to rate their critics in turn.

Like Photo.net, TrekEarth also serves as an online photography workshop. And get this: members can even edit each other's photos and post the results. In photography, there are always different ways to approach a subject, so you can learn a lot from seeing your own photo taken in a different direction.

Membership in TrekEarth is free, and signup is simple. When you post a photo, you're encouraged to provide a note that describes the photo and the place. Many of the notes are beautifully written and, as you might imagine, it's not unusual to find a photo with comments and critiques written in a few different languages. Fortunately, TrekEarth also provides translation links via Babel Fish (*http://babelfish.altavista.com*).

Emailing Your Photos

Ever since Kodak rolled out the Brownie camera, photographers have been slipping snapshots into envelopes and sending them off to friends and family. The same thing goes on today, but with email, it's faster and cheaper. Emailing photos takes just a few clicks and costs nothing (assuming you already have an email account). Email's perfect for quickly sending off a single photo—or even a handful of photos—to friends, family, and co-workers.

> **TIP** If you have more than a couple of photos to share, consider posting them on a photo-sharing Web site. In fact, there's a whole chapter devoted to that subject—Chapter 14.

A variety of programs you've seen throughout this book have tools to help you send photos by email. No matter which program you use, the biggest challenge is always the same: image files are big files. Even when you're emailing just a photo or two, you can take steps to ensure email success. This chapter reveals the best and fastest ways to email photos using these three programs:

- **Kodak EasyShare.** EasyShare appears to have a preference for sending photos you've uploaded to the EasyShare Gallery (page 132), but the program will actually email pictures stored on your PC. All you have to do is adjust its…well, Preferences.

- **Picasa.** Sure, Picasa has a reputation for being a bit more complicated than EasyShare, but not so with emailing photos—it's a simple point and click operation. Again, a preference tweak is required to unleash its emailing powers.

• **Photoshop Elements.** As usual with Elements, you can make email as simple or as elaborate as you care to. For example, you can create customized stationery, Web page–style backgrounds, and Adobe Reader slideshows.

But first things first. Before you email photos in *any* program, you have to learn how to deal with the fact that those beautiful, full-color, high-resolution photos of yours are usually too big to email. Read on.

FREQUENTLY ASKED QUESTION

It Pays to Call a Specialist

Why do I need to use EasyShare/Picasa/Elements to email a few photos? Can't I just use my regular email program, which I already know how to use?

Of course. You can email pictures using virtually any email program out there. The problem is, your average email program lacks any features that *help* you deal with photo files.

If you insist on going it alone, you face at least two hurdles:

• Without nifty tools like albums, thumbnails, and titles, it's harder to root around on your hard drive for the photos you want to send. With the kind of file names digital cameras paste on your photos (IMG_0014.jpg, for example), you'd better have your picture folders systematically named and meticulously organized to have a prayer of locating a given photo. The makers of EasyShare, Picasa, and Photoshop Elements designed their programs specifically to spare you from that drudgery.

• You get no help properly resizing photos for emailing. As explained in "Understanding the File Size Dilemma" on page 325, those multimegabyte digital photos that look so great in prints are unwieldy choking hazards to most email systems. When you email photos using programs like the ones in this chapter, the software slims down photo files to perfect email proportions, with little or no help from you. And they look great on your viewer's computer screen.

If you're still determined to use your regular email program, here are your options:

• Use Picasa. This gem of a program prepares your photo for emailing, and then hands it off to your favorite email program for the actual sending. See page 327 for details.

• Launch your email program and attach the photo to a message just like any file. To squeeze full-size, hi-res files through the email pipeline, you may have to limit yourself to one picture per email, and compress the files (with WinZip, for example).

• Use a photo-editing program to *resize* the file, and then switch to your usual email program to send it. Both EasyShare and Elements can *export* an email-friendly version of your photo. You can email the resized copy, leaving the original intact. In EasyShare, select the photo you want to email, click the Edit button, and then choose Save As in the screen that appears. Elements owners can select a picture in the Organizer and then choose File → Export → To Computer (choose JPEG from the Export Selected Items window that appears).

Understanding the File Size Dilemma

The reason so many people shell out for high-end, multimegapixel digicams (yourself included, perhaps) is to get great-looking prints, ones that rival the sharp resolution and vivid colors of film prints. When you look at photos on a computer monitor, by contrast, all those extra dots are wasted. The average computer monitor displays 96 dots (that's, pixels) per inch. If your audience is merely going to look at the picture in the body of an email or in a graphics program (Windows Fax and Picture Viewer, say), then you can afford to discard a lot of image information from that 300dpi picture file. The photo ends up a lot easier to send (and receive) by email, and looks just as good onscreen.

By way of example, suppose you want to send three photos to some friends—terrific shots you captured with your 5-megapixel camera. Here's the math: A typical 5-megapixel shot consumes two to three megabytes of disk space. So emailing a mere three photos would make at least a 6 MB package.

So what? you ask. Well, here are just a few potential problems:

- **Your recipient may be using a dial-up modem.** While cable modems and other broadband connections are increasingly common in North America, not everyone has access to one yet. And overseas, many citizens still dial their way onto the Internet. With a dial-up connection, those 6 MBs take *24 minutes* to download to your counterpart's inbox. (By the same token, if you're using a dial-up modem, it takes you 24-minutes to *send* that same email.) Few pictures are worth *that* kind of wait, especially if you're paying for phone usage by the minute.

- **The typical Internet account has a limited mailbox size.** Even if your recipient has a nice speedy modem, Internet service providers don't give their customers unlimited server space. A 6 MB message strains the capacity of many email accounts. Some services have a 5 MB limit, so your 6 MB email won't even get through. Although most ISP's have a higher limit (Earthlink, for example, allows its customers 100 MB), your email is only one of many going into that Inbox. Your 6 MB can push the email box over the storage limit, causing other (potentially important) messages to bounce, until your unhappy friend deletes it from the server.

- **Most PC monitors are too small to display full-size pictures anyway.** It's happened to everybody. Some kind soul sends you a full-resolution photo file, thinking that it's going to look really great when you see it on your computer. When you open the thing, you get a mammoth image that goes beyond the boundaries of your screen. As explained at the beginning of this section, because there's a limit to monitor resolution (and it's quite low), extra dots just add up to a bigger picture, not a clearer one. You have to scroll to view a part of the image at a time, never seeing the whole picture—not a good viewing experience.

NOTE Out of consideration for the viewer, many graphics programs automatically shrink over-size pictures to fit in a normal-size window. But that essentially throws away all those pixels that took so long to email.

Of course, when you're emailing photographs specifically for someone to print out on the other end, you *do* need to send the full-size files. The file size dilemma has plagued netizens for years, but all three programs in this chapter are more than adequately equipped to help you deal with it. The rest of this chapter shows you how to resize and email photos using EasyShare (described next), Picasa (page 327), and Photoshop Elements (page 330).

Emailing Photos with EasyShare

Kodak EasyShare has fabulous tools for organizing and displaying voluminous photo galleries in online albums. What most people *don't* know is that EasyShare makes it easy to share (ahem) by email, too. Kodak doesn't publicize that fact, perhaps because the company would prefer to recruit more Kodak Gallery members and sell them prints. But before you succumb to abject cynicism, take heart: With just a few extra steps—changing some settings in the program's preferences—you can make EasyShare email-friendly. Just follow these steps:

1. **In the tabs along the left side of the EasyShare window, click Email.**

 The Email Sharing Options window opens (Figure 15-1). If the window doesn't appear, click the Email Setup button at the top of the EasyShare window.

Figure 15-1:
EasyShare's email-sharing preferences give you two options: Share Online Albums and "Email with Attachments." The initial setting, Share Online Albums, tells EasyShare to sends invitations to your email buddies, with links to your online albums. If you want to email your actual photos, select "Email with Attachments."

2. **Select "Email with Attachments," and then click Finish to close the dialog box.**

 You don't need to touch these settings again (unless you want to change them).

3. Back in the EasyShare window, click the My Collections tab (at left). Select the photo or photos you want to email.

As you select photos, they appear in the task window on the right. (By the way, you can Ctrl+click or Shift+click to select more than one photo, as described in the box on page 100.) To remove any photo after you've added it, select the photo in the task window and then click the Remove Selected Pictures button. (The button has an icon of a circle with a slash through it.)

4. In the tabs along the left side of the window, click Email.

EasyShare presents a dialog box reminding you that it needs to convert your photo(s) to the svelte JPEG format (page 15); this is the first step in slimming down your photos. Click OK, after which you see a form where you enter the usual email information.

TIP To make it easier to reuse the email addresses you're about to enter, enter them in Easy-Share's Address book: Click the Address Book button, and then the New Contact button. A window appears where you can enter an email address, nickname, and so on.

5. In the "From:" box, type your email address. Below, in the "To:" field, type your recipients' addresses, separated by commas. Also, so your friends know what's coming at them, include a subject and a message.

Now it's time to resolve the all-important photo size dilemma. On the screen's left side, look for the "Optimize my pictures" heading and two radio buttons labeled "Original" and "Best for email." Below these buttons, EasyShare displays the size of the file you're about to email.

6. Under "Optimize my pictures," select "Best for email."

This option instructs EasyShare to make a copy of your photo and resize it so that it's suitable for emailing and viewing on the screen. For example, if the original photo is 3.55 megabytes, EasyShare trims it down to .55 megabytes—much better for emailing. (Your recipient can print this emailed photo, but only up to, say, 5×7. Beyond that, there's not enough resolution.)

If you must send the full-size photo, choose Original, and EasyShare sends the photo as is, even if it's a behemoth file.

7. To the left of your message, click Send.

Your photo zips over the Internet to your friend's email box. This email displays your attached photo, along with a message explaining how to save the photo file.

Emailing Photos with Picasa

Emailing your photos with Picasa couldn't be easier. You simply select the photos and click a button. Picasa automatically resizes the photos to email-friendly size

and attaches them to a new email message. There's only one possible hitch in this rosy scenario: You may have to tweak Picasa's email settings before you send photos. (But unless you change your mind, you don't have to tinker with the settings again.)

Here's how to email photos with Picasa, start to finish:

1. **At the top of Picasa's window, choose Tools → Options.**

 Picasa's Options box opens.

2. **Select the Email tab (Figure 15-2).**

Figure 15-2:
Picasa's Options dialog box lets you decide exactly what the program does when you send photos by email. For example, control the size of your photos by adjusting the slider. Choices range from 160 pixels to 1024 pixels (applied to the longest side of your photo).

3. **Click the radio button for the email method you want to use.**

 On your desktop PC, choose the same email program you use every day. If you're setting up Picasa on a laptop, your email method may vary depending on your location. The first option, "Let me choose each time," means Picasa asks what program to use each time you email pictures. For example, you might use Outlook when your laptop's plugged in at work, and Gmail when you're on the road. If you don't use either of these email programs, pick Use Picasa Email, a nifty email service built right into Picasa.

 In the next step, you'll use the slider and radio buttons to resolve the file size dilemma to your satisfaction.

4. **In the Output Options panel, drag the slider to tell Picasa how small to shrink your emailed photos.**

 You choices range from 160 pixels (pretty darn small) to 1024 pixels (big enough to fill most computer screens). The value shown in the slider is applied to the longest side of your photo. As you move the slider, you can read your selected pixel size at left.

5. **Next, under "When sending single pictures," select a file size option.**

 You get two choices: The same size as you chose with the slider above, or Original. If you choose Original, you can email full-size photos simply by sending them one-by-one.

6. **Click the Okay button to save your settings and close the Options box.**

 Now you're ready to email some photos.

7. **With Picasa's window in Library view, click a photo's thumbnail to select it.**

 If you want to email more than one photo, Ctrl-click additional thumbnails. As you select pictures, they show up in the Picture Tray in the lower-left corner (Figure 15-3).

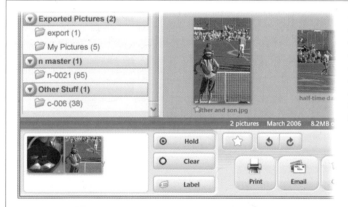

Figure 15-3:
Emailing photos with Picasa is delightfully straightforward. You can preview your selected photos in the Picture Tray (at lower left). When you're ready to send them, click the Email button (at lower right). Picasa does the heavy lifting: It resizes your photos, opens a new email message, and attaches the files.

8. **After you've selected photos to send, click the Email button at the bottom of the screen.**

 What you see next depends on the email program you use. If you use Outlook to handle your email, you see a familiar looking email (Figure 15-4), with your photos as attachements. Edit the subject and body as you wish, and enter the destination email address(es).

9. **Send the email on its way.**

 Send your email as you normally do. In the case of Outlook, for example, click the Send button in the message's upper-left corner.

☑ 3 pictures for you - Message (Plain Text)

File Edit View Insert Format Tools Actions Help Type a question for help

Send »

A B I U

ⓘ This message has not been sent.

To...

Cc...

Bcc...

Subject: 3 pictures for you

Attach... 📄 oregon-10.jpg (8 KB); 📄 DSC_0082.jpg (34 KB); 📄 IMG_0339.jpg (9 KB)

```
You have been sent 3 pictures.

oregon-10.jpg
DSC_0082.jpg
IMG_0339.jpg

These pictures were sent with Picasa, from Google.
Try it out here: http://picasa.google.com/
```

Figure 15-4:
You can edit and send the message just like any other email. This example shows the invitation in an Outlook email. All you need to do is fill in the blanks.

Emailing Photos with Elements

Powerful program that it is, Elements shoulders much of the burden of emailing photo files. You just click a few buttons, and Elements preps your photos, fires up your email program, and attaches the files to an outgoing message.

You get an almost bewildering array of formatting choices for emailing your photos: You can send pre-arranged groups of photos, frame your photos, change the background color (of the email), and so on. Furthermore, Elements gives you a wide range of templates to help you create beautiful and unique custom designs for the body of your email.

Although Elements is bursting with formatting options, don't feel pressured to use them. Sending email with Elements follows the same basic procedure as any bare-bones program. Select photos, type a message, enter an email address, and send. But the fancy options are there when you need them, and this section points them out along the way.

Selecting Photos and Recipients

First you need to pick the photos you want to send. To get started, just follow these steps:

1. **In the Organizer, select the photos and then choose File → E-Mail or simply press Ctrl+Shift+E.**

 The Attach Selected Items to E-Mail window appears (Figure 15-5).

Pulling the Plugs

Emailing photos from Elements has one fairly obnoxious drawback: At the bottom of every message you send is an ad hawking Elements.

Don't want to be in the advertising business? To get rid of Adobe's ads, you can select and delete them like any other text…but that gets old after about the third time.

To eliminate ads from all future Elements emails, browse to C:\Program Files\Adobe\Photoshop Elements 4.0\shared_assets\locales\en_us\email\signatures. Inside the *signatures* folder you'll find a bunch of files. Open them in a text editor (such as Notepad), and remove the advertising lines. Your mail is ad free, now and forever.

NOTE If a window pops up asking you to choose an email program, select either Outlook or Outlook Express. If you use another email program, pick "Save to Hard Disk and Attach File(s) Yourself." Then follow Elements' instructions for attaching files to your own email program.

2. **If you'd like to attach additional photos, in the lower-left corner, click Add. Navigate on your PC to the photo or photos you want to email, and then click OK.**

If you select more than one photo, as described in Figure 15-5, Elements attaches them all to one email message.

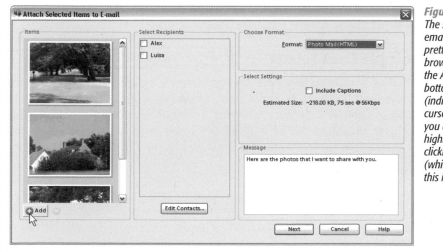

Figure 15-5:
The setup window for emailing in Elements is pretty easy to use. To browse for photos, click the Add button at the bottom of the window (indicated here by the cursor). Remove photos you don't want by highlighting them and clicking the Delete button (which is grayed out in this illustration).

3. **In the Select Recipients box, add the people you want to share the photos with.**

Elements emails the photos to everyone checkmarked in this panel. Of course, if you're doing this for the first time, you don't have any names in this box, so click Edit Contacts (at bottom), and type the name, email address, and other contact info for your intended recipients.

Elements adds this info to your *Contact Book* (a list of people you regularly send email to). From now on, these folks appear in your recipients list, and all you have to do is click to select them. (See the box below for more on the Contact Book.)

The next few sections take you through the rest of your email sending journey.

Contact Book Tips

Elements saves you time by storing the addresses of people you regularly email. When you're creating an email in the Organizer, click the Edit Contacts button (shown in Figure 15-5) to add folks to your Contact Book. In the Photo Browser or Date View, choose Edit → Contact Book, and then click New Contact.

But why type individual names and addresses when you probably already have that information in your regularly scheduled email program? Elements lets you import contact information from Microsoft Outlook or Outlook Express. Actually, you can import contacts from any program as long as you save them in *V-card* format (a popular standard for digitally storing business card information).

In the Contact Book window, click Import, and then choose your source.

You can also create *groups* of names in the Contact Book, for times when you want to send the same photo to several people at once. For example, you can make a group for all the members of your Bunko club. Then when you email the photo of each month's proud winner, you simply select one name (the group name) instead of 11 individuals. Click New Group, give the group a name, and then select entries from your Contact Book and click Add. People you add show up in the group's Members list. (To remove a name from the group, select it in the Members list and then click Remove.)

Choosing an Email Format

The heading to this section begs one question: It's email—how many formats could there be? Elements gives you more options than any other program in this book. Luckily for you, applying different formats is as easy as choosing from a menu: From the Attach Selected Items to E-mail window's Format drop-down menu, choose your preferred method for displaying the emailed photos.

You have three choices:

- **Photo Mail (HTML).** This option actually turns your email message into a Web page, so that your recipients can view your photos right in their email window, and you can add all kinds of fancy Web design touches. When you choose this option, some additional details appear in the Select Settings panel, just below the menu. (For the full story, see the upcoming section "Photo mail options," for more detail.)

 NOTE Most newer email programs handle HTML email just fine, but some ancient software (AOL 4, for example) refuses to display it correctly. In fact, even if a mail program understands HTML, your recipient may have turned that option off and won't see your email formatted as you intended. If you're worried about that, then pick either of the next two options.

- **Simple Slide Show.** Creates a basic PDF format slideshow of all your images. All you do is name your slideshow. Elements does the rest, as described on page 367.

- **Individual Attachments.** Here's the old traditional choice. This option sends each photo as an email attachment. The Convert Photos to JPEGs setting (which appears in the Select Settings panel) automatically changes your files to JPEGs, a good small format for emailing. If your photos are already JPEGs, then this checkbox is grayed out.

Finishing Up and Sending Your Email

Once you've added photos and recipients and selected your formatting options, all that remains is to type some friendly prose in the Message box, and then click Next.

Elements creates your ready-to-send email. What happens next depends on which option you chose from the Format menu. If you're going the Individual Attachments route, Elements now creates your ready-to-send email. You can make any final changes to the message and address just as in any other email program. And you send it off like any other email, too.

If you're creating an HTML email or slideshow, clicking Next launches an Elements Wizard that walks you through the last few settings, described next.

Photo mail options

Elements gives you a ton of options for gussying up your photos if you choose Photo Mail (HTML). When you send Photo mail, your message gets formatted using an HTML-based *template*, a stationery design in which your photo appears. (HTML is the coding language used to create Web pages.)

When you select Photo Mail, you see the estimated download time for the worst-case scenario—a dial-up modem. Use this information to determine if your email's reasonably sized. You can choose whether to display your photos' captions, and below that, you can edit the standard "Here are the photos I want to share with you" text. Once you've finished your work here, click Next and you see the Stationery & Layouts wizard, where you're presented with a long list of stationery theme categories (Animals, Fun Stuff, and so on). When you find a style you like—the preview window updates as you click through different choices—click Next Step.

In the Customize window, you can change the size of your photo(s) if you wish. If you're mailing more than one photo, you have a choice of several different page layouts. Below the layouts, you can choose a typeface (from a list of five common fonts). Click the box to the right of the font name to choose a color for the text. If you've chosen a frame style that leaves empty space around the photo, then you can customize the background color of your email. For some styles, you can adjust the padding (the mat-like space between the photo and the frame) and the frame size. Each time you make a change in the left pane of the window, Elements updates the preview so you can see just what you're getting.

PDF slideshows

You can also email a group of your photos as a slideshow. Elements uses the popular PDF format, which lets your recipients page through each slide using the ubiquitous Adobe Reader program. They just launch the slideshow and view the photos one by one. You can create a PDF slideshow from the Create wizard, or you can make a slideshow right in the E-mail window, which is where the Create wizard sends you anyway.

To do so, just select your photos as described earlier, and then choose "Simple Slide Show (PDF)" as your format in the E-mail dialog box. You get offered a choice of sizes, including "Leave as Is." Name the slideshow and click OK. Elements generates a standard email message with the slideshow as a PDF attachment.

Printing Your Photos

There's a lot to love about digital photos that remain digital. You can store hundreds of shots on a single CD; you can send them anywhere on earth by email; and they won't wrinkle, curl, or yellow (until your monitor does). Still, sometimes there's no substitute for a printed photo. You can paste prints into scrapbooks, display them in picture frames on the mantle, use them to make your own greeting cards, or share them with your Luddite friends who don't own computers.

This chapter looks at three ways to turn your digital photos into prints you can hold in your hand.

- **Making Prints at Home.** The first part of the chapter shows you how to set up a color printer so you can make great prints at home. The actual printing process varies depending on your software, so this chapter takes a step-by-step look at printing with Kodak EasyShare (page 340), Google's Picasa (page 342), and Photoshop Elements (page 343).

- **Making Prints at Kiosks.** You don't need to invest in a printer: The photo kiosks in discount and drug stores do an excellent job (page 351). And you can have prints of your soccer game shots before you even get home!

- **Ordering Prints Online.** For the ultimate in convenience and print quality, you can order prints from an Internet photo service. The last sections of this chapter show you how to do it using EasyShare, Picasa, Snapfish, Shutterfly, and Photoshop Elements.

How to Make Great Prints at Home

Digital photo software like EasyShare or Elements makes printing painless and quick. But making *great* prints—the kind that rival traditional film-based photos in their color and image quality—involves more than simply hitting the Print command.

One key factor, of course, is the printer itself. You need a good printer that can produce photo-quality color printouts. Fortunately, photo printers are getting easier to come by all the time. Even some of the cheapo inkjet printers from Epson, HP, and Canon produce amazingly good color images—and they cost less than $100.

> **NOTE** Don't be misled by the low prices of inkjet printers: The printer company makes their money back on those $40 ink cartridges. Depending on how many ink-hungry prints you make, what you spend on cartridges can easily double or triple the cost of the printer in a year.

However, if you're really serious about producing photographically realistic printouts, consider buying a model that's specifically designed for photo printing, such as one of the printers in the Epson Stylus Photo series or the slightly more expensive Canon printers. Look for a printer that uses six or even eight different colors of ink instead of the usual "inkjet four" (yellow, cyan, magenta, and black). The extra colors greatly enhance the printer's ability to reproduce a wide range of colors on paper.

Even the niftiest printer can spit out disappointing results, though, if you don't take care of factors under *your* control. To coax the best quality images from any printer, you need to pay attention to three important issues: the resolution of your images, the settings on your printer, and your choice of paper.

Understanding Resolution and Print Size

Resolution is the number of individual pixels squeezed into each inch of your digital photo. The basic rule's simple. The higher your photo's resolution, or *dpi* (dots per inch), the sharper, clearer, and more detailed the printout will be. If the resolution is too low, your print appears blurry or speckled. Low-resolution photos are responsible for more wasted printer ink and crumpled photo paper than any other printing snafu, so it pays to do some simple calculations *before* you print, to make sure your digital photo has enough resolution for the print size you want.

Calculating resolution

To calculate a photo's resolution, divide the horizontal or vertical size of the photo (measured in pixels) by the horizontal or vertical size of the print you want to make (usually measured in inches). To find a photo's pixel dimensions in Windows, select the photo and choose File → Properties to open the window shown in Figure 16-1.

Photos printed on an inkjet printer look their best when printed at a resolution of 220 dpi or higher. Suppose, for example, a photo measures 1524 × 1016 pixels and you want to know if it's got the resolution for a good 4 × 6 print. 1524 pixels divided by 6 inches = 254 dpi. So, this photo exceeds the 220 dpi minimum. Your 4 × 6 print will have a resolution of 254 dpi and will look fantastic on paper.

Figure 16-1:
You can find your photo's resolution using Windows Explorer. Find the photo file and then go to File → Properties. (Or you can just right-click any image file and choose Properties from the shortcut menu.) Next, click the Summary tab to see details. At the top of the list, you find the width and height of the photo.

Now then, say you try to print that same photo at 8 × 10. Essentially, you're stretching those pixels that made such a good 4 × 6 print across a larger print area. If you do the math, you can see right away the drop in image quality: 1524 pixels divided by 10 inches = 152 dpi.

TIP While it's important to print photos at a resolution of 220 to 300 dpi on an inkjet printer, there's really no benefit to printing at higher resolutions—600 dpi, or 800 dpi, or more. It doesn't hurt to print at a higher resolution, but you probably won't notice any difference in the final printed photos, at least not on inkjet printers. Some inkjets spray ink at finer resolutions—720 dpi, 1440 dpi, and so on—and using these highest settings produces very smooth, very fine printouts. But bumping the resolution on your *photos* higher than 300 dpi doesn't have any perceptible effect on their quality.

Tweaking Your Printer Settings

Just about every inkjet printer on earth comes with software that adjusts various print quality settings. Usually, you can find the controls for these settings right in

POWER USERS' CLINIC

Cheating on Resolution by Resampling

You can't easily increase a photo's resolution once it's on your computer. That's why it's best to shoot with as high resolution a camera as possible. Any camera rated 3 megapixels or higher (which includes most cameras these days) can shoot photos suitable for printing. If a low-res photo is all you've got, then you can try *upsampling* (that is, increasing) its resolution using software. Photoshop Elements, for example, includes a tool that lets you upsample. Pros frown on this tactic, though, since you're basically asking the program to manufacture new pixels out of thin air.

If you're determined to print a low-resolution photo, and you have Photoshop Elements, test it out for yourself. Choose Image → Resize → Image Size. In the Image Size dialog box, enter your new resolution, and then choose Bicubic Smoother from the Resample Image menu.

You won't be able to gauge the image quality by looking at it on your monitor (which, remember, is perfectly happy with low-resolution images). Instead, you'll need to print out your newly beefed up photo and see if it still looks good.

If you're considerably enlarging a photo, it's best to do it in two or more small steps (called *step* or *stair interpolation*—about 10 percent at a time works well). Elements does a better job with successive small steps than with one big one. Because this work can get tedious, several outfits offer plug-ins (page 290) to automate the process for you. One of these is Fred Miranda (*www.fredmiranda.com*).

the Print dialog box that appears when you choose File → Print in your image-editing program. On most printers, for example, you'll find several different quality levels for printing, like Draft, Normal, Best, or Photo. There may also be a menu that lets you select the kind of paper you're going to use—plain paper, inkjet paper, glossy photo paper, and so on.

Choose the wrong settings, and you'll be wasting a lot of paper. Even a top-of-the-line Epson photo printer churns out awful photo prints if you feed it plain paper when it's expecting high-quality photo glossy stock. You'll end up with a smudgy, soggy mess. So each time you print, make sure your printer is configured for the quality, resolution, and paper settings that you intend.

Choosing the Right Paper

When it comes to inkjet printing, paper is critical. Regular typing paper—the stuff you'd feed through a laser printer or copier—may be cheap, but it's too thin and absorbent to handle the amount of ink being sprayed when you print a full-color digital photo. If you try to print large photos on plain paper, then you'll end up with flat colors, slightly fuzzy images, and paper that's rippled and buckling from all the ink. For really good prints, you need paper designed expressly for inkjets. Also, if you buy paper precut to common photo sizes like 4×6, you have to take your digital photo's dimensions into account as well.

Paper quality

When you choose good photo paper, you get much sharper printouts, more vivid colors, and results that look and feel like actual photographic prints. Glossy photo paper, for example, might run $25 for a box of 50 sheets, which means you'll be spending about 50 cents for an 8×10 print—not including ink. Even so, at sizes over 4×6 or so, making your own printouts is still less expensive than getting prints from the drugstore (even when you factor in the cost of ink cartridges).

Most printers accommodate at least five different grades of paper. Among them:

- **Plain.** The paper used in most photocopiers.

- **High Resolution.** A slightly heavier inkjet paper—not glossy, but with a silky-smooth white finish on one side for printing photographs and other images.

- **Glossy Photo.** A stiff, glossy stock that resembles the paper that photo-developing labs use.

- **Photo Matte.** A stiff, non-glossy paper.

- **Gloss Film.** Made of polyethylene rather than paper, this stock feels the most like traditional photographic paper. It's also the most expensive option for home prints.

> **TIP** To save money and avoid wasting your high-quality photo paper, use plain inkjet paper for test prints. When you're sure you've got the composition, color balance, and resolution of your photo just right, load up your expensive glossy photo paper for the final printouts.

Aspect ratio

You also have to think about your pictures' *aspect ratio*—their proportions. Most digital cameras produce photos with 4-to-3 proportions, which don't fit neatly onto standard print paper (4×6 and so on). Just to make sure you're completely confused, some sizes of photo paper are measured *height by width*, whereas digital photos are measured *width by height*.

If you print photos on letter-size paper, the printed images won't have standard Kodak dimensions. They'll be, for example, 4×5.3 which means they won't fit perfectly into standard picture frames and albums. None of these factors detract from the photo's beauty, though, so you may not care.

Your other option is to print on precut photo paper in the standard sizes like 4×6, 5×7, and so on. To avoid ugly white bands at the sides, you must first crop your photos to standard print sizes in your image-editing software (see Chapters 9 and 10 for information about cropping).

Printing Photos with EasyShare

EasyShare makes printing your photos, well, easy. You need to make a few choices about the size of your photos, how many prints you need, and the photo paper you're using. In exchange, EasyShare handles some of the more detailed, behind the scenes work. You'll get the best results if you pay attention to the three details listed in the previous section: the resolution of your images, the settings on your printer, and your choice of paper.

When you're ready to start, just follow these steps:

1. **On the My Collection tab, select the photo you want to print.**

 To choose multiple photos, click the checkbox icon above the task window after you select each photo in the main window. (Alternatively, select a group of photos and then click the checkbox icon.) As you make your selections, your chosen photos gather in the task window.

2. **Once you've selected your photos, click the Print at Home tab.**

 The screen shown in Figure 16-2 appears.

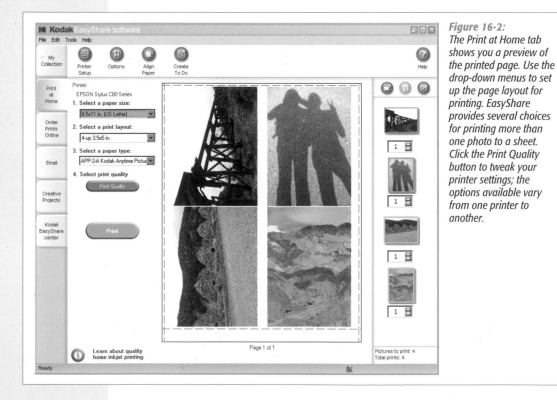

Figure 16-2:
The Print at Home tab shows you a preview of the printed page. Use the drop-down menus to set up the page layout for printing. EasyShare provides several choices for printing more than one photo to a sheet. Click the Print Quality button to tweak your printer settings; the options available vary from one printer to another.

TIP As you select photos, consider details like the size of your prints and what type of photo paper you're using. Printing multiple photos on one large sheet saves on expensive photo paper and ink.

3. **In the upper-left corner of the screen, check the printer make and model listed under the Printer label.**

 For example, it might say something like: Epson Photo Stylus 220. If you don't see your photo printer's name, click the Printer Setup button, and then, in the Windows box that opens, select your printer. (Don't worry about the quality or other printer settings at this point, you'll set those in another step.)

4. **From the drop-down menus at left (Figure 16-2), choose your paper size, layout, and type.**

 Choose the same paper size you've loaded in your printer. The second drop-down menu shows your options for printing your selected photos on that size paper. For example, if you're printing four 3.5 × 5 inch photos on one sheet of 8 × 10 paper, then choose the *4-up 3.5 × 5 in.* option. Finally, choose the type of paper you're printing on. Kodak lists several of its popular photo paper choices in this list. If you're not using one of their papers, go for a close match to ensure that your printer uses just the right amount of ink for your paper's weight and texture.

5. **To adjust your print quality settings, click the Print Quality button (just below the three drop-down menus).**

 In the Printer Setup dialog box, you see your printer's quality settings. As explained in "Tweaking Your Printer Settings" on page 337, make sure your printer's set up for photo quality and paper type. Close the dialog box when you're done.

6. **In the Printer pane at the right of the Print at Home window, make any final changes to the number and selection of photos you're printing.**

 Below each thumbnail is a count box where you can set the number of photos you want to print. As you add photos to the print job, you increase the number of pages you're printing. You can also add and subtract individual photos from the print job.

7. **Last thing before you print, check your print preview.**

 The middle part of the screen shows exactly how your printed pages will look. (If your photo job runs to more than a single page, use the buttons at the bottom of the window to view the additional pages.) Make sure your photos are grouped on each page as you expect.

8. **If all systems are go, click the Print button.**

 Depending on your printer and the quality settings you've used, you may have time to get a cup of coffee while the printer does its job.

9. **Examine the printed results.**

When you finally have the print in your hand, take a close look at it. Is it aligned on the page the way you expected? If not, you can make adjustments with Easy-Share's Align Paper button at the top of the screen.

TIP If your inkjet-printed photos show streaks, the problem may be the print heads, not your paper or settings. Inkjet printer software often gives you tools to clean clogged nozzles. Check your printer's instructions.

Printing Photos with Picasa

Picasa makes printing easy. You make decisions about the size and layout of your photos, and Picasa shows you the results before you print. As explained earlier in this chapter (see "How to Make Great Prints at Home" on page 336), the resolution of your images, the settings on your printer, and your choice of paper all contribute to great prints. In Picasa, you can check your photos' resolution in Library view, and control the other settings on the Print Preview screen.

Here's what you need to do:

1. **In Library view, click the thumbnails of the photos you want to print.**

As you click, the images appear in the Picture tray at the lower-left corner of the window. Ctrl+click to select several photos at once.

2. **To make sure a photo has sufficient resolution for the print size you have in mind, check its resolution by choosing Picture → Properties (or press Alt+Enter).**

The photo's properties, including pixel dimensions, appear in a separate window. As explained on page 336 and shown in Figure 16-3, you can use these numbers to calculate optimal print size for this photo.

3. **When you're done selecting photos, click the Print button at the bottom of the Library window.**

Picasa's Print Preview screen appears. To the right, you see how your photos will print on a sheet of paper. At left are the print settings.

4. **In the panel at left, choose your print layout.**

As shown in Figure 16-4, Picasa provides six different photo layout options.

5. **Click either the "Shrink to Fit" or "Crop to Fit" button.**

Unless you've already cropped your digital photos, they probably aren't going to exactly fit a standard photo-paper size (see "Aspect ratio" on page 339). No worries: Select "Crop to Fit", and Picasa trims the edges for you, giving you a perfect 8×10 or 5×7. If it's important to keep the entire image, even if the proportion is different from a standard photo size, select "Shrink to Fit."

Figure 16-3:
Picasa's photo properties box shows many details about a photo, including its dimensions in pixels. This photo is 3072 pixels wide by 2304 pixels high, perfect for printing landscape style on 8 × 10 inch paper, since 3072÷10 = 307 dpi. (Anything over 220 dpi is enough resolution for a good quality print.)

6. **In the lower part of the panel, check your printer settings.**

 If you have more than one printer attached to your computer, click the button with the printer icon (Figure 16-4) to choose the one you use to print *photos*. To make sure your printer's set up for photo quality printing and paper, click the button next to Printer Setup (see "Tweaking Your Printer Settings" on page 337).

7. **Choose the number of copies you want to make.**

 You can adjust the number of copies you make of each picture by clicking the + or – buttons.

8. **In the lower-right corner, click Print.**

 Photos take longer to print than text pages, so be patient. The higher the quality setting, the longer it takes.

Printing Photos with Elements

Photoshop Elements puts your printing choices in your hands (and in your mouse). You can either go for quick and simple prints or get as fancy as you like, precisely positioning your photos on paper, adding borders, and so on. You can print photos at home (page 336), or prepare them in Elements and send them off to Kodak's EasyShare service (page 361).

When you print at home, you can start the process right from the Editor window, which is convenient if you happen to be working in the Editor. When you're done

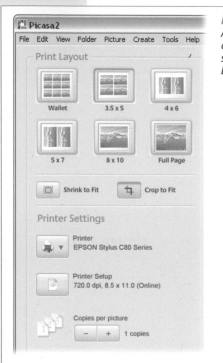

Figure 16-4:
All Picasa's settings for your print job are in this window's left panel. You can choose a layout, decide whether or not to crop your photos to fit a standard photo format, and adjust your printer settings. Use the + and – buttons to set the number of prints you want.

editing a photo, simply choose File → Page Setup and follow the instructions in the next section to print it. No need to make a side trip to the Organizer.

NOTE The Editor lets you print only one photo at a time. To print multiple photos (including contact sheets) you *must* use the Organizer, as described on page 348.

Previewing and Printing from the Editor

Before you actually print your photos, you need to make sure they're set up for great-looking prints. For example, a photo must have enough resolution to produce a good quality print. The bigger the print, the higher resolution you need. (For a refresher, see "Understanding Resolution and Print Size" on page 336.) Also, the type of paper you print on makes a big difference in the color and quality of your output, as explained in "Choosing the Right Paper" on page 338.

You check these settings in two windows—the Page Setup dialog box and the Elements Print Preview Window. First, open your image, and then:

1. **Choose File → Page Setup or press Ctrl+Shift+P. (In the Elements Print Preview window, click the Page Setup button.)**

 Elements uses the same Page Setup window as all the other programs on your PC. It's where you set your page size and orientation and tell the computer which printer to use. (If you have more than one printer connected to your PC, click Printer to choose the one you use for printing photos.)

2. **In the Page Setup window, choose your paper size and orientation.**

Orientation refers to the direction your photo faces on the paper: vertically (portrait) or horizontally (landscape). When your printer and orientation are set, you're ready to go to Elements' Print Preview.

NOTE If you're printing on photo paper or sending your photos out for printing, check to be sure that your photos are cropped to a standard paper size. (See Chapter 10 for the details on cropping.)

3. **Close the Page Setup dialog box. Then, back in Elements, press Ctrl+P to open the Print Preview window (Figure 16-5).**

Don't be intimidated by the Print Preview window. You won't need all these options every time you print, but each setting comes in handy sooner or later.

4. **For simple printing, just check to make sure your photo is properly positioned on the page, and then click Print.**

If you're lucky, a perfect-looking print emerges from your printer. If the positioning doesn't look right, or if you're not happy with the color, the following pages explain how to use the Print Preview dialog box to fix matters.

Figure 16-5:
Print Preview is your control center for printing from Elements. Your options include repositioning, resizing, rotating, adding borders, and more. Turning off the Center Image checkbox (circled) lets you drag your photo around manually, so you can position it wherever you like (assuming you've got room on your paper).

NOTE The Print Preview window lets you work with one photo. To print more than one, click "Print Multiple Photos," which sends you to the Organizer Print dialog box (page 348).

Repositioning your photo

On the left side of the Print Preview window is a thumbnail showing the location where your photo will print. Normally, Elements shows a *bounding box*, the black outline with handles on the corners indicating the edges of your photo. Don't worry, the bounding box itself doesn't print along with your photo. The box just gives you a way to move and resize your image by dragging the handles. If the box bothers you, get rid of it by turning off the Show Bounding Box checkbox.

The familiar Elements rotate symbols appear below the right corner of the image window. Use the rotate symbols if you need to change the orientation of your photo.

TIP If you want to print only part of a photo, Figure 16-6 shows how.

Figure 16-6:
If you don't want to print your entire photo, you don't actually have to crop it before printing it. You can select the area you want and then turn on "Print selected area" (where the cursor is here). The rest of your photo vanishes, and you see only the part you selected. You can treat the selection like an entire image—move it, resize it, put a border around it, and so on.

Resizing your photo

You can resize your photo in Print Preview in several ways:

• **Print Size menu.** Choose any print size from the list or enter a Custom Size. "Fit On Page" changes the size of your image, if necessary, to fit the size of the paper you're using.

• **Scaled Print Size.** Resize your photo by a certain percent or by entering new dimensions here. (If you want a custom size, just enter the size here. You don't have to change the Print Size drop-down menu, too.)

- **Bounding Box.** You can also use the bounding box to change the size of your image. Hold Shift (to keep the proportions the same) and drag one of the tiny white boxes (on any of the bounding box's corners) to make your image larger or smaller.

- **Crop to Fit Print Proportions.** If your image has a different aspect ratio (length to width proportions) than the paper you're printing on, then turn this checkbox on, and Elements crops your print for you.

You need to be cautious about resizing in Print Preview, though. Don't go larger than 100 percent, or the quality of your photo starts to deteriorate and you'll get a warning from Elements (see Figure 16-7).

Figure 16-7:
If your resizing activities are going to reduce your photo's resolution below 220 ppi, Elements warns you about the result. Generally, it's better to do most resizing, especially any resizing upward, before you get to Print Preview. Enlarging your photo in Print Preview can make for grainy, poor-quality prints. If you can see pixilation in the preview window, you know something's amiss, and you should start by checking your resolution.

Print Multiple Photos...

Print Size: 8" x 10"

⚠ Image will print at less than 220 ppi at the selected size

Scaled Print Size

More print options

As a full-fledged image-editing program, Elements has some printing options you may not think of using on snapshots. But features like the Print Preview box's Position tool are great for projects like greeting cards and scrapbooking because you tell Elements where *you* want the photo to go. And adding a border is a nice touch for invitations and greeting cards. Here's a quick run-down of your choices:

- **Position.** This option tells Elements where to put your photo on the page. Elements starts you out with the "Center Image" checkbox turned on. You need to turn it off before you can reposition your image. To change the location of your photo, either drag its thumbnail or, in the boxes provided, type the amount of offset you want. (Top controls how far your image is from the top of the page; Left controls the distance from the left edge of the page.)

- **Border.** When you want to add a border to your photo, turn on the Border checkbox and enter the size you want for your border (in inches, millimeters, or points). Elements shrinks your photo to accommodate the border. Click the white square to bring up the Elements Color Picker so that you can choose a color for your border.

- **Print Crop Marks.** This setting, found to the right of the Border settings, lets you print guidelines in the margins of your photo to make it easier to trim it exactly. Crop marks are primarily useful for trimming bordered photos so that the borders are exactly even.

Economical Print Experiments

If you've just gone out and bought top-quality photo paper, you may be suffering from a bit of sticker shock and perhaps even thinking, "Oh yeah, great. Now I'm supposed to use this stuff experimenting? At that price?"

The good news is, while you'll have to bite the bullet and sacrifice a sheet or two, you don't need to waste the whole box. Instead, try this: make a small selection somewhere in a photo you want to print, press Ctrl+C and go to File → New from Clipboard. You get a new file with only a small piece of your photo in it—your test print.

In Print Preview, turn off the Center Image checkbox and drag your small photo to the upper-left corner of the page. Run the page through your printer using Elements' standard settings. When your print looks good, you're ready to print the whole photo.

On the other hand, if you don't like the result, then press Ctrl+P to bring up Print Preview again. This time, move your test strip over to the right a little bit. Change your settings (taking notes on the changes you've made) and print again on the same piece of paper. Your new test prints out beside the first strip. Keep moving the test area around on the page, and you can try out quite a few different combinations of settings, all on the same sheet of paper.

One word of caution: Make sure the print is completely dry (especially with glossy paper) before running it through your printer again. Otherwise you risk transferring ink to the printer's feed rollers and possibly ruining a subsequent print.

Printing from the Organizer

Elements also lets you print from the Organizer, which gives you many more output options than the Editor, including the ability to print several photos on one page. You can create contact sheets of thumbnails, picture packages (like you'd order from a professional photographer), and labels. The Organizer also lets you easily add all kinds of fancy borders to your photos.

In the Organizer, select the photos you want to print. Then follow these steps:

1. **Press Ctrl+P (or click the Print shortcut icon and then choose Print).**

 The Print Selected Photos dialog box, Organizer's print control center, opens (Figure 16-8). There's a preview window at center, and printing tools at right and left.

 Although you've probably already selected photos for printing, it's not too late to change your mind, as explained in the next step.

2. **Click Add (+) to bring up a window where you can search for additional photos, or highlight a photo's thumbnail and click the – button to remove it.**

 The right side of the Print Selected Photos dialog box gives you a few easy-to-understand options. The printer Elements is about to use is listed first.

3. **If you have more than one printer, then click the little icon to the right of the printer name. Choose your photo printer.**

 The next few steps explain how to use the multiple print options.

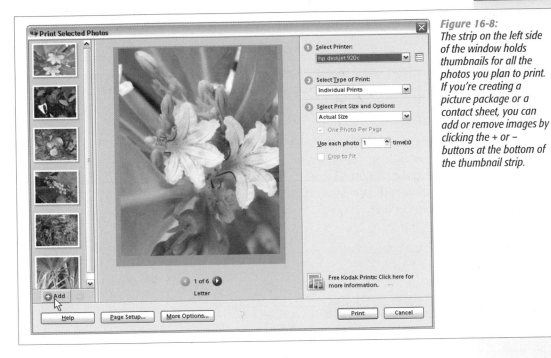

Figure 16-8:
The strip on the left side of the window holds thumbnails for all the photos you plan to print. If you're creating a picture package or a contact sheet, you can add or remove images by clicking the + or – buttons at the bottom of the thumbnail strip.

4. **Select a Type of Print.**

 You can choose to make individual prints, a contact sheet, a picture package of multiple photos, or pick from a few different label styles. See the next section for details on the available choices.

5. **Select Print Size and Options.**

 The size options you see are dependent on the page size you selected in Page Setup. So if you see only letter-sized options and you want, say, A4, then check to be sure you've chosen A4 as your paper size.

 If you're printing multiple images, you can tell Elements how many times you want to use each photo. For example, you can choose to print one photo four times or four different photos one time each.

 If you turn on the One Photo Per Page checkbox, each image prints out on a separate page if you're printing picture packages.

 Crop to Fit tells Elements to perform any cropping as it sees fit (if you want to decide where to crop your photos, use the cropping tools you learned about in Chapter 10).

6. **When you're done with your settings, click Print**

Printing Multiple Images

The Organizer really shines when it comes to printing more than one photo at once. You can print a contact sheet that shows small thumbnails of many images. You can also create a picture package that features multiple pictures in multiple sizes. Finally, you can choose to print your pictures on a selection of label sizes.

Contact sheets

Contact sheets show thumbnail views of multiple images on a single page. They're great for creating a visual reference guide to the photos you've archived onto a CD, for instance. Or you may print a contact sheet of all the photos on a memory card as soon as you download the photos to your computer, even before editing them (see Figure 16-9).

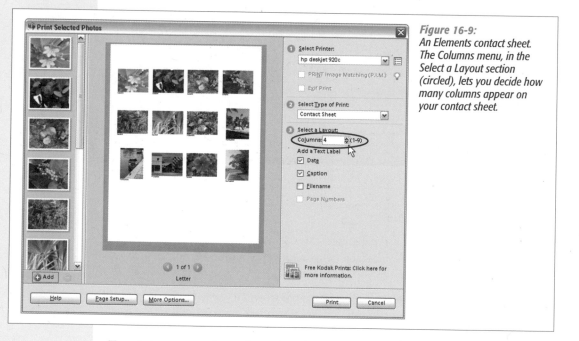

Figure 16-9:
An Elements contact sheet. The Columns menu, in the Select a Layout section (circled), lets you decide how many columns appear on your contact sheet.

To print a contact sheet, first select the photos in the Organizer, and then open the Print Selected Photos dialog box (Ctrl+P). Under "Select Type of Print," choose Contact Sheet from the drop-down menu. Your options immediately change to show "Select a Layout," and you can use the following settings to customize your contact sheet:

- **Columns.** Here's where you decide how many vertical rows of photos to have on a page. Choose up to nine columns per page. The more columns you have, the smaller your thumbnails are. Even if you have only one image currently chosen, increasing the number of columns shrinks the thumbnail size.

- **Add a Text Label.** If you want a caption on each image, you can choose the Date, Caption (any text in the image's caption field), and/or Filename here.

- **Page Numbers.** You can add page numbers if you're printing multiple pages. If all your photos fit on one page, this choice is grayed out.

You can add and remove images as explained earlier. When you like your layout, click Print.

Picture packages

Elements' Picture Package tool lets you print several images on one sheet. You can print a package that's one photo printed repeatedly, or create a package that includes multiple photos.

To get started, choose photos for the package in the Organizer, and then press Ctrl+P to open the Print Selected Photos dialog box. Under "Select Type of Print," choose Picture Package. Next, under Select a Layout, choose which composition style you want. Then choose a frame, if you'd like one, by picking from the Select a Frame drop-down menu.

Once you've chosen a basic layout, you can get creative. Reorganizing your package is drag-and-drop easy:

- As always, you can add photos to your package by clicking the Add button in the lower-left corner of the dialog box. To remove a photo from the package, highlight its thumbnail in the left panel and click the red minus button.

- If you turn on "Fill Page with First Photo," you get an entire page dedicated to each photo showing multiple sizes of the image, instead of a group of different photos on each page.

- If you have empty space in your layout and you want to fill it, just drag a thumbnail from a slot in the layout, or from a thumbnail in the left pane, into the slot where you want to use the photo again.

- Changing the size of a photo is easy. Just drag it from the box it's currently in to a different-sized box (Figure 16-10).

When you've got your package arranged as you want it, click Print.

> **TIP** Turning on the "Crop to Fit" checkbox lets Elements crop your photos to fit their slots, but you're probably better off doing that yourself in the Editor before you start. See Chapter 10 for details on cropping.

Printing at Photo Kiosks

Once upon a time, 24-hour photo developing was the latest craze. But people proved too impatient for that kind of exruciatingly long wait. Soon one-hour photo shops appeared (never mind that many of them took *four* hours to get your

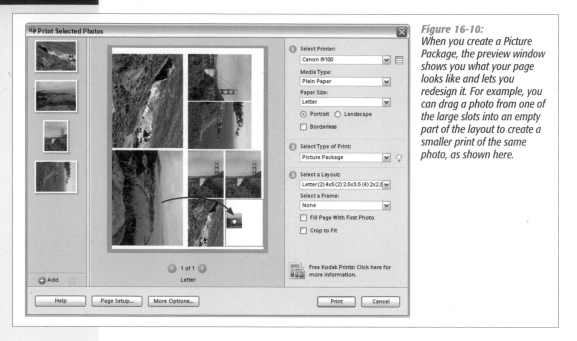

Figure 16-10:
When you create a Picture Package, the preview window shows you what your page looks like and lets you redesign it. For example, you can drag a photo from one of the large slots into an empty part of the layout to create a smaller print of the same photo, as shown here.

prints out). Enter the next evolutionary step: photo kiosks. You can find them everywhere: drugstores, supermarkets, discount stores, and, yes, even photo stores. Kiosks aren't the best way to print your fine art photos, but you can't beat them for instant gratification. When you're shooting on vacation, you can plug your memory card into the nearest kiosk and start enjoying your best shots in minutes.

As with all digital photography, you print only the photos you want. You don't have to develop a whole roll. Many photo kiosks let you perform quick fixes, such as cropping, enhancing colors and red eye removal. If you're comfortable doing quick fixes with a program like Picasa, EasyShare, or Elements, you'll have no problem at the photo kiosk.

Photo Kiosks: What Goes In

You can insert two things into most photo kiosks: a memory card loaded with pictures from your digital camera, or a CD containing photos. Kiosks use just about every type of memory card in existence. For example, Kodak kiosks use: SmartMedia, Compact Flash, Memory Stick, Memory Stick Pro, Memory Stick Duo, Memory Stick Duo Pro, MultiMedia Cards (MMC and RS-MMC), Secure Digital Cards (SD and Mini SD), X-D Picture Cards and USB Flash memory cards.

The CD option is especially handy if you'd like to edit your photos on your own computer before printing at a kiosk. You make better choices when you don't have impatient people in line waiting for you to finish cropping and fiddling with the color balance of your photos. Here are some tips on editing your photos in preparation for printing them at a kiosk:

- Save your photos in JPEG format.

- Make sure your photos are in RGB color mode. (Unless you changed the color mode with a program like Elements, you won't have to worry about this.)

- Don't put your photos in folders on the CD. Just copy the loose files to the CD's root (top) level.

- Use CD-R discs. (Some kiosks don't like the rewritable CD-RW discs.)

- Burn your CDs in the ISO9660 format. This option's easy to find on almost all programs that burn CDs. Or use a program like EasyShare, which makes the right decisions for you.

Photo Kiosks: What Comes Out

Not all photo kiosks are created equal. You'll find different features (in different places) on each one you visit. The ubiquitous 4×6 print is the most common output from photo kiosks, but most kiosks are capable of much more, including prints up to 8×10. You can also usually combine prints on a single sheet of photo paper: two 5×7 inch prints, for example, or nine wallet-size prints on one sheet. Some kiosks let you make special products with your photos, like greeting cards and calendars.

In addition, some kiosks will burn your photos to a CD. If you don't have a CD burner at home, you can slip a memory card of photos into a kiosk and create a photo CD to view on a PC or even a TV set (via a connected DVD player). Photo CDs are also a convenient way to distribute photos in mass quantities, like a season's worth of soccer team shots to parents or wedding pictures to the clan.

Ordering Prints Online

There's no shortage of companies vying for the privilege of printing out your photos. If you've ever ordered anything from Amazon or any other online merchant, then ordering photo prints on the Web will feel pretty familiar. The process usually goes something like this: Select your items (in this case, photos), choose a shipping method (faster costs more), provide your credit card number over a secure connection, and receive your order confirmation.

Ordering prints from online services offers some advantages:

- You get good-quality prints that last longer than most inkjet prints.

- Ordering online usually costs less than using a kiosk or buying paper and ink for home printing.

- You can edit your digital photos at home, send the files over the Internet, and get finished prints delivered right to your mailbox (your *real* mailbox, that is).

- Using online albums, you can share photos with folks on the other side of the country or down the block. Then, if they so desire, they can order their own prints, as described in the box on page 354.

Whether you're using EasyShare (below), Shutterfly (page 358), or Snapfish (page 359), the steps and the order you follow for getting prints are basically the same. All three of these services let you order from any Internet browser. (EasyShare and Shutterfly both offer standalone programs that reside on your computer, which provide a slightly easier alternative to the browser method.)

UP TO SPEED

Printing Other People's Online Photos

When you upload photos to Web sites like EasyShare, Shutterfly, and Snapfish, you can make your online albums available to as many people as you wish (as long as they have Internet access, that is). When you share photos online, distance is no object. If your family lives in sunny California and the grandparents are back East, Grandma can oogle your latest baby pics online the day you shoot them—and order prints of her favorites. As described in "Sharing Your Photos Online" (Chapter 14), you set up your online albums and email invitations to folks you want to share them with.

Now put yourself in Grandma's sensible shoes for a moment. Here's how to look at, and order prints from, an online album someone shares with *you*. You get an email inviting you to view the pictures. In the email message, you'll find a link to the online album. Click it.

In your Web browser, a window displays the shared pictures, usually in the form of thumbnails. Look for a button that says "Order Prints!" or words to that effect. (These sites stay in business by selling prints, so they don't make it hard to find.)

When you click the Order Prints button, the photo sharing Web site usually asks you to type your email address and a password, if you didn't do so when you first entered the site. (The site wants you to create a free account, so it can send you free prints, special offers, and other junk mail. When you come back to the Web site and enter your password, you can see your recently viewed and favorite pictures, check on the status of your print order, and so on.) Once your account is set up, it's simply a matter of selecting the photos you want to print and providing shipping and billing information, as described on these pages.

Ordering Prints Online with EasyShare

Kodak gives you two tools to work with your photos. There's the EasyShare program that you install on your computer, and there's Kodak Gallery on the Internet where you can store and share your photos in online albums. You can order prints from either of these services.

Ordering Prints with the EasyShare Program

If you have EasyShare installed on your computer, that's the simplest way to order prints. On the My Collection tab, select the photos you want to print, just as you would if you were printing photos at home. Then, click the Order Prints tab and follow the onscreen instructions. The program walks you through the process, letting you specify the sizes and quantities you want to order (Figure 16-11).

After you select shipping instructions and review your order, it's time to enter your credit card information. After you've answered all the questions and filled in all the

Figure 16-11:
Ordering prints using Kodak EasyShare is a simple process, but you must have an account before you can order prints. You choose the sizes and quantities, and the program does the uploading and handles the other details.

blanks, click Place Order to complete the transaction. EasyShare emails you an order confirmation, and transmits your photos to the lab for processing. Soon, you have photos in your hand.

Ordering Prints with EasyShare Gallery

The process for ordering prints from your online albums in EasyShare Gallery is very similar, although the screens look slightly different. From Kodak's point of view, the difference is that the photos don't need to be uploaded, since they're already on Kodak's computers in your online albums (page 138).

Just sign into EasyShare Gallery, and then follow these steps to order prints:

1. **At the top of the EasyShare window, click the Buy Prints tab. Then select the album with the photos you want to immortalize.**

 On the next screen, you see thumbnails of your photos. Below each, is a checkbox labeled Buy Prints (Figure 16-12).

2. **When you're done selecting thumbnails, click the Add to Cart button.**

 The next screen shows your online cart (Figure 16-13). You see your photos in the left column, and the costs and quantities for each on the right. If you're ordering several photos, you may need to use the scroll bar on the right to see them all.

CHAPTER 16: PRINTING YOUR PHOTOS 355

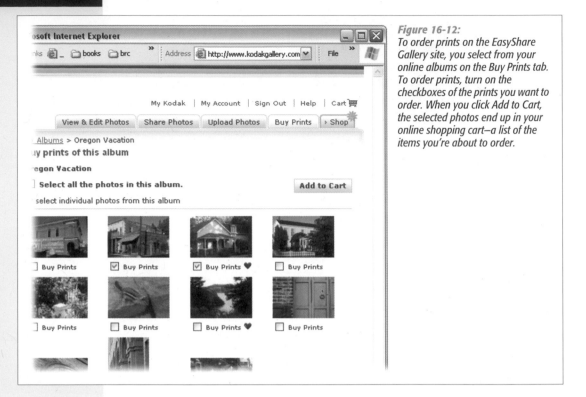

Figure 16-12:
To order prints on the EasyShare Gallery site, you select from your online albums on the Buy Prints tab. To order prints, turn on the checkboxes of the prints you want to order. When you click Add to Cart, the selected photos end up in your online shopping cart—a list of the items you're about to order.

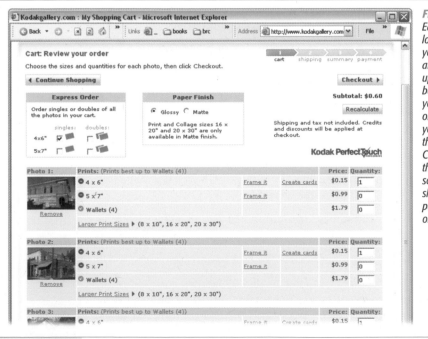

Figure 16-13:
EasyShare's cart should look somewhat familiar if you've ever ordered anything online. In the upper-right, a progress bar shows you how close you are to completing the ordering process. When you're done filling out this screen, click Checkout and you'll go through a series of screens to choose shipping options, payment method, and so on.

3. **Choose your print size and other options.**

 The shopping cart window gives you a world of choice, including:

 Size and Quantity. To the right of each photo, there are columns that show the price per print and number of prints you're ordering. If you want to order 120 of the 5×7 inch prints, for example, then just put 120 in the Quantity box and click Recalculate (in the upper-right corner). Your cart displays your new Subtotal.

 Paper Finish. EasyShare gives you a choice of glossy or matte finish. Make your choice at the top of the screen, and all the photos in your cart will use the selected finish.

 Frames and Cards. Like any good virtual salesperson, the shopping cart page takes the opportunity to upgrade the sale. That's the idea behind those tempting links to order framed photos or to create photo greeting cards. (Read more details on frames and cards and other items in the next chapter.)

 When you've made all your choices, be sure to click the Recalculate button to see the subtotal.

4. **Click Checkout.**

 On the left side of the screen, EasyShare displays the address you provided when you signed up. Turn on the checkbox if that's the address you want to ship these prints to. When you want to ship to a different address, fill in the form at right. Click Next when you're done.

5. **Choose a Delivery Method.**

 You have three ways to get prints in your hot little hands, ranging from standard to overnight.

 On this screen, you can also type a gift note. When you're done, click the Next button to review your order.

 NOTE Any gift message you type also appears on the *index print,* which is like a contact sheet, showing thumbnails of all the photos in your order.

6. **Review the order Summary.**

 This screen looks like a receipt showing your subtotal, shipping costs, and any other charges and discounts. Now's your chance to make sure everything's in order. If something doesn't look quite right, click the View Order Details link in the upper-left corner to revisit previous pages and made adjustments. When the order looks good, click Next one more time.

7. **Choose a payment method.**

 Time to pay up. Type your credit card details. If the billing address for your card is the same one you provided when you signed up to EasyShare, just click the button next to your address. If you need to provide a new address to go with the card, fill in the blanks.

8. **When your credit card information is complete, click Place Order.**

 Clicking this button is the final step. It's the online equivalent of handing your money over to the cashier.

Ordering Prints Online with Picasa

Picasa doesn't have its own online print service, but it does give you a quick way to connect to other services like Kodak Gallery (page 354) or Shutterfly (below). Select the photos you want to print and then click the Order Prints button at the bottom of the window. Picasa asks you to choose from a long list of partners including EasyShare, Shutterfly, Snapfish, Walgreens, Wal-Mart, and Zazzle (page 388).

Once you've chosen your service, everything is automatic: Picasa starts your browser, logs you on to the site you've chosen, and uploads your photos. The steps you take to complete your order depends on the company handling the printing—at this point, you're in their hands.

Ordering Prints Online with Shutterfly

As with Kodak EasyShare, you can order prints from Shutterfly using your online albums (page 146) or with the Shutterfly Express program on your PC (page 143). Shutterfly specializes in making it as fast and easy as possible to get your photos online and order prints (Figure 16-14). No wasted moves here.

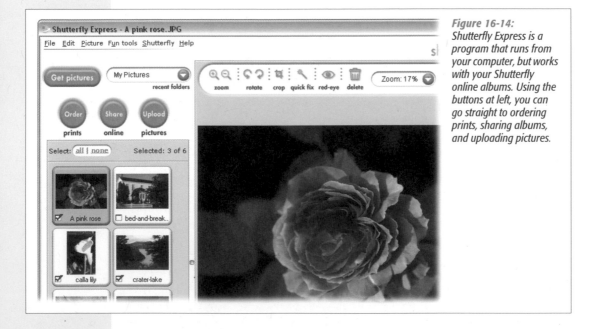

Figure 16-14:
Shutterfly Express is a program that runs from your computer, but works with your Shutterfly online albums. Using the buttons at left, you can go straight to ordering prints, sharing albums, and uploading pictures.

To order prints from photos on your PC, start up Shutterfly Express. The first screen lets you start selecting the photos you want to print. Use the drop-down menu in the upper-left corner to look in different folders. Turn on the checkboxes to select photos. Once you've made a selection, click Order Prints. Shutterfly logs on to your online account, and then shows your shopping cart (Figure 16-15).

Figure 16-15:
The Shutterfly Express cart makes it easy to order prints. It even provides helpful advice regarding the resolution of your photo files (page 336). When a photo doesn't have enough resolution for the size print you've chosen, you get the "not suggested" message. If you're ordering several photos, be sure to use the scroll bar on the right to view your entire order.

Once you've reviewed your cart, it's simply a matter of providing details for shipping and payment.

Ordering Prints Online with Snapfish

Hewlett-Packard created the Snapfish Web site with one purpose in mind: printing photos. Snapfish doesn't disappoint. It makes ordering prints online easy for you and easy on your wallet.

The steps for ordering photos from your Snapfish albums (page 151) are similar to the steps described for the other services. You choose your photos, specify the size and quantity of prints you want, and provide payment information over a secure Internet connection.

Simply log onto your Snapfish account, and then follow these steps:

1. **In the Get Started box at the upper-right corner, click "order prints." In the next window, select the album that contains the shots you want to print, and then click "open this album."**

 A new view shows you the photos within the album. If you need a better view of a photo, click the magnifying glass with the plus sign. Turn on the checkbox

below the photos you want to print. When you're done, click "choose these photos" to start the checkout process.

2. **Choose the size and quantity of your prints.**

 Your cart (Figure 16-16) shows thumbnails of your prints and a list of available sizes. Type a number to specify how many prints you want of each size.

Figure 16-16:
The Snapfish cart has a "quick order" panel at the top so you can quickly choose the same size and quantity for all your prints. Two buttons at the bottom of the cart let you choose either glossy or matte paper.

3. **When you're finished filling out quantities, click "check out."**

 If you want to add more photos to your cart, then click "keep shopping."

4. **Choose a delivery method.**

 Snapfish offers a few typical choices (U.S. mail, 2-day, overnight) and one unusual one: For an extra charge, you can pick up your photos at your local Walgreen's drug store. Click "continue" to go to the next step.

5. **Enter your credit card information.**

 If your billing address is different than the shipping address, you'll need to provide that information, too. When you're done, click "continue."

6. **Review your order.**

 The last step is to review your order and make sure it matches your expectations. If all's well, click "continue," and Snapfish responds by showing you a receipt. After that, it's simply a matter of checking your mailbox for photos.

Ordering Prints Online with Elements

Adobe has partnered with EasyShare Gallery to make it easy to upload photos directly from the Organizer so you can let someone *else* take care of the picture-printing duties for you.

Elements sports an Order Prints pane in the Organize bin, just below where you see your Tags and Collections (see Figure 16-17). This palette makes ordering prints from EasyShare extremely easy. Just drag your photos from the Photo Browser (page 177) right onto the palette.

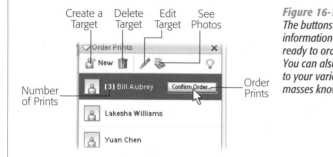

Create a Delete Edit See
Target Target Target Photos

Number
of Prints

Order
Prints

Figure 16-17:
The buttons marked here let you manage your contact information—called targets in Elements lingo—when you're ready to order prints. You can add, edit, or delete a target. You can also check to see which prints you've chosen to send to your various friends—helpful when you want to let the masses know what photos are on their way.

The palette uses *targets* to simplify the process of ordering and sharing. A target consists of a person's name and shipping information. You create a target for each person you regularly send photos to by clicking the New Target button and then entering the information for that person in the window that appears. When you want to send prints to someone, just drag the photos to his target.

To use EasyShare, you'll need to create an account for yourself, if you don't already have one. But you can wait to do that until you're ready to order. The first time you connect to EasyShare, you see a window where you can set up a new account or log in to your existing one.

Then you tell EasyShare how many prints you want of each photo you've selected and which sizes they should be. Confirm your order, and then, in a few days—presto—your prints arrive in the mail. The entire process is very easy, and the pricing is competitive with most drugstore photo printing. The only difference between prints ordered online and regular film prints is that the envelope Easy-Share sends you contains a contact sheet (a page of thumbnail-sized photos), instead of negatives. (You still have your "negatives," which are your original files.)

Once your photos are edited and you're ready to order prints, just follow these steps:

1. **In the Organizer, select the photos you want to print.**

 If the photos you want are scattered around, you may find it easier to make a temporary collection (see Chapter 8 for how to create a collection) so that you can easily see them all once. Alternatively, you can also just Ctrl+click to select the photos you want.

2. **Select a recipient.**

Drag the photos to the name of the person you want to receive the prints. If you don't already have a target for that person in the list, you can create one by clicking the New Target button and filling in her information.

3. **Confirm your order.**

If you want to review which photos you've chosen, click the "View Photos in Order" button to see them. It's the button just to the right of the Edit Contact button (the pencil icon) at the top of the Order Prints Pane. Hover your mouse over each button to see the tooltips text if you aren't sure which is which. When the "View Photos in Order" window opens, you can add or delete photos from your order there before confirming the order. You can also add more photos by dragging them to the target in the Order Prints pane, but the "View Photos in Order" window is the easiest way to remove photos before you start the ordering process.

The number of photos ordered for each person appears in parentheses to the left of the person's name in the target list. When you're ready to order, just click the Confirm Order button and Elements whisks you off to the EasyShare site (although you're still actually in an Elements window, bearing the headline Welcome to Adobe Photoshop Services).

4. **Order your prints.**

An easy-to-follow wizard appears to help you set up your account. (If you already have an EasyShare account, just log in.) Select the size and number of prints for each photo, as shown in Figure 16-18. You'll receive an envelope of prints in the mail a few days later.

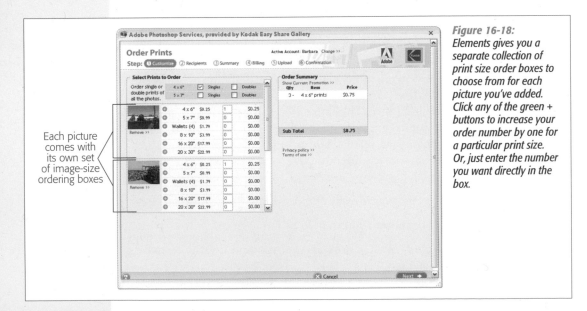

Figure 16-18:
Elements gives you a separate collection of print size order boxes to choose from for each picture you've added. Click any of the green + buttons to increase your order number by one for a particular print size. Or, just enter the number you want directly in the box.

Creative Photo Projects

No doubt about it: digital photography's great. You get to view your gorgeous, full-color pictures on a nice big screen, electronically shoot them across the globe in seconds, and retouch them to your heart's content—all on your computer. But therein lies the rub. Far too many people buy a digital camera, gleefully rush home to transfer the snapshots to their trusty PC…and leave them there. Except for the occasional email or online photo album, all those poor pictures never make it back out of that drab beige box.

That's a shame, because digital photography actually lets you display, reproduce, and repurpose your captured images in *more* ways than ever. Printing is one way to free photographs from their digital prison, as the previous chapter explains. This chapter gives you a sampling of the scores of other possibilities that await. Best of all, all you need are the skills you've already learned in this book. If you know how to organize photo files, upload pictures to an online album, place a Web order, and send email attachments, then you can do every project in this chapter.

For example, with just a few clicks, you can transform your photographs into a dramatic onscreen slideshow, complete with music and transition effects, using the free PhotoShow program. Using the same Web sites covered in this book—Kodak EasyShare Gallery, Shutterfly, and Snapfish—you can use your favorite photographs in custom photo books, calendars, greeting cards, and clever gift items like mugs and t-shirts.

Of course, if you're willing to learn a few new tricks (and pay $100 for a copy of Photoshop Elements), then you can really exercise your creative chops. Elements gives you the power to create video slideshows that you can burn onto a CD and view on a TV, with complete artistic control over the music, timing, and special

effects—you can even add text and narration. Elements also lets you break away from the predesigned book, calendar, and card layouts you find on the Web so you can really create homemade photo projects that are all your own.

> **TIP** Just because you want to create your own layouts doesn't mean you have to do your own *printing*. As you'll see later in this chapter, when you design a project in Elements, you can print it out at home, give it to your local copy shop for printing, or upload it to Kodak Gallery for production. Good news for EasyShare fans!

Making Slideshows with PhotoShow

Think about the first time you saw a documentary by Ken Burns. You were probably mesmerized as one image dissolved into the next, and the camera panned smoothly around the entire image, somehow zooming in on just the right details. A little background music completed the mood. Surprise—Burns created those shows from static images, just like the ones you take with your digital camera.

Sure, all the same Web sites where you create online albums let you display those albums as online slideshows, and usually offer automatic playback, so your audience doesn't have to click to see new pictures. But with a little free software, you can control the time each image stays onscreen, add background music, and choose themes that include borders and other visual effects. When you create slideshows in PhotoShow Express, you share them by uploading them to a free home page on the PhotoShow Circle Web site (which the program creates with your permission).

> **TIP** Spring for the $50 PhotoShow Deluxe, and save your slideshows as self-playing files that you can store on your PC, send by email, burn to CDs, and so on. You also get more editing options, like control over the speed and type of transition between *each* photo. When you try to choose a command that's available only in the Deluxe version, PhotoShow asks if you want to upgrade. This chapter covers the free version.

To get the PhotoShow Express software, visit *www.nero.com*. On the home page, ignore the offers to buy software, and click the Downloads link near the top of the page. Scroll down to "Free Software" and click the link for Nero PhotoShow Express 4. You'll end up with an installer icon on your desktop. If the installer doesn't start automatically, double-click this icon to install the software.

Once you have PhotoShow Express installed, making a complete slideshow with visual effects and a soundtrack isn't much harder than collecting photos in an album. Here are the basic steps:

1. **On your PC, locate the photos you want to put into a slideshow.**

 It's easier if you put all the photos you want to use into a single folder before you start working in PhotoShow.

TIP Pay attention to the orientation of your photos. Photos in landscape (horizontal) orienta-
tion fill the entire screen, but narrow, portrait (vertical) ones get black bars on each side. For the
smoothest, most uniform look, use all landscape shots, if possible. On the other hand, mixing por-
trait and landscape shots can create visual interest (or at least jar your audience awake).

2. **Start PhotoShow. On the opening screen, click the Manage button.**

 The program has three basic modes: Manage, Make, and Share. If PhotoShow is
 already running, then click the Manage tab at the top.

3. **From the list on the left, select the folder that holds your slideshow photos.**

 You may need to click the triangle next to My Pictures to expand the folder list.
 Once you see thumbnails of your photos in the window on the right, you can
 begin to organize your photos. Just drag the photos into position.

4. **Click the Make tab at the top of the window (Figure 17-1), and then choose
 PhotoShow from the options presented at the bottom of the screen.**

 PhotoShow displays the folder you were just looking at in Manage view. At
 right, a scroll bar lets you view all your photos.

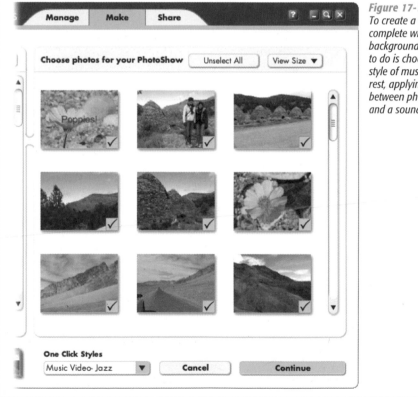

Figure 17-1:
*To create a PhotoShow slideshow
complete with fancy dissolves and
background music, about all you have
to do is choose the photos and the
style of music. PhotoShow does the
rest, applying a variety of dissolves
between photos, camera movement,
and a soundtrack.*

5. **To select individual photos, click each one to add it to the slideshow.**

 If you want to use *all* the photos in the folder, simply click the Select All button at the top of the screen.

6. **From the One Click Styles drop-down menu (Figure 17-2), choose either a Music Video style or a theme.**

 The music styles simply add a prerecorded soundtrack and coordinating transitions to your slideshow. The theme styles also include matching borders and other visual effects. After you choose a theme, click Continue.

Music Video- Pop
Music Video- Rock
Music Video- Jazz
Music Video- Country
Music Video- Hip Hop
Music Video- Electronic
Photo Documentary
Storybook
Old Film
Black & White
Manual Slide Show
Birthday
Love
Wedding
Christmas
Party
Custom

Figure 17-2:
PhotoShow Express gives you a variety of background music options. If you select one of the other styles, such as Storybook or Wedding, then you also get theme-based borders and other effects.

7. **When the PhotoShow info screen appears, type a name for your show and other information if you wish.**

 The show name and some of the other details appear in the title sequence and credits, so be creative (Figure 17-3). Entering comments and keywords helps identify the show later, especially if you share it with other PhotoShow Circle members. Click OK when you're done.

8. **Click the Make PhotoShow button.**

 The program does all the hard work, applying transitions and music to your photos. The end result's pretty snazzy, considering how little actual work you did. Ken Burns may not be impressed, but your friends will get a kick out of it. Behind the scenes, PhotoShow stores the slideshow on your PC, where you can play it from the Manage panel.

9. **To spread the joy, click the Share tab. From the options at the bottom, click Share PhotoShows. When the "Choose a PhotoShow or folder to share" window opens, select one of the slideshows you've created, and then click the Share PhotoShow button.**

 Other buttons on this screen let you email individual photos from your slideshows, or upload photos to a Shutterfly or Snapfish account. But don't be fooled; only the Share PhotoShow button lets you share *slideshows*.

Figure 17-3:
Use the PhotoShow Info box to
give your slideshow a good title.
Turn on the "Rename items…"
checkbox and PhotoShow
renames the photo files using the
name of the slideshow and a
sequence of numbers. So, for
example, this slide show, titled
"Death Valley Days with Mary,"
has photo files named: "Death
Valley Days with Mary-1,"
"Death Valley Days with Mary-2.
" and so on.

10. On the next screen, enter the email addresses of the folks you want to share the slideshow with, and then click Send.

 To use this feature, you must sign up for a free PhotoShow Circle account, if you don't already have one. The first time you share a slideshow, PhotoShow sends you a confirmation email and walks you through a few steps to create a personal Web page where all your shared slideshows will appear. The URL will be *www.photoshow.net/[Your PhotoShow Circle account name]*, so type carefully.

Once you create your PhotoShow page, you can invite friends and relatives to come see the show, much like sharing an online album (but more impressive).

Simple Slideshows in Elements

Like digital photos themselves, digital slideshows come in many different flavors and formats. When you view a slideshow on a site like Kodak EasyShare Gallery, you're looking at a Web page. Some programs, like PhotoShow, save slideshows as a video file.

Photoshop Elements gives you two options: A super-simple PDF slideshow and an elaborate custom slideshow (think Ken Burns), which you can read about on page 369. Elements' Simple Slide Show is easy to assemble and you can email it to anyone, regardless of operating system, since all computers these days can run Adobe Acrobat or another free PDF-viewing program. The Simple option is great when

you've already edited your photos in Elements and just need a quick way to share them. The resulting PDF is impressive, but you can't edit your photos during the creation process, add music, or control the transitions between slides. (The Custom Slide Show, on the other hand, lets you edit away to your heart's content before you finalize your slideshow.)

Emailing a PDF slideshow is almost as easy as emailing a single photo. In fact, you create the slideshow right in Elements' email window:

1. **In the Organizer, select the photos you want to put into a slideshow. Then, in the Shortcuts bar, choose Share → E-mail, or press Ctrl+Shift+E.**

 Actually, you can even start by choosing just one photo, since you can add and remove photos in the Attach to E-Mail window as shown in Figure 17-4.

 TIP If your photos are widely scattered throughout your catalog, it's usually faster to create a collection (page 182) first and start from there. A collection is also a handy way to preselect the order in which your photos appear in the slideshow.

Figure 17-4:
To change the order of your photos, just drag the thumbnails into the order in which you want them to appear. (Due to a bit of Elements quirkiness, this dragging doesn't always work perfectly. You may need to delete the photos and add them back in the order you want.) Use the green Add Photos button to find additional images, or highlight a photo and then click the red Remove button to get rid of it.

2. **From the Format drop-down menu, select Simple PDF Slide Show.**

 You can add or remove photos from your slideshow by using the buttons below the photo area on the left side of the window.

3. **In the File Name field, name your slideshow.**

 You must enter a name before Elements will create the slideshow.

4. **From the Maximum Photo Size menu, choose Small or Medium.**

 On most computers, Medium works well for email slideshows, unless you use a large number of photos. Later, you'll get a chance to see how long your

slideshow will take your viewers to download and change this setting if necessary. The Quality slider is another way to reduce download times (but keep it as high as possible).

TIP If you want to burn this PDF to a CD, then you can safely leave the Maximum Photo Size menu at Use Original Size and let your friends see your pictures at their actual size and full quality. Just complete these steps, and then use your email program to save the attachment to your desktop. Burn it to a CD using either the Windows CD-burning utility or a third-party program like Roxio's Easy CD Creator, for example.

5. **Select email recipients from your Contact list (page 331), and replace the canned message text with your own words. Click Next when you're done.**

 You can also wait until you're in your email program to specify a recipient and message. When you click Next, Elements opens a pop-up window showing you the file size of your completed slideshow and the approximate download time for a recipient who's using a dial-up modem.

6. **Click OK if the size is acceptable, or Cancel to go back to the Attach to E-Mail window to adjust image size and quality, as described in step 4.**

 When you click OK Elements creates your slideshow, launches your email program, and attaches the slideshow to a message. After reviewing or completing the message, you're ready to send off your slideshow.

Custom Slideshows in Elements

Elements Custom Slide Show tool lets you add audio, clip art, and fancy slide-to-slide transitions. All sorts of fun features are available in slideshows and you get several ways to share your completed slideshow, including making a Video CD (VCD) or (if you also have Premiere Elements) a DVD that your friends can watch in a regular DVD player. You can also email your slideshow or share it online (both explained in the section "Saving Your Slideshow" on page 377).

To get started, from the Organizer, select the images you want to include. You can also start with a single photo and add more photos in the Slide Show Editor.

TIP To both choose photos *and* put them in the viewing order you want before you start working in the Slide Show Editor, you can set up a temporary collection (page 182). You can change the order once you're in the Slide Show Editor, but for large shows, you save time if you have things arranged in pretty much the correct order when you start.

When you're ready to launch the Slide Show Editor, click Create, choose Slide Show from the window that appears, and then click OK. Before you enter the actual Slide Show Editor, Elements presents you with the Slide Show Preferences window, described next.

Slide Show Preferences

This window shows you some basic starting settings for all your slideshows, like the duration of each slide and the color of the background. What you see here determines the overall look, feel, and pace of the show. If you change the settings in this window, you change the starting settings for all new slideshows you create. Or just leave this window alone, and you can adjust these settings for just *this* particular show in the Slide Show Editor.

Here are the Slide Show Preferences you can set:

- **Static Duration** controls how long each slide displays before it moves on to the next one.

- **Transition** controls how Elements should move from one slide to the next. If you choose a different transition from the pop-up menu, then you can audition it in the little preview area at the right of the window, as explained in Figure 17-5.

Figure 17-5:
You can set the slide duration, background color, and transition for all your slideshows in the Slide Show Preferences window. If you choose a transition here, Elements automatically applies it to every slide. But you can override this setting for individual slides in the Slide Show Editor's Storyboard by clicking the transition you want to change and choosing a different one.

- **Transition Duration** controls how fast you want the transition to happen.

- **Background Color.** Click the color square for the Elements Color Picker to choose a different background color, which appears if your image isn't big enough to fill the entire slide.

- **Apply Pan and Zoom to All Slides.** If you set up the Pan and Zoom feature (explained later) for one slide, and turn Apply Pan and Zoom to All Slides on, then the camera swoops around *every* slide. It's a great way to get the most bang for your buck if you have only a limited number of images to work with.

- **Include Photo Captions as Text.** If you want to see whatever's in the Caption field for your photo on the screen with the image, then turn on this checkbox.

- **Include Audio Captions as Narration.** Elements lets you record audio captions for your slides. Turning this checkbox off creates a silent version of your show.

- **Repeat Soundtrack Until Last Slide.** If the music file you choose for your show doesn't last until the last slide, this checkbox ensures that Elements repeats your song as many times as necessary to accompany all your images.

- **Crop to Fit Slide.** Turn either of these checkboxes on, and if your image is too large for the slide, then Elements chops off the excess for you. You can choose separately for landscape- and portrait-oriented photos, but it's best if you do any cropping yourself before starting your slideshow.

- **Preview Playback Options.** Choose the quality for previewing your show while you're working on it. This doesn't affect the quality of the final slideshow.

When you're done checking or adjusting the preferences, click OK.

> **TIP** If you don't want to see the preferences every time you start a new show, then turn off "Show this dialog each time a new slideshow is created." You can still get back to the window at any time when you're in the Slide Show Editor by going to Edit → Slide Show Preferences.

Editing Your Slideshow

After you close the Slide Show Preferences box, the Elements Slide Show Editor opens (Figure 17-6). It's just crammed with options, but everything is laid out very logically—in fact, it's pretty similar to the usual Editor window. For example, you get a menu bar across the top of the window, but most of the commands here are available elsewhere via a button or a keystroke (like Ctrl+Z to undo your last action). On the left side of the window is the preview area. Notice the Palette bin on the right side of the screen. You can collapse the bin by clicking its edge when you want to get it out of your way. Collapsing the bin makes the preview space expand across the window. Click the hidden Palette bin's edge again to bring the bin back onscreen.

At the bottom of the window is the *Storyboard*, where you see your slides and the transitions between them. Click a slide or transition here, and its properties appear in the Palette bin. If you don't want to see the Storyboard anymore, go to the Slide Show Editor's View menu and turn it off by removing the checkmark next to its name.

You can finesse your show in lots of different ways in the Slide Show Editor. For instance, you can:

- **Edit your slide.** You can make any kind of editing changes to your photo right here in the Slide Show Editor. In the preview window, just double-click your image and then, using the choices you see in the Properties palette, you can

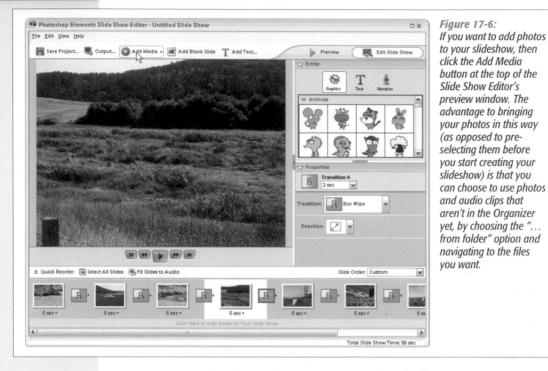

Figure 17-6:
If you want to add photos to your slideshow, then click the Add Media button at the top of the Slide Show Editor's preview window. The advantage to bringing your photos in this way (as opposed to pre-selecting them before you start creating your slideshow) is that you can choose to use photos and audio clips that aren't in the Organizer yet, by choosing the "… from folder" option and navigating to the files you want.

rotate your slide, change its size, crop it, and apply the Auto Smart Fix (page 240) and the Auto Red Eye Fix (page 239). Figure 17-7 shows you more about all your choices.

If you want to do more substantial editing, just click the More Editing button, and Elements whisks your slide over to the Standard Editor for you.

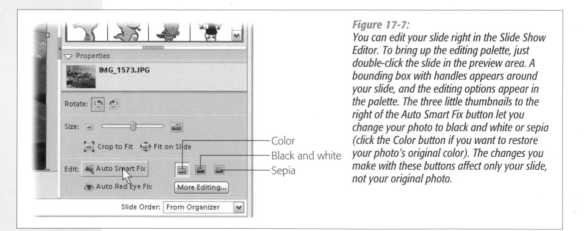

Figure 17-7:
You can edit your slide right in the Slide Show Editor. To bring up the editing palette, just double-click the slide in the preview area. A bounding box with handles appears around your slide, and the editing options appear in the palette. The three little thumbnails to the right of the Auto Smart Fix button let you change your photo to black and white or sepia (click the Color button if you want to restore your photo's original color). The changes you make with these buttons affect only your slide, not your original photo.

Color
Black and white
Sepia

- **Duration.** You see a duration number listed below each slide (in the Storyboard), indicating how long a slide appears on the screen before it transitions to the next slide. Click the arrow to the right of the number for a pop-up menu that lets you change how long that slide appears onscreen. You don't need to assign the same amount of time to each slide.

- **Transition.** Elements gives you loads of different ways to get from one slide to the next. These transitions appear in the Storyboard, and they're represented by tiny thumbnail icons between the two slides they connect. (The transition icon changes to reflect the current transition style when you choose a new transition.) Click any transition to see a pop-up menu listing all transitions, and choose a different kind of transition, if you like.

 Transitions have their own Properties palettes, which appear when you click a transition in the Storyboard. You can choose how long a transition is going to take and, for some transitions, the direction in which you want the transition to move.

If you like to make long slideshows, you'll appreciate the Quick Reorder feature, explained in Figure 17-8. When you switch over to the Quick Reorder window, you see all your slides in a contact sheet–like view, making it easy to reposition slides that would be annoyingly far apart if you had to move them in the Storyboard. In Quick Reorder, you can easily drag them to another spot in the lineup without the hassle of scrolling.

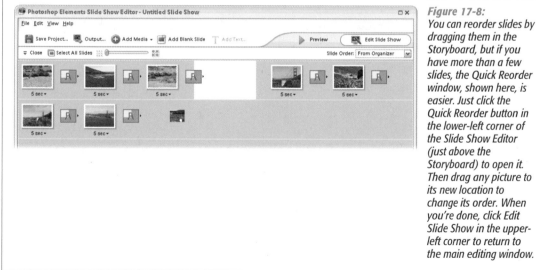

Figure 17-8:
You can reorder slides by dragging them in the Storyboard, but if you have more than a few slides, the Quick Reorder window, shown here, is easier. Just click the Quick Reorder button in the lower-left corner of the Slide Show Editor (just above the Storyboard) to open it. Then drag any picture to its new location to change its order. When you're done, click Edit Slide Show in the upper-left corner to return to the main editing window.

Adding Special Effects

Elements gives you all kinds of ways to gussy up your slideshow, including the ability to add clip art, text, and sound. If you want to create a slide that lists credits, for

instance, then start by creating a blank slide. (Just click the Add Blank Slide button above the preview area.) Elements adds a blank slide to the end of your show, to which you can then add your credits. Here's a rundown of what you can add to your blank slide (or to any of your slides, for that matter, as shown in Figure 17-9). Simply click the relevant button (Graphics, Text, or Narration) in the Extras section at the top of the palette to see your options.

Figure 17-9:
You can add all sorts of clip art to your slides in Elements, as well as create slides that include only art or text. To learn how to do cool tricks with clip art, like crowning your cat, see the box on page 375.

- **Graphics.** Elements gives you a whole library worth of clip art you can add to your slides. The art is divided into these categories: animals, backgrounds, costumes, flowers, food, frames, holidays & special occasions, home items, miscellaneous, ornaments, scrapbooks, sports and hobbies, and thought and speech bubbles.

 You'd use the backgrounds on a blank slide, because they cover a whole slide, but you can add the rest of the clip art to slides that already have something on them. To add a piece of clip art to a slide, just double-click the clip art object's thumbnail in the palette. For advice on making clip art work, see the box on page 375.

- **Text.** You can add text to your slides, and also apply a number of fancy styles to your text. To do so, click the Text button at the top of the palette, and then double-click the text style you like. The Edit Text window pops up. Type in the

Fun with Clip Art

Elements gives you a wide range of clip art that you can use to hilarious effect, like hats, outfits, and glasses. The key is to not overdo it—once per slideshow is plenty—and to make sure your clip art's size, shape, and angle work with the rest of your slide. When you add a piece of clip art (page 374), it appears on your slide surrounded by a frame. You can grab the corners of the frame and drag them to resize the clip art object to the size you want. You can also reposition clip art by dragging it. However, you may notice that you can't *rotate* the clip art on the slide.

Here's a workaround: Rotate the clip art in Elements' standard Editor window, and then add the slide back into your slideshow. Open your slide in the Editor, and then import the clip art image from its original folder: C:\Documents and Settings\All Users\Application Data\Adobe\ Photoshop Elements\Organizer\Graphics. Then, use the Move tool to place the clip art just so and the transform commands to adjust the shape, if necessary. When you're done, reimport your image into the Organizer. Go back to the Slide Show Editor, and click the Add Media button to add the new version to your slideshow.

words you want to add to your slide. When you're through typing, click OK. The text appears in your slide, surrounded by a bounding box, which you can use to place the text where you want it.

TIP When the Edit Text window is active, you can't click OK by pressing the Enter key. That just creates a line break in your text. You need to click the actual OK button.

At the same time, the Text Properties palette appears at the lower right of the Slide Show Editor. You can change the font, size, color, and style in the palette. You can even choose a different color here for the drop shadow if you're using shadowed text. If you want to edit text later on, then click the letters on the slide to bring back the text bounding box and the Text Properties.

- **Narration.** If you have a microphone for your PC, then you can record your own slideshow narration. Just click the slide you want to add your voice to, and then click the Narration button in the palette. You'll see the recording window shown in Figure 17-10. Click the red Record button and start talking. Click it again when you're done. If you don't like how things turned out, then click the trash icon and choose Delete This Narration.

- **Music.** You can add a full-scale soundtrack to your slideshow. To do that, click the bottom of the Slide Show Editor where it says "Click Here to add Audio to Your Slide Show." (These words looks grayed out, but they still work when you click.) In the window that opens, navigate to the audio you want and click Open. You can choose from any MP3, WAV, or WMA files you have on your PC.

NOTE If you use iTunes, you'll need to convert your iTunes AAC files to one of these formats before Elements will acknowledge their existence. To do so, right-click any song name in iTunes and choose, from the pop-up menu, "Convert Selection to MP3."

Figure 17-10:
Adding a narration to your slides is easy. You can even save your narration as an audio caption for the original photo. Just turn on "Save Narration as an Audio Caption" before you click Record. Clicking the folder icon to the right lets you import an existing audio file—like a candid recording of your child's voice that you made another time.

You can make your slideshow fit the duration of the music, if you like. At the top of the Storyboard, click "Fit Slides to Audio," and Elements spins out your slideshow to last the entire length of your song. Or, if you'd rather repeat a short audio clip over and over, then go to Edit → Slide Show Preferences and turn on "Repeat Soundtrack until Last Slide." If you don't choose either one, then Elements doesn't make any attempt to synchronize the length of the soundtrack and the length of the slideshow.

TIP If you have problems getting the Organizer to play one of your MP3 files, you may have better luck if you use an audio program to re-encode your MP3 as a variable bit-rate MP3 file. Check your audio program's options or Help files for instructions on how to do this.

• **Pan and Zoom.** To create your own Ken Burns effect, click the slide you want to pan over then, in the Properties palette, turn on the "Enable Pan and Zoom" checkbox. When you do so, the palette displays two little thumbnails, labeled Start and End. Click the Start thumbnail, and then move the pan frame to the spot on your photo where you want to start the pan. Drag the frame around, and drag corners to resize the frame, until you've got just the right starting image.

Then, in the Properties palette, click the End thumbnail and repeat the process to set the end point for panning and zooming. If you decide you want to edit the effect, then you can always click either thumbnail again to bring back the pan frame. You can also click the buttons between the thumbnails to swap where you start and end.

You can pan more than once on a slide, too. To do that, click "Add Another Pan and Zoom to This Slide." If you want all your slides (or selected slides) to show the same pan and zoom you just set up, then go to the Edit menu and, from the pop-out menu, choose what you want to do: "Apply Pan and Zoom to Selected Slide(s)," or "Apply Pan and Zoom to All Slides."

TIP While Elements doesn't give you a way to create scrolling credits, you can fake them by creating a slide with a list of who you want to credit and then applying the pan and zoom effect to the slide multiple times.

Saving Your Slideshow

After you've finished all your work creating your slideshow, be sure to save it. (If you forget, Elements reminds you to do so when you exit the Slide Show Editor.) As long as you save your slideshow as a Slide Show, you can always go back and edit it whenever you like. To edit an existing slideshow, just right-click its thumbnail in the Organizer and, from the pop-up menu, choose Edit. Elements opens your show up in the Slide Show Editor so that you can make your changes.

> **TIP** You can watch a full-screen preview of your slideshow by clicking the Preview button above the Palette bin, or by pressing F11. (Pan and zoom effects usually look pretty jerky when you preview your slideshow, but they'll be smooth in the final slideshow.)

Once your magnum opus is complete, you're almost ready to save your file. But first you've got to decide which format you want to use for finalizing your slideshow. To see your Output options, click the Output button above the Slide Show Editor's preview window. You get a new window (Figure 17-11) where you can choose from several ways to save and share your slideshow.

Figure 17-11:
Elements Slide Show Output window gives you a lot of options. No matter which you choose (except for PDF) you end up with a Windows Media Video (WMV) file. Folks with Windows and even Macintosh computers can download Windows Media Player for free, but if you must create a PDF file, see the box on page 379.

• **Save as File.** Choose this option to save your slideshow to your hard drive as a PDF or Windows Media Video (WMV) file. The PDF options are explained in the box on page 379. If you choose WMV, you have several choices for size and quality. There's no need to change the setting that Elements proposes unless you already know how you're going to use the WMV file and which setting you'd want for that use. Otherwise, just leave the menu set to Maximum for now.

- **Burn to Disc.** You can create a Video CD (VCD) using Elements. This disc plays in a DVD player, just like a regular DVD, but you don't need a DVD recorder to *create* one. The downside is that VCD is a very tricky format—the quality is low and you can expect to have some problems getting the discs to play in some DVD players. If you want to send VCDs, then you may want to make a short test slideshow for your friends to be sure they'll be able to watch one, before you invest a lot of time in creating a large project. To learn more about the format and compatible players, head over to *www.videohelp.com/vcd*.

You can also choose to include other slideshows on the same disc if you turn on the "Include additional slide shows I've made on this disc" checkbox in the Output window. Then click OK to bring up the "Create a VCD with Menu" window where you can choose the slideshows you want to include.

In the "Create a VCD with Menu" window, you must choose between the NTSC or PAL formats for your disc. Choose PAL if you're sending your slideshow to Europe or China, and choose NTSC for most other areas, including the United States. Then click Burn to begin burning your disc.

> **NOTE** If you also have Adobe's Premiere Elements software (and a drive that can create DVDs), then you can send your slideshow to Premiere Elements to make a true DVD. (If you have a DVD recorder, but no Premiere Elements, you can save your slideshow and then use any other DVD-authoring software you've got loaded on your PC.)

- **Email Slide Show.** You can send your slideshow via email, either as a WMV file or a PDF document. When choosing a size from the Slide Size pull-down menu in the Output window, just remember that your friends with dial-up Internet connections won't thank you for sending giant files.

- **Share Online.** If you set up a Kodak EasyShare Gallery account (page 132), you can post your slideshow there for your friends to watch. If you want people who have dial-up Internet accounts to be able to see your slideshow without waiting hours for it to download, choose Low Bandwidth. If your friends all have broadband Internet connections, you can choose High Bandwidth.

- **Send to TV.** If you have Windows Media Center Edition 2005, or later, running on your PC, and your television is connected to your computer, then you can send your slideshow straight to the TV for large-screen viewing. In the Output window, click Send to TV, and then type a name for your slideshow in the Name box. Next, choose the option in the Settings pull-down menu that correctly describes your TV, and then click OK. (If you aren't sure what to choose in the Settings menu, click the Details button to learn more about the currently selected choice.)

Making a PDF from a Custom Slide Show

When you create a Custom Slide Show, you can choose between making a Windows Media Video (WMV) file or a PDF. Picking the PDF format sounds like the best of both worlds, right? You figure you're getting a very compatible format (PDF), with all the bells and whistles of a Custom Slide Show.

Not really. When you create a PDF this way, you lose the pan and zoom feature, the audio, and the transitions that you set. You do keep any custom slides, text, and clip art that you added, though. On the whole, this feature's best used when you've created a full-scale Custom Slide Show, but one or two of the people you want to send it to won't be able to view it in Windows Media format. The people who get the PDF won't see everything the WMV recipients do, but it's faster than trying to recreate a separate version for the WMV-challenged.

To create a PDF from the Slide Show Editor click the Output button, and then choose "Save As a File" in the Slide Show Output window that opens. (Or, to make a PDF from an existing slideshow, right-click the slideshow's thumbnail in the Photo Browser and then choose Edit.) On the right side of the Slide Show Output window, click the PDF File button.

This button brings up a series of settings just for your PDF:

- **Slide Size.** This setting starts out at Small. If you're going to burn a CD, you can choose a larger size. If you want to email the final file, then choose Small or Very Small for your images. There's also a Custom choice for when you want to create a size that's different from one of the presets.

- **Loop.** Turn Loop on, and the slideshow repeats over and over until your viewer stops it by pressing the Escape key.

- **Manual Advance.** When you want recipients to be able to click their way through the slideshow instead of having each slide automatically advance to the next one, turn Manual Advance on.

- **View Slide Show after Saving.** Turn this setting on, and as soon as Elements is through creating your slideshow, it launches Adobe Reader so you can watch the results of your work.

When you've got everything set the way you want it, click OK to bring up the Save As dialog box. Name your file and then save it.

Posters, Calendars, and Photo Books

Of the hundreds of photos that come out of your digital camera every year, a few stand out. You know the thrill when you see a really good photo—right away you know it deserves better than the typical 4×6 print. The same online services that print photos—EasyShare, Shutterfly, and Snapfish—let you showcase your special shots on wall posters and calendars. After all, why stare at somebody else's nature photos or pets every month when *yours* are so much better looking? And the handsome photo books you can order from these sites make unforgettable gifts (and ones that'll never end up on eBay).

When you sign into your favorite photo Web site (as described in Chapter 6), you're just a click away from starting these projects. Look for an "online store" link—the folks in the marketing department make sure you won't miss it. Once you choose a project—poster, calendar, or book—the site walks you through choosing the details. Shutterfly is the most helpful, letting you watch a video demo

of the process. All of the sites let you either use photos already in your account or upload new ones from your PC as you create your project. If you're making a photo book, set aside some extra time for all the decisions you have to make, like choosing a cover, book size, page count, design theme, and laying out the individual pages.

You're spending more money when you create a calendar or a photo book, so it's important to choose your photos carefully and double-check the final project before you click the Place Order button. Before you place your order (and pay for it), take your time to review the entire project. Make sure everything's just the way you want it. Keep an eye out for missing pages, upside down photos, and so on. If there's text in the project, be sure you double-check the spelling, or better yet, have another person proofread it for you.

Here are some points to keep in mind when choosing photos for online projects:

- **Focus.** Especially with posters, even slightly out-of-focus shots jeopardize your results. Flaws that appear minor in a 4×6 photo become major problems in a 20×30 poster.

- **Orientation.** Choose photos that match the project's templates. If you're putting a tall portrait photo on a wide, landscape format calendar page, for example, then the online form may offer to crop the excess at top and bottom for you. Make sure you don't lose the top of someone's head. For more control, you can do your own cropping on your PC first (as explained in Chapters 9 and 10).

- **Resolution.** Make sure your photo's resolution matches the project. You can check resolution in Windows, as explained on page 336. If a photo's resolution is too low for your job, the online service lets you know with an exclamation point or other warning symbol. If you're in doubt, you can almost always find minimum requirements listed in the online service's help text.

Posters

When you've got a great photo and you want to make a big impact, it's hard to beat a poster-size print. Kodak Gallery, Shutterfly, and Snapfish all offer prints up to 20 x 30 inches. They cost between $20 and $23. As mentioned previously, when you enlarge a picture to this size, you magnify everything that's good *and bad* about it. Save posters for shots whose exposure and focus are close to perfect. Kodak recommends at least 1600×1200 pixels for photos for large format photos—consider that the *minimum* resolution.

Once you have the image you want, the rest is easy. Upload the file to your online album and order it as you would any other print. If you don't immediately see the large formats listed with the other photo sizes, then look around a little. You'll see a link that says "poster prints" or "larger size prints" somewhere on the page.

Another poster-like option is to print your photos onto canvas and have it stretched on a frame. You have the option of a photo realistic image or one that has a brushstroke effect applied, to give it the appearance of a painting. The cost for a 20 × 24 inch print is about $100.

Calendars

Calendars are another natural for publishing your photos, and they make wonderful family or business gifts. You can choose photos that match the current season or month, or do your own version of the ever-popular "Sexiest Exterminator of the Month."

The most common calendar is made up of 8.5 × 11 inch landscape pages, with a photo at the top and the days of the month below. They run about $20. But you can also find year-at-a-glance calendars with a single photo at the top, priced by size from $1 to $20. Shutterfly also offers calendar magnets and mouse pads.

Again, the important issues for creating good calendars are the quality and resolution of the photos. For a typical month-by-month calendar with 8.5 × 11-inch pages, you need a photo with the same resolution you'd use for an 8 × 10 print—at least 1536 × 1024 pixels.

Custom Photo Books

Whether you want to remember a family event, honor a little league team, or send baby photos to grandparents, photo books are just about the classiest way to go. No more clunky albums with photos sliding around inside plastic pages. For about the same amount that you'd pay for an album from the drug store, you can print your own photo book.

Photo books come in an enormous range of sizes, styles, and prices. Simple, spiral-bound 4 × 6 flipbooks start at about five bucks for five pages. A more elaborate 20-page hardcover book is close to $20 or $25. You can often choose to print photos on just one side of the page, in which case lefthand pages are blank, or you can print on both sides. Additional pages are usually about a dollar for each printed side.

Creating and laying out a photo book takes more time and care than any other photo project, but it's an enjoyable process, consisting mostly of choosing options—all of which are attractive. Do you want a paperback or a hardcover? Do you want linen or leather bound? All the while, you get to relive those happy memories as you lay your photos out on the pages. Shutterfly's page layout tools (Figure 17-12), show a typical example.

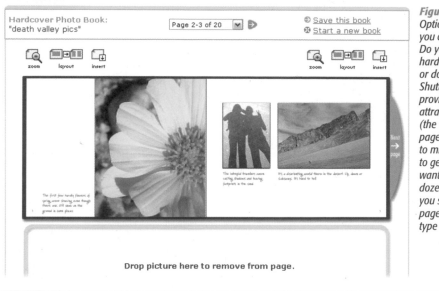

Hardcover Photo Book:
"death valley pics"

Page 2-3 of 20

🔁 Save this book
❌ Start a new book

zoom layout insert

zoom layout insert

Next
→
page

Drop picture here to remove from page.

Figure 17-12:
Options abound when you create a book online: Do you want softcover or hardcover? Single-sided or double-sided pages? Shutterfly, shown here, provides a variety of attractive page layouts (the view here is of a 2-page spread). You're free to mix and match pages to get just the look you want. By choosing from a dozen different styles, you select from different page backgrounds and type styles.

GEM IN THE ROUGH

Book Binding with Mypublisher.com

MyPublisher.com specializes in creating photo books and offers a wide variety from paperback pocket books (about $10) to leather-bound hardcovers (about $40). At the high end, you can order a book that's 16-inches wide and 12-inches tall with extra-thick, archival quality paper (about $60). Open this magnum opus and it spreads to almost a yard. It's a great choice for remembering special events like weddings.

To create your book, download the free BookMaker software, which helps you organize your photos and lay out your book.

BookMaker lays out the book automatically, but you can make changes to the layout. For example, if a page has a single photo on it and you'd like to show three photos on that page, then simply drag and drop a page template that has three photos onto the page. All you have to do after that is drag your three photos into position. It's easy to drag photos from page to page to experiment with different layouts. When you're done, you upload the results and receive the finished book in about seven days.

More Elements Creative Projects

EasyShare, Shutterfly, and Snapfish make it easy to create photo books, calendars, and other projects. They give you tons of options, but you're still limited to choosing from templates, layouts, colors, and designs created by others. Starting from a completely blank slate is intimidating even for professional designers, though, so Elements gives you just about the best of both worlds. The program helps you through the process while giving you full creative control.

Elements' Create projects make it easy to whip up photo books, album pages, greeting cards, calendars, and more. All these projects use easy-to-follow wizards, which launch from the Creation Setup window (Figure 17-13). Furthermore, you're not locked into purchasing your finished project from any one place. Elements produces your project as a PDF file, which you can publish as you see fit. Depending on your equipment, you can print it out at home, deliver it to a copy shop (by email or CD), or upload it to Kodak EasyShare Gallery for printing.

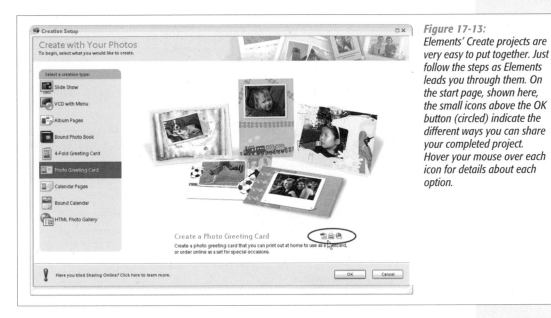

Figure 17-13:
Elements' Create projects are very easy to put together. Just follow the steps as Elements leads you through them. On the start page, shown here, the small icons above the OK button (circled) indicate the different ways you can share your completed project. Hover your mouse over each icon for details about each option.

You can get started on any of the Create projects from either the Editor or the Organizer:

1. **On the Shortcuts bar, click the Create button.**

 In the Organizer, you can also go to File → Create and choose what you want to do. (This takes you straight to the wizard for your project type, bypassing the main Create window.)

 The Creation Setup window appears.

2. **From the list on the left side of the window, choose the type of project you want to create, and then click OK.**

 In the first wizard screen, "Step 1: Creation Setup," you see a variety of choices depending on the project you chose.

3. **Select a design (called a *template*) from the list available, and then choose your options at the bottom of the window.**

 Usually you can choose the number of photos per page, and whether to include page numbers or captions. Some templates also let you choose to add

additional text in the form of headers (text above your photo) or captions (which appear below your photo). When you've made your choices, click Next Step.

4. **On the "Step 2: Arrange Your Photos" screen, choose the photos you want to use (if you didn't already have some photos selected when you started your project).**

 Drag photos to change their order, or add or delete photos by using the buttons at the top of the page. "Use Photo Again" places a duplicate of an image you've already used once in your project into the list again. You'd use this option when making a calendar where you want more than one month to show the same photo, for example.

5. **When you're satisfied with the number of photos and the order they're in, click Next Step.**

 In step 3 of the wizard, you see a preview of your project. If your project has space for text, you can add it as shown in Figure 17-14. You can change the font, size, and justification (alignment) for multiple lines of text, but the starting options are usually pretty effective, too. Use the pull-down menu above the image to navigate to the different pages of your project, if it has more than one page, or use the arrows to step backward and forward through the pages. When you've got your text entered, click Next Step.

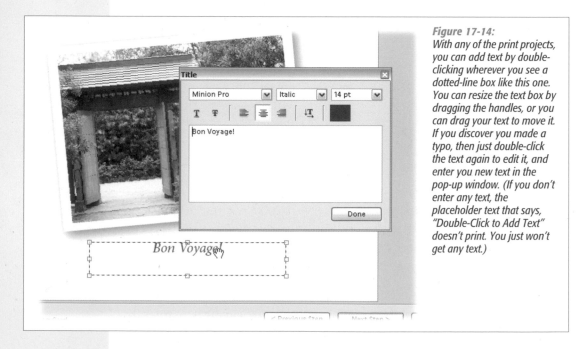

Figure 17-14:
With any of the print projects, you can add text by double-clicking wherever you see a dotted-line box like this one. You can resize the text box by dragging the handles, or you can drag your text to move it. If you discover you made a typo, then just double-click the text again to edit it, and enter you new text in the pop-up window. (If you don't enter any text, the placeholder text that says, "Double-Click to Add Text" doesn't print. You just won't get any text.)

6. **In "Step 4: Save," name your project and save it.**

If you chose to enter a title, you have the option of using that title as the saved file's name. Just turn on the checkbox. You can also choose to have the photos you've used appear in the Photo Browser when you finish, so you can easily create another project with the same photos. Click Save when you're done.

7. **In the "Step 5: Share" screen, choose what to do with your project.**

You can choose to create an Acrobat (.pdf) file, attach your creation to an email, or print it out. If printing by Kodak EasyShare is an option (if you created a photo book, for example), then the Order Online button is available for clicking.

At any time, you can back up to a previous step or cancel your project altogether by using the buttons at the bottom of the window. When you're finished, your completed creation gets added to the Organizer. You can see a list of all your stored Create projects by going to File → Open Creation.

While the basic steps are the same every time you run the Create wizard, your choices vary depending on what you're creating. The next section covers some Elements Create projects in more detail.

What You Can Create

Elements Create projects give you almost more choices than you can count. Fortunately, the wizard screens are clean and simple. But just to make extra sure you don't miss a single chance to get creative, here are some notes about a few popular project types:

- **Album Pages.** Elements lets you create individual album pages to put in a binder. You can choose whether or not to create a title page, and whether to include captions (Elements starts you out with any comments it finds in your Organizer), page numbering, and headers and footers (text above or below the photos).

 In step 1 of the Album wizard, click a template to preview its style. At the lower-left corner of that window, choose how many photos you want to include on each page. You also can specify how many photos you want to appear on succeeding pages so that every page isn't identical. To do so, click the menu "Number of Photos Per Page," and you see a list that lets you set the pattern you want, like a page with one photo followed by a page with two photos.

- **Photo books.** When you order hardbound photo books through EasyShare, your Title photo appears through a cutout in the cover (see Figure 17-15). Books can be up to 80 pages long, depending on the style you select. If you have less than 20 pages of photos, you get nagged to add more pages when you order, but you can order a book with blank pages at the end if you want to. You have the same options for the number of photos per page, title page, captions, page numbering, and header or footer text that you get when creating an Album Page.

You can edit the size of your photos in step 3 of the Project Creation wizard. Click Reset Photos if you decide you don't like the changes you made, and your page goes back to the way Elements originally set it up.

When you order your book, check out the Material pull-down menu on the Order page to see the different cover choices available—they make quite a difference in the cost of the book.

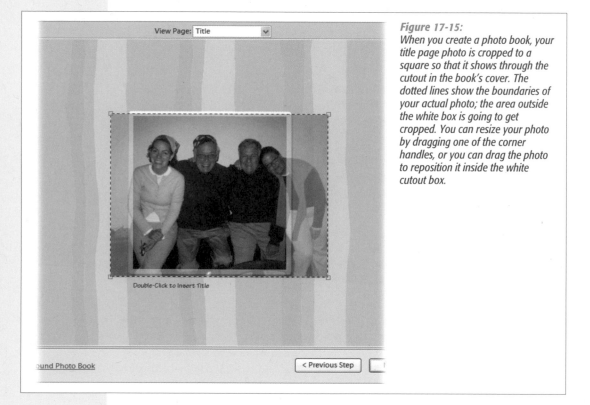

Figure 17-15:
When you create a photo book, your title page photo is cropped to a square so that it shows through the cutout in the book's cover. The dotted lines show the boundaries of your actual photo; the area outside the white box is going to get cropped. You can resize your photo by dragging one of the corner handles, or you can drag the photo to reposition it inside the white cutout box.

- **4-fold Greeting Cards.** These cards are intended for home printing on a full-sized sheet of paper that you then fold into quarters, so the finished card is quite small. (If you want a larger card, check out the Photo Greeting Cards, or set up your card yourself in the Editor.)

You can use only one photo in a Greeting Card. Elements may need to crop away part of your photo, so in step 3, you'll see your entire photo displayed, with a light mask over the portion that will be cropped away in the completed project. 4-fold cards have space for text inside them, so in step 3 don't forget to choose Inside from the pop-up menu above the preview area if you want to include text inside your card.

- **Photo Greeting Cards.** These are single-sided half-page sized cards, like postcards. The wizard works pretty much the same as the one for 4-fold Greeting

Cards, only of course you don't get an option for an inside page. You can order some styles online, which is a great way to create cards for holidays and special events.

TIP 4-fold Greeting Cards and Photo Greeting Cards rely on the paper size you choose in Page Setup (page 344) for the size of the final output. A popular workaround for resizing projects to an exact size that you can't get using your available paper sizes is to create a PDF in step 5 of the Create wizard, and then open the PDF in Adobe Reader to resize it to exactly the size you want.

- **Calendar Pages.** These pages are calendars you print out at home. In step 1 of the Create wizard, you can choose from a number of different styles, and you can also choose how many months you want your calendar to cover. (Each month gets one page.) While the wizard is set up for an annual calendar, by using the pop-up menus at the lower-left corner of the window in step 1, you can choose to make a calendar of any length from one month to several years.

 A one-year calendar usually requires 13 images (which you'd plug in during step 2: Choose Your Photos), since most styles have a separate title page that also needs a photo. You can use one of your monthly photos for the title page if you like, by clicking it and then clicking Use Photo Again. Then drag the duplicate and position it wherever you want it on the title page.

 You can take your printed pages to a local office supply store or copy shop for binding, if you want to make a bound calendar from these templates, or just use the Create Bound Calendar wizard and order your calendar from EasyShare.

- **Bound Calendar.** A very popular gift item. You upload your completed project to EasyShare and get back a spiral-bound calendar. The Bound Calendar wizard works just like the Calendar Pages wizard (but you get some fancier designs to choose from), and step 5 gives you the option of ordering a bound calendar online. You can also print these Bound Calendars at home as unbound calendar pages, if you prefer.

Photo Mugs, T-Shirts, and More

Your photos don't have to be relegated to a two-dimensional existence—they can become three dimensional *objets d'art* (well, if you consider aprons and playing cards *art*). EasyShare, Shutterfly, Snapfish, and a firm named Zazzle provide options that range from the sublime to the ridiculous (see the table at the end of this chapter for a full rundown of all your options). For example, take a picture and put it on a coffee mug, a keepsake box, or a mini-soccerball. It won't take long before you come up with the perfect combination of photo and object.

Here are some tips for ordering photo-adorned trinkets online:

- Cotton and canvas behave a little differently than high-resolution photo paper, so simple, vivid images usually work better than delicate, detailed ones. Experiment with high-contrast and saturated colors if you want something other than

a photo-realistic look, like the examples shown on EasyShare in Figure 17-16. EasyShare's cartoon and coloring book effects (page 276) can also create great looking t-shirts.

Figure 17-16:
Don't be a slave to fashion: create your own. You'd be surprised how many wearable objects you can create

- Many online services offer nearly identical products; compare prices to take advantage of the competition.

- You may even make back a bit of money to support your digital shutterbug habit: Zazzle (*www.zazzle.com*) not only lets you buy products with your photos on them, it lets you *sell* them to other people (Figure 17-17). You'll have some competition for those visitors' dollars, though: Zazzle offers Special Collections from the likes of Disney, Star Wars, Marvel Comics, and the Library of Congress.

Figure 17-17:
The Zazzle Contributor's Gallery lets you showcase and sell your work to a large online marketplace. For example, you can turn a cute dog photo into a touching Get Well card or a clever t-shirt. You earn a 10 percent royalty every time someone buys a product with your design. Typically, Zazzle collects your royalties until they amount to $25 and then sends you a check.

- T-shirts are popular and, at around $15, affordable. But since you can't always predict fit, consider options where size isn't an issue. For the greatest variety in wearable photography, check out Snapfish. They have a mind-boggling array of products, including neckties, aprons, and scarves.

- If you're ordering a batch of gifts, such as travel mugs for your entire softball team, it's wise to order one sample first. Then, you can check the quality and double-check the design before you place a large order.

Table 17-1. Some sites specialize in different types of items. Only Snapfish, however, offers boxer shorts

	EasyShare	Shutterfly	Snapfish	Zazzle
Albums	Yes	Yes	Yes	
Aprons	Yes	Yes	Yes	
Archive CDs or DVDs	Yes	Yes		
Bibs			Yes	
Books	Yes	Yes	Yes	
Box - Storage		Yes	Yes	
Boxer Shorts			Yes	
Calendars	Yes	Yes	Yes	
Candy Tin			Yes	
Canvas Prints	Yes	Yes	Yes	
Children's Picture Books		Yes		
Clipboard			Yes	
Clocks			Yes	
Coasters	Yes	Yes	Yes	
Collage	Yes			
Frames	Yes	Yes		
Golf Towels			Yes	
Greeting Cards	Yes	Yes	Yes	Yes
Magnets		Yes		
Mouse Pads	Yes	Yes	Yes	
Mugs	Yes	Yes	Yes	
Neckties			Yes	
Notepads			Yes	
Pet Bowl			Yes	
Placemat			Yes	
Pillows			Yes	
Pillow Cases			Yes	
Playing Cards	Yes		Yes	
Postage Stamps	Yes			Yes
Posters	Yes	Yes		Yes
Puzzles	Yes		Yes	
Scarves			Yes	
Shirts	Yes	Yes	Yes	Yes
Stickers	Yes		Yes	
Tote Bags	Yes	Yes	Yes	

Index

DIGITAL PHOTOGRAPHY: THE MISSING MANUAL

Colophon

Philip Dangler was the production editor and proofreader for *Digital Photography: The Missing Manual*. Darren Kelly and Marlowe Shaeffer provided quality control.

Karen Montgomery produced the cover layout with Adobe InDesign CS using Adobe's Minion and Gill Sans fonts.

David Futato designed the interior layout, based on a series design by Phil Simpson. This book was converted by Abby Fox to FrameMaker 5.5.6. The text font is Adobe Minion; the heading font is Adobe Formata Condensed; and the code font is LucasFont's TheSans Mono Condensed. The illustrations that appear in the book were produced by Robert Romano and Jessamyn Read, using Macromedia FreeHand MX and Adobe Photoshop CS.